The Egyptian Revival

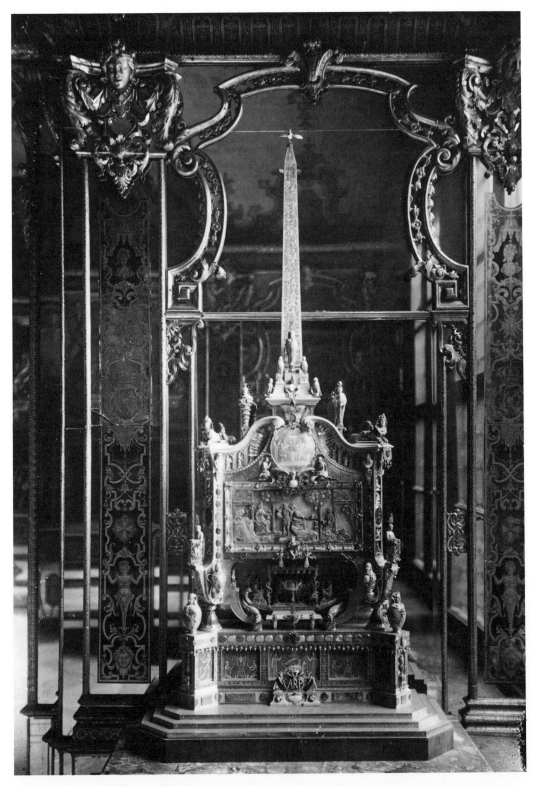

Frontispiece The Apis altar (1731) by Johann Melchior Dinglinger (1664–1731) for the Elector August the Strong of Saxony. Note the panels in the Egyptian taste, the 'Canopic' figures, the crowning sphinxes, the Egyptian figures, and the Egyptian obelisk with hieroglyphs (*Grünes Gewölbe. Staatliche Kunstsammlungen, Dresden. VIII.202*).

The Egyptian Revival

An introductory study of a recurring theme in the history of taste

JAMES STEVENS CURL

London
GEORGE ALLEN & UNWIN
Boston Sydney

George Allen & Unwin (Publishers) Ltd,
40 Museum Street, London WC1A 1LU, UK

George Allen & Unwin (Publishers) Ltd,
Park Lane, Hemel Hempstead, Herts HP2 4TE, UK

Allen & Unwin Inc.,
9 Winchester Terrace, Winchester, Mass 01890, USA

George Allen & Unwin Australia Pty Ltd,
8 Napier Street, North Sydney, NSW 2060, Australia

First published in 1982

British Library Cataloguing in Publication Data

Curl, James Stevens
 The Egyptian revival.
1. Civilization, Occidental 2. Egypt–Civilization
I. Title
909'.0981'2 CB245
ISBN 0·04·724001·6

Set in 10 on 11 point Baskerville by Fotographics Ltd, Bedford
and printed in Great Britain
by Mackays of Chatham

for
Sarah, my mother,
and John, my brother

By the same author

European Cities and Society. The Influence of Political Climate on Town Design (London, Leonard Hill Books, 1970 and 1972.)

The Victorian Celebration of Death (Newton Abbot, David & Charles, 1972.)

City of London Pubs. A Practical and Historical Guide (co-author Timothy M. Richards) (Newton Abbot, David & Charles, 1973.)

Victorian Architecture: its Practical Aspects (Newton Abbot, David & Charles, 1973.)

The Cemeteries and Burial Grounds of Glasgow (City of Glasgow District Council Parks Department, 1975.)

The Erosion of Oxford (Oxford Illustrated Press, 1977.)

English Architecture: an Illustrated Glossary (Newton Abbot, David & Charles, 1977.)

Nunhead Cemetery, London. A History of the Planning, Architecture, Landscaping and Fortunes of a Great Nineteenth-Century Cemetery. Originally printed in the *Transactions* of the Ancient Monuments Society, edited by E. M. Yates, this paper was published as a separate volume by the Society in 1977.

Mausolea in Ulster (Belfast, Ulster Architectural Heritage Society, 1978.)

Moneymore and Draperstown. The Architecture and Planning of the Estates of the Drapers' Company in Ulster (Belfast, Ulster Architectural Heritage Society, 1979.)

A Celebration of Death. An introduction to some of the buildings, monuments, and settings of funerary architecture in the Western European tradition (London, Constable, 1980.)

Classical Churches in Ulster (Belfast, Ulster Architectural Heritage Society, 1980.)

The History, Architecture, and Planning of the Estates of the Fishmongers' Company in Ulster (Belfast, Ulster Architectural Heritage Society, 1981.)

Introduction to a facsimile edition of John Claudius Loudon's *On the Laying Out, Planting, and Managing of Cemeteries, and on the Improvement of Churchyards* (Redhill, Ivelet Books, 1981.)

Egypt! from whose all dateless tombs arose
Forgotten Pharaohs from their long repose,
And shook within their pyramids to hear
A new Cambyses thundering in their ear;
While the dark shades of forty ages stood
Like startled giants by Nile's famous flood.

LORD BYRON (1788–1824): *The Age of Bronze.* Pt V.

Contents

List of Illustrations

PLATES

Frontispiece Apis altar by Johann Dinglinger

xiv

FIGURES

Illustrations not otherwise acknowledged are reproduced from material in the author's collection.

Acknowledgements

... the land of Egypt, when we sat by the flesh pots,
and when we did eat bread to the full.

<div align="center">EXODUS: XCI. 3.</div>

I have been greatly helped by many people to assemble the great mass of material that forms the basis of this book.

First of all, I am grateful to my publishers, and especially to Mr Rayner Unwin and Mr John Newth for so quickly seeing the possibilities in my first ideas. Mr Merlin Unwin subsequently became closely involved at the formative stage, and took the process through to publication. Mr John Harris and his staff at the R.I.B.A. Library Drawings Collection have been more than helpful. I should also like to thank Herr Ulf Cederlöf of the Teckning och Grafik department, Statens Konstmuseer, Stockholm; Dr Marianne Fischer of the Staatliche Museen Preussischer Kultur-besitz; the staff of the Kupferstichkabinett und Sammlung der Zeichnungen, Staatliche Museen zu Berlin; the staff of the Deutsches Theatermuseum, Munich; Dr Gerald Heres and the staff of the Grünes Gewölbe, Staatliche Kunstsammlungen, Dresden; Dr Manfred Boetzkes of the Theater-museum, Köln; Mr Nicholas Thomas, Director of the City of Bristol Museums; Miss M. V. Gordon; the staff of the Historisches Archiv of the Fried. Krupp GmbH, Villa Hügel, Essen; Mr David Dean and the staff of the R.I.B.A. Library; Mr Ernest McKee and the staff of the Bank of Scotland, Queen Street, Glasgow; Mr C. A. McLaren, Keeper of Manuscripts at Aberdeen University Library; the Caisse Nationale des Monuments Historiques et des Sites; Dr Štefan Krivuš and the staff of the Matica Slovenská; Miss Ursula McMullan of the Mansell Collection; the staff of the Cooper-Hewitt Museum, the Smithsonian Institution's National Museum of Design, New York; Dr sc. K.–H. Priese, Abteilungsleiter, Ägyptisches Museum, Staatliche Museen zu Berlin; Mr John Hopkins and the staff of the Society of Antiquaries of London; the staff of the Bodleian Library, Oxford; the staff of the British Library; Mr Bryan Hucker and the Director of Greenwich Hospital; the staff of the Victoria and Albert Museum; the staffs of the Lincolnshire Library Service at Boston and Lincoln; the staff of the Bibliothèque Nationale in Paris; the Direzione Generale Musei Vaticani; the staff of the Biblioteca Apostolica, Città del Vaticano; and the staff of the Courtauld Institute of Art. I owe especial thanks to Mr Ralph Hyde of the Guildhall Library, City of London; to Mr John Morley, Director of the Art Gallery and Museums and the Royal Pavilion at Brighton; and to Mr Peter Clayton. Mr Hyde has been a tower of strength in providing notes, references, and pictures of Egyptianising material, while Mr Clayton's expertise and generosity have made the task of writing this book very much less onerous than would have been the case without his help.

I am very grateful to Mr F. H. Thompson, General Secretary of the Society of Antiquaries of London, and to the Society itself for practical help from the Research Fund. Other persons who very kindly assisted in the project with advice, information, and time, were Mr Harold Allen, Mr David Atwell, Mr Geoffrey de Bellaigue, Miss Eileen M. Bennett, Mr I. L. Bradley, Unit Administrator, Biddulph Grange Orthopaedic Hospital, Professor Richard G. Carrott, Mrs Bridget Cherry, Mr Giles Clotworthy, Mr Howard Colvin, Mrs Elizabeth Conran, Curator of the Bowes Museum, Mr H. G. Conway, Dr Maurice Craig, Miss C. H. Cruft, Miss Astrid Curl, Miss Ingrid Curl, Mr John McK. Curl, Mr Martin R. Davies, Mr T. Dimmick, Mrs Michael Drew, Mr Edmund Esdaile, Dr Marianne Fischer, Heer Jan Geeraerts of the Koninklijke Maatschappij voor Dierkunde van Antwerpen, Mr P. C. Gibbling of the Faringdon Collection Trust, the late Mr John Gloag, Mr Richard Gray of the Cinema Theatre Association, Mr John Greenacombe, Mr Leslie V. Grinsell, Herr Helmut Grosse, Mr K. T. Groves, Mr Raymond Hall, Miss Mary Harvey, Mr T. O. Haunch, Librarian and Curator of the Freemasons' Hall in London, Miss Hermione Hobhouse, Mr Ian Hodgson, Professor Mátyás Horányi, Mrs Penelope Jessel, Miss Sylvia Katz of the Design Council, Mr Kenneth Kettle, the late Dr Hans Knappertsbusch, Dr Susie Lang, Mr Gilbert Lewis,

<div align="right">xvii</div>

Professor Göran Lindahl, Herr Björn Linn, Mr Peter O. Marlow, Miss Glenise Matheson of the John Rylands University Library of Manchester, Mr Willem A. Meeuws, Mr Geoffrey Middleton, Mr Denis F. McCoy, Miss Helen O'Neill of the Glyndebourne Festival Opera, Prof. Arno W. Oppermann, Sir Nikolaus Pevsner, Mr L. A. Porri, Miss Anne Riches, Madam Edith Róth, Mr John Sambrook, Dr Melanie Simo, Mr Alan Spencer, Mr Malcolm Starr, Miss Nicola Stevens, Mr David Walker, Mr Theon Wilkinson and the British Association for Cemeteries in South Asia (BACSA), the late Dr R. E. Witt, Mr Kevin Smith Wheelan, Mr Arnold Whittick, and Mr Christopher Wood.

I am greatly in debt to Mr Rodney C. Roach of Oxford who has done a splendid job processing the pictures. Other illustrations were supplied by Addys (Boston), Mr James Austin, Herr Klaus Broszat, Geremy Butler Photography, Mr Peter Clayton, A. C. Cooper, Carreras Rothmans, Godfrey New Photographics, Giraudon of Paris, Mr Guy Gravett, Dr Štefan Krivuš, Herr Willy Meyer, Professor Arno W. Oppermann, Messrs A. G. Porri & Partners, and Mr Alan Spencer. Mr H. J. Malyon of the General Cemetery Company allowed me to photograph monuments in the General Cemetery of All Souls, Kensal Green, as well as to inspect documents. Mr Gilbert Rumbold, who originally discussed the Art Déco period with me in Guernsey in 1957, was most helpful when I talked further with him in Belfast in 1958. Mr Rumbold contributed a number of designs to *The Savoy Cocktail Book* 1930 and to many other publications. I shall always remember his amusing company. I was greatly helped by Signorina Luciana Valentini and by the staff of the British School at Rome during the research stages, and I acknowledge the kind assistance of the Assistant Director of the School. Mr Peter Bezodis very kindly provided much information in correspondence and conversation, and I am most grateful to him for his help over the years. Sir John Summerson most courteously gave access to material in Sir John Soane's Museum, and discussed aspects of the Revival with me. Professor Richard G. Carrott kindly granted permission to quote from his admirable book on the Egyptian Revival. Dr S. Lang and Sir Nikolaus Pevsner graciously allowed me to quote from their pioneering essay on the Revival, and have my warmest thanks. Their work provided a valuable skeleton on which Chapter III of the present study is based. Miss Jean M. Adcock-Neal of J. J. Neal, and Mrs Pamela Walker, of Leicester, transformed my chaotic notebooks and much scribbled-over manuscripts into respectable typescript, and have my gratitude and admiration. I am grateful to my wife, who has had to put up with my Egyptianising obsession since we first visited Mozart's birthplace in Salzburg together in 1960 and saw Schinkel's drawings there. I am in debt to her for her support. My younger daughter, Ingrid, very kindly told me about, and photographed, various Egyptianisms in France, and my brother, John, helped to track down Egyptianising mausolea in Ireland.

If I have inadvertently omitted anyone from these notes of thanks I hope that a sincere expression of my indebtedness to everyone who helped me will suffice. Without the assistance of friends, colleagues past and present, and a great many people I only know slightly or in correspondence, the task of writing this book would have been impossible.

JAMES STEVENS CURL
Winchester, 1978–81

The Egyptian Revival

Introduction

Truly at weaving wiles the Egyptians are clever.

Æschylus (525–456 bc): *Fragments.* Frag. 206.

Many architectural styles have been the subjects of studies in recent years. The Gothic Revival has had many devotees, while Neoclassicism, the Greek Revival, the Italianate style, and the Queen Anne or Domestic Revival have provided architectural historians with rich quarries. The Egyptian Revival has not received the attention it deserves, however, and this study will attempt to redress the balance by tracing its origins in the obscure byways of European taste, and by chronicling its oddly stubborn and surprising persistence throughout the centuries.

It is a commonly held belief that the Egyptian Revival was a short-lived aberration in a period of eclectic revivals following the Napoleonic campaigns in Egypt. While it is true that there was indeed a marked increase of interest in the architecture and art of ancient Egypt in the first decades of the nineteenth century, the history of the Revival spans a much greater length of time, and leads the student from the present age back to the centuries that saw the rise of Hellenistic culture in the lands of the Pharaohs and in those of Asia Minor.

The singular importance of the Alexandrian cults within the Roman Empire has been noted by many distinguished historians. No student of taste acquainted with the great collections of antiquities in European museums (especially those of Rome itself) can fail to be aware of the immense amount of material with an Egyptian flavour that survives today. Egyptian antiquities first arrived in Europe because they were associated with the growing cults of the Nilotic deities, but many ancient Egyptian objects (such as obelisks) were also brought to Europe because they demonstrated that Egypt had been subdued by Rome. The worship of Isis, of Serapis, and of other gods and goddesses, together with a fashion for collecting Egyptian objets d'art, ensured not only a steady export of Egyptian antiquities to the cities of the Roman Empire, but that such antiquities would be copied by craftsmen working in Europe. Egyptian forms, such as the statues of deities, obelisks, lions, sphinxes, pyramids, and so on, entered into the language of Roman Imperial architecture and decoration to an extent that has been largely unacknowledged. Eventually, such Egyptian or Egyptianising motifs ceased to be recognised as having Egyptian connotations at all, so that by the time artists of the Middle Ages saw them, their origins were obscure, to say the least. Only with the Renaissance did large numbers of antiquities with an Egyptian ancestry reappear to be exhibited with other Classical objects in the great collections of the period. They were greatly prized, for the appreciation of ancient works of art grew apace at that time.

It is clear that Egyptian elements were of immense importance during the Roman Empire. The many obelisks that grace the squares and open spaces of the Eternal City, for example, provide evidence of the esteem in which these Egyptian objects were held in Imperial times. The collections of Egyptian pieces and of Roman works in the Egyptian style in the Vatican and Capitoline Museums indicate how widespread were such objects during the Empire, and study of the literature dealing with the sites where ancient artefacts were discovered reveals that Egyptian cults had a powerful influence in Imperial Rome. Many of the most spectacular discoveries were made on or near the sites of Isiac temples. Some statuary, such as that depicting the god Bes, or the representations of the many-breasted Diana of Ephesus, startle with their bizarre Asiatic imagery. We are often brought up to consider ancient Rome in the light of a pure Classicism, but such a view is unbalanced because the Rome of the Emperors was embellished with many items from Egypt and elsewhere. The impact of Egyptianising objects in Renaissance art is clear from

1

the collections of drawings in the Vatican, notably the Codex Ursinianus in the Biblioteca Vaticana in Rome, and the Codex Pighianus (drawings by S. V. Pighius) in the Staatsbibliothek in Berlin, while statuary from Hadrian's Villa at Tivoli, especially the Egyptianising *telamoni* now in the Sala a Croce Greca in the Museo Vaticano, provided inspiration for many, including Raphael and Giulio Romano. The very many drawings of Egyptian and Egyptianising antiquities made by Renaissance masters indicate the extent of interest at the time.

The threads of Egyptian influences that run through western European civilisation are many and varied. The continuity of an Egyptian religion and the revival of the Hermetic Tradition have been admirably chronicled by Dr Frances Yates, Dr R. E. Witt, T. Hopfner, M. Münster, N. M. P. Nilsson, and others. Particularly interesting in the illumination of the Marian cultus and its connexions with antiquity are the works of Theodor Trede, Serafino Montorio, St Alfonso Maria de' Liguori, and Hippolytus Marraccius. The magisterial *Isis in the Graeco-Roman World* by Dr R. E. Witt covers the early influence of Egyptian cults with enviable erudition and style, and is especially useful for its sources. Dr Witt has drawn attention to the persistence of an Egyptianising religion, and has gently reminded us of the antiquity of elements in Christian liturgies and beliefs that connect our own European civilisation with something infinitely older that developed by the banks of the Nile.

Anne Roullet's *The Egyptian and Egyptianizing Monuments of Imperial Rome* records systematically in a catalogue raisonné those objects that once adorned the capital of the Western world, and is essential reading for those who wish to pursue the subject. Scholars including A. Rusch, P. Saintyres, Frances Yates, Nikolaus Seng, Carlos Sommervogel, and René Taylor have discussed the importance of the Hermetic Tradition, especially in relation to the period of the Counter-Reformation and the Society of Jesus. The importance attached to Hermetic philosophy by Renaissance thinkers is now generally recognised, and Dr Frances Yates has shed light on the byways of sixteenth- and seventeenth-century intellectual life in her *Giordano Bruno and the Hermetic Tradition* and *The Rosicrucian Enlightenment*. The Hermetic-Egyptianising elements that recurred from the Renaissance period in writings and in illustrations produced an iconography becoming more overtly Egyptian after the triumph of the Counter-Reformation in central and southern Europe. A select list for further reading is included in the Bibliography which, though extensive, is by no means exhaustive. However, the general reader should find sufficient material to enable further pursuit of aspects discussed in the text. Eighteenth- and early nineteenth-century stage-design, for example, is a subject in itself, and can only be touched on by selected pictures and descriptions.

As far as scope is concerned, this book will discuss the Egyptian Revival in western Europe within the last two millennia, but will not dwell in detail on the history of the Revival in America which has been admirably covered by Professor Richard G. Carrott in his *The Egyptian Revival. Its Sources, Monuments, and Meaning. 1808–1858*. In certain instances there will be an inevitable overlap as sources are identical. The courteous help given by Professor Carrott is here acknowledged.

Coherent and consistent threads run through the story of the Egyptian Revival from Classical times to the present day and this is an attempt to trace them and to demonstrate the manifestations of Egyptian art, architecture, and forms in the West. All the known examples will not be named, for this is not a catalogue. Furthermore, the work is not concerned with the wider aspects of social conditions of each period covered. Economic considerations preclude the inclusion of illustrations of every item mentioned: it is hoped that the pictures finally selected will serve to enhance and explain points in the text.

This study begins with an outline of how important aspects of Egyptian religion were absorbed into Graeco-Roman culture and later into European civilisation as a whole. Early manifestations of a vogue for Egyptian objects from the time of the Roman Empire will be discussed, together with descriptions of the most important forms and images associated with the Nilotic religions. The interpretation of Egyptianising objects during the proto-Renaissance of the thirteenth century in Italy will be mentioned, especially in relation to Cosmati sphinxes and lions. The rediscovery of Egyptian and Egyptianising (in the sense of making pieces in the Egyptian style)

motifs in the Renaissance period will be described, together with the great interest in Hermes Trismegistus and the mysteries of Nilotic culture that developed in the time of the humanists. The significance of sixteenth and seventeenth-century attitudes to occultism, alchemy, and the Hermetic Tradition will be outlined. The richness of Marian symbolism clearly owes much to that associated with the Egyptian goddess Isis. Apparently Baroque inventions, like the celebrated Honigschlecker on the altar of St Bernhard in the basilica of Neu-Birnau on the northern shore of Lake Constance, are similar to Graeco-Roman images of Egyptianising deities to be found in many European collections. Egyptianising elements in the works of Fludd, Kircher, Maier, Masonic writers, and in iconography will be mentioned. The use of Egyptian forms within the Rococo and Neoclassical periods will be sketched in, while the importance of archaeological and scholarly correctness after Egyptian buildings and artefacts had been studied in detail will be stressed.

An acquaintance with funerary architecture cannot leave the Egyptian Revival unnoted, for many mausolea, catacombs, cemetery gates and lodges, and designs for tombs owed much to the style. Even the pyramidal form of funerary monument that will be familiar from the time of Bernini owes its origins to Egyptian prototypes. Egyptian motifs in art and architecture were favoured in Renaissance times. Raphael used Egyptianising figures, while sphinxes and obelisks were commonly found in doorcases and in funerary architecture. Egyptian elements recur during the sixteenth and seventeenth centuries, but the rediscovery of Egyptian architecture, correctly observed, like the architecture of ancient Greece, dates from the eighteenth century. Yet even before an archaeological approach was adopted, Piranesi had a complete Egyptianising interior built in Rome as a *capriccio*. The French Academy in Rome produced architects of genius who used Egyptian forms in exotic combinations, and their works abound with references to pyramids, obelisks, sphinxes, Egyptian cornices, columns, and details.

The Egyptian Revival in the last two centuries was an international movement, and was the final phase of Romantic Neoclassicism. The aesthetic ideals of Neoclassicism tended to strive for greater simplicity, grandeur, and massiveness, first by returning to the architecture of ancient Greece, especially the Doric Order, and then going back even further to the buildings of ancient Egypt. Many designers working with Neoclassical forms became fascinated by the problems of designing for commemoration, possibly the purest type of architecture as there is no problem of daily and changing use with which to contend. The 'visionary' architects of eighteenth-century France employed simple geometry, huge blank walls to emphasise the terror and finality of death, and Egyptianising motifs for their schemes for cemeteries, mausolea, cenotaphs, and memorials. The Egyptian Revival from the eighteenth century was partially associated with a funerary tradition and with the search for what Boullée called *architecture parlante*. It was also important in the search for an architectural expression of the Sublime. Perhaps the most lasting legacy of the Revival has been the value given to simple, clear, blocky elements by architects and architectural critics. It is possible that Otto Wagner, Karl Friedrich Schinkel, Willem Marinus Dudok, and even the young Frank Lloyd Wright could not have designed buildings where solid, cubic blocks play such an important part, without the precedent of the Egyptian Revival and its influence on Neoclassicism as a whole. The memorable images produced by Gilly, Boullée, Schinkel, Ledoux, and others have been admired by architects of this century, and Schinkel especially has had a considerable following. Schinkel's sets for Mozart's *Die Zauberflöte* are masterpieces in the Egyptian Revival style, appropriately enough for this Masonic *Singspiel*. Many pamphlets, frontispieces, and illustrations associated with Freemasonry are not guiltless of Egyptian elements. The iconography of European Freemasonry, that potent force in the Enlightenment, was steeped in Egyptian design, for ancient Egypt provided a main source of Masonic wisdom. Napoleonic discoveries brought accurate pictures of ancient Egyptian art and architecture to Europe, and soon a Revival of Egyptian styles in architecture made its appearance in halls, showrooms, exhibition buildings, factories, cemetery lodges, and mausolea. Pugin lampooned the style in his *An Apology for the Revival of Christian Architecture in England,* for it was used in some of the early commercial cemeteries because of its associations with death.

The nineteenth century produced many examples of the Egyptian Revival. Buildings,

furniture, jewellery, paintings, ornaments, and even chimney-pots offer thousands of variations in the style. Egyptianising motifs became fashionable in the Victorian period largely through the drawings, writings, and photographs of travellers who ventured to the Nile. Egypt was a popular goal for the Thomas Cook tours, and artists, photographers, and collectors made Egypt familiar. Victorian jewellery in the Egyptian style, some of it designed by May Morris, was sought after, while furniture in the Egyptian taste by Liberty, Holman Hunt, and others became popular. Alma-Tadema used Egyptianising furniture in his paintings, and there are strong Egyptian elements in paintings by Edwin Long, Edward Poynter, the Hon. John Collier, John Summerscales, David Roberts (mostly fine topographical work), and Holman Hunt. Ceramics and glass in the Egyptian taste proliferated, and fakes and forgeries of 'original' ancient Egyptian work were produced on a massive scale. At the end of the century the pictures by Arnold Böcklin and his circle had several Egyptian Revival elements, notably in the variations on the *Toteninsel* theme.

In the twentieth century there have been further outbreaks of Egyptomania, the most spectacular occurring after the discovery of the tomb of the Pharaoh Tutankhamun. The famous exhibition in Paris in 1925 stimulated more Egyptianising in architecture, furniture design, interiors, jewellery, ceramics, and ornament. Cinemas, and even factories, acquired exotic plumage in the 1920s and 30s, and films featuring Cleopatra and ancient Egypt, culminating in the massive movie with Elizabeth Taylor as the Queen, encouraged revivals of the Revival. The success of the Tutankhamun travelling exhibition in Europe and America has aroused further interest in the Nile style.

The Egyptian Revival has had a longer life than most people suppose. This study will discuss a recurring theme in the history of taste, and will describe the sources of the Revival, its influences, and its physical manifestations. The inspiration of Egyptian art and architecture for the West is not yet dissipated: the ways in which Egyptianisms have permeated our culture are many. This study will outline some of the most important examples and will trace an extraordinary and persistent thread that leads back to the ancient cultures of the Nile.

1

The idea of Egypt in the European mind.
The Isiac religion. The absorption of Egyptian religion in the Graeco-Roman world. Some manifestations of Egyptianisms in Western art and architecture during the Roman Empire.

It flows through old hushed Egypt and its sands,
Like some grave mighty thought threading a dream,
And times and things, as in that vision, seem
Keeping along it their eternal stands.

JAMES HENRY LEIGH HUNT (1784–1859): *The Nile.*

The lands of the South that were once part of the Roman Empire sometimes seem haunted by ancient deities. There, the clear landscapes seem to hold in a luminous intensity the man-made expressions of the simplest shapes, uncomplicated and rational in their pure geometry. The old gods seem at times to be violent and cruel, like a noontide demon that brings fright and shadows to the calm warmth of the countryside, inducing a sudden chill in those who have experienced that southern phenomenon. Something passes by at midday, something primeval, and incredibly old. The sirocco that blows from the domains of the frightful Seth shrouds the pellucid clarity of the South, bringing melancholy and torpor. On clear days, however, before noon, and on light evenings when the moon dominates the heavens, there is another universal presence that is entirely beneficent. It is a sense of cleanliness, of kindliness, and of infinite compassion. It is of this world, and is recognisable, comfortable, and unmysterious. It is the reproducing principle of nature, the eternal recurrence of life itself, and the selfless love of motherhood. It is wisdom, rationality, and reality.

That presence seems to drive the violent demons into the shade, and to offer a powerful answer to the visions of death and suffering conjured by the Crucifixion and by the story of the dismemberment of Osiris. The presence derives from Egypt, and is the Great Goddess, Mother of the God. She was a goddess who was wise and life-giving, able even to resurrect the dead. Her legacy to European civilisation is immense, and her presence, in attributes and symbols, in religion and philosophy, in architecture, art, and design, is very real. As the Mother of the God, she helped to remove the particularist aspects that had survived in the Christian Church, and by her femininity and oecumenical appeal, she became revered and loved. The devotion she inspired in ancient times was considerable, and that devotion is still obvious, even in parts of western Europe. She is the key to an understanding of the thread that joins our own time to the distant past, and that explains a great deal within our own cultural heritage.

The part that the culture of ancient Egypt played in the development of Western civilisation is not often recognised even though the importance of the cult of Isis in Alexandria and in Italy has long been known. There can be no question that this cult was a profound influence on other religions, including Christianity. As Dr R. E. Witt has noted in his admirable *Isis in the Graeco-Roman World,*[1] the more we probe the mysterious cult of the goddess Isis, the greater that goddess

5

appears in historical terms. The ancient religions of Egypt cannot be ignored in the light of their influence on Graeco-Roman culture and its successors: Isis was a familiar figure in the cosmopolitan cities of Rome and Alexandria, in the towns of Pompeii and Herculaneum, and in the city-states of the Hellenistic period in Asia Minor. The goddess and her attributes were no strangers to Graeco-Roman civilisation at the times when the Emperors ruled, when St Paul made his travels, and when the Christian Church began to spread. For nearly eight centuries she had been revered in the lands of the eastern Mediterranean, and for generations before that she was worshipped in the land of the Pharaohs. She cannot be ignored or wished out of existence, nor can it be assumed that one day she simply vanished from the minds of men.

Isis was the ruler of shelter, of heaven, of life. Her mighty powers included a unique knowledge of the eternal wisdom of the gods. Her tears caused the waters of the Nile to flood, so the goddess was associated with rebirth and with the resurrection of the dead.[2] Every Pharaoh was understood to be a reincarnation of Horus,[3] and was therefore the offspring of Isis, the mother-goddess, who could not die, was incorruptible, and was closely involved in the resurrection and reassembly of the dead.[4] She was the sacred embodiment of motherhood, yet was known as the Great Virgin,[5] an apparent contradiction that is familiar to Christians as well. Isis, as the goddess of procreation, had many symbols, the most startling of which was the cow.[6] Enthusiasts who have pursued the Marian cultus of the Christian Church, and who are familiar with the remarkable works of Hippolytus Marraccius, St Alfonso Maria de' Liguori, and Antonio Cuomó, will recognise the young heifer as a symbol of the Virgin Mary, whose crescent moon on many paintings of the post-Counter-Reformation period recalls the lunar symbol of the great Egyptian. In imagery Isis is often represented as a comely young woman with cow's horns on her head-dress.[7] The horns themselves usually frame the globe of the moon (Pl. I). The goddess often held in her hands a sceptre of flowers, or one of her breasts and her son, Horus.[8]

To Plato and others, Egyptian culture was already very ancient.[9] Indeed, Plato mentions the so-called Lamentations of Isis as being of considerable antiquity in his own day.[10] Herodotus suggested that the deities of Egypt had been adopted by the Greek city-states,[11] and that, specifically, Demeter and Isis were one and the same.[12] Symbols, such as the sistrum, or rattle, occur in Greek statues that can be identified as Isiac, and Herodotus, who had actually visited Egypt and had studied the religion of that country, noted certain clear similarities between Hellenic and Egyptian deities.[13] Others[14] have noted the occurrence of Isiac symbols in Cretan art, suggesting great cross-currents between Crete and Egypt. The importance of the sea routes in spreading cultural influences cannot be overstressed.[15]

The realities of life in Egypt produced their own symbolism. The fruitful Nile Valley, renewed in its fecundity by Isis each year, was in stark contrast to the deserts that bordered it. The Valley was the land of Isis, but the deserts were the domains of the terrible Seth (otherwise identified as Typhoeus or Typhon), enemy of Isis, and killer of Osiris. From the lands of Seth came death, disease, blight, eclipses of the sun and moon, and evil itself. Needless to say, it was from the country of Seth that the sirocco, or mistral, that oppressively hot and disagreeable south wind, blew over the fair lands by the northern shores of the Mediterranean.[16]

For centuries the Nile had watered the lands that bore corn and palms, flax and papyrus. The skills of weaving and spinning were also attributed to Isis.[17] The light papyrus, used for writing and for making boats, was closely associated with the goddess, who also protected those about to die.[18] After death, the overseer of the embalming ritual was Anubis,[19] the transporter of souls, the friend and messenger of Isis. In that other kingdom justice was dispensed with infinite wisdom by the god and consort-brother of Isis, Osiris, just as was to be the case with the Hellenistic successor of Osiris, named Serapis.[20] Osiris, with his sister-wife, enjoyed the most general worship of all the ancient Egyptian gods.[21] His colour, as that of the god associated with life, was green,[22] and his sacred tree was the evergreen tamarisk.[23] The Greeks identified Osiris with Dionysos.[24] Originally Osiris had ruled as a king, and introduced agriculture, morality, and worship, until his brother Seth cruelly killed him by imprisoning him, by a ruse, in a wooden chest.[25] This chest was cast into the Nile, and the grief-stricken Isis eventually retrieved it from Phoenicia. Seth again discovered it, and cut the body into small pieces which were scattered.[26] These parts were collected by Isis, and

the body was duly resurrected by her, although the phallus was missing.[27] The worship of Serapis was first developed during the Ptolemaic period in Alexandria, the most beautiful temple there being the Serapieion.[28] The conception of the god was extended in Hellenistic times to include the Egyptian Osiris, the Greek Pluto, the Greek god of healing, Asclepius (Aesculapius), and Zeus-Jupiter in one deity.[29] The worship of Serapis, with the cult of Isis, spread rapidly from Egypt to the coast of Asia Minor, to the islands and mainland Greece itself, and finally to Rome and Italy generally:[30] in Imperial times, especially during the reign of Hadrian, the cults of Serapis and Isis extended throughout the Roman world.[31] The incorporation of the character and attributes of Aesculapius within Serapis ensured his worship as the god of healing.[32] Serapis was represented, like Pluto, with an animal by his side. The animal would have the head of a dog, of a lion, or of a wolf, with a serpent curled around its body. As Zeus-Serapis the deity is to be seen in the celebrated and colossal bust in the Vatican, with a *modius,* or corn measure, as a symbol of the abode of the dead, on his head.[33] A similar image occurs on one of the capitals in the church of Santa Maria in Trastévere (Pl. 24). Roman representations of Aesculapius often show him with a staff around which a serpent is coiled. Serpents are peculiarly Egyptian motifs: they are found in cornices, on either side of the orb with wings, and are associated with the goddess Isis.[34] The associations with healing must be stressed.

During the extraordinary fusion and mixing of religions in the Ptolemaic period, Isis and Osiris became further merged with many deities.[35] In particular Isis became, in time, through the range of her powers, 'the most universal of all goddesses',[36] and held sway over the dominions of heaven, earth, the sea, and, with Serapis-Osiris, of the other world beyond.[37] She was an arbiter of life and death, deciding the fate of mortals, and she was the dispenser of 'rewards and punishments'.[38] Her cult spread to Greece and Rome, and during the Empire was recognised by the state, thus establishing itself in all parts of the Roman world.[39]

The ritual worship of Isis consisted of a morning and evening service; of annual festivals to celebrate spring and the beginning of the navigation season; and of autumnal rites to prepare for winter.[40] The spring festival was held on 5 March throughout the Roman world, and involved the *Navigium Isidis,* in recognition of the goddess's being the patroness of navigation and the inventress of sail.[41] During this festival a sailing vessel, built on Egyptian lines, and decorated in the Egyptian style, was laden with spices and cast upon the sea.[42] Such a ship must be regarded as a Revival of traditional Egyptian forms and decoration. The autumnal festival commemorated the grief of Isis and her joy on finding Osiris again.[43] The attributes of Isis in Hellenistic art are a serpent, a cornucopia, a *hydreion,* or vase, ears of corn, the lotus, the moon with horns, and the sistrum, or metal rattle, that was employed in the service of the goddess[44] (Pls. 1, 7).

The development of the cults of Isis and of Serapis is complex. This study must necessarily include only the briefest outline, and will concern itself with the migration of the cults to centres throughout the Roman Empire and especially to Rome itself. It appears that the cult of Isis spread in the Graeco-Roman world from the fourth century BC when there was an Isiac sanctuary in Piraeus. Temples and shrines dedicated to the Alexandrian deities were erected along the shores of Greece and Asia Minor. There were ambitious Isiac temples at Alexandria, Puteoli (Pozzuoli), and Delos, and the Egyptian religions were spread by traders and mercenaries. Isiac shrines were built in Rome itself at the beginning of the first century before Christ. From about the third century BC the cult became Hellenised, and the language used in the service of Isis became Greek: even her statues became Hellenistic. Apart from her identification with Demeter, she later embodied Aphrodite, and was certainly closely associated with the Ptolemaic Queens (Pl. I). The best preserved shrine of Isis in Italy is found at the temple in Pompeii, and there are several of her temples still standing in Egypt. Pedimented *aediculae* tombstones from Athens have survived showing priestesses of Isis holding the sistrum and *situla,* or hydreion. Figures holding similar objects adorn niches on Roman tombstones of Isiac priestesses. Isis herself is shown with Serapis, the Apis bull, Jupiter, Juno, and the Dioscuri in a relief from Rome, complete with phoenix. Wall paintings of the Isaeum at Pompeii clearly show sphinxes, Nilotic flora and fauna, the Adoration of the Mummy of Osiris, Isis as Fortuna, Isiac ritual, dance, and legend, and the sacred symbols of the goddess. The mixture of Egyptian elements with Roman motifs emphasises the syncretism of

7

the Isiac cults. A unique pottery lamp found in the Agora at Athens represents the goddess in the form of a wrapped mummy, with lotus buds on her head. Ptolemaic images of Isis show her seated, with cow's horns and moon-disc, suckling her son Horus. Later Hellenistic versions of the goddess often give her a Greek face, an Egyptian head-dress crowned with lotus buds, and cow's horns. It is quite clear, therefore, that conscious copying of Egyptian motifs was a feature of cult statues associated with Isis in the Graeco-Roman world.

Isis and Osiris were usually worshipped near each other.[45] The same was true of Isis and Serapis. There were celebrated temples of Isis and Osiris at Philae, and there was a temple of Isis in the Serapieion at Delos, built by the Athenians in about 150 BC. Dedications are known to 'Isis, Mother of the God'.[46] Isis was refreshingly different compared with the Olympians, and her qualities appealed to civilised Romans and Greeks who were no longer enamoured of the barbarities and licentiousness of their more traditional deities. She became associated in her capacity as Mistress of the Heavens with the moon, and so became identified with Artemis and Diana. The close connexion of great personages with the deities in ancient times ensured that Cleopatra became a moon goddess or Isis, while Antony became a curious mixture of Dionysos and Osiris.[47] In the Ptolemaic temple at Dendera Cleopatra VII (69–30 BC) is shown with Isiac cow's horns, moon-disc, and sistrum, presenting her son Caesarion (Ptolemy XV Caesar) to Isis, Re-Herakhte, Osiris, Horus, and Mut[48] (Pl. I). Isis became identified as Pallas Athene, as Persephone, as Demeter, as Aphrodite-Venus, and as Hera (whose images in Greek art are very similar to those of Isis).[49] The Egyptian goddess was queen of earth, of heaven, and of hell.[50] As a moon-goddess she was Artemis-Diana,[51] goddess of chastity, and ruler of the mysteries of childbirth and procreative cycles.[52] Her son, Horus, became Apollo himself. Isis, in her catholicity, was astonishing.

Even when Christianity was being established in the Roman Empire, the cult of Isis was claiming many converts, and in Italy it exerted a powerful influence. There are tombs on the Appian Way[53] that can be identified positively as Isiac. Egyptian religion, in the deities of Isis and Osiris, became established in the holiest places: from being a powerful goddess in the Egyptian pantheon, Isis became a deity of world stature.[54]

The widespread honour in which Isis and other Egyptian deities was held ensured that images of the goddess and of her attributes proliferated. An Isiac altar of Roman workmanship, now in the British Museum, shows the Apis bull on one side, the Isiac crescent moon on his side echoing the shape of his head; an Egyptianising offerant flanked by incised Nilotic emblems on another; and a worshipper crowned with roses on a third side. Late Roman *cippi* of Horus-Harpocrates are often fully Egyptianising, with the mask of the god Bes, crocodiles, serpents, and hieroglyphs, while altars are often conventionally Classical, save for the representations of cars drawn by hippopotami, and the usual assembly of Nilotic flora and fauna. Roman bronze statuettes of Harpocrates often show him seated on a lotus flower, with a cornucopia and serpent, and Egyptian crown. Occasionally Egyptianising head-dresses can be found on altars. It is abundantly clear from altars, statuettes, mosaics, ornament, cippi, coins, and other artefacts, that Isis, Horus-Harpocrates, Serapis, Nilotic flora and fauna, and Isiac emblems such as the serpent, the crescent moon, and the cow's horns, were familiar throughout the Graeco-Roman world. The temple of Isis in Rome appears on a funeral relief from the tomb of the Haterii, now in the Vatican. The entrance, inscribed *Arcus Ad Isis* was in the form of a triumphal arch, and is shown on a coin of the Emperor Vespasian with a segmental pediment in the tympanum of which was a relief of Isis-Sothis seated 'side-saddle' on the back of a running dog.

Columns from the Isaeum Campense, the grandest of the Roman Isaea, survive in the Museo Capitolino, Rome, in the Museo Archeologica in Florence, and elsewhere. These are of several types, but the most spectacular are the grey granite Roman creations in the Egyptian style that show Isiac processions around the bases. The figures carry Canopic vases and other objects, and stand on miniature pylon-like stools. Egyptian Revival Hathor capitals, lotus capitals, papyrus capitals (Pl. 20), cobra friezes (Pl. 16), winged globes with uraei (Pls. 14, 15), usually placed in segmental pediments, and other architectural ornament, carved in the Egyptian style in Italy, are set out in the catalogue raisonné of Anne Roullet's book.[55] Even *antefixae*, unknown in Egyptian

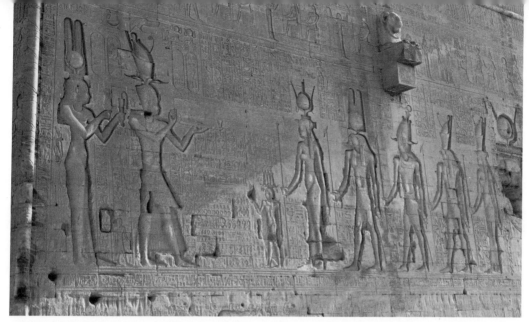

Plate 1 Cleopatra VII presenting her son Caesarion (Ptolemy XV Caesar) to the Egyptian deities. Cleopatra is shown with Isiac horns, globe and sistrum. The Queen and Isis wear the cow's horns and the lunar globe. The carving is in the Ptolemaic temple at Dendera, and dates from about the fourth decade BC. The graceful and sensuous figures of the Queen and the goddess should be compared (*Peter Clayton*).

Plate 2 (above left) Marble antefixa, allegedly from the temple of Demeter-Isis at Ostia, and now in the Museo Greg. Egizio in the Vatican. This is Roman work in the Egyptianising style, and features two uraei with a lotus. An almost identical antefixa was found by Kircher in the seventeenth century among the remains of the Isaeum Campense in Rome, and was exhibited in his museum. The Kircher antefixa was illustrated in his *Oed. Aeg.*, III p. 61, and was also drawn by Cassiano dal Pozzo. The drawing is discussed by Cornelius C. Vermeule, in 'The Dal-Pozzo-Albani Drawings of Classical Antiquities in the Royal Library at Windsor Castle' published in *Transactions of the American Philosophical Society*. LVI.2.1966 (*Museo Egizio, Musei Vaticani, Rome. No. 94. Archivio Fotografico No. 22860*).

Plate 3 (above right) Egyptianising antefixa of Luna marble from Rome, probably the Isaeum Campense. Note the uraei and lotus bud. Antefixae are architectural elements used above cornices to cover the ends of roof tiles, and are characteristic of Greek and Roman architecture. They are never found in native Egyptian architecture. Egyptianising antefixae were produced with uraei, crowns, lotuses, papyrus, and other Egyptian motifs to adorn Hellenistic and Roman temples dedicated to Isis, Serapis, and Egyptian deities (*Museo Egizio, Musei Vaticani, Rome. No. 96. Archivio Fotografico No. 22861*).

architecture, were embellished with uraei and other Egyptian motifs when used to adorn Isiac buildings in the Roman Empire. Antefixae of this type, Roman creations in the Egyptianising style, once crowned the cornices of the temple of Isis at Ostia, the temple of Jupiter Dolichenus on the Aventine, and the great Isaeum Campense (Pls. 2, 3). The latter must have been one of the richest repositories of Egyptian and Egyptianising elements in Rome, if not in Italy, and has provided an incomparable legacy of beautiful and curious examples of how the Egyptian style influenced design in Imperial times. Surviving parts of the Isaeum are now in various collections in museums, or form parts of later churches and other buildings.

Life, all life, was sacred in ancient Egypt. Isis herself, by her reconstitution and resurrection of Osiris, and through her instructions for his worship, was the founder-teacher of Egyptian religion. Her association with Artemis-Diana (see the tondo of a silver patera from the Boscoreale treasure in which emblems of Diana and Isis appear) was strengthened by the idea that Artemis became Bast, the cat goddess, when she fled to Egypt.[56] The cat goddess was an important deity, with her chief temple at Bubastis, and, most significantly, her symbol and musical instrument was also the rattle, or sistrum. The route for pilgrimage to her shrine was the Nile itself. When Isis became Hellenised, the attributes of Bast-Artemis were taken over by her. Many Roman sistra are decorated with representations of cats, especially those found at Pompeii. Isiac temples in Italy were decorated with paintings and mosaics representing plants and animals associated with Egypt, so that palms, lotuses, the papyrus reeds, mummies, cats, serpents, crocodiles, ibises, sphinxes, lions, scarabs, lunar crescents, bulls, monkeys, jackals, and vultures, as well as architectural features associated with the Alexandrian deities, became familiar to worshippers. The sistrum was well known, as was another Egyptian symbol, the *ankh*. The Christian symbol of the cross would seem to owe much to the *ankh* sign, with the horns at the top anticipating the nimbus around the head of the Christ. Indeed, when Christian mobs destroyed the Serapieion at Alexandria this Isiac symbol was recognised as a crucifixion sign, and as a prophetic emblem that looked forward to the triumph of Christianity.[57]

Isis gradually emerged at the centre of an oecumenical cult. Despite its monotheism, even Christianity developed doctrines of the Trinity, of the status of the Virgin Mary, and of the Communion of Saints. Yet initially Christianity held apart from other creeds, and was even hostile to them, while the cult of Isis merged with traditional forms of Graeco-Roman religion. The goddess was not infrequently found in *lararia* with the household gods, and, in particular, she appeared in the guise of Fortuna to watch over daily life. There cannot be any doubt that, of the 'mystery' religions in Italy before the destruction of Pompeii in AD79, the most popular were those of Isis and Serapis.

The key to the remarkable early spread of the Egyptian religions was Alexander the Great, who was closely identified with Zeus-Ammon, and with Dionysos, as well as becoming heir to the Pharaohs.[58] When Alexander conquered Egypt, the ancient deities gained a new and potent influence throughout the Hellenistic world.[59] Unlike many conquerors, Alexander did not attempt to superimpose his own culture and exterminate the indigenous civilisation. Like Napoleon, Alexander brought scholars with him to study and interpret the riches of the Nile Valley: Egypt was to contribute enormously to Hellenistic culture. The founding of the great city of Alexandria was to be closely associated with a harbour presided over by Isis Pharia, and the new capital was to become a fountain-head from which Egyptianised Hellenistic civilisation would flow. The early death of the god-like Alexander caused the elevation of the first Ptolemy, who transformed Alexandria into a splendid metropolis. Ptolemy II followed the precedents of Pharaonic Egypt and married his own sister, who was closely identified with Isis.[60] Under this Pharaoh, Nilotic culture and religion were exported to Italy, Asia Minor, and Greece, while splendid new temples were built at Philae dedicated to Isis and Osiris.[61] Significantly, the architecture at Philae was Egyptian, not Greek. Thus Egyptian architecture and motifs had entered into the language of Classicism, and in any case there had been a long history of the revival of ancient Egyptian architecture in Egypt itself, notably under Psammeticus the Restorer in the XXVIth Dynasty.

10

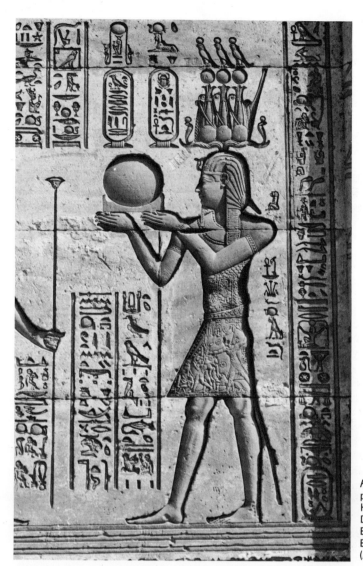

Plate 4 The Emperor Augustus presents the sun on its horizon to Hathor in his *Mammisaeum* at Dendera. The complete Egyptianisation of the Roman Emperor is startling (*Peter Clayton*).

The Ptolemaic Empire forged links over a wide geographical area. In Alexandria cultural life flourished, the great museum and library were to be presided over by Isis, and Egyptian deities were accorded the same status as that of the Greek gods and goddesses.[62] At the celebrated Serapieion not only was there a centre for scientific and medical research of an empirical nature, but incubation cures were also sought similar to those chronicled at Lourdes in recent years. The transformation of the Ptolemies into gods was not only helped by the Isiac religions, but in turn assisted the spread of Egyptian cults. Later, when even the Roman Emperors became gods, the precedent of Egypt was powerful, and Isis enjoyed much Imperial favour. Domitian built both an Isaeum and a Serapaeum in Rome, where the sick underwent 'incubation' by sleeping within the holy precincts. Frequently, where a temple was built for Serapis, a chapel or altar for Isis was erected within it. The parallel with the Lady Chapel in Christian churches is striking. At Philae additions made by the Romans showed Augustus and Tiberius offering myrrh, incense, and other gifts to Isis and to her family: at the temple of Dendera, the Mammisaeum of Augustus contains a representation of the Emperor giving the sun in its horizon to Hathor (Pl. 4): and at Kom Ombo, Tiberius presents two small bowls with the White Crown of Upper Egypt and the Red Crown of

11

Lower Egypt in them. The complete Egyptianisation of the first Roman Emperors was deliberate and clear.[63]

Even during the Roman Republic there appears to have been a Serapaeum in the third century BC at Ostia, which was only a few days' sail from Alexandria. The huge Isaeum in Rome itself was a temple of singular importance, and was adorned with obelisks, segmental pediments, stone lions, crocodiles, and sphinxes.[64] A familiarity with Egyptian motifs was encouraged by the fact that the Alexandrian deities were worshipped in temples that were readily accessible from the market place. The old Olympians had their temples in precincts, remote on the acropolis. Vitruvius commented upon this fact that perhaps partly explains the popularity of Isis among the common people.[65]

Numismatists cognisant with Roman coins from the time of Diocletian will realise the importance of Isis and her cult, for the goddess is shown on the reverse, identified normally by the sistrum, and sometimes depicted with Serapis.[66] Until the fourth century AD, her connexion with navigation was closely defined on coins.[67] Isis also appears with the Nile, the Sphinx, and other characteristic Egyptian elements on the fourth-century coinage. It is thus obvious that the Isiac cult was still alive, and that even the Imperial mints continued to issue visual reminders of the Egyptian goddess.[68] After the Serapieion in Alexandria was destroyed under Theodosius and the old festivals were officially demoted in favour of Christian practice, the Isiac cults did not die, and celebrations connected with the sea and with navigation continued. Constantine, who recognised Christianity as the official religion of the Empire, was supported on the reverse of his coins by Isis, safely embarked on a ship. That Emperor was also responsible for requesting that the sacred measure of the Cubit (associated with the rising of the Nile) should be removed from the Serapieion to a Christian church,[69] thereby demonstrating the awe and reverence felt for the ancient Egyptian religion, and was an early attempt to absorb facets of that religion within the Christian Church.

To the worshippers of Isis, life was a journey over the seas of life, with frequent pauses in harbours, and final rest. The mediaeval pilgrim, noting the labyrinth patterns on the floors of cathedrals, the signs of the Zodiac, and the symbolic aspects of his journey in a large place of worship, would not have found the idea unfamiliar. Frequent pauses by images, side-altars, and reliquaries were experienced by Christian pilgrims, in much the same way in which devotees of Isis paused during their worship, although we do not know much about the existence of wayside shrines like those of the Madonna in Roman Catholic countries today. It is not improbable, however, that little aediculae, containing images of the goddess, graced corners of buildings, crossroads, and roadsides in the heyday of the Roman Empire. Processions, carnivals, and the like, with floats, are probably successors of Isiac festivals: men dressed as women (signifying the hermaphrodite sides of the cult of Isis), as animals, or as grotesque monsters are survivals of the ancient Egyptian religion. Some commentators have suggested that even the term 'carnival' may be derived from the procession of the Isiac ship-float to the harbour for the *Navigium Isidis.*[70] Quite apart from the revelry that precedes Lent in certain countries (usually where the Roman Catholic religion has a long, unbroken tradition), there appear to be many aspects of Isiac custom that survive in the Orthodox Church, including the Blessing of the Waters of the Nile, in which the river is actually named[71] and asked to rise.

When the Empire established its ascendancy over the ancient land of Egypt, and Roman Emperors followed Hellenistic precedent by identifying with deities, Egyptian custom was absorbed and continued. The apotheosis of the Emperors to the status of gods is clearly linked with Isiac religion. When Octavian established the Empire, the cult of Isis had not been confined to Egypt. There had been shrines of Isis in Rome at the time of Sulla, and Isiac altars had existed on the Capitol during the first century BC. Despite official persecution under both Augustus and Tiberius, Philae had representations in the Egyptian style of both Emperors paying homage at the Isiac holiest of holies. Caligula encouraged the cult of Isis, imported a large Egyptian obelisk to beautify Rome,[72] and built a palace of Isis on the Palatine hill in which was a fresco illustrating the symbolism of redemption. Further Egyptianising was suggested by the marriage of Caligula to his

sister. Under Claudius, Isiac cults grew in importance, and many funerary monuments of the period record Isiac priests and priestesses. Titus and Vespasian spent the night before their triumph in the Isaeum, and other Emperors publicly worshipped the goddess.[73] By the time of Vespasian the Imperial and Isiac cults had become intimately associated, and both he and Titus were familiar with Egyptian architecture and religion. Domitian rebuilt the great Isaeum in Rome, and reconstructed the Isiac temple at Beneventum where he was depicted in Egyptian regal garments. Obelisks at Beneventum were inscribed with acclamations affirming the immortality of Domitian, who was Serapis-Osiris incarnate. Indeed Domitian built generously for Isiac deities, and was clearly inclined to the Nilotic religions.[74] The Emperor Trajan is known to have consulted the oracle at Heliopolis, and is shown on sculpture in Rome with Isis and Horus.[75]

Under Hadrian, a taste for Egyptian artefacts and religion grew in Rome: the Emperor knew Egypt, and encouraged Isiac cults. After his visits to Alexandria, Canopus, and Saïs, Hadrian determined to create Egyptianising surroundings in the grounds of his celebrated Villa Adriana at Tivoli, the Tibur of antiquity, in the second century. As the Emperor's biographer, Spartian, relates,[76] Hadrian 'created in his villa . . . a marvel of architecture and landscape-gardening; to the different parts he assigned the names of . . . buildings and localities, such as the Lyceum, the Academy, . . . the Canopus, . . . and Tempe, while in order that nothing should be wanting he even constructed a representation of Tartarus.' At Tivoli Hadrian indulged his eclectic tastes by building copies of admired architecture in the Empire. One of the places modelled was Canopus, a town that, according to Strabo, was situated some distance from Alexandria, and contained a canal at the end of which was a revered temple of Isis and Serapis. Hadrian constructed another canal at his villa with a temple in the background for festivals to be held in the Egyptian manner. At the end of the valley that was cut in the tufa is a large and well preserved recess, with a fountain (an Isiac and subsequently Marian symbol), beyond which was a system of subterranean halls terminating in a shrine that contained a statue of Serapis. This canal at the Villa suggested the Alexandrian settlement, and it was lined with a magnificent display of Egyptian statues and Roman copies of Egyptian originals. This 'Canopus' was created around AD 138, possibly stimulated by the drowning of Antinoüs, the Emperor's 'favourite' (as he is primly referred to in most sources), in the waters of the Nile. The death may have been an accident, or it may have been caused by melancholy: there have even been suggestions that the golden youth drowned himself in an act of self-adoration. Whatever happened, Hadrian elevated the dead and once-beautiful Antinoüs to the status of a god, caused Egyptianising statues (Pl. 5) of the new deity to be carved on a considerable scale, and founded a new city called Antinoupolis in his memory. At the Villa Adriana Egyptian art was prominently displayed. Nilotic landscapes were represented by crocodiles, papyrus, and other flora and fauna that flourished by the Egyptian river: the entire ensemble was embellished with many Egyptian and Egyptianising statues. Antinoüs himself was often shown with an Egyptian head-dress, and with clenched fists (Pl. 5), and there were several representations of Isis, including the serenely beautiful colossal head of white marble (Pl. 8) now in the Vatican. Many other statues of Isis, of Antinoüs, and the celebrated *telamoni* also decorated this extraordinary place. Imperial taste doubtless encouraged a fashion that other connoisseurs followed, and collectors vied with each other to build up comprehensive shows of Egyptian objets d'art. The Villa Adriana however, had many eclectic elements: in the Canopus Hadrian created a Revival idea, although the contents of the Villa were a catholic selection from all corners of the Empire, something of which the oecumenically minded Isis would no doubt have approved.[77]

Even before the Canopus was constructed at Tivoli, gardens with an Egyptianising flavour had been known in Italy. Nilotic scenes and Egyptianising statues enlivened walls and gardens, notably in Pompeii. Nilotic gardens of the 'Euripus' type (that is with gardens and statues disposed along an artificial canal) had been created in the time of Cicero, when they were regarded in much the same way as Gothick and Chinoiserie fripperies were viewed in eighteenth-century England. These gardens, for profane rather than sacred purposes, nevertheless suggested the Alexandrian deities. Sacred gardens contained images of the Egyptian gods and goddesses that were often of high quality. The gardens of Sallust on the Pincio in Rome were pleasure gardens created by the historian about forty years before Christ. In the reign of Tiberius

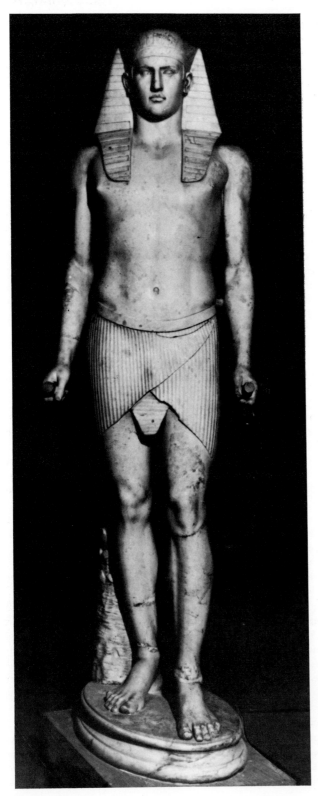

Plate 5 Antinoüs from the Villa Adriana at Tivoli, a Hadrianic sculpture of Parian marble in the Egyptianising style. Note the head-dress, clenched fists, and positioning of feet. This statue, 2.41 metres high, should be compared with the telamoni, also from Tivoli, shown in Pl. 29, and with the Rue de Sèvres fountain in Paris, shown in Pl. III (*Museo Egizio. Musei Vaticani, Rome No. 99. Archivio Fotografico No. XXX.II.37*).

they became Imperial gardens, and acquired statues, a pavilion in the Egyptian style, and an obelisk that still stood there in the eighth century.

Thus Isis herself was no stranger to mainland Italy. Hadrian encouraged a style that might be described as Egyptiennerie. Coins of his reign are adorned with Isiac symbolism which continued to appear during the time of the Antonines. Commodus was devoted to Isis, and wore a palm of victory with radiating leaves from which the nimbus of deified Emperors and halos of saints derive. The aura of sanctity, depicted as a nimbus, derives from the Heliopolitan cults. Septimius Severus was closely identified with Serapis, and is known to have visited Alexandria, Memphis, and the pyramids.[78] Under Caracalla interest in things Egyptian became greatly aroused, and sanctuaries to Isis were built in some numbers. Caracalla is represented with the Nemes head-dress in Egyptianising statuary now in the Museo Nazionale in Rome and in the Museo del Sannio at Benevento. Heliogabalus imported Egyptian fauna in quantities, and Alexander Severus embellished Rome with statues of Isis and Serapis. Under Diocletian (who knew Egypt well) Roman and Egyptian deities were worshipped at Philae,[79] and the gods of both cultures were accorded equal status. During the Tetrarchy Isis and Serapis adorned public buildings and monuments as well as coins. Under Julian the Apostate Isiac symbols were redis-covered, and for a while it even seemed that Christianity would be eclipsed by the Egyptian deities:[80] the celebrated Cubit was returned to the Serapieion, and the Emperor announced his devotion to Isis. The effects of Julian's reign were reversed by subsequent developments when the supremacy of Christianity was reaffirmed and the Serapieion suffered destruction:[81] a Greek papyrus survives that shows the Emperor Theodosius standing in an aedicule in which is a statue of Serapis, while a monk throws a rock at the building.

The influence of Egypt on Graeco-Roman art and architecture is at times obvious, and at others is oddly elusive. The ancient Egyptian rock-cut tombs at Beni Hasan have sixteen-sided columns, slightly tapering towards the top and separated from the lintels by *abaci*, set *in antis*. The projecting cornices over have representations of beam ends carved out of the solid rock. Some com-mentators have seen these ancient designs as prototypes of the Greek Doric Order, especially when in some cases each face is hollowed to resemble a Doric flute. Yet there are problems with such an interpretation. The *abacus* (like all Egyptian work) is flush with the beam above it, and the Beni Hasan tombs are older than early Doric examples by about two millennia. Nevertheless, the discovery of these fascinating Egyptian tombs led architectural historians to assume that Greek architecture was derived directly from Egypt. Carl August Ehrensvärd, in the eighteenth century, showed buildings with stumpy Greek Doric columns in a water-colour which he entitled 'Egyptian Architecture in a Nordic Landscape', now in the Nationalmuseum, Stockholm (Pl. 82). Robert Rosenblum has pointed out the 'squat and earthbound' colonnades that 'seemed more appropriate to a pre-Greek architecture and were hence considered Egyptian'. Early Doric temples, like those of Corinth and Paestum, were much admired by Ehrensvärd and by other late eighteenth-century artists. The Egyptian sixteen-sided column recurs at the mortuary temple of Queen Hatshepsut, about a millennium later than the Beni Hasan tombs. The links between Egyptian work of about 1500 BC and those of Greece about eight or nine centuries afterwards are slight, yet the problem remains: did the Greek Doric column derive from Egyptian sources, or did it develop independently?[82] In basic arrangement rock-cut tombs in Lycia, Arcadia, and Macedonia have similarities to those of Beni Hasan,[83] and it is not unlikely that there was some transportation of architectural ideas, although the geometry of formal spaces sheltering a dead body would appear to have been arrived at by a number of civilisations. Perhaps more intriguing is the appearance of Egyptian decorative motifs in Greek art and architecture (Fig. 1). Palm motifs occur in capitals at the Tower of the Winds in Athens; the Egyptian decorated bell-cap suggests an archaic Corinthian capital; Egyptian wall paintings and caps featuring the lotus suggest the basic form of the Ionic capital; the *anthemion* as a design is not all that far removed from the stylised lotus flower; antefixae in Greek architecture recall Egyptian painted work; while sphinxes and other composite creatures are not uncommon in Greek designs. Greek sculpture of the Archaic period often has Egyptianising elements in the style. Egyptianising statuettes are often similar to the faience figures and vases in the Egyptian style found in east Greek sites, and may have been

15

a

b c d

(a) Winged solar globe or disc, with uraei. This motif is usually found in the cavetto or 'gorge' moulding that crowned pylons, walls, or doorcases in Egyptian architecture.

(b) Capital from Larissa in Aeolis. Note the volute motifs that resemble stylised Egyptian paintings of the lotus.

(c) Fragment of necking ornament from a column at the temple of Apollo, Naukratis, featuring lotus flowers and buds. The lotus became a favourite decorative motif of the Greeks, and was often combined with the palmette. appearing alternately with it in friezes, as at Massalia.

(d) Capital from Neandria. Note the fan-like palmette motif between the volutes. These Aeolic capitals may be the origins of the Ionic Order, but their ancestors are clearly Asiatic and Egyptian types. The palmette pattern was borrowed by Minoan Cretans from Egypt, and Greeks of the seventh and sixth centuries BC appear also to have derived it afresh from Egyptian sources. Many designs found in Cyprus and elsewhere feature paintings of capitals of the Aeolic type, with strong Egyptian influences.

e f g h i j k l m n

(e) Egyptian lotus and papyrus decoration. Note the resemblance between the stylised lotus palmette and the Aeolic type of capital.

(f) Egyptian painted papyrus decoration. Note the resemblance to a bell capital.

(g) Egyptian painted lotus-flower decoration. Note the resemblance to the fan form and to the palmette.

(h) Egyptian lotus-flower painted decoration.

(i) Egyptian lotus-bud painted decoration.

(j) Egyptian wall painting that shows a capital-like arrangement with volutes and lotus flower.

(k) Palmette design with vestigial floral and volute decorations of bronze, from Cyprus. The anthemion of Greek decorations usually featured the lotus or palmette.

(l) Egyptian pier at Karnak decorated with papyrus heads.

(m) Egyptian stylised painted papyrus.

(n) Egyptian piers at Karnak decorated with lotus flowers. Note the volute-like effect.

o p q r s t u

(o) Papyrus capital from Philae.

(p) Egyptian bell capital from Thebes showing lotus flowers and papyrus stalks and buds combined. The shape of the capital is like a stylised papyrus.

(q) Egyptian bud capital, based on the lotus.

(r) Volute capital from Philae. The similarity in form to that of the Corinthian capital is clear.

(s) Egyptian palm capital from Edfu.

(t) Hathor-headed capital from Philae. Note the stylised lotus forms.

(u) Typical Egyptian pylon form, halved, with opening, and cornice with gorge and roll. Note the position of the winged solar globe.

v w

(v) Corinthian capital from the Tower of the Winds in Athens. This unusual design has an upper row of palm leaves.

(w) Perspective of the capital of the Choragic Monument of Lysicrates in Athens.

x

(x) Detail of the Corinthian capital from the Choragic Monument of Lysicrates in Athens. The flutings are unusual in that they terminate in leaves, and suggest the uraeus frieze of upright cobra heads facing outwards. The foliage above consists of sixteen small lotus leaves over which is a single row of acanthus leaves between which are eight-petalled flowers like the Egyptian lotus (not shown). Palmettes were placed in the centre of each convex abacus.

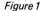
Figure 1

made in Rhodes. Markedly Egyptian hair-styles can be found in Greek statues from Naukratis dating from the beginning of the sixth century BC, and examples may be seen in the Fitzwilliam Museum in Cambridge. The palmette design itself has clear Egyptian origins. A sixth-century relief from Samothrace, now in the Louvre, shows Talthybios carrying the herald's *caduceus,* a wand capped by a needle's eye over which are upturned horns. The caduceus is therefore not unlike the Egyptian ankh, and although the relationship between them may be tenuous, the visual similarities are undeniable.

If some consider Egypt to be the possible source of the Doric Order, the origins of the Ionic Order are more markedly from the southern Mediterranean. The characteristic volute or scroll-capital may have been derived from the Egyptian lotus, and there are similarities to Mycenaean scroll work. Early caps of the Ionic type in Cyprus, Lesbos, Naukratis, and Neandria have volutes that are probably derived from vegetation, with palmettes interposed.[84] The Ionic Order was particularly favoured in Asia Minor, and the most celebrated buildings in which it was used were the temples of Artemis at Ephesus and the Mausoleum at Halicarnassos.[85] Statham points out that there is a 'quasi-Asiatic stamp about'[86] the Ionic Order. The slight batter of the doorway of the north portico doorcase of the Erechtheion and other Ionic buildings also recalls Egyptian architecture. In Egyptian temples capitals, decorated with papyrus, lotus, bud, or combinations of these, are usual. In some cases, however, the caps are replaced by the face of a goddess with drooping sacerdotal hood repeated four times at the head of each column. Heads of bulls (the bull was associated with Serapis-Osiris) at the Sanctuary of the Bulls at Delos, and the caryatides at the Erechtheion suggest derivatives of the basic Egyptian idea.

The spread of the Egyptian religious cults brought an Egyptianising of sculpture and architecture. Classical statues identified with Isis sometimes had strongly Egyptian features and head-dresses, while the left foot placed before the right was common to both Egyptian and Greek statuary (Pl. 6). Other representations of Isis seem almost completely Hellenistic, save for the Isiac attributes of sistrum, hydreion, and head-dress (Pl. 7). The fine Roman marble statue of Isis found

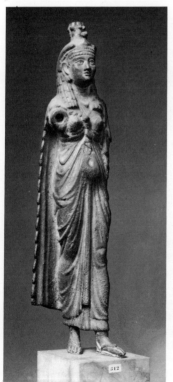

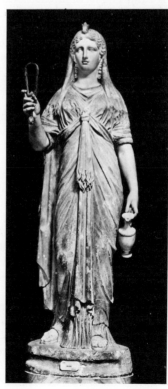

Plate 6 (left) An Egyptianising Roman statue of Isis, made of bronze, now in the Louvre. The eyes are inlaid and the arms are missing. Note the head-dress and the strongly Egyptian face. The left foot placed before the right is common to both Greek and Egyptian statuary (*Mansell-Alinari No. 23945*).

Plate 7 (right) A Roman representation of Isis, found at Pozzuoli. In the right hand is the sistrum, or rattle, and in the left is the hydreion, or jug. Fertility is represented by the knot on the breast of the goddess. The Egyptianising head-dress in Pl. 6 is suggested by the ringlets and drapes, and especially by the vestigial lotus bud above the forehead (*Mansell-Anderson No. 23124*).

at Pozzuoli has the sistrum in the right hand, the hydreion in the left, a fertility knot at the breast, and a vestigial lotus bud on the head. The Egyptian head-dress is suggested by the ringlets and drapes. Vestigial lotus buds are often found as a form of crowning feature on the head, not unlike the upper *acroterion* found at the apex of Greek pediments. There is a head in the Vatican (the features of which are entirely Graeco-Roman) that has a head-dress closely derived from Egyptian prototypes, and a lotus crown of purely Egyptian form (Pl. 8).

Even more startling are the statues of Artemis of Ephesus, with many breasts identified by modern commentators as eggs. Anatomically, the many breasts are impossible, and are represented as eggs on coinage, as Bloomer Trell has pointed out. However, the breasts also appear as fountains in some Renaissance statuary. Breasts, fountains, and eggs have iconographical significance as symbols of rebirth and of fecundity (Pl. 9). Artemis-Diana was identified with Isis as the mother-goddess. The cult statues were sculpted with the suggestion of a wrapping of the body, rather like the binding of an Egyptian mummified corpse. Horned animals also decorated the statue, suggesting the cow's horns of Isis that were later symbolised in the lotus flower. The heads of such statues had either widespread drapes or decorated moon-like discs suggesting halos. One of the finest surviving examples of these strange figures was made in the second century AD for Hadrian's Villa at Tivoli, and is now in the Vatican. As Pijoan points out, we know that there were Oriental architects like Apollodorus of Damascus at Rome from Trajan's time on. 'Hadrian, no doubt, had both Asiatic and Egyptian artists in his service.'[87] Pijoan also draws our attention to the great intellectual activity in the early years of the Empire. He mentions the Egyptian portraits painted on wooden panels and set in the mummy wrappings during the Roman period: 'youths with crisp hair' and 'women with great black eyes and elongated faces' are familiar images to haunters of museums where there are Egyptian collections. The fact that the style of these portraits is also found in primitive Christian paintings as well as in certain decorative themes that passed from Egypt to Rome cannot be overlooked. 'Oriental and Egyptian religions seem to have exerted so strong an influence upon Rome that even the appearance of the old gods became changed. Jupiter became Ammon with his horns . . . and Diana was represented in the form of the Syrian Diana of Ephesus with her countless breasts.'[88]

The building of Isaea and Serapaea was accompanied by an Egyptianising of certain architectural elements such as capitals, bases, statuary, and decoration. Obelisks were particularly prized by Romans. Under Augustus and his successors several Egyptian obelisks were set up in Rome after Egypt had been subdued. The obelisk in the Piazza del Pòpolo (Pl. 10) was originally erected in 10 BC in the Circus Maximus, and was moved to its present position by order of Sixtus V in AD 1589.[89] The obelisk in the centre of the Piazza di San Pietro was brought to Rome from Heliopolis by Caligula, where it stood in the *spina* of the Circus.[90] The obelisk in the Piazza di San Giovanni in Laterano was originally brought by the Emperor Constantius to the Circus Maximus in AD 357, and was re-erected by Sixtus V on its present site in 1588. The obelisk in the Piazza Colonna was originally brought to Rome by Augustus, but has stood on its present site since 1789. The Isaeum Campense in Rome was adorned with several obelisks as well as with many other Egyptian and Egyptianising motifs. Four obelisks from this Isaeum now stand in Rome: in the Piazza della Rotonda in front of the Pantheon; in the Piazza della Minerva before the church of Santa Maria sopra Minerva; in the Piazza Navona; and in the Piazza Dogáli. This Isaeum, part of which lay under what is now the church of Santa Maria sopra Minerva, contained basalt lions, crocodiles, sphinxes, segmental pediments, and other objects now in collections in Rome and elsewhere. It would be tedious to list all the obelisks brought to Italy in ancient times and set up there: it is sufficient to note that while thirteen obelisks stand in Rome, only five still remain upright in Egypt itself.

At Palestrina, the Roman Praeneste, one of the most ancient towns in Italy, is the site of the celebrated temple of Fortune, now beneath the cathedral. In the second century BC Isis was identified in Greece with Tyche, and the magnificent surviving mosaic from the temple of Fortuna Primigenia (another goddess to become merged with Isis) at Praeneste features Nilotic scenes, with Egyptian animals and plants in their natural habitat. The date of this mosaic has not been established, but it appears to have been made some time during the first century AD. The

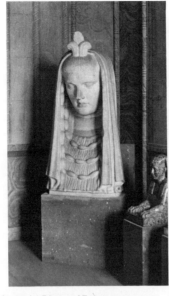

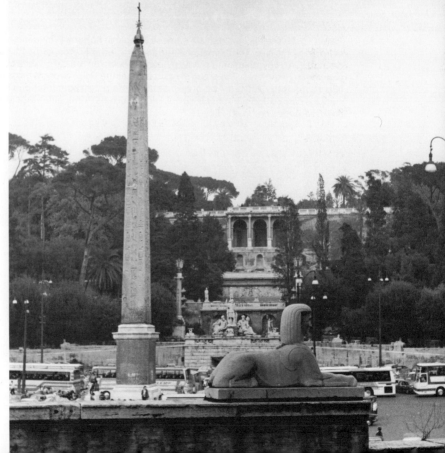

Plate 8 (*left*) The goddess Isis interpreted. Note that the face is now completely Graeco-Roman. The head-dress still suggests Egyptian prototypes, and the lotus crown is almost purely Egyptian. Note the sphinxes. The head, now in the Vatican, is of white marble, and came from the Villa Adriana at Tivoli. It is a Roman creation and we know it was drawn by Dupérac, Pighius and Pozzo, among others.

Plate 9 (*right*) The many-breasted Artemis-Diana of Ephesus, an example of the mixing of Graeco-Roman and other traditions. Such figures were identified with Isis as the mother-goddess. Note the horned animals, suggesting the cow's horns of Isis herself (later symbolised in the lotus flower), and the halo-like disc behind the head. The wrapping of the garments suggests the bindings of an Egyptian mummified body. This replica of a cult statue with symbols of potency and fecundity dates from the second century AD. It came from Hadrian's Villa at Tivoli, and is now in the Galleria dei Candelabri in the Vatican.

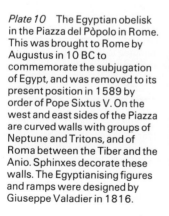

Plate 10 The Egyptian obelisk in the Piazza del Pòpolo in Rome. This was brought to Rome by Augustus in 10 BC to commemorate the subjugation of Egypt, and was removed to its present position in 1589 by order of Pope Sixtus V. On the west and east sides of the Piazza are curved walls with groups of Neptune and Tritons, and of Roma between the Tiber and the Anio. Sphinxes decorate these walls. The Egyptianising figures and ramps were designed by Giuseppe Valadier in 1816.

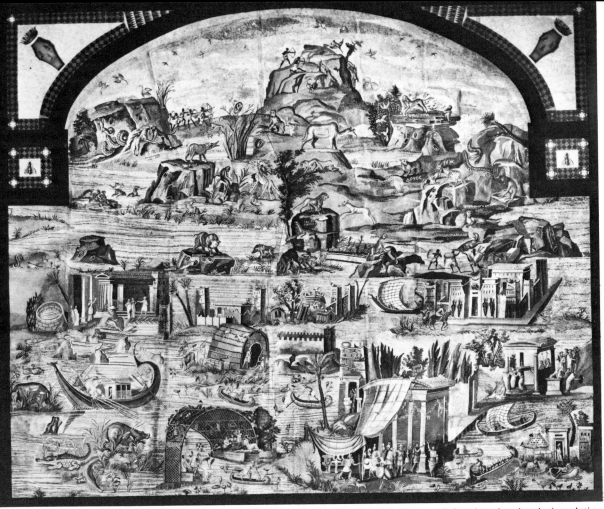

Plate 11 The celebrated mosaic from the temple of Fortuna Primigenia at Palestrina, showing the inundation of Egypt by the Nile. The animals include a sphinx, a rhinoceros, serpents, various apes, hippopotami, and other creatures. An Egyptian temple, with pylons, is shown on the right, while other temples and shrines have segmental pediments. The group of figures under the trellis-work at the bottom left is similar to the famous Nile statue in the Vatican. Two obelisks stand before the segmental-pedimented portico, centre left. A cult statue is carried under a canopy, bottom right. Fortuna Primigenia was closely identified with Isis (*Mansell-Anderson No. 41156*).

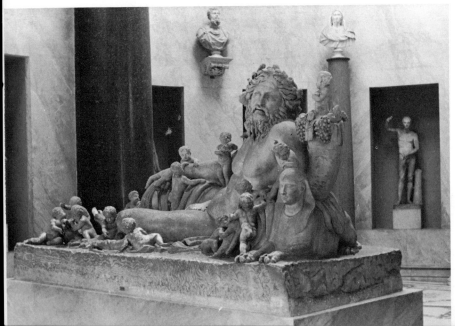

Plate 12 The colossal statue of the Nile, discovered in 1513 under the church of Santa Maria sopra Minerva in Rome. This extraordinary church was built over part of a Roman temple dedicated to Isis and Serapis. The river god is shown with a fine sphinx by his left elbow and a crocodile at his feet. The work is Roman of the second century AD, perhaps inspired by a lost Hellenistic original. The face of the Sphinx has become almost completely Romanised, although the head-dress remains Egyptian. This statuary group is now in the Braccio Nuovo in the Vatican. Compare with Pl. 157.

Nile is seen flowing from the mountains to the delta lands. Throughout the picture are various Egyptian animals, including hippopotami, rhinoceri, apes, serpents, and even a live sphinx. A temple in the Egyptian style, with pylons, is shown, and there are various shrines and temples with segmental pediments over porticos. This segmental shape appears to have had a particularly exotic significance for Romans, and can be traced to Egyptian sarcophagi lids and to the symbolic shape of the moon, and so must be interpreted as Isiac. The buildings with segmental pediments are like the mausolea in the cemetery near Ostia, which was a known centre for the Alexandrian cults. The composition of figures under the trellis-work at the bottom of the picture resembles the grouping of the cubits around the river god Nilus[91] in the Vatican (Pl. 12). Two obelisks stand before the segmental-pedimented portico at the centre left of the mosaic. Here, in this brilliant design, worshippers within the temple of Fortuna Primigenia could see the sacred animals in their sacred land of Egypt (Pl. 11). The fact that Egyptian scenes, flora, fauna, and buildings could be shown in such detail in Classical Italy points to the fascination Egypt held for the Graeco-Roman world. The carrying of the cult statue in procession in this mosaic irresistibly reminds us of the processions in which images of the Virgin Mary are carried in Roman Catholic countries today. The depicting and building of segmental pediments are associated with the worship of Isis. Segmental pediments are among the most lasting architectural legacies of an Egyptianising religion and culture in the Graeco-Roman world. The sculptural and pictorial representations of cities and of rivers recur during the Empire. The allegorical Nile group, now in the Vatican, may be inspired by a Hellenistic original, but is Roman work of the second century AD. It was discovered in 1531 near the site of the Isaeum Campense, and probably came from that building. The river god is completely Graeco-Roman in appearance, yet he is shown with a fine Egyptianising sphinx by his left elbow and with a crocodile at his feet. The sixteen children playing around him represent the sixteen cubits associated with the level of flooding of the river. The cornucopia behind the god is also significant as a symbol of fruitfulness and plenty, and is associated with Isis. The base shows the waves representing the river, and there are some lively reliefs of Nilotic flora and fauna (Pl. 12).

The cemetery of Isola Sacra that served the town of Portus Augusti during the second and third centuries AD contains a number of mausolea, usually constructed of *opus reticulatum,* of brick, or of these combined, with vaulted roofs expressed by segmental pediments over the façades.[92] Significantly, these date from the reigns of Trajan or Hadrian during which the worship of Isis and Serapis flourished. Surviving mosaics from the cemetery feature the pharos (lighthouse) and other Isiac attributes. Sir William Gell and John P. Gandy, in their *Pompeiana, The Topography, Edifices, and Ornaments of Pompeii,*[93] mention a painting in the 'Temple of Bacchus' at Pompeii showing a temple which 'is singular, from having a curved pediment. It is guarded in the Egyptian manner, by sphinges.' What Gell and Gandy failed to note, however, was that the segmental pediment is crowned by an Isiac crescent moon, and that a crocodile is devouring a figure in the foreground (Pl. 13). Therefore Roman artists must have regarded segmental pediments as peculiarly Egyptian, and certainly Isiac. The frequency with which segmental pediments have recurred in European architecture will hardly need emphasis, but the Egyptian associations of the form will be unfamiliar. The shape recalls both the bow of Diana and the crescent moon of Isis. Two spectacular segmental pediments survive in the Ägyptisches Museum in Berlin, both with winged globes and uraei (Pls. 14, 15). They probably crowned aedicules or niches. P. Gilbert, in his *Chronique d'Egypte,* points out the frequent use of the segmental pediment in shrines of the early Imperial period, and that this form of pediment was used in Classical architecture from the second century AD, notably in the great Roman Isaeum Campense itself, where the façade had a huge segmental pediment as well, and many others over niches and aedicules. Friezes of the Isaeum Campense were frequently adorned with Egyptianising features such as uraei (Pl. 16). Segmental alternating with triangular pediments became common architectural motifs (Pl. 32).

Pyramids began to appear in Roman architecture. An elegant example is the tower-tomb in the Lebanon at Hermel of the first century BC. It consists of two stages with a slight batter towards the top, and sits on a base of three steps of black stone. The lower stage has angle pilasters between which are carved reliefs, while the upper storey has four pilasters on each face. Above the

21

Plate 13 (above) An engraving by Charles Heath showing paintings at the 'Temple of Bacchus', Pompeii, published in *Pompeiana. The Topography, Edifices, and Ornaments of Pompeii*, by John P. Gandy and Sir William Gell, 1852. Note that the temple 'is singular, from having a curved pediment. It is guarded in the Egyptian manner by sphinxes.' The segmental pediment is crowned by an Isiac crescent moon, and a crocodile is devouring a figure in the centre of the picture. Roman artists appear to have regarded segmental pediments as peculiarly Egyptian, and certainly Isiac. The painting dates from the first century AD.

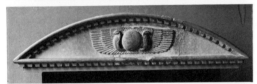

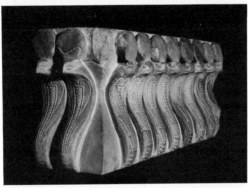

Plate 16 (above) Part of a frieze of uraei, originally in the Isaeum Campense in Rome. This is Roman work in white marble, carved in the Egyptianising style (*Ägyptisches Museum, Staatliche Museen zu Berlin. No. 16784*).

Plate 14 (left) Segmental pediment with winged disc and uraei, probably the crowning feature of an aedicule or niche. Roman work in the Egyptianising style from the Isaeum Campense in Rome. Segmental pediments are Egyptianising features that appear in Classical architecture for the first time from the end of the first or beginning of the second century AD. Segmental pediments occurred in some numbers in Isaea and are associated with the shape of the Isiac moon and with the bow of Diana (*Ägyptisches Museum, Staatliche Museen zu Berlin, No. 16785*).

Plate 15 (left) Segmental pediment with winged disc and uraei from the Isaeum Campense in Rome (*Ägyptisches Museum, Staatliche Museen zu Berlin. No. 16786*).

Plate 17 (right) The tomb of Gaius Cestius, of the time of Augustus, that stands on the line of the Aurelian Wall in Rome, near the Porta San Páolo, formerly the Porta Ostiensis. This is a large pyramid of brick-faced concrete covered in marble blocks. Clearly, Egyptian prototypes may have suggested this curious monument that stands sentinel over the Protestant Cemetery and the grave of Keats.

crowning cornice is a pyramid. This tomb has obvious similarities to the Greek tombs at Cnidos and Halicarnassus.[94] The best known of the pyramidal Roman tombs is, of course, that of Gaius Cestius, of the time of Augustus, which stands on the line of the Aurelian Wall near the Porta Ostiensis (Pl. 17). It is a large pyramid of brickfaced concrete covered in marble slabs. Clearly Egyptian prototypes may have suggested this curious monument that now stands sentinel over the Protestant Cemetery in Rome, although the Roman pyramid rises at a more acute angle than many Egyptian examples. There was another large Roman pyramid in the necropolis on the Vatican Hill. It was known as the Meta Romuli during the mediaeval period, was bigger than the pyramid of Cestius, and stood between the basilica and the mausoleum of Hadrian. It was partially demolished by Pope Alexander VI to enable a new street to be constructed between the Vatican and the mausoleum (then as now the Castel Sant' Angelo), but a fragment of the pyramid remained visible until the second part of the sixteenth century. The foundations were unearthed in 1948. It is shown in a view of Rome in *Cronica cronicarum ab initio mundi usque ad annum 1493* (the Nuremberg Chronicle), in a miniature by Jean Colombe in *Les très riches heures du duc de Berry* (now in the *Musée Condé* at Chantilly), and in the miniature by Pol de Limbourg in the same work. The Limbourg miniature also shows the Cestius pyramid and the obelisk of the Circus Maximus (in a recumbent position). Some writers[95] have shed doubts on whether or not Roman pyramids were designed in imitation of Egyptian types, as the Roman varieties are more slender and 'stand midway between an obelisk and a pyramid'.[96] Egyptian pyramids were known to Hellenistic and to Roman travellers, and after the conquest of Egypt and the fashion for collecting Egyptian sculpture had begun it is not beyond the bounds of possibility that Romans built pyramids from descriptions of Egyptian examples without the benefit of accurate measurement or proportion being noted. A pyramid is, after all, a strong architectural or sculptural statement, and its simple form could easily be described in words. Yet Roman authors were knowledgable about Egypt. There is nothing odd in that, for the country was part of the Empire from the time of Augustus. Furthermore, the pyramids at Jebel Barkel near Meroe had more acute angles and were more slender than those of the Giza group, and may have been more attractive to Roman eyes. The pyramid with a section approximately an equilateral triangle became more stereometrically pure, and therefore pleasing to those versed in Classical proportion. Such 'ideal' pyramids became usual in eighteenth-century designs despite the fact that pyramids of the Giza (i.e. squatter) type were known in some detail by then. There is also no doubt that the steeper pyramid of the Cestius or Meroe type was also favoured in Egypt itself. The Pyramidion of Minemhab (twelfth to eleventh centuries BC, now in the Fitzwilliam Museum in Cambridge) is of this type, and is much nearer the Neoclassical ideal than are the pyramids of the Giza group.

Pyramidal tombs and monuments occurred in places all over the Roman Empire. There is a fine example at Vienne in France. The eastern part of the Empire had many ambitious tombs, some of which were rock-cut. As was the case at Beni Hasan and derivative Persian examples, façades were cut into the vertical face of the cliffs, with burial chambers behind. Graeco-Roman and Semitic traditions mixed on occasion, as in the Kedron Valley complex and at Petra. One of the more interesting examples is the large, square block, cut free from the rock face, known as the Tomb of Absalom. This consists of a cube standing on a rock-cut base that is surrounded by engaged Ionic columns set in antis between corner piers surmounted by a Doric frieze; this in turn is overhung by a heavy Egyptian cornice. Over this is an ashlar plinth above which is a circular drum. On this sits a cone of concave section surmounted by a finial. The Tomb of Zechariah in the Kedron Valley is also rock-cut, and has engaged Ionic columns with corner piers. Above is a heavy entablature with a cornice of the Egyptian type, and the whole is crowned by a pyramid, basically a similar arrangement to that of the Hermel tower-tomb. A curious illustration shows a mixture of tombs, some of which are in the Kedron Valley, with sarcophagi in the foreground. One of these is of the Egyptian type, with a segmental lid. Other sarcophagi have pitched lids with simplified acroteria-blocks at the corners. These forms became staple elements in the repertoire of Neoclassical designers, and must be seen as having Egyptian associations since they date from the time when burial of the whole body, rather than cremation, began to be favoured. The reasons for a change in attitude do not depend on the hostility of the Christian Church to

cremation. Semitic peoples and those who adopted the Egyptian religions favoured inhumation or preservation in loculi or in sarcophagi,[97] and the architectural forms of sarcophagi (literally 'flesh-eaters') were familiar in Egypt and in the Hellenistic world. Despite a devotion to the Nilotic religions cremation remained the rite of the Emperors until comparatively late. The pyramids in the background of the illustration, although they are of the Egyptian proportions, may be attempts to show the pyramids set up by Helena beside the tomb of Izates in the first century AD (Pl. 18).

In the sixteenth century a profitable search for works of ancient art was instituted at Tivoli, and the ruins yielded many of the principal treasures of the Vatican, Capitoline, and other museums, including several Egyptian and Egyptianising pieces. In the Museo Gregoriano Profano, formerly in the Museo Lateranense, but transported to the Vatican by desire of Pope John XXIII in 1970, is a mosaic pavement[98] restored from fragments discovered in an ancient building on the Aventine. The central part is lost, but there is a border featuring Nilotic fauna with an Egyptian figure in the corner that is similar to the telamoni from the Villa Adriana (Pl. 19). The mosaic has an inscription identifying it as the work of Heraklitos, but the mosaic is probably a copy of a Hellenistic original described by Pliny the Elder.[99] From Pliny's description it would appear that the mosaic in its complete form was similar to the famous mosaic of the second century from the Villa Adriana, now in the Museo Capitolino.

Plate 18 An architectural fantasy of the early nineteenth century, showing sarcophagi in the foreground. Note the segmental Egyptianising sarcophagus on the left. *Centre*: the 'Tomb of Zechariah'; *behind* it the 'Tomb of Absalom'. Other rock-cut tombs are shown, while the pyramids (perhaps an attempt to show the structures erected by Helena, Queen of Adiabene, in the first century AD) add a further Egyptianising touch. The Egyptianising cornice on the 'Tomb of Zechariah', with the crowning pyramid, should be noted. It is significant that the eastern parts of the Roman Empire contained many elaborate tombs where Egyptian elements, such as coved cornices, pyramids, and the like, may be found.

Plate 19 A mosaic featuring Nilotic fauna in the Museo Gregoriano Profana. Note the Egyptian figure similar to the telamoni from the Villa Adriana. The mosaic is Roman, probably copied from a Hellenistic original, and probably dates from the second century AD (*Mansell-Alinari No. 29914*).

An interesting example of a statue of an Egyptian deity produced in Italy in the early part of the third century AD can be found in the Fitzwilliam Museum in Cambridge. It is a marble statue of the god Bes, shown squatting, with his hands on his knees, and follows the Egyptian prototypes quite closely. There are many glazed pottery figures of this somewhat unattractive god from Pompeii that make it clear that Bes had his followers during the first century. There is an almost identical Alexandrian figure in the Museo Barracco in Rome.[100]

In the third century the Emperor Caracalla began the baths that bear his name, although they were extended by the eccentric Heliogabalus, and were completed by Alexander Severus. The magnificence of these baths was unparalleled, and the buildings included a lavish Serapaeum embellished with Ionic capitals that had the added enrichment of heads of Egyptian deities. These may be the caps in the church of Santa Maria in Trastévere, although Lanciani, in the *Bulletino della Commissione archeologica comunale di Roma* of 1883, explained that the exact source is in doubt. Whether the capitals are from the baths or from the Isaeum Campense, they are among the most curious examples of Egyptianising, where representations of Egyptian deities actually invade the Order itself. Isis and Serapis had become one with the capital, their faces flanked by Ionic volutes.

The connexion between Fortuna Primigenia, Isis, and the Tyche has been noted at Praeneste, and is especially apparent in the Nilotic mosaic. The Tempio della Fortune Virile in Rome has aspects that may suggest a slight association with Egypt. This pseudo-peripteral tetrastyle temple has a deep Ionic portico in the Etruscan manner, but a pronounced Greek influence is apparent in the carving of the frieze. The dedication to Fortuna Virilis is by no means certain. Both this temple and the adjacent circular temple in the Forum Boarium have been associated with Mater Matuta, goddess of dawn, and it is likely that the circular temple was dedicated to this deity. The rectangular building may have been in honour of Portunus the harbour god. Isis herself was closely associated with harbours, navigation, lighthouses, and the safety of sailors. Curiously, the rectangular temple became a church in the ninth century,[101] and in the early sixteenth was re-dedicated to Santa Maria Egiziaca at a time when there was a revival of interest in Egyptian art in Rome. The thread may be coincidental, however, but is nevertheless intriguing.

Nearly all the Egyptian antiquities that were taken from Egypt to Rome are late in date, and nearly all come from Lower Egypt. Most were removed from religious buildings, and consist of obelisks, sphinxes, lions, animal-headed gods, and other familiar motifs. Some plain imported obelisks appear to have acquired their rather coarsely carved hieroglyphs in Rome, possibly suggesting that there were Egyptian artists, or sculptors trained in the Egyptian style, working in the Imperial capital. There seem to have been at least eight large and some forty-two smaller obelisks in Rome, all of which came from Egypt.

However, Egyptianising rather than genuine Egyptian works occur in great numbers in Italy. This points to the growing importance of the Egyptian cults and to the Egyptomania among fashionable Romans for a suitably exotic décor in private houses. It is clear that exact, or semi-exact copies were made of real Egyptian pieces, but there were also many imitations in the Egyptian style, intended to suggest a Nilotic setting. Imitation stone was developed to a considerable extent under the Julio-Claudians. Postiche emulating the close-grained Egyptian granites was used: the oleagenous quartzes and scintillating mica aggregates helped to produce the desired effects. Scagliola, imitating marble with great cunning, was an equivalent development of the Baroque period. If anything, the Imperial postiche was even more remarkable for its realism and hardness. Marble was used for architectural features, and could be obtained readily in Italy, but there was a considerable trade in imported Egyptian stones, including red and black granites from Aswan, for statuary. These Egyptian stones came by sea direct to Rome. Egyptian red porphyry was also used; and onyx (not used by the Egyptians themselves) provided the eyes of statues. This material was exploited to add detail to real Egyptian statues undergoing refurbishment. Coloured marbles were prized for statuary from the time of Hadrian because it was cheap and easy to cut, as well as being decorative. The *rosso antico,* as it is known (actually Greek red marble), was in particular favour, for it could be brought to a high polish, and the material would then look like a dark Egyptian stone. The Antinoüs from the Villa Adriana (now in the Glyptothek in Munich), and many other works were made of this material. The Villa Adriana telamoni were

25

of red granite, however (Sala a Croce Greca, Museo Pio-Clementino in the Museo Vaticano, Inv. 196, 197), and there are other Egyptianising Antinoüs sculptures in white and Parian marbles in the Louvre and the Vatican. The figure in the aedicule in the Rue de Sèvres fountain in Paris by P.-N. Beauvallet (Pl. 111) is based on the Egyptianising Antinoüs of the time of Hadrian (Pl. 5). The Isaeum Campense in Rome had many Egyptianising sculptures (Pl. 20), and is described in Anne Roullet's *The Egyptian and Egyptianizing Monuments of Imperial Rome.*[102] The building of Egyptianising structures, then, included works of statuary, obelisks, shrines, and even parts of temples and whole architectural ensembles.

There is also evidence that a conscious Egyptian Revival occurred in ancient Egypt itself. The so-called *Mammisi* birth houses at Edfu, Dendera, and Elephantine (now destroyed) are unusual among Egyptian buildings in that they consist of a *cella* on a podium with a peripteral arrangement of columns. At Edfu the corner columns are inclined to become piers square on plan, but the two columns at either end and the six on each side are circular on plan. At Elephantine, the temple, dedicated to Isis, had a cella with seven columns square on plan on either side, and two columns circular on plan set between the square corner columns at each end. This temple at Elephantine was studied by the scientists who accompanied Napoleon, and drawings were published in the *Description de l'Egypte* (Pl. 21). The square columns and the filling-in of the spaces between the columns up to the height of a balustrade later became part of the architectural vocabulary of certain Neoclassical architects, notably Karl Friedrich Schinkel and Alexander 'Greek' Thomson. These temple types clearly became the models for a strangely persisting taste for the types of a bygone age in the time of Psammeticus the Restorer. Egypt was recovering after the Assyrian occupation, and had established a new capital at Saïs. The ancient temples and other monuments were restored in the antique style, and a group of buildings of the Saïte period survives at Philae, an island particularly associated with the cults of Isis and Osiris. Under and after Psammeticus of Saïs a revival of ancient Egyptian art took place between 664 and 525 BC. During this period close connexions with Greece were forged, and many Greek mercenaries joined forces with Psammeticus to restore the independence and power of Egypt. Traditional art, architecture, and religion were revived to emphasise cultural continuity. The Greek colony of Naukratis was founded in 610 BC, and some strange mixtures of Greek and Egyptian art have been found at Sakkara. A Carian grave *stele* of 550–530 BC, now in the Fitzwilliam Museum, Cambridge, has a segmental head, and is decorated with incised carvings. At the top of the stele, following the line of the segmental head, is the winged sun-disc with uraei and wings above a drawing of a man taking leave of a woman that is entirely east Greek in style. This stele is one of the earliest instances in which a purely Egyptian motif appears with a representation of figures that are purely Greek[103] (Plate 22).

Under the Ptolemies Philae became an important place of pilgrimage, and the buildings, though still in the traditional Egyptian style, had a refinement suggestive of the temples of Edfu, Dendera, and Elephantine. The complex of buildings at Philae included a large Isaeum, a temple

Plate 20 (*left*) Capital from the Isaeum Campense in Rome, of Luna marble. It is a Roman version of an Egyptian papyrus capital, and was found near the church of Santa Maria sopra Minerva in 1852 (*Museo Egizio, Musei Vaticani, Rome, No. 77. Archivio Fotografico No. XXX.II.18*).

Plate 21 (*opposite*):
(*Top left*) Plan, elevation, and capital of the temple at Syene.
(*Top right*) Northern temple at Syene, showing columns square on plan.
(*Centre*) View of the Island of Elephantine and its surroundings.
(*Bottom*) Perspective view of the southern temple at Elephantine showing the peripteral arrangement of columns. Note the square columns down the long sides. From *Déscription de L'Egypte . . . A*, vol. I, pl. 38 (*Trustees of Sir John Soane's Museum*).

ÎLE D'ÉLÉPHANTINE ET SYENE.

Pl. 38.

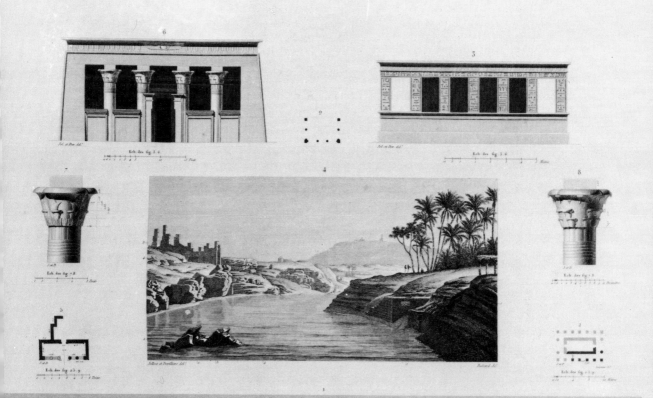

1 VUE PERSPECTIVE DU TEMPLE DU SUD A ÉLÉPHANTINE. 2.3 TEMPLE DU NORD. 4 VUE DE L'ÎLE ET DES ENVIRONS

5.6.7.8 PLAN, ÉLÉVATION ET CHAPITEAUX D'UN TEMPLE A SYENE. 9 PLAN D'UN ÉDIFICE RUINÉ A SYENE.

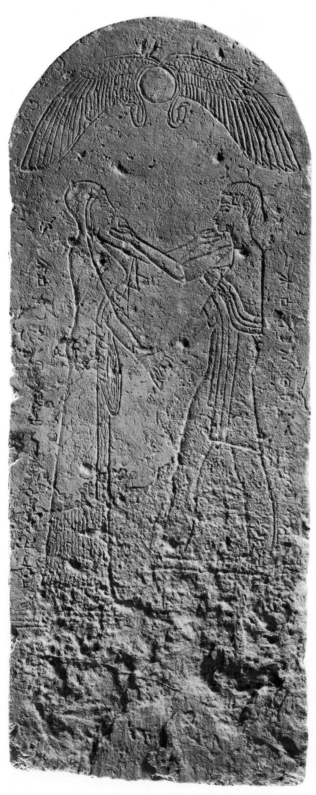

Plate 22 The incised Carian grave stele of 550–530 BC showing the Egyptian winged sun disc with uraei above the drawing of a man taking leave of a woman. The winged disc with uraei is Egyptian in style, while the drawing of the man and woman is in the late Greek style (*Fitzwilliam Museum, Cambridge, Exhibit number E.1. 1971. Neg. No. FMK. 1201*).

of Osiris, a Mammisi or birth house, pylons, various shrines, and a hypostyle hall. While the bulk of the Philae buildings dates from the Ptolemaic period (332–30 BC), there were later shrines erected to Augustus and Trajan, and the celebrated Kiosk itself is largely Trajanic (Pl. 23). This small temple, with four columns at the ends and five on the flanks, has elaborate floral capitals surmounted by stone blocks that were evidently to be carved with Isiac heads. There is a crowning cornice of typically Egyptian type. The spaces between the columns are filled with panels to half the height of the columns. This Kiosk, then, is an example of Egyptian Revival in architecture of the time of the Empire. To a certain extent the whole group of buildings erected at Philae under the Ptolemies must be regarded as Revivalist.

At Napata, the capital of Nubia, the ancient Egyptian temples differ somewhat from those of Thebes, but at Meroe, the second capital, are some strange remains. The temples of Meroe are Egyptian in character, but the sculptures betray a local development not derived from the main-stream Egyptian style.[104] The temples have more in common with the Mammisi at Edfu, Dendera, and Elephantine, and with the Kiosk at Philae. In Nubia we do not find the characteristic Theban arrangement with courts and hypostyle halls. The great temple at Meroe, which appears to have been associated with the cult of the sun, had two enclosing walls and a colonnade surrounded the temple, an arrangement that suggests Greek or Roman practice. In Nubia the kings were buried in pyramids, and when the Ptolemies were reigning in Alexandria, the kings of Nubia were building pyramids at Jebel Barkel near Meroe. As previously stated, these pyramids were sharper and more slender than the familiar 'Egyptian' type at Giza. It is unlikely that a definitive answer to the question of whether or not the Meroe pyramids were the models for pyramids of the Roman Empire will emerge now. Nubian temples and pyramids may be of more significance to Classical architecture than is generally admitted. The pyramidal tombs of the Roman Empire are indicative of the relations of the Romans with Egypt, and of the interest the Romans took in that mysterious land. In Egypt at the time of the Ptolemies there was a renaissance of Pharaonic art in which traditional motifs were revived, notably the pyramidal

tombs, and new Egyptian temples were built more as free-standing objects in their own precincts, like Graeco-Roman temples. Egypt exported many architectural ideas. The inverted *gola,* for example, found above the doorways of the palace of Darius at Persepolis, is an Egyptian form, pointing to the eclecticism of Persian taste. Persepolis also had a hypostyle hall, capitals featuring the heads of bulls, and a *propylaeum* with massive winged bulls adorned with human heads. These composite creatures recall the sphinxes of Egypt.

Egyptian art, architecture, and religion permeated the very fabric of the Empire. Some of the grandest buildings in Rome were dedicated to Egyptian deities, and Nilotic statuary, mosaics, and even buildings were known to the cosmopolitan citizens of the capital of the world. Manufacture of objects in the Egyptian style flourished, and the Alexandrian religions were of immense importance in the Empire. Egyptianisms were to be seen on all sides, and Egyptian ideas entered deep into the consciousness of Romans. Such a remarkable phenomenon could hardly vanish overnight, and indeed much that derived from the Nile Valley survived.

2

Some manifestations of Egyptianisms from the end of the Roman Empire to the Early Renaissance period

The tap'ring pyramid, the Egyptian's pride,
And wonder of the world! whose spiky top
Has wounded the thick cloud.

ROBERT BLAIR (1699–1746): *The Grave*. 1. 190.

Graeco-Roman writers drew much inspiration from Egypt, especially after it became part of the Empire: Herodotus tells us much about Egypt and Asia Minor; Diodorus Siculus devotes a whole book to Egypt; Plutarch of Chaeronea wrote about Egypt, which he knew; Gaius Plinius Secundus recorded much about Egypt; and Ammianus Marcellinus of Antioch included Egyptian information in his works. The writings of these Classical authors survived the collapse of the Empire in the West, and knowledge of Egypt was preserved in written form throughout the so-called Dark and Middle Ages. During the Renaissance writings about Egypt were rediscovered and given a new piquancy by the inaccessibility of Egypt. To the writers of the Middle Ages the celestial city was both Constantinople and Jerusalem,[1] and, as such, was portrayed as the City of God in manuscripts, wondrously illuminated and imaginatively described. To the educated Roman of the late Empire, the Holy City was Memphis or Alexandria, and the pyramids, the Sphinx, and Serapieion were as potent ideas as the Temple, the Holy Sepulchre, and Jerusalem to mediaeval Europeans.

Artists of the Middle Ages created extraordinary beasts to adorn churches, cathedrals, and illuminated texts. Exactly how many of these fanciful monsters were influenced by Egyptian or Egyptianising prototypes is difficult to assess, but paintings and sculptures of composite animals were known in Imperial Rome, and many survived the collapse of the Empire. Yet in St Paul's Epistle to the Romans, Egyptian religions are specifically denounced for giving the deities zoömorphic shape. Paul noted that pagans professed 'themselves to be wise', but they 'became fools'. They 'changed the glory of the incorruptible God into an image made like to corruptible man, and to birds, and fourfooted beasts, and creeping things'.[2] Paul could hardly have avoided knowing something of the Egyptian religions, and often used words and terms associated with the mystery religions. Even Tarsus, Paul's birthplace, had shrines for the Isiac cults, and it is perhaps worth noting that Paul's blindness and conversion have Isiac associations in that Isis could blind with her sistrum those who offended her, and yet could later restore sight.[3] Both Isis and Serapis were greatly valued for their powers to cure blindness. Paul's journeyings took him to places where Isiac cults were strong: Isis-Artemis ruled in the great temple at Ephesus, one of the wonders of the ancient world. The devotion to the Greek goddess, Isis-Artemis of the many breasts, was intense, and menaced the new religion of Christianity by the very fact that it was oecumenical. Isis was widely worshipped, and, as the goddess of a Myriad Names was dangerous by her very catholicity. Antioch had thriving Hellenistic religions, and Philippi was not guiltless of

a devotion to Isis the Great Queen. In the *Acts* of the Apostles the names of many of the personages are full of Isiac overtones, as might be expected in a narrative partially concerned with the conversion of followers of other faiths to Christianity. The use of terms such as *eucharistia* and *ecclesiae* doubtless reminded followers of Isis and Serapis of the worship and the sanctuaries in Isiac shrines, so the language was comfortingly familiar.[4] The move from the Isiac religions to that of Christ was not such a jump for someone in the Graeco-Roman world of Paul's day. With the acceptance of Egyptian deities into the pantheon, a certain blurring of identities undoubtedly occurred. The association of Isis with the many-breasted Artemis-Diana may even have been known to Paul, whose intelligence was not likely to miss noting the point. The statue of Diana of Ephesus in the Vatican has an extraordinary array of breasts, as well as a wrapping suggestive of a mummified corpse decorated with the torsos of horned animals (Pl. 9). Certainly, Paul was aware of the oecumenical powers of Isis.

This blurring of identity unquestionably continued after Christianity had become accepted orthodoxy, and the fact that Isis shares so many titles and attributes with the Virgin Mary[5] cannot be overlooked. It is clear that Isis continued to attract her devotees, and her symbols, including the lily and the fountain, proliferated, as did her names. Significantly, the cult of the Virgin Mary dates from the same time as the destruction of the Serapieion and other Egyptian shrines. Many churches were built on the sites of Isaea, and there is a probability that the use of old Isiac buildings as future churches was deliberate policy.[6] There is also some evidence that images of Isis remained in Christian churches, and that the origin of the black Madonnas found in Europe can be found in Isiac representations.[7] The rediscovery in the Renaissance period of the writings attributed to Hermes Mercurius Trismegistus, who was thought to be a contemporary of Moses, and their translation into Latin and Italian in the fifteenth century, brought Neoplatonic ideas current in the third and fourth centuries in Alexandria to Renaissance Europe. These texts became important to scholars throughout the civilised world, and were seen as links between Christian doctrine and philosophical and magical practices going back to ancient Egypt. The world of the Renaissance humanists was greatly influenced by pagan philosophy, but Christianity was not rejected as a result. Rather, it was reinterpreted in the light of the wisdom of ancient texts, and the basic goodness in all religions and philosophies was explored. Marsilio Ficino (1433–99) was a follower of Platonic ideas, and indeed saw in the Greek philosopher's work much that was Christian. The discovery of Greek and Latin texts led to a new philology, largely the creation of Lorenzo Valla (1407–57) who revealed the *Histories* of Herodotus in his Latin translation. Interest in things Egyptian was thus further stimulated, for Herodotus was a mine of information. Many works dealing with ancient architectural remains appeared in the course of the fifteenth century, notably those by Flavio Biondo (1392–1463), Ciriaco d'Ancona (1391-1455), and Cristoforo de Buondelmonte of Florence, who discovered the fifth-century Greek text on hieroglyphs known as *Horapollo* in 1419. Ciriaco recorded a great number of Egyptian monuments in Egypt itself, but did not gather his material systematically, so his work failed to be of much use. Aldus Manutius' celebrated edition of *Hypnerotomachia Poliphili* of 1499 illustrated many strange objects of antiquity, including an Egyptian obelisk the hieroglyphs of which gave it an added spice. Interest in the occult was a feature of the Renaissance, and many looked to Egypt as the source of all mysteries. Considerable impetus was given to the study of Egyptian philosophy and antiquities by the appearance of the various works of Athanasius Kircher in the seventeenth century. Kircher not only established a museum of Egyptian antiquities but used the ideas of the Pythagorians, of Plato, of Pico della Mirandola, and those found in the works of Hermes Trismegistus, to set up systems to explain the cosmos. His use of intersecting light and dark pyramids in diagrams is derived from the works of Robert Fludd, and owes a considerable debt to the system of numbers adopted by the sage of Croton, Pythagoras. Kircher sought to explain the pagan cultures to his own Catholic world. Yet even before Kircher, Giordano Bruno had held that even the cross was Egyptian in origin, and that the most reasonable theology had grown from Egypt.

In 1964 a remarkable book was published called *Giordano Bruno and the Hermetic Tradition.*[8] In this work, Dr Frances Yates illustrates one of the oddest aspects of the sixteenth century. Bruno,

an unfrocked monk, believed that the ancient wisdoms of Egyptian religion were of great significance to Christianity, and for this dangerous questioning of the uniqueness of Christianity he was burned at the stake on 16 February 1600. To Bruno, Egyptian theology was acceptable, and there is some evidence that he may have influenced certain Hermetic developments in Protestanism, and in Rosicrucianism.[9] Bruno demanded a return to Egyptian religion and good magic, and Dr Yates has suggested fascinating influences on Elizabethan England, Lutheran Germany, and Freemasonry.[10]

Another Italian, Giovanni Pico della Mirandola (1463–94), unquestionably exercised an influence so that aspects of Egyptianising religious practices were visible again in fresco work at the Vatican, while certain elements of ancient Egypt had not even vanished during the Middle Ages. Indeed, Pico evolved a complex mystical system in which Christianity was shown to be true through Cabbalistic and Hermetic texts. The obelisks were still in Rome, and Isiac works survived: there were even some surprising sphinxes carved in the thirteenth century at Viterbo and in Rome. The ferment of the fifteenth and sixteenth centuries revived interest in remote Egypt, notably through Giordano Bruno's Hermetic influence, and in particular his influence on John Dee, on the English and northern European Renaissance, through what Dr Yates has called 'the Rosicrucian Enlightenment'. Egypt, with its wonders and remarkable architecture, seemed to be the source of all wisdom, and its inaccessibility following its capture by forces of (and subsequent adherence to) Islam gave it added fascination. The mysterious inscriptions on obelisks and other works were no longer decipherable by Europeans. Egyptian religion, architecture, and sculpture took on new significance as products of a great culture from which all skills had come. The craft of building, and especially the skills of quarrying, cutting, dressing, and carving stone, were associated with Egypt. The mason's art had come from Egypt, and the stone buildings of Egypt became symbols of excellence and causes of wonder in European minds.

Eusebius, the father of ecclesiastical history (264–340), tells us much about Egypt, and Isidore, Bishop of Seville (c. 560–636), in his *Originum seu Etymologiarum libri* (probably the most influential encyclopaedia in the Middle Ages), writes of obelisks, pyramids, and other Egyptian structures. Isidore specifically refers to pyramids as a type of tomb. Descriptions of architecture are notorious for their problems of interpretation, and mediaeval ideas about Egypt were hazy in the extreme. The capture of Egypt by the Arabs in 641 made the country inaccessible to Western Christians, and consequently the architecture and art of Egypt entered into the realm of the fabulous. Surviving Egyptian monuments in Rome remained on view, however, and the obelisk near San Pietro must have aroused considerable curiosity among those who visited the Mother Church of Christendom. It was known as Pyramis Beati Petri from the tradition that it had witnessed the martyrdom of St Peter. In the mediaeval period, apparently from the eleventh century, the obelisk was thought to be the mausoleum of Julius Caesar, whose ashes were supposed to lie in the bronze ball at the tip. Alas! in 1587 the ball was found to be empty. The obelisk was also associated with the martyrdom of Christians who were killed in the Circus under Nero, as Tacitus has described in his *Annals*. It is probably the obelisk identified by Pliny in *Historia Naturalis* as erected by Ptolemy II at Alexandria. This huge Egyptian obelisk stood throughout the mediaeval period at a point east of the two chapels on the south side of the ancient basilica of St Peter.[11] Other obelisks stood, but several had fallen and broken, and many became submerged beneath rubble and vegetation. Enough Egyptian artefacts and descriptions of Egyptian work survived after the fall of the Empire to keep the curiosity of observers simmering.

Again, we must not forget the extraordinary vitality of art and architecture in the Eastern Empire, where the Christian religion kept alive many aspects of Egyptian culture. The Panagia-Theotokos of Orthodoxy, her face displaying grief, is universal in the Eastern Church, and many of the processions of her ikon today recall Isiac processions in the Praeneste mosaic.[12] It is abundantly clear that the Blessed Virgin, Mother of Jesus, gradually replaced the Graeco-Roman Isis-Sophia. There was a time in the history of the Church when the expressions in the Book of Canticles (*Canticum Canticorum*, the Song of Songs, called in the Authorised Version the Song of Solomon) were applied to the Virgin Mary. Her chief emblems are the sun, the moon, and the stars. 'And there appeared a great wonder in heaven; a woman clothed with the sun, and the

moon under her feet, and upon her head a crown of twelve stars.'[13] She is Stella Maris, as was Isis; Rose of Sharon;[14] the Lily among Thorns;[15] the Tower of David;[16] the Mountain of Myrrh and the Hill of Frankincense (both significantly Isiac in that they are associated with the rites of the dead);[17] the Garden enclosed, the Spring shut up, the Fountain sealed (springs, fountains, and gardens were also Isiac);[18] the Palm Tree (again a significantly Egyptianising motif);[19] and many others as well. She was Queen of Mercy, Mother of Mankind, our Life, Protectress in Death (very Isiac), Hope of All, Refuge, Help, and Asylum, Propitiatory of the World, Queen of Heaven and of Hell, Dispenser of Graces, City of Refuge, Patroness, Protectress from the Devil (again a connexion with Seth and Isis), Ladder of Paradise, Gate of Heaven, Mediatrix, Omnipotent, Peacemaker, Intercessor, Advocate, Redeemer, and Saviour. Among the authorities for this catholicity of titles is none other than St Alfonso Maria de' Liguori (1696–1787), founder of the Redemptorists, whose *Glories of Mary* appeared in translation in London in 1852. St Alfonso could apparently resurrect the dead, create rain, and fly. Maria Myrionymos is also amply discussed in the aretalogy of Hippolytus Marraccius, whose *Polyanthea Mariana* appeared in no less than eighteen books. Like Isis, Maria Myrionymos was Augusta, Primigenia (note the connexion with Fortuna and Tyche), Gubernatrix, Aurora, Exorcista, and many others. The same author's *Bibliotheca Mariana alphabetico ordine digesta,* is also illuminating reading for northerners unversed in Dominican Counter-Reformation literature. Serafino Montorio's *Zodiaco di Maria,* printed in 1715, tells us of a couple of hundred varieties of Madonna to be found in southern Italy, a region that is arranged on the principles of the Zodiac.[20] In this respect Kircher and Fludd are remembered. Montorio's work is dedicated to the Gran Madre di Dio who could equally well have been the Magna Mater, Diana of Ephesus, herself. Quite clearly Isis, the Great Goddess, was alive and well in Counter-Reformation Europe. For those who wish to pursue the byways of curiosities among the Saints, Theodor Trede's *Das Heidentum in der römischen Kirche. Bilder aus dem religiösen und sittlichen Leben Süditaliens* is a mine of information with copious scholarly notes and references to back up his relentless account of improbable and mysterious happenings. As an antidote to the sober Lutheran's diligent researches (the sources are unquestionable), various eighteenth and nineteenth-century monographs offer an insight of a world of belief and mysticism that is hardly comprehensible today. The *Vita del Venerabile servo di Dio Fra Egidio da S. Giuseppe laico professo alcontarino* reveals that the Venerable Fra Egidio resurrected a dismembered and slaughtered cow in a butcher's shop by the simple expedient of making the sign of the cross with his cord. This act recalls the Isiac resurrection of the parts of Osiris, and the cow, it will be remembered, is associated with Isis. There are many other obscure pamphlets dealing with the lives of various southern saints that were published during the last two centuries, and nearly all contain Isiac overtones, or suggest an Egyptianising religion. Flying monks and nuns, ability to conjure and perform good magic, the creation of rain or springs, a facility to perform the resurrection of the dead, successful battles with demons in the shape of curious composite creatures (very Egyptian), and other remarkable happenings recur. Miraculous images of the Madonna and Child with powers as impressive as those of ancient Egyptian deities suggest the familiar Isis-Horus idea.

The worship of Mary in the early Church was regarded as heretical, but it appears that from the fifth century such worship began to take place within the Church.[21] Now this is most significant. In past language of the Church, the Virgin was sister and spouse of God (like Isis), and sister of Christ. She was associated with agricultural fertility, and was termed the cornucopia of all our goods, again an Isiac symbol, as we have seen. She was symbolised by a young heifer (note the connexion with the Bull-Serapis and the cow's horns of Isis), and was Medicina Mundi (again note the Isiac association with healing). She was, like Isis, Pelagus, or the Pharos, shedding light in the darkness and leading us to harbour. She was the Salvatrix of sailors, like Isis, and, like the Egyptian, was an inventress and dispenser of justice. She was associated with deer, with swallows, with the moon, and with other horned creatures, and so can be identified with Diana of Ephesus, whose image includes horned animals, mummy-like wrappings, a halo-like disc, and allusions to the moon, as well as the symbols of her motherhood in her many breasts. St Jerome himself[22] wrote:

Scribebat Paulus ad Ephesios Dianam colentes, non hane venatricem, quae arcum tenet et succincta est, sed istam *multimammiam,* quam Graeci πολύμασιν vocant, ut scilicet ex ipsa effigie mentirentur omnium eam bestiarum et viventium esse nutricem.

Some writers have naïvely (or perhaps primly) supposed that this mode of representation refers to the fountains over which Diana presided, but the correct view is undoubtedly that which treats the multiplication of breasts as a symbol of the productive and nutritive powers encouraged by the goddess (and, of course, by Isis). The Mater Dei was installed at Ephesus in the place of Magna Mater. Fountains and breasts appear to be symbolically interchangeable. Breasts in the Ephesian context are also interpreted as eggs, as previously mentioned.

It is clear that the absorption of the Marian cultus within the Christian Church took place at the time when Theodosius began the destruction of the great pagan temples, including the celebrated Serapieion. The fourth-century songs of Paulinus do not appear to include any reference to the Madonna: the cult only begins to appear after the time of Theodosius. An official Christianity could hardly change the worship of Isis that was of considerable antiquity: however, it could absorb that worship, so that Isis became associated with Jesus. Yet we must beware of assuming a sudden change. Over several centuries, the blending of religions took place slowly, almost imperceptibly, so that even images of Isis could become confused with the Madonna, for after all the diadem, the palm, the infant, the moon, the rose, were common to both. It is beyond the bounds of possibility that a goddess so universally revered as Mistress of the Word; Source of Grace, of Truth, of Resurrection, of Life; Supreme Goddess; Mother of God; and Queen of Heaven could have vanished overnight by some act of worldwide rejection.

The eternal renewal of the Eucharist had its parallels too in the eternal tears of Isis, bringing constant renewal by the banks of the Nile. The Christian religion quite clearly owes as much to the Nile as it does to the Jordan, and for the Church Alexandria should be as important as Rome or Jerusalem. In both western and eastern iconography the attributes of Isis survived. Coptic stelai show the Mother and Child, identified as Christian by the Greek crosses on either side of the head, but the basic iconography of the image is that of Isis and Horus, later to become Mary and Jesus. In Constantinople itself, the great church of Hagia Sophia was given to the Virgin for safe-keeping, and Byzantine images owe much to Ptolemaic and Romano-Egyptian art. Holy water was known in Isiac temple and in Christian church, and the rattle of the sistrum was replaced by the bell.[23] Indeed, the *crotalus,* or rattle, was used instead of the bell in the Christian Church, especially on Maundy Thursday, and was in common use in the Ethiopian Church. The orthodox Christianity before Theodosius was lacking a female element, and consequently seemed somewhat forbidding to Mediterranean peoples: the Madonna supplied Christianity with an element it lacked, and could be widely interpreted.

The Madonna Achiropita, as we learn from the life of the appropriately named St Nilus, favoured purple as the colour of her garment, and was a saviour of mankind from plague and invasion. Unlike many ikons, hers were not painted by St Luke (whose output in this genre was remarkable), and had a pronounced resemblance to the ancient Magna Mater whose image also had a divine origin. She was *acheiropoeta,* that is not painted by any human agency. The Gnostics held that Isis and the Virgin Mary shared attributes: when the dogma of the Virgin Mother of God[24] was adopted in 431 at Ephesus (itself a world centre of the Isiac cult), the theologians could not have been unaware of the continuing importance of Isis. The Council of Ephesus, anxious to resolve the Nestorian controversy, first gave official recognition to the elevation of Christ's Mother, and in so doing clearly realised the potency of the position of Isis throughout the civilised world. Obviously such an oecumenical goddess was a great danger to the Christian religion, with its ascetic traditions that were repugnant to many people in the Empire. The grimness of the Crucifixion and the male-dominated religion cannot have appealed much to the devotees of Isis. The absorption of so much of Isiac religion by Christianity was an obvious choice, and was later to revive overt Isiac symbolism within the Marian cultus of the Counter-Reformation period. The rival claims of Christ and of Isis caused conflict. In this respect the Flight into Egypt is not

insignificant, for some early commentators ascribed the healing powers of Jesus to His stay in that country, and suggested He had been taught by Isis. So powerful was the goddess that even nominal Christians tended to appear at the altar of Isis Medica[25] at Menouthis when ill rather than rely on the less accredited (and presumably derivative and therefore weaker) powers of Christ. The Archbishop of Alexandria was thus forced to destroy the Isiac temple, but he cunningly had the relics of Christian saints[26] interred on the site and built a church there that was to become a landmark for sailors. The properties of the hallowed place as a beacon and as a source of healing therefore became Christianised. The Neoplatonist Eunapius remained un-convinced by it all, and in his *Lives of the Sophists* defended the old pagan traditions against Christianity. One can imagine the ill-concealed scorn with which a cultivated pagan mind viewed the attempts to give legitimacy and continuity to Christian sites. The church of Santa Maria sopra Minerva in Rome stands over the site of a huge Isaeum, and there are several examples where Christian churches were built on sites already sanctified to Isiac cults.[27]

As Isis was the greatest of all Egyptian sources of power and wisdom, her translation, the re-consecration of her sacred sites to Christianity, and the absorption of her best qualities were essential to the survival and growth of the new religion. In some instances Egyptian deities are depicted with Christian angels, notably in Graeco-Roman jewellery, where Thoth and Anubis associate with Michael and Gabriel; and John, the Bearer of Glad Tidings, was sometimes identified with Hermes and Anubis. Horus-Harpocrates was occasionally shown as a warrior on horseback, attacking Seth-Typhon, who had transformed himself into a crocodile. Such images obviously affected Christian iconography,[28] with particular reference to St Michael and to St George. Horus is also depicted in catacombs in Alexandria trampling on crocodiles.[29] Indeed, both SS. George and Michael are held to have fought dragons that are identified with the Devil.[30] Michael waged war against the dragon-serpent persecutor of a pregnant woman, who can be Isis. A curious pamphlet, *Novena in Onore di S. Michele Arcangelo,* published in 1910, contains a Litany giving the titles of the Archangel. These include Secretary of God, Liberator from Infernal Chains, Defender in the Houerator from Infernal Chains, Defender in the Hour of Death, Custodian of the Pope, Spirit of Light, Terror of Demons, Lash of Heresies, Wisest of Magistrates, Commander-in-Chief of the Armies of the Lord, Conductor of Mortals, and Custodian of the Holy Family. Here is a catholicity of titles with clear Egyptian connotations. The idea of a sort of armed guard for the Holy Family might startle some, but those who are familiar with the veneration shown to the oddest of objects in southern Europe will scarcely be surprised. Abstractions are foreign to the South: attitudes to deities are positive and direct. An Isiac family is easier to grasp than the Trinity as an immediate idea and image. There are obvious parallels between the Isis-Horus representations and those of the Madonna and Child. Furthermore, Ptolemaic Egypt unquestionably exerted considerable influence on Byzantine religious imagery: pictures or statuary of the Mother and Son had been known for centuries before Christianity.[31] Diehl's *Manuel d'Art Byzantin,* published in Paris in 1925, is explicit on this point, and insists that Hellenistic Egypt had a profound influence on the pictorial art of Byzantine culture. In south Italy even today beliefs imported from ancient Egypt can be found mingled with Western demonology. Serpents and dragons tend to be synonymous, as they were in ancient times: they represent devastation and envy, and the rage of dark and untamed forces. Further south Italian Egyptian-isms occur in Calabria at San Demetrio, for example, where parts of columns of African marble and Egyptian granite survive as well as a mosaic pavement featuring leopards and serpents.

The gradual merging of the Egyptian religions with official Christianity ensured a longevity of Isiac emblems. Before the Mahommedan invasion of Egypt many Christian ascetics inhabited the ruined cities of Thebes and Memphis, and so the imagery of ancient Egyptian architecture passed into Christian experience. It is a matter of speculation as to how many of the fearsome demons described by Christian mystics were derived from Egyptian temple reliefs, for many of the early Christian hermits who settled in Italy were Byzantines, Africans, or Egyptians, and many would have been familiar with the zoömorphic creatures of Isiac cults. Loneliness, semi-starvation, and religious fervour could conjure up memories of strange images in some new and menacing brew. This merging seems to have begun with the attacks on the worship of pagan deities under

Theodosius in the fifth century following the attempts to revive paganism by Julian the Apostate (AD 361–3), although, as noted previously, Isis was a familiar figure on Roman coins. Christendom's loss of Egypt in the seventh century added a mysterious attraction to that land. Scholars knew of Egypt and its monuments throughout the mediaeval period, although the detail became confused and fabulous in the process. When Egypt and so much of the old Hellenistic and Roman world fell to Islam, specialised knowledge of Egyptian architecture became speculative, and memories grew dim. Apart from surviving Egyptian and Egyptianising artefacts in Italy and in Christian Europe, and apart from the descriptions in literature, Egyptian architecture and details became inaccessible, remote, and infinitely mysterious. This fact, and the curiosity of those obelisks and other items that were on view in Rome, must have aroused considerable interest in things Egyptian. Sphinxes were familiar to collectors in the Roman world, as were canopic jars, Egyptian statuary, and, of course, obelisks. Sphinxes without wings had been known to the Etruscans, who used this motif for decoration. Large numbers of Etruscan vases adorned with sphinxes were discovered in the thirteenth century, according to Stendhal in his *Histoire de la Peinture en Italie*.[32] A manuscript by Ristoro d'Arezzo of 1282, now in Florence, describes the discovery.

Many early Christian churches re-used materials looted from Roman temples and public buildings; pieces of the entablature often come from several different buildings and so the continuous entablatures in many early Christian naves seem coarse and disjointed. Columns were quite frequently of different heights, so bases and capitals vary considerably. The architectural results of such re-use of elements from older buildings are often uncomfortable and the archaeological and historical interest outweighs the aesthetic effects. The original church of Santa Maria in Trastévere was probably founded before the reign of Constantine and completed in the fourth century. It was rebuilt by Innocent II in 1140, and consecrated by Innocent III in 1198. Some fifty years after the sack of the great Isaeum Campense in 1084, twenty-eight columns of dark reddish-brown granite, with Ionic capitals carved in marble, were set up in the nave of the basilica of Santa Maria in Trastévere. As previously mentioned, some of these capitals were decorated with heads of Egyptian deities, and may have come from either the Isaeum Campense or the Baths of Caracalla, the latter being quoted more frequently as the source.[33] However, the columns from the Baths of Caracalla are probably those now in the church of Sant'Agnese in Rome. The capitals in Santa Maria in Trastévere are spectacular, and are more likely to be from the Isaeum which had been damaged only comparatively recently. The interest in these capitals lies in the fact that Egyptian deities were deliberately added to a typical rather grand Imperial version of the Classical Ionic Order. Some of the heads have been deliberately mutilated or broken off. The re-use of capitals is commonplace in Rome, and the fact that these capitals have been re-used obviously does not point to a survival of interest in Isiac religion in the twelfth century. In fact it is quite possible that the Egyptianising elements were not recognised as such at all by the builders of the Christian church, just as the Cosmati sculptors did not recognise the sphinxes and lions that they saw as Egyptian in origin. It is highly unlikely that the heads of deities were mutilated in early times, for after all the lush Ionic carvings themselves were purely pagan in origin and do not seem to have worried the church builders at all. The subsequent mutilation of some of the heads does suggest, however, that the ancient deities were feared sufficiently to merit the destruction of their images at some time, and indeed it appears that most of the damage was done in 1870 under Pope Pius IX, whose zeal needs no emphasis today. In that year the basilica of Santa Maria was renovated rather drastically, so it would appear that the 'purifying' of the capitals occurred then. Some heads, including that of Serapis, with modius, or corn measure, placed firmly on his head, survived to be photographed (Pl. 24). If these remarkable objects did come from the Isaeum Campense, they were only a very small part of a large number of Egyptian and Egyptianising antiquities that were in that complex of buildings. There must have been many more objects that did not survive the fires and other disasters that struck the splendid temples. The survivals include antefixae, capitals, columns, friezes, pediments (segmental, of course), reliefs, obelisks, statues of Horus, Isis, Osiris-Canopus, and Sekhmet, various Pharaohs, sundry Egyptianising figures, an Apis bull, baboons, crocodiles, cows, lions, sphinxes, canopic jars, a

Plate 24 (*left*) An Ionic capital from the Baths of Caracalla, or possibly from the Isaeum Campense according to R. Lanciani in *Bulletino della Commissione archeologica comunale di Roma*, 1883 (although Lanciani cannot say exactly where the caps originated), re-used in the nave of the church of Santa Maria in Trastévere in Rome. The head in the centre is probably that of Serapis, with a modius, or corn measure, on his head (*Mansell–Anderson No. 3148*).

Plate 25 (*right*) The capital and abacus of a pier in Malmesbury Abbey, Wiltshire. Note the repetitive palmette motif that is almost identical to similar designs found in ancient Greek and Egyptian work. The pier was associated with a statue of the Virgin Mary, and dates from *c.* 1170. Compare the palmette with Pl. 151.

cippus, a stele, and various vases. There were other Isaea and temples dedicated to Egyptian deities in Rome itself and throughout the Empire; at least two pyramidal tombs that resemble the pyramids in southern Egypt at Meroe and those further north at Deir-el-Medina; several obelisks in circuses (where they could be seen by multitudes) and in other positions; Nilotic scenes in gardens and temples as well as in mosaic floors; pavilions in the Egyptian style in gardens such as those of Sallust (where there was also an obelisk); and, of course, the huge complex of buildings at the Villa Adriana at Tivoli.

Isis and other Egyptian deities were familiar from temples, private houses, and gardens, while Nilotic scenes, plants, and animals were shown in paintings, in mosaics, and in sculpture. Alexandrian deities were not only worshipped by the Roman aristocracy, but the Emperors themselves were identified with Serapis. Isis and images associated with the Great Goddess were plentiful. Some Isaea survived, and the sites associated with the consort of Serapis remained, some becoming Christianised in the twelfth century, when the cult of female saints expanded on an awesome scale. Especially significant was that of the Virgin Mary. In southern Europe the Holy Family, and especially the Mother, became revered. One is not aware in Italy of the adult Christ in the iconography of the period to nearly the same extent as one is of the infant in His Mother's arms. There appears to have been a political reason for this. Many early saints were Byzantines or North Africans, even in Italy, and they replaced the local Classical deities. Roman Catholic orthodoxy was not at all happy about this state of affairs. The Marian cultus provided an attractive means of providing a universal figure that would be more powerful than local male saints, although the latter had been useful as fighters and protectors. At the same time, the growing cults that had developed after the changes in the fourth century, and especially after the sixth century, carried forward the old Isiac tradition and, with the image of the Virgin and Child, the tradition of Horus-Harpocrates and *Lar Familiaris*. Nevertheless, it is clear that the multitude of saints was replaced by a host of Madonnas, especially in southern Italy: some were notably pugnacious, like Santa Maria della Libera and Santa Maria di Constantinopoli, two warlike southern Italian Madonnas of clear Egypto-Byzantine origins. Madonnas could multiply with bacteriological ease, yet would not lose power or credibility. The very catholicity of the Madonna ensured that anything could be attributed to her, and that her histories, with their mythopoetic ramifications, could embrace almost anything.

There can be no doubt that the imagery of Egyptian artefacts remained an important element

during the Romanesque period. Greek terracotta antefixae, with elementary volutes on either side of smiling heads crowned with palmettes have their origins in archaic capitals from Larisa in Aeolis. Similar compositions prepare us for the capital from the *tholos* in the precinct of Athena Pronaia at Delphi, with its volutes and central anthemion motif. The early capitals from Neandria have simple volutes on either side of a primitive motif that is derived from a lotus shape. Early capitals from Cyprus, Lesbos, Naukratis, and elsewhere have been noted, with volutes flanking palmettes or anthemion motifs. An almost precise miniature version of this theme is repeated as a continuous frieze around the abacus of the capital of the third pier from the west in the southern nave arcade at Malmesbury Abbey in Wiltshire. The repetitive motif featuring the palmette (here interpreted as the fleur-de-lis) held between two primitive volutes is continued all round the abacus. This decoration on a Norman building, dating from *c.* 1170, is an exact derivative of an ancient Graeco-Egyptian design, and, significantly, the pier was associated with a statue of the Virgin Mary that attracted great devotion until the Reformation. This is probably the earliest example of an Egyptian motif in England that dates from the Middle Ages (Pl. 25).

By the twelfth century the Virgin had become a figure of universal devotion throughout Christendom. One particular image recurs frequently from the thirteenth century, especially in the woodcarving of Germany. That image is of the Virgin of Mercy, depicted with her sheltering mantle, and has been in the forefront of European ideas of Our Lady. The mantle (usually coloured blue) is a shield against disasters, notably plague, famine, and war. These disasters are often shown as arrows, shot by God at humanity as punishments for threefold concupiscence. The most enchantingly beautiful of such images of the Virgin of Mercy are those carved in lime-wood by German sculptors during the fourteenth and fifteenth centuries. Michael Erhart of Ulm's charming Virgin of Mercy, of *c.* 1485, shows a figure with outstretched cloak sheltering knee-high human beings in contemporary dress. Michael Baxandall's book[34] is most illuminating on sculptors of the period. The sheltering cloak also suggests the outstretched protective wings of Egyptian work.

In the thirteenth century an Egyptian Revival of limited extent took place, although it was of brief duration. The monument to Rolandino de' Passeggeri at Bologna, for example, had a pyramidal roof on an arcaded version of a tower-tomb, and although it is essentially a canopy, like a gigantic reliquary, and is Gothic, it is still Classical in form. The resemblance to tombs of the Imperial period is obvious. The cloisters (*chiostro*) of San Giovanni in Laterano, constructed in 1222–34 by members of the Vassalletus family, are of peculiar interest, as there is little other Romanesque architecture in the Eternal City. This is because of the survival of a Classical tradition, and because there was so much Roman work that could be quarried for new building. The delicate twisted barleysugar twin columns inlaid with patterned glass mosaics (Cosmati-work) are the special features of the chiostro. These coupled columns carry semicircular arches in groups of five or more openings between the piers, and form an arcade around the four sides of the *cortile*. The oddity about these cloisters can be found in the central arch of one side, where access to the cortile can be gained. There are four openings, one in the centre of each side. The double columns stand on bases that are set on wide slabs forming the top of a die or continuous pedestal. Flanking one of the openings, and carrying the stone top of the die, are two sphinxes, facing inwards. One is bearded, both have Egyptian head-dresses (Pl. 26). Other thirteenth-century sphinxes exist at Civitá Castellana and at Viterbo. The sphinx at Viterbo, signed by Fra Pasquale, is now in the Museo Civico, and originally came from Santa Maria in Gradi. All three mediaeval Egyptian Revival sphinxes are by Cosmati designers. The Cosmati group of marble cutters that was established in Rome in the thirteenth century clearly derived much inspiration from ancient sculptures surviving from Imperial times. 'Cosmati' is a generic term that is given to coloured marble and other stone inlay decorative work. The name is derived from craftsmen named Cosmas, whose names occur in relation to the cloisters at Santa Scolastica in Subiaco, pavements at Anagni, and other sites. There were several groups of Cosmati workers, notably the Vassalletus and Laurentius families, and many individuals. Cosmati work is easily recognisable, and consists of white marble inlaid with stars and discs of coloured glass and stones. It was applied to colonnettes in cloisters and bell-towers, and large areas of it occur in nave floors, such as that in

Plate 26 Sphinxes in the chiostro of San Giovanni in Laterano in Rome, of 1222–4.

San Clemente in Rome. Paschal candlesticks, tombs, pulpits, thrones, and other objects were enriched with Cosmati work. The characteristic use of inlay derived from south Italy and from Byzantium, whilst antique forms such as those of lions or sphinxes were also exploited by the Cosmati designers. The fashion for this form of decoration spread as far afield as England, where Cosmati designers worked on the tombs of Edward the Confessor and of King Henry III from 1268. Egyptian sphinxes and lions in Rome were used as exemplars by the Cosmati artists, and most of these were either late works from Egypt or Roman copies of Egyptian originals. The slight and mysterious smile on the antique versions thus became emphasised, so that the thirteenth-century sphinxes (and sometimes lions as well) acquired wide smiles and wrinkles by the eyes, giving them an almost caricature effect. Smiling sphinxes occur in the chiostro of San Giovanni in Laterano, at the entrance to Sant' Antonio Abbáte (1269) in Rome, on the choir-screen, now in an oratory near the high altar of the Cathedral of Santa Maria at Città Castellana, and at the door of the sacristy at the Cathedral of Ferentino. The Lateran sphinxes are particularly interesting, for the laughing sphinx appears to be female, and the companion sphinx is a bearded unsmiling male. This pair is of considerable importance to this study, for pairs of male and female sphinxes are Revivalist rather than *echt*-Egyptian. Pairs were to occur with increasing frequency during the Renaissance period. Two earnest sphinxes, also by Vassalletus, and of indeterminate sex, support a Paschal candelabrum in the Cathedral of Santa Maria in Anagni. All these Cosmati sphinxes have chests at right angles to the bases or set forwards, while real Egyptian sphinxes appear more relaxed, and less likely to spring out at the beholder. The somewhat primitive appearance of the Cosmati sphinxes seems to be due to the difficulty of placing a human head on a lion's body, and making the sphinx carry a column or pair of columns on a slab on its back. The Viterbo sphinx is very strange, for the head is not Egyptianising at all, although the body, without wings, is clearly derived from Egyptian or Egyptianising prototypes.[35] In addition, the head is turned to the left, and there is a base with an inscription instead of the usual hieroglyphs. Two sphinx bodies without heads survive in the chiostro of San Paolo fuori le Mura in Rome.

In the thirteenth century the famous lions of Nectanebo I could still be seen in front of the Pantheon, as Magister Gregorius had noted in the previous century, and these provided models for Cosmati sculptors at the porch of the church of Santi Apostoli in Rome. There, a lion, with its head turned to the right, a round beard, crossed forepaws, and a tail laid along the base, lies on guard. It is signed by Bassallectus. The beard, the ears and chin, and the rounded profile are clearly derived from Egyptian, or from Egyptianising originals, and are also marked in Cosmati lions. Egyptianising influences are also obvious in the lions at the entrance of the church of San Lorenzo in Lucina, in the choir of San Lorenzo fuori le Mura (both in Rome), in the sacristy of the Cathedral of Ferentino, and in the bishop's throne at Anagni. Now all these lions with heads turned sideways and paws on the axis of the body derive from antique lions in Rome, and indeed there were several Egyptian or Egyptianising lions known in the mediaeval period that could be copied including those now on the Capitol. The Cosmati were also engaged to erect an obelisk on the Capitol during the thirteenth century; they took the upper part of an obelisk from the Isaeum Campense, completing the shaft with a new re-cut piece of granite. The whole was given a base and four lions based on Hellenistic rather than Egyptian models. This might indicate that the lions and sphinxes copied with such obvious delight by the Cosmati were not consciously identified with Egypt, but rather were associated with the past in general, and with ancient Roman architecture and sculpture in particular. Other mediaeval lions, like those at Modena cathedral, for example, are derived from antique Egyptianising prototypes.

It is important to realise that Romans could see the *Navigium Isidis* processions even at the end of the fourth century, while Ammianus Marcellinus describes the magnificence of the monuments of Rome in the reign of Constantius. Until the dawning of the fifth century the old Roman families remained faithful to the Egyptian deities (especially Isis and Serapis) in spite of the advances of the new religion of Christianity. Roman Emperors, including Caracalla, were shown in statuary wearing the Egyptian *nemes* head-dress (also sported by Antinoüs), and sphinxes in pairs guarded the mausoleum of Diocletian at Split (Spalato). The great Isaeum at Rome was probably not destroyed until 1084 when the Campus Martius was wrecked by the Norman and Saracen invaders. Anne Roullet reminds us that there were known Egyptian remains visible in and near Rome in the mediaeval period, including obelisks, the two pyramids, a baboon, and several lions and sphinxes. An immense amount must have been lost, however, for Magnus Aurelius Cassiodorus Senator, who held high office under Theodoric, tells us in his *Variae* that marble was being burned for quicklime, buildings were being looted for materials, and sculpture was vanishing even in his time (*c.* 500). Cassiodorus has considerable historic importance, not least for his topographical remarks. In the tenth century there was a marked increase in the interest of the historical remains of Rome, as is brought out by L. Urlichs in his *Codex urbis Romae topographicus* of 1871. *Mirabilia* and the *Graphia Aurea Urbis Romae* were composed in the tenth century, and contain notes on the monuments and legends of Rome. By the following century writers expressed the view that pyramids and obelisks were tombs of ancient heroes, and in the twelfth century, inspired perhaps by the damage done by the invaders of a few years earlier, antiquities and ancient buildings were becoming the subject of serious consideration. This proto-Renaissance encouraged archaeological excavation and even restoration of Roman buildings. Magister Gregorius, in his great work on the city of Rome, described both pyramids and obelisks under the title of *pyramis* and singled out the lions by the Pantheon for mention. Two centuries were to pass, however, before Rome was awakened again to its great heritage of monuments.

Although the Cosmati lions and sphinxes derive from existing models dating from antiquity, many Etruscan vases decorated with sphinx motifs were discovered about the time the Cosmati decorators were active. The sphinxes mentioned in the Lateran, Ferentino, and elsewhere are startling in their context, yet the archaeological element must not be overlooked. Perhaps a revival of interest in Egypt was triggered partly by the rebuilding of the chief church of the Dominicans in Rome, Santa Maria sopra Minerva, in 1280–5, in the Gothic style (always curiously uncomfortable and apparently out of place in central Italy). Part of this church stood on the site of the temple of Minerva that had been founded by Domitian, and part stood on the site of the Isaeum. These considerable building operations (and others in 1347) unearthed a number of

Egyptian objects that had graced the Isiac buildings, although the famous Nilotic group was not uncovered until the sixteenth century. One discovery was a dog-headed figure, possibly representing Anubis, the guide of the dead, and guard of Osiris. In Roman work, Anubis is also shown carrying the herald's wand of Hermes-Mercury, and on his dog's or jackal's head he wears the crescent moon of Isis and the solar disc.

A few intrepid voyagers ventured into Egypt, and some noted the existence of the pyramids, identifying them with sepulchres. The Sphinx was identified with Isis, and the enormous size of these monuments caused comment.[36] Even before the sack of Constantinople in 1453 brought scholars and books to the West, interest in Greek texts and in Egypt had been aroused. The connexion between Apollo and Horus was clear by the early fifteenth century when the Greek script (already mentioned) dealing with Egyptian hieroglyphs was rediscovered.[37] It is not often realised that part of the Renaissance scholarly tradition derived from the assorted writings ascribed to 'Hermes Mercurius Trismegistus Contemporaneus Moisi', as he is described by di Stefano in the celebrated *Sgraffito* decoration in Siena Cathedral. An Egyptian priest, who was the contemporary of Moses, thus became a revered figure in Renaissance Europe. The 'Hermetic' texts, however, appear to have been by various writers in Alexandria of the third and fourth centuries. These texts were seen as profound truths that predicted Christian belief, and established a thread of wisdom from ancient Egypt to the Jews, the Greeks, and the Romans. The Hermetic teachings, regarded by some as going back to Moses or even Abraham, were a source of spiritual and intellectual stimulation that cannot be overestimated. They were particularly important to Kircher. The discovery of the *Hori Apollonis Hieroglyphica* by Cristofero de Buondelmonte in 1419 in a mediaeval version of the Greek original had a profound effect on the study of Egyptian relics. Renaissance humanism became permeated by a desire to grasp the key to the mysteries of ancient times, especially as enshrined in hieroglyphs, in Hermetic philosophies, and in other ancient texts. The importance given to Hermetic ideas in the time of Renaissance humanism is stressed by the splendours of the noble figure of Hermes Trismegistus, exhorting Moses and other oriental figures in the celebrated pavement of Siena Cathedral, and by the appearance of Hermes Trismegistus, the Great Goddess Isis, and Moses in one group in the Appartamento Borgia in the Vatican. These visual representations of Hermes can all be traced to the rediscovery of the texts, and to the increasing Egyptianism of the Bishop of Rome himself. The real impact on Western culture, however, was made after Marsilio Ficino translated these Hermetic texts into Latin in 1463,[38] and later into Italian. Ficino's translation was printed in 1471, and the original Greek text was published by Aldus Manutius in 1505. The excitement was considerable, for now it appeared that the mysteries of Egypt would be revealed: it must be remembered that the notion that all magic, all knowledge, all skills, and all basic architectural wisdom came from Egypt had never died. Now, encouraged by Ficino's Latin translation, the Hermetic Tradition revived. The rediscovery of Ammianus Marcellinus'[39] work on hieroglyphs and its transcription by Niccolò Niccoli, the Florentine bibliophile, added new impetus to an enthusiasm for Egypt. Indeed, we owe to Niccoli, 'a member of that accomplished circle of friends which surrounded the elder Cosimo de' Medici',[40] the completion of the works of Ammianus Marcellinus and other books. It was Niccoli who persuaded Cosimo to buy a manuscript of Pliny from a monastery library in Lübeck, and Niccoli himself spent his entire fortune buying books and manuscripts. Thus it was that knowledge of Egypt came gradually to be rediscovered, just as the works of Greek and Roman authors emerged from obscurity into the clear light of the Renaissance.[41]

3

Further manifestations with Egyptian connotations in Europe from the Renaissance to the end of the sixteenth century

... concerning Egypt
I will now speak at length,
because nowhere are there so many marvellous
things, nor in the whole world beside
are there to be seen so many works
of unspeakable Greatness.

HERODOTUS: II. 35

Burckhardt has said,[1] that the civilisations of Greece and Rome exerted an influence in the so-called Dark Ages and in the mediaeval period. Romanesque architecture in northern Europe had remarkable allusions to antique forms. With the development of civic life in Italy from the fourteenth century, enthusiasm for antiquity could flourish. Poggio Bracciolini (1380–1459) began his walks in Rome,[2] and the study of architectural remains was for the first time associated with a study of the literature left by ancient authors. It was Poggio who discovered the manuscript by Ammianus Marcellinus (c. AD 330–c. 395) that contained descriptions of Egyptian hieroglyphs, in a library in Germany.[3] Poggio and Guarino were the two great book-finders: the former acted as an agent for Niccolò Niccoli, and scoured the abbeys of Germany for ancient texts. He discovered the complete works of Quintilian (c. AD 35–c. 100) at St Gall in Switzerland and much else besides. Largely through Poggio's diligence Niccoli managed to complete the collected works of Ammianus Marcellinus, one of the major source-books of the Egyptian Revival.

Ammianus Marcellinus was descended from an educated Greek family. He served in Gaul and knew Antioch, Egypt, Greece, and Thrace. In 380 he settled in Rome where he became an intimate of members of the pagan aristocracy. He is regarded as the last great impartial historian of antiquity: this is borne out by his attitude to the Christian clergy about whom he wrote with irony, although he clearly respected their beliefs. Poggio was one of the first to record system-atically the inscriptions of ancient Rome, and he removed vegetation which had obscured the carvings and even the forms of buildings.[4] It is unfortunate that Poggio's work was not more complete and was not illustrated, for very much more of ancient Rome survived in his day than during the life of Raphael. Many of the buildings Poggio described have long since disappeared, since not only were the ancient buildings quarried for material to be erected elsewhere, but vast amounts of marble were burned down to be used as quicklime:[5] paradoxically, a love of antiquity and the desire to emulate the great monuments of the past hastened the demolition of antique fabric. Poggio was also to translate sections of the works of the Greek historian Diodorus Siculus, who lived in the times of Julius Caesar and Augustus, and whose *Bibliotheca* included six books dealing with the history and mythology of the Egyptians. During the fifteenth century the new discoveries led to the systematic creation of libraries. Ancient books were copied by armies of

scribes: Poggio himself was an accurate and remarkably quick copier. There was a rapid multiplication of translations from ancient Greek texts. Cardinal Bessarion (1403–72) collected Christian and pagan authors, and his library became the heart of the Biblioteca Marciana. The great library of Frederick of Montefeltro, established with the help of the bibliophile Vespasiano da Bisticci later passed to the Vatican.

With the enthronement of Pope Nicholas V (1447–1455) came a new passion for embellishing Rome, bringing, as Burckhardt has noted,[6] new dangers for the ruins as well as a new respect for antiquity.[7] Pope Pius II (1458–64) was also an enthusiastic antiquarian, and was among the first to record the ancient remains around Rome. He was particularly attached to Viterbo, and was there-fore probably familiar with the thirteenth-century Cosmati sphinx and the Etruscan representa-tions of wingless sphinxes on vases there. Pius was also associated with Siena, for his family, the Piccolomini, came from Rome and settled there. It is important to realise that enthusiasm for the past was not confined to Roman remains alone. Boccaccio, in *Fiammetta,* had described the ruins of Baiae near Naples, and collections of antiquities of all kinds (including books, sculptures, and artefacts) became the vogue. One of the most diligent collectors of inscriptions and sketches was Ciriaco of Ancona (*ob.* 1457), who travelled throughout Italy and other countries in search of antiquities. He travelled, notably, in Egypt at the behest of the Florentine intelligentsia, and copied inscriptions near the pyramids of Giza.[8] In fact, he brought back many records of inscriptions as well as drawings of buildings and other artefacts. When asked why he took all that trouble, he replied that he wished to wake the dead.[9]

The fascination that Egyptian objects held for Renaissance scholars was considerable. Flavio Biondo, or Blondus of Forlì (1392–1463), described Egyptian items such as hieroglyphs, pyramids, and obelisks in his works.[10] Biondo's *Italia Illustrata* of 1450 discusses the Villa Adriana at Tivoli (probably one of the earliest occasions on which the building is mentioned during the Renaissance, as Pevsner and Lang have pointed out[11]). Biondo really began the discipline of historical geography and his works display a great depth of knowledge of antiquity. He and Poggio were among the founders of modern archaeology: Biondo's *Roma Instaurata* was based on the works of Sextus Julius Frontinus (*c.* 30–101), on the *Libri Regionali,* and on Anastasius. Frontinus had written a comprehensive work on the aqueducts of Rome which was much admired by Renaissance antiquaries. Poggio's *De Varietate Fortunae* set new standards and methodically described the remains of the ancient city of Rome. Biondo set out not only to describe what existed, but to attempt to recover what had been lost. His *Roma Triumphans* was the first comprehensive effort to provide a complete exposition of Roman antiquity. En passant, Leone-Battista Alberti, perhaps the most important of humanist architect-theoreticians, also discussed Egyptian remains in his celebrated *De Re Aedificatoria,* in Lib. VIII. He stated, interest-ingly, that:

> few perhaps have built their Pyramids with three Sides, but they have generally been made with four, *and their Height has most commonly been made equal to their Breadth.*[12] Some have been particularly commended for making the Joints of the Stones in their Pyramids to close, that the Shadow which they cast was perfectly straight without the least Interruption. Pyramids have for the most part been made of square Stone, but some few have been built with Brick. As for these Columns which have been erected as Monuments; some have been such as are used in other Structures; others have been so large as to be fit for no Edifice; but merely to serve as a Monument to Posterity.[13]

'Monuments' of the obelisk type are frequently referred to by Renaissance writers by the term 'Julia' or *guglia.*

It is a sobering thought that the roads leading from Rome had over a quarter of a million tombs built with architectural pretensions in antiquity, and that Alberti knew many of the surviving examples. The pitiful handful of mutilated tombs that still stand is an indictment of the vandalism that has occurred since Renaissance times, and even in our own century. A comparison of the state of the tombs on the Via Appia Antica today with those photographed by

J. H. Parker on glass-plate negatives in the last century[14] is enough to demonstrate the shocking rate of destruction even in living memory.

A curious feature of the recording of antiquities in Renaissance times was that hieroglyphs (the key to the meaning of which had long been lost) were treated in an extraordinary fashion. They were inaccurately noted, and often 'records' of them were not records at all, but owed more to wishful thinking or to the imaginations of artists. Alberti, in Book VIII, Chapter IV, of his *Ten Books of Architecture,* noted that:

> the Aegyptians employed Symbols in the following Manner; they carved an Eye, by which they understood God; a Vulture for Nature; a Bee for King; a Circle for Time; an Ox for Peace, and the like.[15]

In respect of his interpretation of hieroglyphs, Alberti seems to have relied on Ammianus Marcellinus and on Ambrosius Theodosius Macrobius, who flourished at the beginning of the fifth century, and whose antiquarian compilation of seven books treating of a number of historical, mythological, and antiquarian subjects in the form of table talk was known by the title *Convivia Saturnalia.* Like his contemporaries, Alberti appears not to have compared the corrupt interpretations of hieroglyphs in the printed sources of the period with the real hieroglyphs on surviving obelisks and sculptures in Rome – a strange oversight, one feels. The *Horapollo* texts were also corrupt in that they also gave imaginary versions of the meaning of hieroglyphs, and in any case dated from the time when the key to an interpretation had already been lost.[16] Even Alberti's well-known motif of the winged eye, used by him as a trade-mark, was derived from European interpretations of hieroglyphs, and later turns up as an emblem of the French architect Ledoux. In Ledoux's case the eye unquestionably expresses the architect's involvement with mystical and Masonic ideas, and was believed to have had antique Egyptian origins, although it is quite clearly in the manner of hieroglyphs rather than an accurate depiction of a real ancient Egyptian emblem.[17]

Poggio's descriptions [18] of Egyptian remains in Rome stimulated some archaeological activity, and the enthusiastic antiquarian and cosmographer, Pius II, caused the resurrection of several buried obelisks. Despite this enthusiasm, an elegiac melancholy began to pervade the works of Poggio and of Pius II. Even Petrarch and Boccaccio have a similar sense of sadness on occasion, induced no doubt by the realisation of what had been lost, as well as by a knowledge of how vulnerable the existing remains actually were.

Perhaps even more significant to this study than Alberti is the work of the architect Antonio Averlino, who adopted the name Filarete (*c.* 1400–*c.* 1469).[19] Filarete's *Trattato d'Architettura* (the earliest edition of which is the *Codex Magliabecchianus* in Florence) includes details of his ideal city of Sforzinda designed for Francesco Sforza. The startling design for the House of Vice and Virtue at Sforzinda in the Biblioteca Nazionale has a statue on top (representing Virtue) not unlike Isiac figures of Roman workmanship. The catholic facilities in this house included lecture-rooms, a whore-house, and a university: the oecumenical aspects of Isis are suggested in this ambitious programme. Sforzinda was to have sixteen subsidiary squares linked by roads and canals to the gates. The connexion with the sixteen cubits of the Nile may be circumstantial, yet, in the description of Sforzinda, Filarete describes obelisks that were to be erected and decorated with hieroglyphs and with animals to suggest an Egyptian character.[20] Despite the fact that Sforzinda remained on the drawing-board, Filarete's influence, as Dr Rosenau has demonstrated,[21] extended throughout the high Renaissance and Mannerist periods. The treatise was unpublished until the nineteenth century, but various manuscripts in the original Italian and in Latin translations are known to have circulated freely.[22]

Filarete was probably influenced by Giovanni Boccaccio (1313–75), who knew Petrarch, and exploited the outline of the story used by Boccaccio as the hook on which he hung his architectural and sculptural theories. In turn, Francesco Colonna's *Hypnerotomachia Poliphili,* published by Aldus Manutius (1450–1515) in Venice in 1499, appears to have been influenced considerably by Filarete. The book is a phantasy, written in Latin and Italian, with some passages

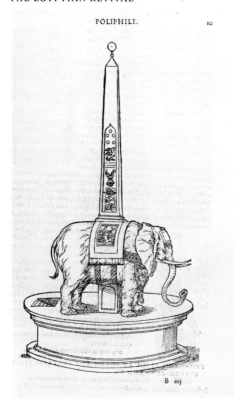

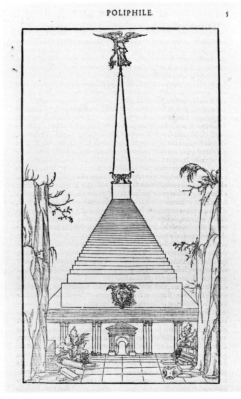

Plate 27 (*left*) Ab obelisk on an elephant's back. From *Hypnerotomachie*, published in Paris in 1561. This was a French version of *Hypnerotomachia Poliphili* (*Trustees of Sir John Soane's Museum*).

Plate 28 (*right*) An illustration from Poliphilus's *Hypnerotomachia* in the French version of 1561 shows a monument that is derived from the description in Pliny of the Mausoleum at Halicarnassus. Other drawings of that time also tend to show obelisks on top of the pyramids themselves, demonstrating the very uncertain knowledge of Egyptian architecture. The obelisk resting on balls or elephants is also a Renaissance feature (*Trustees of Sir John Soane's Museum*).

in Hebrew and in Greek, and was written originally in 1467. The Manutius edition was illustrated with woodcuts that often depict, fairly accurately, Classical architectural and sculptural remains. Huge colonnades and avenues, partly submerged in woods and undergrowth, figure in the pages of this strange book. These were among the first illustrations of Classical ruins. Even before the publication of Colonna's work, some fine topographical drawings by a pupil of Domenico Ghirlandaio of about 1480 showed some fascinating panoramas of Rome. These are in the so-called *Codex Escurialensis,* fol. 40. The pictures in *Hypnerotomachia* that purport to show ancient monuments with an Egyptian flavour are exceedingly strange. This marvellous but eccentric book appeared in a French translation in 1545, and there is a superb French edition of 1883, edited by C. Poplin, that includes the woodcuts and an illuminating introduction. The *Hypnerotomachia Poliphili* contains Egyptianising motifs, including what some authorities believe to be fake hieroglyphs,[23] as well as the familiar image of an obelisk carried on an elephant's back (Pl. 27). The *Hypnerotomachia Poliphili* also includes one of the first pictorial representations of one of the Seven Wonders of the ancient world. In a dream, Poliphilus visited a monument which he describes: a monument that is clearly derived from Pliny's description of the Mausoleum at Halicarnassus, although it has an obelisk on top of the stepped pyramid (Pl. 28).

The enormous series of paintings known as the Triumph of Caesar by Andrea Mantegna (1431–1506), bought by Charles I in 1627, and now at Hampton Court, contains some hieroglyphs of the bogus decorative type. Unquestionably some painted 'hieroglyphs' were of the playful

variety, very much intended to suggest Egyptianising without any serious attempt to portray them accurately. Other authorities have suggested that some Renaissance 'hieroglyphs', notably those planned by Bramante for the Belvedere in the Vatican, were supposed to mean something to those who looked upon them. Certain allegorical ideas were suggested by objects such as circles, vases, or palms.[24]

Egyptian elements, then, began to occur in the work of Quattrocento artists. In Florence, Burckhardt's first modern state,[25] art was liberated from the confines of the Middle Ages. Perhaps one of the most celebrated examples of Florentine art of the period, and one that includes an Egyptian motif, is the set of gilded bronze doors that Lorenzo Ghiberti (1378–1455) made from 1425 until 1452 for the Baptistry to the west of the cathedral in Florence. These doors are divided into ten large panels in which scenes from the Old Testament are constructed, using remarkable perspective techniques. Most of the reliefs were planned by 1437, and so must be considered among the most advanced works of art of the time. Michelangelo considered these doors were worthy to form the Gates of Paradise itself, according to Giorgio Vasari (1511–74) in his *Lives of the most excellent Painters, Sculptors, and Architects,* first published in 1550.[26] The pyramid in the left-hand door in the second panel from the top clearly shows a correctly proportioned Egyptian pyramid on the Giza rather than the Cestius-Meroe model. Obelisks also began to be featured from this time, notably on medals. Pisanello, more properly known as Antonio Pisano (c. 1395–c. 1455) was pre-eminent as a designer of portrait medals. His celebrated medal of John VIII Palaeologus of c. 1438 was one of the first to feature obelisks. The portrait medallion, as perfected by Pisanello, was a revival of antique Roman practice.[27] The pyramid based on the Cestius model was also featured in art during the fifteenth century. The fresco of the Martyrdom of St Sebastian on the west wall of the interior of La Collegiata in San Gimignano by Benozzo Gozzoli of 1465 clearly shows pyramids of the Cestius type flanking the central picture of the martyrdom.

Pope Sixtus IV (1471–84) caused items of Egyptian sculpture to be exhibited in the 1470s when the Capitoline Museum was founded, but even before that Pius II had busied himself with antiquities, and was particularly interested in the remains of Tivoli. Indeed, Pius had erected two telamoni from the Villa Adriana at the bishop's residence in Tivoli where they were drawn (rather crudely) by Giuliano da Sangallo (c. 1443–1516), (Pl. 32), the architect and sculptor, who was an ardent student of the antique. The telamoni were subsequently removed to the Vatican Museum where they can be seen with other Egyptianising items today in the Sala a Croce Greca (Pl. 29). They were among the most important Roman motifs of the Egyptian Revival, for not only were they recorded by da Sangallo, [28] but they appear in many drawings and designs of later periods.[29] They were widely copied by many Renaissance artists, and became the models for designers who used Egyptian motifs.

Ancestor worship took on bizarre forms at this period. Pope Pius II drew attention to the antiquity of his own family, the Piccolomini, and there appears to have been a great desire among many illustrious houses to establish long and distinguished pedigrees.[30] Renaissance man sought to find his Classical roots. Paul II claimed descent from Ahenobarbus; the Massimi from Q. Fabius Maximus; the Cornaro from the Cornelii;[31] and the Dominican Annius of Viterbo (*ob.* 1502) was involved in an elaborate deception to demonstrate the descent of the Borgias from none other than Osiris, presumably before that deity's sexual organs were mislaid. Annius took as the basis of his flimsy structure the Apis bull on the arms of the Borgias.[32] This bull, of course, is associated with Serapis, but Annius went further. By producing Egyptian artefacts, allegedly excavated in Italy, the idea was to demonstrate a close connexion between Roman, Etruscan, Greek, and Egyptian art, and hence the descent of the Pope from Osiris. Burckhardt, in his *The Civilization of the Renaissance in Italy,* tells us that there was even a Borgiad that celebrated the family in heroic terms. By the last decades of the fifteenth century, magnificent processions, recalling Imperial Triumphs, formed part of the Roman Carnival, and were encouraged by Popes Paul II, Sixtus IV, and Alexander VI. They undoubtedly included many Isiac symbols and Egyptianising motifs as depicted in Mantegna's *Triumph of Caesar.*

A series of discoveries of antique objects was made in Rome, including one that captured the

47

Plate 29 The Sala a Croce Greca in the Museo Vaticano showing the two telamoni from the Villa Adriana at Tivoli. These were two motifs that were copied frequently after their rediscovery in Renaissance times. They are of red granite, and are similar to the Antinoüs figures (See Pl. 5. See also Pl. 32). They are numbered 196–7 in the Inventory of the Vatican (*Mansell–Alinari No. 20173*).

contemporary imagination. On 18 April 1485 the corpse of a young Roman woman of the Classical period was found by Lombard masons, who were digging out a tomb in the gardens of the Convent of Santa Maria Nuovo on the Appian Way beyond the tomb of Caecilia Metella. The body was in a wondrous state of preservation, and was seen by a great number of people until it was secretly buried at night by order of Pope Innocent VIII. The body had been covered with a perfumed antiseptic cream, and was fresh and flexible. The colours of life were said to be preserved, but this may have been due to a mask of wax placed on the face. Again the notion of an Egyptian attitude to preserving bodies must be noted, and the body was thought to be far more beautiful than anything known in modern times. Under Julius II followed the astounding discoveries of the Laocoön, the Vatican Venus, and the torso of Cleopatra. Pius II's *Commentarii* wax almost sentimental about antiquities, and the first pictures of Roman ruins appeared about 1467, with texts by 'Polifilo' (Francesco Colonna or Franciscus Columna), in the celebrated work referred to earlier. The respectability of the past was assured. Ancient things were to be revered: ancestral roots were essential, and the further back they went, and the grander they appeared, so much the better.

One of the oddest manifestations of ancestor worship, going back to the Egyptian period, occurred in the Vatican itself, in the Appartamento Borgia. These papal rooms were decorated by Bernardo Pintoricchio (also known as Pinturicchio) and by his assistants, including Antonio da Viterbo, for Rodrigo Borgia, Pope Alexander VI (1492–1503). The paintings were restored by Ludwig Seitz under Leo XIII in 1889–97. The strangest room of all was painted by Pintoricchio himself, and is called the Room of the Lives of the Saints. On the vaulting is the legend of Isis and Osiris, including the discovery of Osiris' limbs, with the Apis bull: the Medallion of the Madonna is over the door; St Catherine of Alexandria, bearing the features of Lucrezia Borgia, disputes with

Maximian on the back wall; hermits in ancient Thebes are shown; and Hermes Trismegistus, Moses, and Isis face the Apis bull in procession. The connexion between the Borgias and Osiris, suggested by Annius of Viterbo, is emphasised by the Apis bull shown, not as an heraldic device, but in full procession. An effigy of the Apis bull is also depicted, carried within an aedicule by figures behind which are Nilotic flora. In the tympanum of the aedicule is Hermes, also associated with Anubis: under the aedicule is a winged sphinx and a horned head (Pl. 30). This is one of the strangest works of the period that incorporates Egyptian allusions, although there is no overt Egyptian form to be found among the rich decorations.

Pintoricchio and his pupils also adorned the Libreria Piccolomini in Siena Cathedral with the brilliant frescoes of 1505–9. The library was built by Cardinal Francesco Piccolomini (the future Pope Pius III (1503)) to house the collection of books formed by his uncle, Pius II. The decorations in the Libreria feature the crescent moons of the Piccolomini crest in the window reveals and in the floor, and there are sphinxes in number in the enrichments between the panels. Siena Cathedral also contains a celebrated sequence of marble pavements enriched with *sgraffito* decoration. At the west end of the Cathedral, in the nave, is a figure of Hermes Trismegistus of 1482–3, with winged sphinxes in the inscriptive panel. The beautiful city of Siena contains a number of other Egyptianisms. The Palazzo Saracini there has a vaulted ceiling to the rear court that is adorned with pretty paintings: these include Egyptian telamoni, sphinxes on plinths, and a Diana of Ephesus, heavy with many breasts. The startlingly brilliant Renaissance paintings and sgraffito decorations point to a considerable awareness of Egyptian motifs in the Siena of the fifteenth and sixteenth centuries, and indicate the increasing respectability of antiquity, even Egyptian antiquity, as the source of much that was held to be important.

The Egyptianisation of Pope Alexander VI is clear, although F. Saxl[33] held that he was 'within the limits of orthodoxy'.[34] Apart from Annius, another influence must be mentioned in Pico della Mirandola: as Burckhardt says, he was 'the only man who loudly and vigorously defended the truth and science of all ages against the one-sided worship of classical antiquity.'[35] He knew Hebrew, the Cabbala, the Talmud, and the mediaeval mystics, and was rather more oecumenical in his views than orthodoxy (especially the orthodoxy of the Counter-Reformation) was to smile upon.[36] Pico's speech on the Dignity of Man comes down to us as perhaps one of the noblest works of the Renaissance: God made man to *know* the laws of the universe, to love its logic and its beauty, and to admire its immensity. Man was not bound to a fixed place, to slavery in his work, but had the will to be, to know, to move, to understand. Man was neither heavenly nor earthly, neither mortal nor immortal only. Man, according to Pico, was free to shape and to overcome his own limitations. In these ideas, Pico anticipated Nietzsche's Superman. As Rilke put it:

> *Wer seines Lebens viele Widersinne*
> *versöhnt und dankbar in sein Sinnbild fasst,*
> *der drängt*
> *die Lärmenden aus dem Palast*
> *wird anders festlich, und du bist der Gast,*
> *den er an sanften Abenden empfängt.*
>
> *Du bist der Zweite seiner Einsamkeit . . .* [37]

Pico della Mirandola and Bruno tried to keep the lamps of truth alight. Their enlightenment contained much that derived from Egypt. Had their freedom of thought prevailed over a suffocating orthodoxy that was to snuff out the clear light of a kindly and all-embracing knowledge, Nietzsche's

> *Nun lacht die Welt, der grause Vorhang riss,*
> *die Hochzeit kam für Licht und Finsternis . . .* [38]

might have come true in the sixteenth century. Men, or rather men with great spirits, were capable of growth and development, and bore within themselves the germs of universal life. Pico

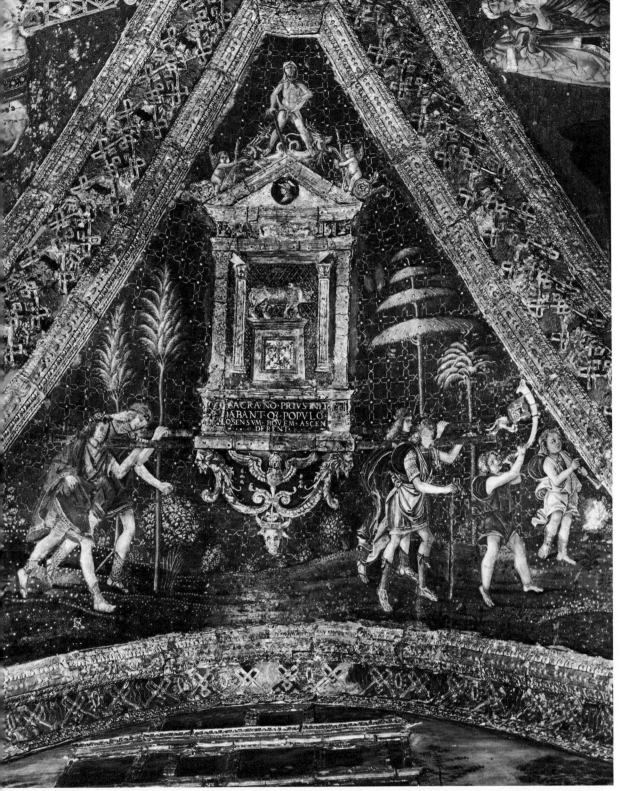

Plate 30 Pintoricchio's work in the Appartamento Borgia, showing the Apis bull in procession. Note the Isiac palms, the head of Hermes in the tympanum of its aedicule, the winged sphinx, and the horned head (again Isiac) (*Mansell–Anderson No. 5005*).

refuted astrology by analysing the weather forecasts of astrologers and showing that over a given period seventy-five per cent of their forecasts were hopelessly wrong, which was even worse than the statistics of guesswork. Pico's notion of the freedom of the will and the logic of the universe made a considerable impression in his day: it was Pico who, by his forthright logic, could lead the way to a realisation that Christianity was not unique and that quite a lot of the True Religion was, in fact, much older than Christian reactionaries would care to admit. The unthinkable therefore happened: Pope Alexander VI installed Isis in the Vatican itself, with Hermes Trismegistus in Pintoricchio's astonishing frescoes. The strongly Egyptianising flavour has echoes in the events of 1515 when the Madonna dell'Arbore in Milan Cathedral wept. Prato records this and the discovery of a dead dragon during the excavations for a mortuary chapel near San Nazaro. It will be remembered that Isis shed tears which caused the Nile to flood each year: the re-Egyptianisation of the Virgin was proceeding apace.

So important were antiquities, and especially those antiquities that were even older than Roman remains, that their estimation threatened to change even the planning of the basilica of San Pietro in Rome itself at one time.[39] The Egyptian obelisk had stood in the great circus from Imperial times, so its position was regarded as particularly important. When Bramante (1444–1514) was engaged by Pope Julius II to redesign the basilica, he intended to swing the axis round so that the obelisk would be in front of the church.[40] In the event, Domenico Fontana (1543–1607) transported and re-erected the obelisk on its present site in the Piazza in 1585-6. From the pontificate of Pope Nicholas V it had been the intention to have the obelisk in front of the new basilica because of its associations with martyrdom. According to Golzio, Raphael had proposed the re-erection of another obelisk from the Mausoleum of Augustus to stand before St Peter's.[41]

The age of the humanists not only appreciated antiquity, but rediscovered it and began to reproduce it. A suitable excellence in epistolography was deemed essential, and competent Latinists were in demand by popes, princes, and republics for the writing of speeches, and for taking on the correspondence of the state. The letters of Cicero and of Pliny were regarded as models of style. At the beginning of the sixteenth century the letters of Pietro Bembo set new standards, and were prized as masterpieces of the Latin style as well as of the art of elegant letter writing. With the rise of stylistic excellence in Latin came the development of a mature use of Italian in correspondence, the model of which was once more Bembo. The Italian Classical style was thoroughly imbued with the ideas of Classical antiquity.

Interest in Egyptian ideas and objects appears to have increased during the sixteenth century, especially after the spectacular Mensa Isiaca was unearthed. This was also known as the Tabula Bembi, or Bembine Tablet of Isis (after the Cardinal Pietro Bembo, excellent Latinist, humanist and friend of Raphael), and probably belonged to the Isaeum Campense in Rome. It is now preserved, with other antiquities in the Museo di Antichità in Turin (Pl.31). The Mensa Isiaca is a bronze tablet that is inlaid with silver and gold, and features hieroglyphs, Isiac figures, and Nilotic flora and fauna. It is an authentic work of antiquity but is not Pharaonic. It is an Egyptianising piece, probably by a Greek named Neilos, and probably dates from the reign of the Emperor Claudius. In the centre of the design is Isis flanked by attributes, including serpents. There are Apis bulls, Thoth, the solar disc, and Isis the moon goddess. Anubis and Bast the cat goddess are also featured. Clearly the maker or makers of the Mensa Isiaca knew their Egyptian gods and goddesses, the Egyptian style, and the detail. Some authorities say that the tablet was found in the reign of Pope Paul III (1534–49), but, according to K. Giehlow, Bembo sent drawings of it to acquaintances before he left Rome in 1520. Godwin says the tablet was first recorded as having been bought by Bembo after the Sack of Rome in 1527.[42] Giehlow, in his admirable paper of 1915 (probably the most comprehensive work on Egyptianising in the age of humanism, and one to which the present writer is indebted) discusses the question of dates at length. L. Pignorius,[43] Johan Georg Herwart von Hohenburg in his *Thesaurus Hieroglyphicorum,* and Iversen[44] are also considerably illuminating on the subject of the extraordinary Mensa Isiaca. There is a beautiful engraving of the table in von Hohenburg's great work (Pl. 31). The illustrations of the Mensa Isiaca became a mine from which designers took Egyptianising elements after Enea Vico de Parma first

published details in *Vetustissimae tabulae aeneae hieroglyicis... literis coelatae* in 1559. Piero Valeriano mentions the table several times in his *Hieroglyphica* of 1567, although there appears to have been an earlier edition of 1556. Franco made an engraving of the table in 1600, and Pignorius first published his *Vetustissimae tabulae aeneae ...* in 1605. From the seventeenth century the Mensa Isiaca was used as a major reference work for Egyptological studies until, in the nineteenth century, it was at last correctly identified as Roman or Alexandrian work. Anne Roullet suggests it may have been made for a sanctuary in the reign of Claudius, whose name is the only intelligible piece of hieroglyphs among what appear to be masses of the pseudo-decorative kind. Another Roman Egyptianising inlaid bronze work known as the Egyed hydria should be mentioned. There is an extensive bibliography on the Mensa Isiaca in *Jahrbuch d. Römisch-Germanischen Zentralmuseums Mainz* by G. Grimm published in 1963.

The illustrations of this celebrated table fascinated many artists: Piranesi was clearly familiar with the illustrations; and the tablet was one of the richest sources for Kircher and others, providing important motifs for many artists to copy and interpret. The design may be related to the letters of the Hebrew alphabet and to Tarot cards, or, as Kircher thought in his *Oedipus Aegyptiacus,* it may be a representation of a cosmic scheme. The tablet is discussed in detail, and illustrated, in Manly Palmer Hall's *The Secret Teaching of All Ages: an Encyclopedic Outline of Masonic, Hermetic, Qabbalistic and Rosicrucian Philosophy.*

The sixteenth century saw interest in Egyptian antiquities develop further and many designs incorporated Egyptianisms. Sebastiano Serlio (1475–1564) produced a number of stage sets, with magnificent perspective effects. His set for a tragedy, illustrated in a woodcut in his *Architettura,* shows an obelisk and stumpy pointed pyramid in the background. Pirro Ligorio (c. 1500–83), the Neapolitan architect, painter, and antiquarian, published several large collections of drawings of Egyptian antiquities. However, he has been suspected of forging ancient artefacts for gain, and has been called a prince among forgers, apparently manufacturing coins, texts and sculptures with creative exuberance. For his patron, Cardinal Ippolito d'Este, he designed the beautiful Villa d'Este at Tivoli. He undoubtedly recorded much genuine material and was aware of the importance of the collections of the Villa Adriana, including the telamoni, yet his precise contribution to the revival of interest in Egyptian and Egyptianising objects is difficult to assess despite the number of books written about him.[45] Drawings by Ligorio, and copies of his drawings by others, were well known to Renaissance artists and formed a collection in the Vatican. He also built the Casino in the Vatican Gardens in 1560–1.[46] Copies of real hieroglyphs were made by others, and there are records of many pieces of Egyptian and Egyptianising work by several sixteenth-century artists, not all of them Italians. Baldassare Peruzzi (1481–1536), the Sienese painter, architect, and stage designer, has been credited with drawings of Egyptian objects in the surviving sketches that bear his name, but some authorities consider them not to be by him. The definitive work on these books is still H. Egger's *Entwürfe Baldassare Peruzzis für den Einzug Karls V in Rom.*[47] After the Sack of Rome in 1527 Peruzzi was captured but escaped to his native Siena, where he stayed until 1530–1, when he became architect to the Republic. The Sienese sketch-book includes the Villa Adriana telamoni and an Egyptian or Egyptianising head. Other artists who came to Rome also recorded Egyptian motifs in considerable numbers: during his stay there (1532–6) Maerten van Heemskerck, the Netherlandish painter who worked with Jan van Scorel, made many drawings of ancient and modern buildings and sculpture which he brought back with him to northern Europe. That was not all he brought back, for he fell under the spell of Michelangelo and emulated the master, bringing a robust Roman style to his homeland. The altarpiece at Linköping, Sweden, originally painted for Alkmaar in the Netherlands, is a case in point. Two of his Italian sketch-books are now in Berlin, and his work as a recorder is valuable historically as well as for its artistic sensitivity. The sketch-books include familiar motifs such as sphinxes supporting a sarcophagus, and other Egyptianisms.[48] Heemskerck also produced an engraving of the pyramids of Egypt almost a century after *Hypnerotomachia Poliphili* which shows obelisks on top of stepped pyramids and obelisks on balls set on podia, demonstrating how very vague was the understanding of Egyptian architecture, even in the latter part of the sixteenth century. Some commentators thought Poliphilus' pyramid with the obelisk on top was Egyptian,

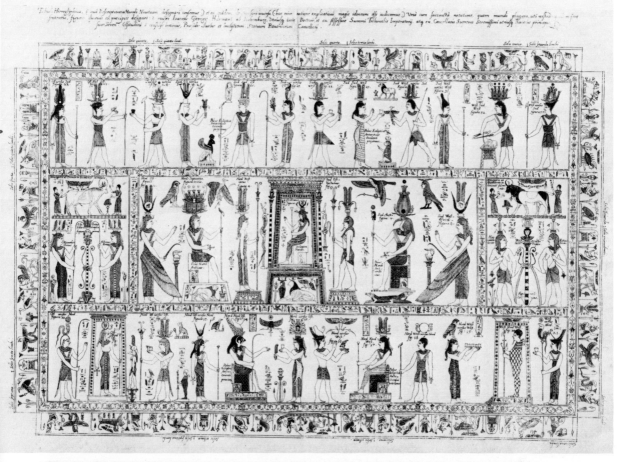

Plate 31 The Mensa Isiaca, from Herwart von Hohenburg's *Thesaurus Hieroglyphicorum*. This Roman or Alexandrian work probably dates from the reign of Claudius, and is of bronze inlaid with silver. It is in the Egyptianising style, and is covered with representations of deities and with bogus hieroglyphs. It was probably made for the sanctuary of a temple dedicated to Egyptian deities, and was rediscovered in the first part of the sixteenth century. The table was first published by Enea Vico de Parma in 1559, and from the beginning of the seventeenth century it became a standard source for Egyptological scholarship (*British Library 3, TAB. 62. Trustees of the British Museum*).

and it is likely that the stepped roof of the Mausoleum at Halicarnassus was confused with the pyramids of Giza in Renaissance minds. These pyramids, having lost their outer casing, were now stepped like the Mausoleum. Obelisks and pyramids were often jumbled images in the Renaissance and Mannerist periods and do not appear to be properly categorised until the eighteenth-century publications clarified matters. Vanbrugh certainly knew the difference.

Hieroglyphs from obelisks and from other sources were illustrated in the Codex Ursinianus, now in the Vatican Library. The city of Rome was awakened to its great past and the Renaissance period saw the rediscovery of several Egyptian monuments of Imperial times, most of which were recorded in the sketch-books of artists and antiquaries. These documents really begin with Ciriaco d'Ancona's work of about 1450. Christian Hülsen's *La Roma antica di Ciriaco d'Ancona* of 1907 is still indispensible concerning Ciriaco. Cronaca and Giuliano da Sangallo (Pl. 32) produced many interesting and influential records of Egyptianising remains between about 1485 and 1510; Giovanni Colonna, whose work can be seen in the Biblioteca Vaticano (Vat. Lat. 7721), added his recorded impressions in the 1520s; Maerten van Heemskerck made his drawings in the 1530s; Amico Aspertini, Francesco d'Ollanda, and Lambert Lombard made theirs in the late 1530s;

53

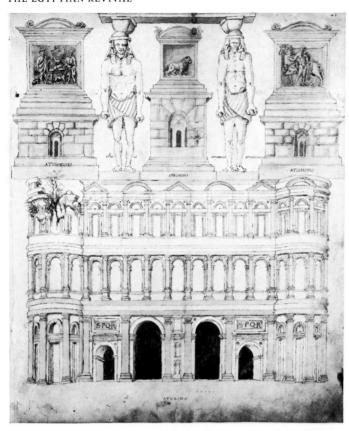

Stephan Vinand Pighius and Pirro Ligorio in around the mid-1550s produced their important sketches and studies of Egyptianising and other antique objects; Pighius executed the drawings now in the Codex Ursinianus in the 1560s; Giovannantonio Dosio, Pierre Jacques, and Baldassare Peruzzi followed suit; and around the turn of the century Dupérac and Pozzo also drew a number of works, or copied them from other sketch-books by other hands.

Now all these sketch-books included Egyptian antiquities in Rome but, with the exception of the obelisks (which had aroused considerable interest anyway), all the artists seem to have recorded the Egyptian or Egyptianising works only incidentally without according them especial significance. The exceptions are the sketch-books of Pirro Ligorio, the Codex Ursinianus, and the drawings of Etienne Dupérac, all of which appear to offer some kind of systematic organisation of the visual evidence of Egyptianising antiquities as they were unearthed. It was then that the publications began to come out. *De gli obelischi di Roma* by M. Mercati was published in 1589; J. G. Herwart von Hohenburg's *Thesaurus Hieroglyphicorum,* with illustrations collected in Rome by N. van Aelst, appeared in about 1608; and L. Pignorius brought out his work on Egyptian antiquities. The collections of sketches by the artists mentioned above contain drawings of telamoni, sphinxes, lions, obelisks, and other Egyptianising objects, including the Villa Adriana figures and the Egyptian head from the 'Peruzzi' sketch-book in Siena. These are the major source-books of Renaissance Egyptiana. Among the illustrations are several details from the Mensa Isiaca, and an accurate drawing of the much admired cynocephalus discovered in the Middle Ages. Similar collections were made by non-Italian artists, and so Egyptian forms became familiar to artists and to patrons throughout western Europe, although it must be emphasised that these were records of existing known pieces, and were not original designs as such. The extraordinary page from *The Missal of Pompeo Colonna* (Pl. 35) seems to be composed of real Egyptian or Egyptianising objects that were familiar from the fine collections mentioned earlier.

As the obelisks in Rome were disinterred and studied, they aroused considerable interest, and ultimately became focal points of the master-plan for Rome carried out by Fontana. The great number of engravings of obelisks and columns in the Cinquecento testifies to their importance, and the fine fresco of Pope Sixtus V's master-plan in the Vatican Library shows how these obelisks almost dominate the plan (Pl. 33). Sixtus and his architects placed the obelisks at points where, during the coming centuries, splendid urban spaces would develop.[49] Thus the centrepieces of the great civic spaces, as well as the focal points of streets, from the time of Sixtus V (1585–90) were Egyptian or Egyptianising. That fact must not be underestimated: in Rome, the Eternal City, where the Roman Catholic Church had its nerve centres, Egyptian objects were not only set at the most important points of the master-plan, but were the pivots from which great axes led.

Of all Cinquecento Egyptianising, however, there can be no doubt that Raffaello Sanzio, otherwise known as Raphael (1483–1520), produced the most celebrated examples. He decorated four state rooms of Pope Nicholas V's palace in the Vatican known as the *Stanze* of Raphael. The painted decoration framing the large scenes in the *Stanza dell'Incendio* was designed by him and painted between 1514 and 1517 by Giulio Romano (*c.* 1499–1546), who is credited with the design as well by some authorities.[50] On two walls are Egyptian telamoni clearly based on those from the Villa Adriana (Pl. 34. Compare with pls. 19 and 29). In the *Stanza della Segnatura* painted during the pontificate of Julius II (1503–13) Raphael joined with his contemporaries in an enthusiasm for the antique, for in these paintings we can find Diana of Ephesus, with her many breasts, as well as Ptolemy and other Egyptianesque features. The term 'Egyptianesque' is used deliberately since, as Pevsner and Lang pointed out, [51] the Tivoli telamoni were of Roman provenance and were nearer the spirit of the times than were many ancient Egyptian artefacts, with the exception of sphinxes, lions, obelisks, and pyramids. These works by Raphael and Romano move away from the mere recording of Egyptian and Egyptianising features to a creative interpretation of Nilotic and Isiac elements, and the tendency became more marked with time. A further step in this direction is indicated by the illumination of the Missal of Pompeo Colonna with Egyptian motifs which is particularly interesting, since it displays a good array of Egyptian forms and decorations known to Renaissance artists. It is therefore a creative arrangement of motifs found in collections

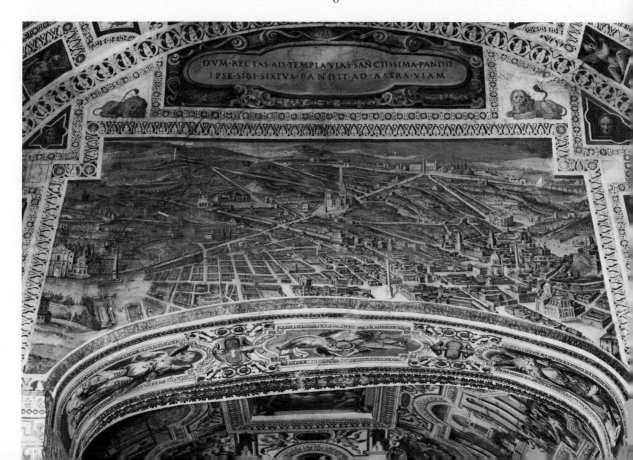

Plate 34 (left) A painted Egyptian figure, based on the telamoni from the Villa Adriana, in the Sala detta dell' Incendio di Borgo in the Palazzo Vaticano designed by Raphael, and painted by Giulio Romano (*Archivio Fotografico, Musei Vaticani, No. XVIII. 40.9*).

Plate 35 (opposite) A page from the Colonna Missal (*Rylands Latin MS. 32, folio 79r*), showing the Egyptian motifs. At the top, in the centre, is the Apis bull, flanked by cats (Bast) with vases, and by a lion and ram in the corners. The rest of the border is much more Egyptian: it consists of a Trajan-style column on one side and an Egyptian obelisk resting on sphinxes on the other; items from the Mensa Isiaca; a baboon (based on an actual find that had previously been recorded); animal-headed gods flanking an aedicule in which is an Egyptian figure (based on drawings by Pirro Ligorio); a telamone from Tivoli on the bottom left; a part of the Mensa Isiaca on the bottom right; and two sphinxes with putti in the large panel at the base. The capital letter features cornucopiae above and below the many-breasted Diana of Ephesus (identified with Isis) who is flanked by harts (*John Rylands University Library of Manchester*).

like the Codex Ursinianus. The date of this Missal is uncertain, but is given as 1520 in M. R. James' *A Descriptive Catalogue of the Manuscripts in the John Rylands Library*[52] (where the Missal can be found today). According to a footnote in Pevsner and Lang,[53] Pompeo Colonna was created a Cardinal in 1517, and since he is described as Divo Pompeio Cardinali Columnae in the Missal, the illuminations may date from after his death in 1532. Pevsner and Lang also quote the authority of Anne Roullet [54] for suggesting a later date, as the details in the Missal that are derived from the Mensa Isiaca appear to be more like those published by Enea Vico in 1559 rather than those of the original tablet or drawings of the Tabula. Yet Giehlow has shown [55] that Pietro Bembo distributed several copies of drawings of the tablet and details of it in his lifetime before 1520, and those may just possibly be the sources. On balance however, the Vico published version seems to have a closer resemblance to the details of the Missal, so the date would appear to be some time in the second half of the sixteenth century.

The details of the Egyptianising page in the Missal are of great interest and relevance to this study. The paintings of Pintoricchio in the Appartamento Borgia had suggested Isiac and other Egyptian ideas without being overtly Egyptianising in manner; the style was firmly Roman. Egyptian motifs *were* used in the Missal, however, despite the strongly Renaissance features of some of the items. At the top, in the centre, is the Apis bull, flanked by cats (suggesting Bast) with vases, and by a lion and ram in the corners. The rest of the border is much more Egyptian and consists of: a Trajan-type column on one side and an Egyptian obelisk resting on sphinxes on the other; items from the Mensa Isiaca; a baboon (based on an actual find that had previously been recorded); animal-headed gods flanking an aedicule in which is an Egyptian figure (based on drawings by Pirro Ligorio) and above which are Egyptian terms; a telamone from Tivoli on the bottom left; a part of the Mensa Isiaca on the bottom right; and two sphinxes with *putti* in the large panel at the base. The capital letter features cornucopiae above and below the many-breasted Diana of Ephesus who is flanked by beasts. It is a strange and unsettling piece of work (Pl. 35). Unlikely though it may seem, the reasons for the Egyptianising in the Missal appear to be similar to those behind the creation of the Pintorrichio works for the Borgias. According to F. Mugnos, in his *Historia della Augustissima Famiglia Colonna*, Cardinal Pompeo Colonna and his family claimed descent, not from Roman ancestry, but from something much more mysterious, older, and therefore better. It must be remembered that the worship of antiquity created a desire for exotic and extremely long pedigrees. Apis, that is, Osiris, was once more the illustrious ancestor claimed by Colonna.[56]

During the sixteenth century Egyptian motifs found in architecture are usually confined to obelisks, sphinxes, and telamoni based on the pair from the Villa Adriana. Sphinxes became relatively popular, usually as supports for sarcophagi, although they can also be found supporting

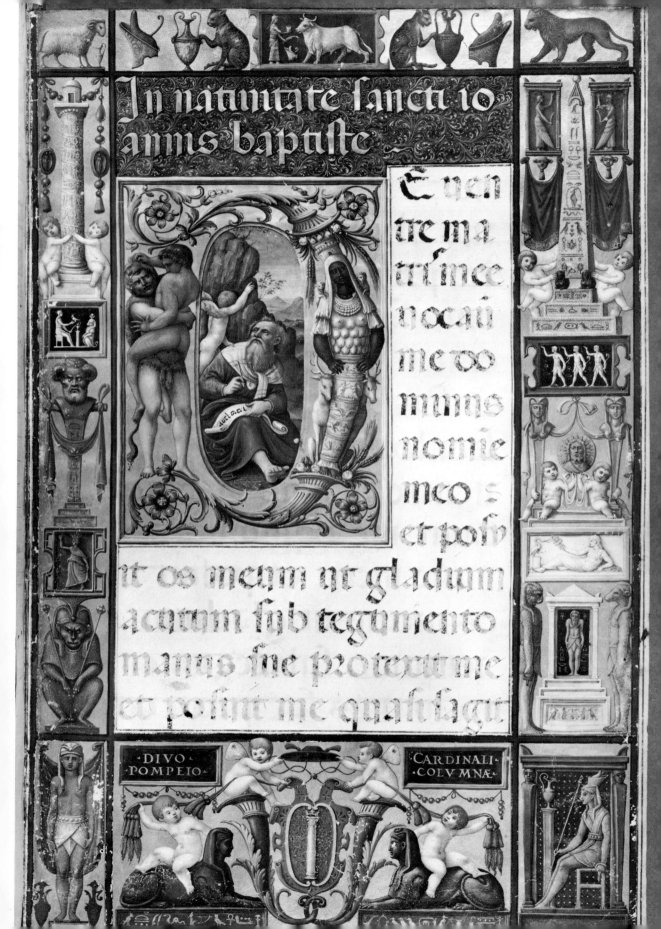

In natiuitate sancti io
annis baptiste

Et uen
tre ma
tri fuce
uocam
me do
minus
nomie
meo s
et posu

it os meam ut gladium
acutum sub tegumento
manus sue protexit me
et posuit me quasi fagit

DIVO
POMPEIO

CARDINALI
COLVMNÆ

columns, as in the porch of Sant' Antonio Abbáte in Rome (1269), where wingless Cosmati sphinxes support an Order, and recall the obelisk on sphinxes on the right of the page from the Colonna Missal (Pl. 35). This porch was noted by Thomas Hope in his Sketch-Book, now in the Royal Institute of British Architects British Architectural Library Drawings Collection. It must have appealed to him as a model for some of his furniture designs, as must the lion *monopodia* from the bishop's throne in Santa Maria in Cosmedin, also drawn by Hope.[57] In the church of Santa Maria della Pace (erected by Sixtus IV in 1480, and rebuilt by Pietro da Cortona during the pontificate of Alexander VII (1655–67)) there are several tombs of the Cesi family. Two sphinxes of unusual design embellish the mid sixteenth-century tomb of Angelo Cesi. The bodies are visible from the front and the heads and shoulders are turned round to face outwards. The usual arrangement is for the spine of each sphinx to lie at right angles to the length of the sarcophagus. The sculptor was Vincenzo de Rossi. The more conventional type of straight symmetrical sphinx supports can be found in the tomb of Guillaume du Bellay of 1557 at Le Mans Cathedral. The du Bellay and Cesi tombs both have semi-reclining effigies on the sarcophagi. This idea first seems to appear in Renaissance work in 1505 on the tomb of Ascanio Sforza by Andrea Sansovino in the choir of Santa Maria del Pòpolo in Rome. The Sforza tomb has an elaborate aedicule flanked by niches, but the sphinx-like forms are not truly Egyptianising.[58] Sarcophagi resting on sphinxes had been known in Classical times, and various artists, including Heemskerck, had drawn these motifs. The du Bellay monument may have been derived from Sansovino's designs or from drawings of antique fragments themselves. It is clear, however, that a regard for the antique had become fashionable in France as well as in Italy, for Guillaume du Bellay is shown in classical armour. In addition, Joachim du Bellay, a relation of Guillaume, was a member of the group of writers known as La Pléiade.[59] This group was animated by a common veneration for the writers of antiquity and it desired to elevate standards in France as a whole. With a high regard for ancient literature came an admiration for antique sculptural and architectural motifs as well. The enthusiasm of the group for the sonnet form stimulated developments in England. Significantly, the title was first given to a group of seven priests in the reign of Ptolemy Philadelphus that included Theocritus, Lycophron, and Aratus. Joachim du Bellay wrote a poem in praise of Diana and, according to Pevsner and Lang,[60] was a friend of Pierre Belon, one of the first Frenchmen of modern times to visit Egypt and publish his impressions. Belon's book came out in 1553 and included descriptions of the pyramids and of a sphinx.

Pierre Bontemps (*c.* 1507–68) has been credited with the sculpture of the du Bellay tomb. He was particularly associated with Primaticcio at Fontainebleau and it is at that great palace that we find some extraordinary Egyptianising motifs. This is not surprising for Francesco Primaticcio (1504–70) had worked under Giulio Romano at Mantua; then from 1532 he worked with Giovanni Battista Rosso Fiorentino (1494–1540) at Fontainebleau where French Mannerism developed. The precise parts that Rosso and Primaticcio played there cannot now be established with certainty.

Fontainebleau became the focus of the cultural ambitions of François I, who collected objets d'art there and employed Rosso Fiorentino, Francesco Primaticcio, and Benvenuto Cellini to provide a setting for his court. François also employed Sebastiano Serlio as painter and architect to his court in 1541, a post he occupied until succeeded by Delorme. Serlio was certainly acquainted with Egyptianising motifs and he worked for some time at Fontainebleau. He also published a book on portals called *Livre extraordinaire* which had a considerable vogue. The style that developed at Fontainebleau, although based on Italian Mannerist examples, became some-thing quite new in France and inspired a generation of architects and artists. In the Galerie François Ier, for example, the painted figures of the murals appear to grow into three-dimensional sculptures and mix with the strapwork, putti, swags, and sphinxes. Significant to this study, however, is the doorway of the Pavillon de L'Horloge at Fontainebleau of about 1540 which is flanked by Egyptianising caryatides. It is called the Porte des Aumonières and faces the Jardin de Diane (Pl. 36). Primaticcio used Egyptian sphinxes and other motifs in his designs for the Galerie d'Ulysse and he may have designed the female figures at Fontainebleau. On the other hand the Fontainebleau figures are female terms (pedestals like inverted obelisks supporting, or merging

Plate 36 The Egyptianising doorway on the Pavillon de l'Horloge, called Porte des Aumonières, at Fontainebleau, facing the Jardin de Diane.

Plate 37 The tomb of Diane de Poitiers at the Château of Anet. Note the sphinxes supporting the sarcophagus (*Lauros-Giraudon No. LAC 92737*).

with, busts) unlike the Villa Adriana telamoni[61] known as *atlantes* or *atlantides,* that is, heroic male figures used instead of columns to support an entablature), and unlike the paintings by Raphael and Giulio Romano in the Vatican (Pl. 34). Some authorities have noted a connexion between an engraving of an Egyptian figure by Cornelius Bos and the figures at Fontainebleau.[62] The engraver Ducerceau also published a sheet of *canephorae* (young persons bearing baskets on their heads),[63] including an Egyptian figure almost identical to the stone terms at Fontainebleau, but Schéle says that it is likely this Ducerceau work is derived from Bos.[64] A more likely source for these figures is quite simply the telamoni from Tivoli. They were well known and it would not have been a feat of great daring or imagination to make them female: indeed, some drawings of the telamoni by Peruzzi and others make the breasts female. The reason for the change of sex is probably in deference to Diane de Poitiers, for they face the Jardin de Diane. Furthermore, the stucco terms in the Chambre du Roi were conceived in the form of Dianas of Ephesus, while the Chambre de la Reine was designed with sphinxes on the chimney-piece. There is a fine drawing of the Dianas of Ephesus (presumably another reference to Diane de Poitiers, mistress of Henri II) by van Thalden in the Collection Frits Lugt. It may lie within the realms of possibility that the designer of the door-way at Fontainebleau was none other than Serlio. The date fits, and his facility as a designer of portals is obvious from his *Livre extraordinaire* of 1551. Egyptianising elements were carried by the followers of the Fontainebleau School to other parts of France. At the Château of Bourdeilles in the Dordogne there are sumptuously painted ceilings by Ambroise Le Noble and sphinx motifs with wings of birds and insects on the beams. The gold room, as it is called, also contains a tapestry after a cartoon by Primaticcio showing François I and his falconers.[65]

A Diane Chasseresse by Primaticcio also enlivened the room of François I at the Château of

Chenonceaux, where there is a painted sphinx over the fireplace in the Chambre de César de Vendôme. Indeed, allusions to Egyptian features, especially sphinxes, telamoni, and various Isiac symbols, such as the crescent moon and Diana, recur in French Renaissance interiors. In the gardens at Fontainebleau are four remarkable sphinxes facing the fountain with their tails towards the long canal. They are of sixteenth-century date and have the massive breasts and other characteristics also found on the tomb of Diane de Poitiers herself. Diana as huntress also occurs in Parma in the Camera di S. Paolo at the convent of San Paolo, where the celebrated frescoes were painted by Antonio Allegri of Correggio from 1518. Over the fireplace is Diana the huntress, complete with crescent moon on her head, the entire work set on a truncated, steeply pitched pyramid – a very early example of this type of composition.

Frontispieces and other painted devices of the sixteenth and seventeenth centuries often contain a surprising amount of Egyptianising. Pevsner and Lang[66] have drawn attention to a design for a device of Henri II of France published in Venice in 1566, featuring two female Egyptian terms flanking a crescent moon, clearly an Isiac symbol suggesting Diane de Poitiers, the king's mistress. Diana was equated with Isis in ancient times and the Isiac suggestions of Diane's name would not have escaped an age that was much more alive than our own to the reality of symbol, allegory, and attribute. According to Dr Frances A. Yates the château of Diane de Poitiers was depicted as an Isiac temple in pictures created for the house.[67] It is therefore possible that the caryatide-terms at Fontainebleau might be connected with Diane de Poitiers, whose tomb at the Château of Anet consists of a kneeling effigy on a sarcophagus resting on the backs of full-breasted sphinxes with crescent moons on their heads. The crescent moons and the full breasts are again related to the Diana of Ephesus-Isis ideas (Pl. 37).[68]

The fleur-de-lis is an emblem particularly associated with France and French royalty. It is a motif often found in finials and other terminal features and is, as the name suggests, derived from the lily. As an heraldic lily, the fleur-de-lis is closely associated with both Isis and the Virgin Mary. Its basic form also suggests the lotus bud that is often found on the forehead of Isis in Graeco-Roman work. Fleurons in mediaeval work are often formed in shapes not unlike lotus buds.

Drawings, paintings and a love of antiquity brought Egyptian motifs to a wider public throughout Europe. Pieter Brueghel's *Construction of the Tower of Babel* shows some suspiciously Egyptianising terms on the middle storey of the tower, possibly derived from Patenier or his school. Brueghel must have been aware of fashionable Egyptian elements in Italian work at the time, for such motifs suggesting the exotic and mysterious were already starting to appear.[69] The Mensa Isiaca was published in 1559; Celio Calcagnini published his *De Rebus Aegyptiacis* in Basle in 1544; and Pierio Valeriano, also known as Giovanni Pietro delle Fosse, brought out *Hieroglyphica sive de Sacris Aegyptiorum Literis Commentarii* there in 1556.

During the sixteenth and seventeenth centuries studies of traditions which had an Egyptian background developed. Hermetic and Cabbalist ideas, with alchemy, achieved expression in the Rosicrucian manifestos. The Renaissance Hermetic Tradition was developed by Marsilio Ficino (1433–99) and Pico della Mirandola (1463–94) and gained a new lease of life in the seventeenth century.[70] Robert Fludd[71] was an adherent of the philosophy of the 'Egyptian' priest Hermes Trismegistus, as is apparent in his *Tractatus Apologeticus Integritatem Societatis de Rosea Cruce defendens* and *Apologia Compendiaria Fraternitatem de Rosea Cruce suspicionis & infamia aspersam, veritatis quasi Fluctibus abluens & abstergens*. Fludd's *Utriusque Cosmi Historia, Tomus Primus, De Microcosmi Historia* set out the basic scheme developed by Pico della Mirandola when he added the Cabbala to the revival of Hermetic philosophy encouraged by Ficino's interpretation of the recovered Hermetic texts. Giordano Bruno and Michael Maier also figure prominently in what Dr Yates has called the 'Rosicrucian Enlightenment'.[72] Maier wrote *Arcana Arcanissima, Hoc est Hieroglyphica Aegyptio-Graeca*, and was himself close to the court of the Emperor Rudolph II, who appears to have been devoted to magic and alchemy.[73] The title-page of *Arcana Arcanissima* featured two obelisks, each set on four balls on pedestals, with figures of Osiris, Isis, and Typhon, the Ibis, the Apis bull, and a cynocephalus. Maier's *Symbola Aureae Mensae duodecim Nationum* is a volume not entirely innocent of Egyptian or Egyptianising ideas, and it contains material on

Hermetis Aegyptiorum Regis et Antesignani Symbolum.[74] Both Maier and Fludd were published at Oppenheim and both had connexions with England, the Netherlands, the court of the Elector Palatine, and the court of the Empire itself. Maier, like Fludd and Dee, did much to promote 'Egyptian Hermetic' truth. His *Symbola* enthuses over the wisdom of Hermes, king of Egypt, and celebrates the sacredness of the Virgin Queen Chemia.[75] The book ends with the hymn of regeneration.[76] Chemia is obviously Isis, who was the fount of wisdom and the notion of the Virgin Queen is also found in Elizabethan times: even Spenser is not guiltless of Hermetic-Egyptian ideas. According to Dr Yates, John Dee is also a key figure in what she calls the 'Rosicrucian Enlightenment'. Giordano Bruno too made use of Hermetic themes. He preached a reformation in the world based on a return to Egyptian religion and wisdom as taught in Hermetic treatises. Religious differences were to be overcome through love and magic. Bruno had carried his philosophy, with potent additions of mythological notions, to France, Germany, and England. Dr Yates has suggested[77] that Bruno's ideas became enshrined in the Rosicrucian movement. Certainly Bruno's religion was Egyptianising, and there was much deriving from Egypt or from Graeco-Roman interpretations of Egyptian ideas that influenced cultural development in seventeenth-century Europe.

Yet Bruno himself was to die at the stake for his conviction that the wisdom and magic of ancient Egypt were greater than a repressive orthodoxy that burned dissidents. His denial of the unique nature of Christianity brought about a reaction from the authorities and his painful death in February 1600. The man who said that even the cross was a symbol invented by the Egyptians, and who clearly saw the debt that Christian belief and practice owed to the ancient cults of Isis and Osiris, must have smiled a wryly cynical smile when considering that the Inquisition demanding his life had ignored the presence of Isis and other deities in the Borgia apartments themselves. The Vicar of Christ himself had claimed descent from Osiris through the dubious researches of Annius of Viterbo. The infamous burning of Bruno will live on as one of the most extraordinary examples of double standards ever provided by a powerful organisation. Furthermore, numerous paintings of the period show unquestionably Isiac symbols now associated with the cult of the Blessed Virgin Mary. Perhaps one of the most startling of the early images of the Virgin and Child in this respect was that produced by Francesco Vanni of Siena (1563–1610). The Virgin is shown standing with a crescent moon at her feet, flanked by lilies and roses, with fountains in the background. In the following century the Baroque and Rococo artists were to depict the Virgin with her Isiac symbols on the ceilings and altarpieces of churches throughout Roman Catholic Europe.

The Doctrine of the Immaculate Conception was proclaimed by Pope Paul V (1605–21), and it immediately inspired an image of the Virgin not seen until that time. The seventeenth-century Immacolata was a young girl supported on a crescent moon and crowned by stars. One of the first representations of this new image was by Guido Reni (1573–1642) in the celebrated fresco in Paul V's chapel in the Palazzo del Quirinale. The crescent moon, an important Isiac symbol, does not appear to occur often in connexion with the Blessed Virgin until the seventeenth century, although other Isiac symbols like the lily, the garden, the fountain, and the rose had long been associated with Mary. It is particularly interesting that the crescent moon should appear in pictures of the Virgin at precisely the same time when Egyptianisms were occurring with increasing frequency in art and architecture. There is one celebrated example of mediaeval architecture, however, where the crescent moon is in evidence much earlier than one would expect. In the Lady Chapel of the Collegiate Church of St Mary in Warwick, otherwise known as the Beauchamp Chapel, the splendid gilt effigy of Richard Beauchamp, with eyes open and hands raised in adoration, gazes up at the figure of the Virgin on the vaulted roof. Mary is shown as Queen of Heaven, standing on a crescent moon: her head is crowned and the arrangement of the decorative elements of the crown suggests the crescent moon on her head as well. She carries the orb and a sceptre decorated with the fleur-de-lis. Now the crescent moons associated with the Queen of Heaven in a fifteenth-century English chapel are a century and a half earlier than the Doctrine of the Immaculate Conception was proclaimed, although that Doctrine had been systematised by Duns Scotus in the thirteenth century. The figure of Mary does not appear to have

been remade after the chapel was partially vandalised in the seventeenth century, so it is likely that the lunar attributes were covertly acknowledged in the Middle Ages. The Beauchamp Chantry Chapel is one of the first fifteenth-century instances where the crescent moon is quite openly shown in association with the Marian cult, and not merely in connexion with Diana-Artemis or in heraldry.

The revered figure of Isis, the greatly loved, the most universal of all goddesses, could hardly be wished out of existence. Her catholicity and her essential syncretism were absorbed, and Maria Myrionymos took over where her Egyptian forerunner left off. An official ending of Isiac worship did not mean that the cult of the goddess died, for, quite apart from the iconography of the Eastern Church, mediaeval legend in the West included references to Isis as the Planter, or Divine Engrafter. The idea of Isis in this rôle was identified with the conception of Christ by the Virgin. Christine de Pisan's version of the legend was published in Paris as *Les cent histoires de troye* in 1499. It appears that a number of images of Isis survived in Christian churches for some time, including a Roman Isis that stood in the church of St Germain des Pres until it was broken by Bretonneau, suggesting a fear of the continuing power of the goddess, or a desire to purify the imagery of 'non-Christian' elements. It is clear, however, that the merging of the Isiac cult with Christianity in the veneration of the Virgin was a long and subtle process and the Isiac pictures and images often survived. The great number of churches dedicated to Mary that stand on the sites of Isaea point to a deliberate absorption of Isiac worship. Augustine himself had advocated the re-dedication of pagan sites for Christian worship. The church of Santa Maria Navicella in Rome, for example, has an Isiac boat outside that reminds us of the Isaeum Metellinum.

4

Egyptian elements in seventeenth and eighteenth-century Europe to the time of Piranesi

The lunatic, the lover, and the poet,
Are of imagination all compact:
One sees more devils than vast hell can hold,
That is, the madman; the lover, all as frantic,
Sees Helen's beauty in a brow of Egypt.

WILLIAM SHAKESPEARE (1564–1616):
A Midsummer Night's Dream, V, i. 7.

Research into the histories of Rosicrucianism and Freemasonry has been somewhat hindered by the enormous amounts of sensational, inaccurate, and so-called 'occultist' publications. Responsible research began in the Germany of the *Aufklärung* and the work of J. G. Buhle provided a framework for an essay by De Quincey in 1824.[1] De Quincey believed that Rosicrucianism became Freemasonry in England and that it was exported to Europe as Free-masonry, but this idea has problems of interpretation. There is no doubt that there were close cultural connexions between Germany, the Netherlands, and England in the sixteenth and seventeenth centuries. The work of Dr Frances A. Yates is invaluable to those wishing to pursue the subject,[2] while Knoop and Jones[3] have contributed an important work on Freemasonry that brings modern scholarship and criticism to the topic. Dr Yates has suggested that Renaissance Hermetic Traditions had an important influence on Masonic mythology.[4]

The Masonic traditions hold that Freemasonry is as old as the art and science of architecture and so there are debts to Egypt, to great works like King Solomon's Temple, and to mediaeval European cathedrals. Guilds of mediaeval masons who were responsible for building the fabric of the ecclesiastical buildings are also held to be forerunners of Freemasonry. Certainly in the Middle Ages there existed a guild of skilled stonemasons: this guild, in modern parlance, was a 'closed shop' and members protected themselves by the secrecy of their craft and by covert signs and symbols. English Masonic historians seem to consider that there was little intercourse between English and Continental groups, but individual Freemasons were often welcomed in foreign lodges. All historians are agreed that what is now Freemasonry arose from the meeting of the London Lodges in 1717 at which the Grand Lodge of England was formed. The transition from craft guilds of masons to an organisation or organisations concerned with what Dr Yates calls 'the moral and mystical interpretation of building',[5] and thence to 'a secret society with esoteric rites and teaching'[6] is somewhat difficult to establish in terms of chronology although the appearance of 'speculative' or 'philosophical' (rather than vocational) membership appears to date from the sixteenth century. The development of an ethical teaching within Freemasonry dates from this period. One of the first recorded non-operative Masons was John Boswell of Auchinleck, who was initiated in 1600. The history of the art of building is told in mediaeval poetry,[7] and such poetry is prized by Freemasons. The Manuscript Constitutions of Masonry[8] identifies masonry, building, and architecture with geometry. These accounts stress the antiquity

of geometry, even suggesting that Abraham taught the subject to the Egyptians. Another source derived from Diodorus Siculus states that geometry was invented by the Egyptians to work out the inundations of the Nile and that it was developed by Thoth-Hermes, otherwise Hermes Trismegistus. Thus the beginnings of masonry, and therefore of Freemasonry, are traced to Egypt,[9] from whence all wisdom sprang. *The Constitutions of Freemasons* by James Anderson, published in 1723, traces the history of geometry throughout Biblical history. From Jerusalem architecture was brought to the Greeks and then to Rome, where Augustus was Grand Master of the Masonic lodge and patron of Vitruvius, 'Father of all true Architects to this day'.[10] Roman expertise, according to Anderson, declined until James I revived the Lodges in Britain and caused Roman architecture to be rediscovered. Anderson mentions Palladio and his 'rival' in England, 'our great Master-Mason Inigo Jones'.[11] Sir Christopher Wren and Charles II were also Freemasons.

It seems clear that Freemasonry as an organised closed society began in modern times in England with the revived interest in Vitruvius and Classical architecture. Inigo Jones appears to be a key figure and it is likely that the success of the Augustan style coincides with the rise of institutional Freemasonry, and indeed the two are clearly closely connected. Theories concerning the proportional systems of Solomon's Temple are closely allied to early Renaissance architectural principles.[12] Dr Yates has also shown a close connexion between the founding-members of The Royal Society, Rosicrucianism, and Freemasonry.[13] The great organisation that is Freemasonry has a ritual and a code that demonstrate a direct link with the mysteries of antiquity and especially with the rites of Isis and Osiris. Yet it was not only in Protestant Europe, in Rosicrucianism, and in Freemasonry that Egyptianisms occur. The Hermetic Tradition had produced some startling ideas in Roman Catholic Europe, and even in the Vatican itself. Hermes Trismegistus is depicted in Siena Cathedral and in the Vatican, while Isiac and Hermetic attributes occur in Missals, in painted apartments, and in later religious paintings. The Hermetic Tradition also played a not inconsiderable part in the development of the Society of Jesus (of which Athanasius Kircher was a distinguished member) and, as René Taylor has pointed out in *Baroque Art: The Jesuit Contribution,* Hermetism and Mystical Architecture became closely associated with the Counter-Reformation. Isiac attributes became overtly part of Marian imagery in the Roman Catholic countries, and that most Isiac symbol, the crescent moon, is particularly associated with the Blessed Virgin from the seventeenth century. Nikolaus Seng, J. Seznec, Carlos Sommervogel, René Taylor, and M. Whitrow are illuminating on these points.

The relationship between alchemy, geometry, Freemasonry, and Rosicrucianism is complex. It is significant that iconography we can identify with Freemasonry and with a Hermetic Tradition often includes squares, circles, and triangles. Northern European funerary monuments, frontispieces, and decorative arches acquired arrays of obelisks from the time of the Virgin Queen in England. The feature of the obelisk will be familiar to all those who have seen parish churches or cathedrals with funerary monuments of the sixteenth and seventeenth centuries. These obelisks represent pyramids and signify Eternity: they are known as 'Antiques' or 'Anticks'.[14] The fashion for obelisk 'Anticks' cannot be explained entirely by the rediscovery of Egyptian obelisks in Rome and by their re-erection starting with the mighty town-planning scheme of Sixtus V. Small obelisks are not features associated with Italian funerary art but are very common in northern Europe, especially in the funerary architecture of the Netherlands, northern Germany, and England. It seems likely that the obelisk as a symbol of eternity may have achieved fashionable status through the iconography in printed sources, many of them in the Hermetic Tradition derived from Pico della Mirandola and Giordano Bruno. Inigo Jones used obelisks as part of his architectural vocabulary and it is not impossible that obelisks enjoyed a symbolic significance associated with the influential Freemasons, with Rosicrucian mysteries, and with alchemical-cabbalistic traditions. It is particularly interesting that a widespread use of an Egyptianising element as individual as the obelisk should have been so popular in largely northern, Protestant countries, where Freemasonry and a Rosicrucian search for Enlightenment (derived partly from the questioning unorthodoxy of Bruno) were influential. Obelisks were also used, especially in the Netherlands and in Germany, to provide crowning embellishments for gables. The Town Hall at

Leiden (*c.* 1579) has crowning obelisks and features with Ionic caps that look oddly like the Fontainebleau caryatides from a distance. The Stadtweinhaus at Münster was crowned by spectacular banded obelisks. The massacre of St Bartholomew's Day in 1572 drove many Protestant craftsmen to England, and Continental skills were quickly allied with native expertise: obelisks became common features in English architectural enrichment. Other decorative effects common in sixteenth and seventeenth-century work include the ribbon-like decorations loosely draped around vertical arrows or shafts, suggestive of the Egyptian serpent entwined around a vertical object. Putto heads with wings recall the outstretched wings on either side of the solar globe, and there are many other motifs of the time that have affinities with Egyptian prototypes.

Egyptian decorations occurred in printed sources for a considerable period. One of the first cool and objective writers to observe Egyptian work in relatively recent times was George Sandys (1578–1644) who travelled extensively in Italy, Egypt, and Palestine. He recorded his impressions of the pyramids in his *Relation of a Journey, Begun Anno Domini 1610,* calling them monuments of 'prodigality and vain glory'. Indeed, from the seventeenth century a new atmosphere of scholarly reason and scientific observation encouraged the study of Egyptian as opposed to Egyptianising artefacts. Claude-Nicolas Fabri de Peiresc, traveller and indefatigable correspondent, included Egyptology among his many interests. He speculated about the mystery of hieroglyphs and we know he corresponded with Camden, the antiquary and historian.[15] Pevsner and Lang have also noted the correspondence between Rubens and Peiresc about a mummified corpse drawn by Rubens and a figure of Isis known to Camden. Peiresc corresponded with Lorenzo Pignorius (who brought out a new edition of the Mensa Isiaca in 1669 called *Pignorii Mensa Isiaca* with a frontispiece featuring a pyramid, obelisks, cynocephalus figures, and a term), and with Girolamo Aleandro, secretary to the Cardinal Barberini, whose family had a taste for Egyptian objects (they owned the Nilotic mosaic from Praeneste).[16] Peiresc also knew the German Jesuit priest, Athanasius Kircher (1602–80), who became a leading light in things Egyptian and who made collections of Egyptian objects. Kircher's publications include *Lingua Aegyptiaca Restituta* of 1643, *Oedipus Aegyptiacus* of 1652, *Obeliscus Aegyptiacus* of 1666, and *Sphinx Mystagoga* of 1676, but a great part of his *oeuvre* is speculative. His collection of material, however, included statues, inscriptions, sphinxes, and other items, and was one of the first to be devoted to Egyptian objects alone. There were other seventeenth-century collections, notably those of the Farnese family and of the Dukes of Tuscany. The pyramids on the frontispiece of Kircher's *Sphinx Mystagoga* are of the excessively pointed variety, owing more to Cestius and to obelisks than to the Giza pyramids.

The Society of Jesus had origins that are not entirely clear and it would seem that Jesuits shared certain interests with the Rosicrucians. Hermetic and occult philosophies formed a considerable part of the *oeuvre* of Athanasius Kircher, whose writings appear to have been much used in Jesuit missionary activity. There are clear parallels between the work of Kircher and that of John Dee, as Dr Yates has pointed out. In some instances Rosicrucian symbolism was used by the Jesuits to show that the two Orders shared attributes, suggesting that the Rosicrucians were a power to be reckoned with. The battle for ascendancy resulted in the rise of Freemasonry so opposed by the Jesuits, and contributing to the most secret and yet elemental threads leading to the Enlightenment and, ultimately, to the explosion of the French Revolution.

Kircher was probably one of the greatest of universal men of his day. His philosophy was based not only on orthodox Roman Catholicism but also on the teachings of Hermes Trismegistus. Kircher was certain that the Egyptians were in the van of metaphysical knowledge, and that it was to Egypt that we should look for the origins of art, science, and religion. Kircher began his life as an important figure in seventeenth-century learning at Avignon when he met Peiresc, a wealthy patron who had heard of the Jesuit's expertise in linguistics, and interest in Egyptian antiquities and he presented Kircher with a copy of the Mensa Isiaca. Kircher also found rare books on Egypt in the library at Speier. Thanks to Peiresc's influence, Kircher was ordered to remain at the Jesuit College in Rome, with a brief to study hieroglyphs. His Museo Kircheriano was one of the first public museums in Europe, and his privileged position enabled him to publish a phenomenal number of works. Kircher regarded Egyptian polytheism as the source of Greek and Roman religion as well as the origin of the beliefs of the later Hebrews, Indians, Chinese, Japanese, and

Mexicans. His *Oedipus Aegyptiacus* is one of the most remarkable books of the seventeenth century. The volume that had first stimulated Kircher's interest in Egyptological studies was Johan Georg Herwart von Hohenburg's *Thesaurus Hieroglyphicorum* (s.d.), although that great work treated hieroglyphs as decoration only, a view that Kircher believed was incorrect. Shortly after his arrival in Rome, Kircher began to study the Coptic language using material provided by Peiresc including the collection of Pietro della Valle. Kircher's *Prodromus Coptus sive Aegyptiacus* of 1636 and the *Lingua Aegyptiaca Restituta* of 1643 were the basis of all subsequent studies of the Coptic language. Although he believed Coptic was closely related to the tongue of Pharaonic Egypt, he failed to decipher the hieroglyphs correctly as he regarded them as symbolic rather than linguistic. The phonetic system eluded Kircher in his interpretation. It must be remembered, however, that Hermes Trismegistus was credited as inventor of hieroglyphs, and that the mysterious signs were thought to enshrine the highest mysteries of divinity itself. The re-erection of an obelisk to stand before the Palazzo Pamphili in the 1640s provided Kircher with a chance to study the hieroglyphs, and to suggest designs for the worn and lost pieces of the inscription. In *Obeliscus Pamphilius* he described his method of hieroglyphic interpretation which remained the basis for his theories. His interpretation was inductive, and he tended to read into ancient Egyptian inscriptions what he had gleaned from later works on philosophy, wisdom, theology, astrology, the Cabbala, and magic. The *Oedipus Aegyptiacus* also contains much information on Hermetic doctrine and interpretation of the Mensa Isiaca. The frontispiece of the book shows a winged sphinx, with obelisks, Egyptian colonnades, and stepped pyramids, and the illustrations are particularly interesting. The obelisk excavated in 1665, and now standing on the back of an elephant before the church of Santa Maria sopra Minerva, is fully depicted, as well as having its inscription interpreted. One of the best illustrations is of the Mensa Isiaca, which for Kircher and his immediate successors was a rich source of Egyptian motifs. Kircher's observations of hieroglyphs, though subsequently proved unsound, did stand him in good stead when a broken obelisk was found in 1666. Only three sides could be seen and Kircher produced a drawing of the likely appearance of the fourth side. When the obelisk was raised he was found to be correct. The events are described in his *Obeliscus Aegyptiacus.* His last work on Egyptian matters was the *Sphinx Mystagoga* which discussed the inscriptions on mummy cases, among other matters. Kircher's success with the fourth side of the obelisk from the gardens of Sallust can be traced to his accurate observation of the other three sides and his recognition of the similarity to the Augustan obelisk. In this respect he was far ahead of his time, for most attemps to record hieroglyphs at this period were inaccurate. Kircher's ideas of how pyramids appeared were curious. He illustrated tall, Cestius-type pyramids covered with hieroglyphs, as well as a Pyramid of Cheops that looks forward to Fischer von Erlach and Ledoux.[17]

William Warburton, Bishop of Gloucester, did not approve of the Neoplatonic mysticism of Kircher and others. In his *The Divine Legation of Moses* of 1741, Warburton mentions Egypt and hieroglyphs, and specifically denounces the 'late Greek Platonists, and forged Books of Hermes'. Kircher's approach, to Warburton, was a futile journey through the 'fantastic regions of Pythagorean Platonism'. English Georgian rationalism was not impressed by the murky occultism of Renaissance Egyptology: nevertheless the Hermetic Tradition, and the belief that Egypt was the source of all wisdom, lived on in Freemasonry, in Rosicrucianism, and in certain circles in Rome and Vienna.

Of some importance as a man who knew Egypt and the East, Pietro della Valle (1586–1652) published his *Viaggi* in 1650. Della Valle had brought back material from Egypt in 1626 that passed to Peiresc and became the basis of Kircher's work on the Coptic language. Anthony Blunt, in *The Drawings of G. B. Castiglione and Stefano della Bella in the Collection of H.M. the Queen at Windsor Castle*, describes a drawing by Stefano della Bella which shows the Pyramids and the Sphinx. It has been suggested that this picture was intended to illustrate della Valle's work.[18] Stefano della Bella spent some time in Paris, where he worked for Cardinal Richelieu, and in Italy he had worked mostly for the Duke of Tuscany: his accurate drawing is very likely based not on della Valle's written description, but on the writings of Tito Livio Burattini, who had known Egypt in 1640. Burattini was a scientist, and was altogether more accurate as an observer than some of his

contemporaries. He had travelled in Egypt with John Greaves, Professor of Astronomy at Oxford, who in 1646 published *Pyramidographia,* the first objective and truly thorough work on the pyramids. The drawings and measurements are generally reliable, and *Pyramidographia* stands out by virtue of its unsensational and cool descriptions. Greaves had actually been inside the Great Pyramid with Burattini, and his sectional drawing of the pyramid is based on notes he made on site. Greaves, Sandys, and Burattini impress as observers who can be relied upon. While Kircher had a successful career, his reputation has suffered from his (understandable) failure to decipher hieroglyphs. Nevertheless his work is fascinating from many angles, and his must be regarded as one of the most interesting minds of the era, especially in relation to Egyptology, the Hermetic Tradition, the Society of Jesus, and occult philosophy.

A growing taste for Egyptianising ornaments in gardens begins perhaps with the re-erection of obelisks in Rome. The Bóboli Gardens in Florence, laid out by Tribolo in 1550 under Cosimo I and extended by Buontalenti and da Bologna, has an Egyptian obelisk and an ancient basin of grey granite to the rear of the Palazzo Pitti. An obelisk from the temple of Isis Capitolina was presented by the Roman Senate to Ciriaco Mattei in 1582 to grace the grounds of his villa beside the church of Santa Maria in Domnica (S.M. della Navicella), in Rome. The obelisk that once stood at the Mausoleum of Augustus was erected in the Piazza dell'Esquilino in front of the choir of Santa Maria Maggiore by Sixtus V in 1587. The vogue for obelisks as centrepieces of urban spaces was assured when Domenico Fontana succeeded in moving a great obelisk to the centre of what was to become the Piazza di San Pietro in 1586. Spectacular as these obelisks are, they are probably eclipsed by the sheer daring of the design of 1647 for the Fountain of the Four Rivers in the Piazza Navona in Rome by Gianlorenzo Bernini (1598–1680). Completed in 1652, this consists of a rocky, grotto-like base representing the four corners of the earth, round which are grouped the river gods of the Danube, Ganges, Nile, and Rio de la Plata. Over this massive and heroic base Bernini placed the obelisk that had originally been erected in honour of Domitian, and had later been transferred to the Circus of Maxentius. During the pontificate of Innocent X the obelisk lay in fragments in the Circus on the Via Appia, and the whole idea behind the fountain was to provide a suitable base for the obelisk that the Pope wished to bring back to Rome. Bernini (who was in disgrace at the time) was restored to favour when his design was seen and approved by Innocent.[19] Obelisks also featured in architectural compositions and in capricci, especially when antiquity was suggested. The *Town Scene with Ancient Ruins* (Pl. 38) by Viviano Codazzi (*c.* 1630–70) shows a broken obelisk (originally set up on a base by Caracalla) in a composition featuring a triumphal arch, a broken portico and other familiar motifs of the capriccio.

Bernini also designed a base for the small obelisk that was found in the garden of Santa Maria sopra Minerva, and derived his design from the woodcut of the elephant carrying an obelisk in the 1499 edition of *Hypnerotomachia Poliphili.* The elephant with the obelisk on its back was set up in the Piazza Santa Maria sopra Minerva in 1666–7 largely through the influence of Pope Alexander VII, who was particularly interested in Egyptology and acquainted with Athanasius Kircher. The re-erected obelisk was to be a special memorial to the reign of Alexander, and the symbolism suggests the bringing of the sun's rays on the back of Wisdom[20] (Pl. 39). In the following century an obelisk, removed from the Mausoleum of Augustus, was set up in 1787 in the Piazza del Quirinale with the colossal marble Horse Tamers that had been erected on the site in 1589. The obelisk from the garden of Sallust that stands outside the church of Santissima Trinità de' Monti was put up in 1789, and is an antique imitation of the obelisk in the Piazza del Pòpolo. In the Pincio is the obelisk, put in its present position in 1822, that Hadrian erected in front of the tomb of Antinoüs in the Via Labicana.

A taste for Egyptian garden ornaments in France may have derived from Roman and Florentine precedent. However, some Egyptian statues belonged to Nicolas Fouquet, builder of Vaux-le-Vicomte, and were known to his gardener, Le Nôtre. After the arrest of Fouquet, Louis XIV acquired the services of Fouquet's architect, Le Vau, his painter, Le Brun, and his gardener, Le Nôtre. The trio was asked to outdo its achievements at Vaux-le-Vicomte for the King at Versailles.[21] Even the plan of the town of Versailles owes its origin to the planning of the Piazza

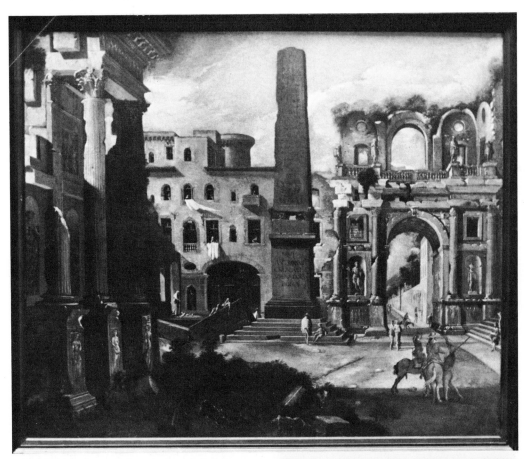

Plate 38 (*above*) *Town Scene with Ancient Ruins*, by
Viviano Codazzi (*c.* 1603–70), showing a fallen
obelisk. The base carries an inscription to Caracalla
(*Reproduced by permission of The Bowes Museum,
Barnard Castle, Co. Durham*).

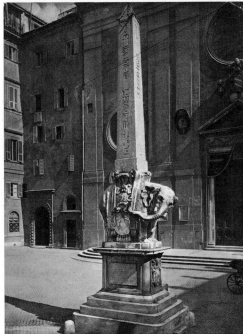

Plate 39 (*right*) The Egyptian obelisk on the
elephant's back in the Piazza delle Minerva, as set up
to designs by Bernini in 1666–7 (*Mansell-Alinari No.
27380*).

del Pòpolo where the centrepiece is a large Egyptian obelisk.[22] The King was identified with Apollo. Cecil Stewart has noted[23] the 'remarkable affinity between Louis' château at Versailles and Hadrian's villa at Tivoli'. Louis and Colbert set up a French Academy in Rome to excavate and study antiquities and to record paintings and monuments. Certainly, just as Hadrian's villa contained a great number of Egyptian and Egyptianising objects, so the gardens of Versailles contained numbers of Egyptianising sculptures, including sphinxes and obelisks. The desire to emulate Versailles brought Egyptian garden furniture to every corner of civilised Europe.

There were close connexions between Italy and France in the seventeenth and eighteenth centuries. Nicolas Poussin (1593–1665) used Egyptian elements, including some from the Praeneste mosaic, in his three paintings of the Moses story. Other Egyptianising motifs used by Poussin derive from an Isiac funerary chamber.[24] Poussin's *Ordination* also contains Egyptianising buildings that appear to be at least a century and a half later in style than they are. French writers, too, contributed to an understanding of Egypt and its monuments. Especially important in this respect is Bernard de Montfaucon (1655–1741), whose *L'antiquité expliquée et représentée en figures* was published in ten volumes in Paris between 1719 and 1724. This mighty work is a comprehensive archaeological study and discusses Egyptian as well as Classical antiquities, based on Montfaucon's travels in Italy (he did not visit Egypt). The work includes pyramids, sphinxes, and other familiar objects, including mummies (which were being collected from this time) (Pls. 40–41). Montfaucon systematically set out his examples of Egyptian artefacts and was critical of earlier research, which he regarded as speculative and undisciplined. He rejected the far-fetched interpretations of hieroglyphs, despised the admiration of 'Egyptian Wisdom', and denounced Egyptian religion and art as monstrous. Here was the mind of the Enlightenment at work: sober, discriminating, rational, unemotive, and sceptical. Montfaucon shared with Bishop Warburton a deep distrust of the mysticism of Kircher and others. Pythagorean Platonism was relegated to a shadow of a dream in the fantastic world of occultism: a new scientific rationalism was abroad. Yet despite a rejection of Alexandrian Neoplatonism, Egyptian art became the subject of serious study, and there were attempts to understand it. Eventually archaeological investigations revealed it as a definitive style.

It is significant that in the early years of the eighteenth century an architect of genius, Johann Bernhard Fischer von Erlach (1656–1723), collected sketches and drawings he had made over the years, and published them with a text in French and German as *Entwurff einer Historischen Architektur, in Abbildung unterschiedener verühmter Gebäude, des Alterthums und fremder Völker* in Vienna in 1721. Another edition with French and German texts came out in Leipzig in 1725. Book 1 contains engravings of the Great Pyramid (No. IV) (Pl. 42), and two pyramids (No. XI) (Pl. 43). Other Egyptian forms can be found in Plates Nos. XIII and XV. There are interesting interpretations of Chinese, Siamese, and Turkish architecture in the work. Book 4, Nos. III, IV and V are of some curiosity value. Most of Fischer von Erlach's works were 'historical' buildings in the sense that they were eclectic and displayed their creator's love of great architectural achieve-ments in the past. Fischer knew the Roman archaeologists and antiquaries, notably Athanasius Kircher and Giovanni Pietro Bellori,[25] and had met Sir Christopher Wren. Fischer's *Entwurff* was translated into English by Thomas Lediard and published in 1730 as *A Plan of Civil and Historical Architecture*. Fischer believed that Classical architecture derived from the Temple of Solomon (a particularly Masonic concept), where the Orders were used for the first time. This Masonic idea was further expanded in his book by tracing the development of architecture in ancient Egypt, Persia, Greece, and in non-European countries. Fischer clearly knew his written sources well and gives chapter and verse for them. Where possible he tried to get drawings of buildings or ruins, and this helped him to achieve accuracy in some cases, although it must be admitted that his pyramids are a little too steep. Fischer had drawn Egyptian vases and other objects in Italy. He was acquainted with the philosophy of Leibnitz and derived from it his own theocentric ideas of the world, where God was the greatest of all architects (a significantly Masonic notion). His enthusiasm for antiquity was perhaps fired by the antiquarians he had met at the court of Queen Christina, and his cosmopolitan circle of friends included many in Protestant northern Europe. It

Plate 40 A plate from the English edition on 1721–2 of Bernard de Montfaucon's *Antiquity Explained and Represented in Sculptures*. Several items were 'found at Rome', and several are Egyptianising objects. On the top right hand corner is part of the Mensa Isiaca (*Mansell Collection*).

Plate 41 A plate from Montfaucon that includes Egyptianising items from Kircher, Peiresc, and other collections with several examples of the sistrum, and other objects (*Mansell Collection*).

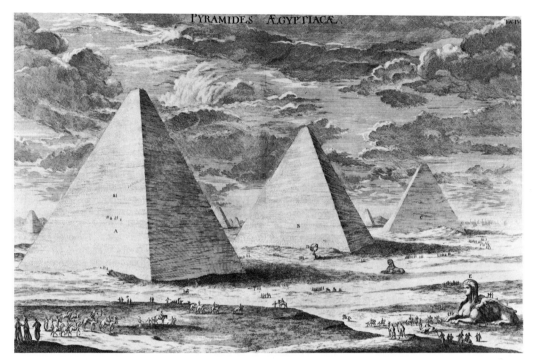

Plate 42　The Giza Pyramids and the Sphinx from Part IV of Johann Bernhard Fischer von Erlach's *Entwurff einer Historischen Architektur* of 1721 (*Trustees of Sir John Soane's Museum*).

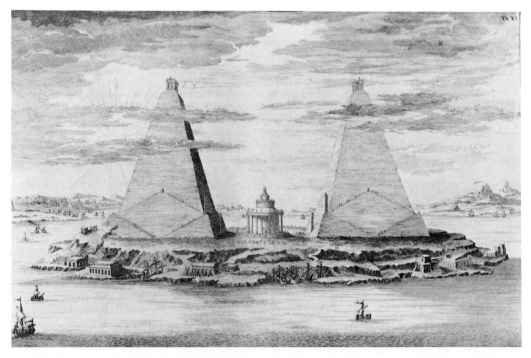

Plate 43　Fischer von Erlach's Plate XI from *Entwurff . . .* showing two improbable pyramids. The resemblance to Boullée's designs later in the century should be noted (*Trustees of Sir John Soane's Museum*).

is most unlikely that he avoided all contact with Freemasonry, and indeed some of the ideas expressed in his *Entwurff,* and especially his looking back to the Temple of Solomon and Egypt, might suggest that he was a Freemason himself. His use of architectural elements was eclectic in the extreme: one has only to analyse the brilliant Karlskirche in Vienna to find many strands, even the Temple of Solomon. In Vienna also he used an obelisk for the Castrum Doloris for Kaiser Joseph I in St Stephen's Cathedral (1711), and sphinxes and atlantes in the staircase of the Gartenpalais Trautson in 1710. Lukas von Hildebrandt, Fischer's great rival, used sphinxes at the Belvedere terraces in Vienna that sit up alertly, but are distinctly Rococo in manner. Fischer's sphinxes at the Trautson Treppenhaus are full-breasted, reclining, and have paws like those in the gardens of Veitschöchheim. Fischer refers to Jean de Thévenot and Paul Lucas in his *Entwurff* in connexion with the pyramid and Sphinx. These were travellers who wrote about their journeys and who were much read at the time. Egyptianisms occur in profusion throughout Europe in the eighteenth century. The spectacular Haus zum Cavazzen in the Marktplatz, Lindau-am-Bodensee, of 1729, now the Städtische Kunstsammlungen, has a marvellously inventive Baroque façade that features painted sphinxes on the stucco. The Isiac crescent moon can also be seen near the Haus zum Cavazzen, on the ceiling of the Stiftskirche in Lindau, painted by Appiani, where the Virgin Mary is carried aloft in glory (Pl. 44).

Throughout Baroque central Europe can be found many instances where the Marian symbolism is clearly derived from that of Isis. Quite apart from the crescent moon, a common attribute of the Virgin, Baroque ceilings in which the Blessed Virgin is celebrated often show other symbols. At Wallfahrtskirche Steinhausen, for example, Johann Zimmermann's ceiling of 1730–1 shows Marian-Isiac symbols including the fountain. Such symbols are met again and again, painted in ceilings of south German churches. The Fons Signatus, the Rosa Mystica, the Stella Maris, the Oliva Speciosa, the Hortus Conclusus, the Stella Matutina, and the Salus Infirmorum are all Marian, and, ultimately, Isiac. The Lily among Thorns, the Chalice and the Host, and the Healer of the Sick are familiar motifs. Maria Pulchrae Dilectionis is also the Cedra Exsaltata, and

Plate 44 The painting by Appiani in the Stiftskirche in Lindau-am-Bodensee, showing the Virgin Mary on her crescent moon.

73

the Mater Dolorosa, with her everlasting tears, also reminds us of Isis. Panels of Graeco-Roman mosaics from Antioch show initiation ceremonies in the House of the Mysteries of Isis in which the goddess herself is shown with emblems of stars and moon, draped in robes similar to those worn by the Virgin in Baroque ceilings. At Altenburg in Austria, the superb frescoes by Paul Troger and J. J. Zeiller of 1732–4 are particularly interesting in the context of this study, for the central painting shows an interpretation of Revelation, chapters 4, 12, and 13. The vision is of overpowering splendour, and features the Woman in Heaven with a crown of stars and the moon under her feet. She is in travail, and carried aloft out of the reach of a fearsome dragon that is waiting to devour the new-born child. God the Father in Majesty is carried on a throne of clouds borne by angels and surrounded by blinding light. The Archangel Michael swoops down with blazing sword to attack the many-headed dragon, and Baroque angels defeat the forces of Hell in this astonishing interpretation of *And there was war in heaven . . . Es erhub sich ein Streit.* The parallels with Seth-Typhon, Horus-Harpocrates, and the pregnant Isis have already been described in Chapter 1. Representations of Horus-Harpocrates in the Graeco-Roman world often show a putto-like figure with wings and his fingers to his lips. A parallel may be found in the basilica of Neu-Birnau, designed by Peter Thumb, that stands sentinel on the southern shores of the Bodensee. In this enchanting church is the celebrated figure by Jacob Feuchtmayr of the Honigschlecker, a putto caught with his finger still sweet with honey, in a gesture that could only come from the Graeco-Roman Horus-Harpocrates. It is perhaps one of the most charming of all eighteenth-century sculptures in a German church.

Such overt identification of the Madonna with Isiac emblems, and the use of the Horus-Harpocrates image in an eighteenth-century Roman Catholic basilica, seem startling, yet even from the Middle Ages there had been allusions to Isis. The Egyptian goddess was closely associated with wisdom, healing, nature, and the mysteries of life itself. As Divine Engrafter, and as a deity concerned with bringing plants to life, she was identified in mediaeval legends with the Virgin Mary, who is also noted for her powers of encouraging agricultural fertility. As Iuvencula, Mary is the young heifer (Isis-Hathor), Nympha Dei, a deer, the moon, a swallow (note the crescent moon symbolism), and a figure on whom innumerable praises are showered. The Blessed Virgin's myriad names may be studied further in the colossal work of Hippolytus Marraccius. The cultus is further discussed in Antonio Cuomó's *Saggio apologetico della bellezza celeste e divina di Maria SS. Madre di Dio,* published in Castellamare in 1863, a strange, even weird concoction of quotations that is used to justify much.

Jacques-François Blondel (1705–74) was one of the most important teachers of architecture in eighteenth-century France, and, like Laugier, advocated the use of elementary geometrical forms.[26] This advocacy looked back to Egypt, and indeed P. W. Dorigny's *L'Egypte ancienne* appears to have influenced Blondel. Frederik Ludwig Norden's *Travels in Egypt and Nubia* was a further important book in the history of the Egyptian Revival. Norden had travelled in Egypt in the 1730s, and went to London in 1741 when he became a founder-member of a club called the Egyptian Society.[27] This Society also had as a founder-member Richard Pococke, who had travelled in Egypt during the 1730s, was chaplain to Lord Chesterfield, and became Bishop of Ossory and Meath. Pococke's *Observations on Egypt* was published in 1743. Norden's book has lavish illustrations of high quality (Pl. 45), and his and Pococke's books were the standard Egyptological sources from the time of their publication until the Napoleonic studies came out. Other important scholarly reports by travellers who had been to Egypt were produced by Paul Lucas in 1705 and by Carsten Niebuhr in 1774.

The fashion for Egyptian motifs (usually hieroglyphs, sphinxes, obelisks, and pyramids in its earliest manifestations) grew in the eighteenth century. We have noted the sphinxes used by two of Austria's greatest architects, Fischer von Erlach and Lukas von Hildebrandt, but there were other outstanding instances where Egyptianisms appear in Austrian Baroque architecture of the first rank. The parish church (formerly a house of the Augustinians) at Dürnstein has an elegant tower with large obelisks at the corners of the third stage. Obelisks are also used as terminals to the attic storey of the elaborate portal in the courtyard. Now each face of these obelisks is decorated, and from a distance these decorations appear as hieroglyphs, although they are

nothing of the sort. A kind of impressionistic Egyptianising is suggested. The architects were Josef Munggenast, with probable co-operation from Jakob Prandtauer, and the work was carried out between 1721–5. Perhaps one of the first examples where a large range of Egyptian items appeared in one three-dimensional work of the eighteenth century was the Apis Altar that was decorated with bird-headed figures derived from the Mensa Isiaca and surmounted by an obelisk adorned with bogus hieroglyphs. It was made by Johann Melchior Dinglinger in 1731 and was encrusted in gems. This fashion is also known as Egyptiennerie. Dinglinger's Altar survives in the Grünes Gewölbe in Dresden (Frontispiece). As court jeweller to the Elector August the Strong he also produced the Dianabad of 1704 that featured stag's horns, and the Obeliscus Augustalis of 1722. The Apis Altar also has a detail of the Apis bull on a boat propelled by Egyptian figures, one of whom wears the Isiac crescent moon on his head. This Altar is perhaps the finest of the early Egyptian Revival pieces in Baroque Europe.[28] The court of August was glittering and cosmopolitan. The rich fantasy of the Zwinger Palace at Dresden had its smaller scale counterparts in Dinglinger's work, and the court jeweller produced other exotic masterpieces for his extraordinary and gifted monarch.

The publication of *Recueil d'Antiquités Egyptiennes, Etrusques, Grecques et Romaines* by Anne-Claude-Philippe de Thubières, Comte de Caylus, in 1752–67[29], brought new light to Egyptology, for the Count not only produced volumes that were full of detail and illustrations, but clearly appreciated the aesthetic possibilities of Egyptian art. Caylus argued that the arts were formed in Egypt, passed from there to Tuscany, and from there to Greece and Rome. He also writes persuasively of the qualities of grandeur, primitiveness, simplicity, massiveness, and argues in their favour. Like Laugier and Blondel, Caylus was now looking at simple forms without prejudice. Simple, basic forms were gradually being appreciated in their own right.

Such lavish and well-produced books made Egyptian motifs familiar. Obelisks, sphinxes, and pyramids were reproduced throughout Europe during the eighteenth century. As Pevsner and Lang have pointed out, sphinxes in gardens 'are so common and often look so frankly Rococo that one tends to forget their Egyptian ancestry'.[30] The sphinxes at the Belvedere in Vienna have already been mentioned, but the charming sphinxes (more like courtesans from a Rococo Salon) in the gardens of Veitshöchheim have many Egyptianising attributes. The gardens were laid out in 1763–75, with a lake and grottoes, for the Prince-Bishops of Würzburg. The sculptures are by J. W. van der Auvera, F. Dietz, and J. P. Wagner. The sphinxes are vastly pretty (Pl. 46) and although not immediately Egyptian in form, being entirely Rococo in manner, clearly owe much to Egyptian prototypes. The sphinxes on the terrace of the Belvedere in Vienna are more severe than those at Veitshöchheim, but are similar in spirit. It is perhaps worth recording that when the author visited the gardens of Veitshöchheim in 1979 they were found to be in a poor state of preservation and maintenance. Big-breasted Rococo sphinxes occur at Stift Altenburg in Austria, a Benedictine monastery Baroqueised by Josef Munggenast in 1730–3. The sphinxes recline on pedestals in the courts of the monastery buildings. It will be recalled that Munggenast used obelisks to considerable effect at Dürnstein a decade earlier. Obelisks and sphinxes commonly are found in the gardens of both sacred and profane buildings of the period, but it must be remembered that Baroque palaces and Baroque monasteries in the Holy Roman Empire looked much the same, and their worldly inhabitants would have enjoyed the current styles. It is clear that a denial of the Egyptian origins of these garden ornaments is nonsense. Just because some sphinxes veer towards a Rococo appearance does not alter their ancestry. The sphinxes at Versailles are of the more standard and correctly Egyptianising pattern, owing more perhaps to Roman copies of the Hadrianic period than to the *echt*-sphinxes from Egypt, and those at Chenonceaux are also overtly Egyptian in feeling. Interestingly, Chenonceaux was presented by Henri II to Diane de Poitiers, but the sphinxes there appear to be of eighteenth-century date. The sixteenth-century sphinxes at Fontainebleau are more animated and possess many of the characteristics of the sphinxes that adorn the tombs of Guillaume du Bellay and Diane de Poitiers. Sphinxes are often shown as garden furniture in paintings of the eighteenth century. A design for a Beauvais tapestry by Francesco Casanova (brother of the more celebrated adventurer) known as *The Pleasures of Youth* shows a sphinx as garden furniture in the Chiswick or Chenonceaux

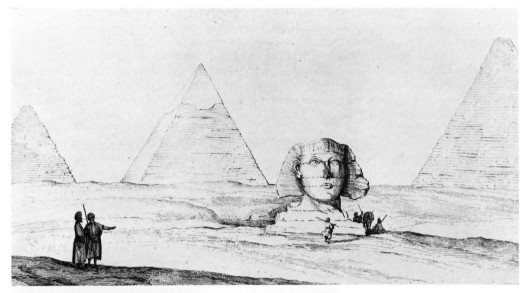

Plate 45 (*above*) The Sphinx and the Pyramids of Giza. Plate XLV from F. L. Norden's *Travels . . .* (*Trustees of Sir John Soane's Museum*).

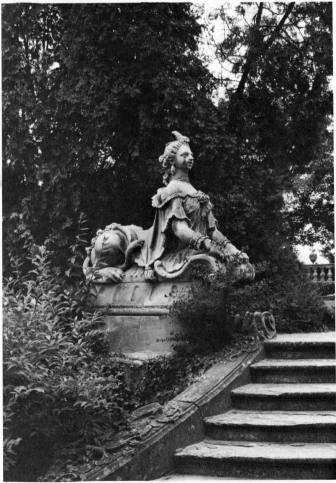

Plate 46 (*left*) A Rococo Sphinx in the Gardens at Veitschöchheim.

manner. Lord Burlington's villa at Chiswick had grounds embellished with sphinxes on pedestals and with obelisks, designed by William Kent (1684–1748). There are handsome sphinxes at Blickling in Norfolk. The chimneys at Chiswick are obelisks, but then obelisks had been familiar in England since Elizabethan times. Pyramids are not so common, but very steep pyramids can sometimes be confused with obelisks. Vanbrugh designed a pyramid with proportions near those of Giza in the gardens at Stowe. At Castle Howard he erected the Great Obelisk of 1714, and the Pyramid Gate (proportioned in the Cestius manner) in 1719. In his sketch of the English cemetery at Surat, now in the Bodleian Library at Oxford, he shows a splendid array of pyramids on pedestals, obelisks, and thin pyramids of the Cestius type. Kent had used a stepped pyramid with Egyptian proportions at the Temple of British Worthies at Stowe in 1733, and pyramids (usually of the Cestius type) as well as obelisks are found in plenty in the South Park Street Cemetery in Calcutta, founded in 1767.[31] The largest pyramid in South Park Street Cemetery commemorates Elizabeth Barwell and dates from 1779. It stands on a podium, with a pediment on each face, and is thus similar to Hawksmoor's pyramid of 1728 at Castle Howard. There is a pyramid-tomb of Olof Adlerberg at Järäfalla in Sweden of 1757; an elongated pyramid (almost an obelisk) of about the same period in the churchyard of St Anne's, Limehouse; and a mausoleum in Chiddingstone churchyard, Kent, with a pyramidal stone roof of 1736.

The almost desperate gaiety of the Veitshöchheim sculptures is contrasted with the severity of the sphinxes at Versailles, Blickling, or Chiswick. That spirit also lies behind the paintings of Watteau and Fragonard, and permeates that last jest of the age, Mozart's *Così fan tutte.* The hazards depicted in Fragonard's celebrated vision of the swing; the strange melancholy of the gardens of Veitshöchheim; and the bitter, disturbing realities of human frailty in *Così* suggest a dark shadow over the apparent splendour of European culture at its apogee. The noontide demon lurks within these haunted works.

During the latter half of the eighteenth century the interest in simple forms in architecture increased. Appreciation of Doric and Egyptian architecture grew, and ancient Egyptians were seen to be wise and enlightened. The architecture of Egypt was not regarded as primitive in a pejorative sense: starkness and boldness came to be valued. In France particularly the younger generation of architects took to basic geometrical forms with enthusiasm. The atmosphere in the Academies in Paris and in Rome encouraged a development of huge schemes in which blank walls and simple architectural motifs were exploited.

This characteristically French approach can be contrasted with that of eighteenth-century England. Certainly Egyptian forms had been used by Vanbrugh and Hawksmoor in a manner that suggests the French Academic approach of the end of the century, but Egyptian elements are generally treated in the same way as Chinese, Gothick, and Classical forms were used in gardens. They were playful, entertaining, and perhaps slightly exotic. Egyptian garden ornaments or rooms in the Egyptian manner tend to be in the spirit of Rococo. Hautecoeur, in his monumental *L'architecture classique en France,* quotes several instances where Egyptian motifs occur. Hubert Robert, for example, painted a capriccio using Egyptian forms in 1760 in Rome, which was shown at the Royal Academy of Arts in 1967–8 in an Exhibition of French eighteenth-century art.[32] Robert (1733–1808) produced a number of capricci in which Egyptian and Egyptianising motifs appeared. In the Bowes Museum, for example, there are two architectural compositions, one of which features Egyptianising lions adorning a massive Piranesian bridge, while the other shows a Berniniesque colonnade and a huge Egyptian obelisk (Pl. 47). The latter is particularly interesting, for the obelisk rests on a base, the four sides of which are supported by the Villa Adriana telamoni. Thus Robert takes Egyptian and Egyptianising elements and composes them in a new combination. Various artists also produced Egyptianising designs in the course of the eighteenth century: Cherpitel drew an Egyptian temple in the 1760s, and Desprez designed an Egyptian funerary temple in 1766.

It is quite clear that not a little of the Egyptian Revival can be traced to Edmund Burke with his ideas of the Sublime and the Beautiful.[33] Sublime works of art could induce emotional reactions like terror, awe, dread, and amazement, and Egyptian architecture had certain Sublime qualities. Boullée realised this, and mentions the fact in his ideas of *architecture parlante* when he makes use

of great blank walls, vast scale, and Egyptianising elements to suggest the desolation and terror of death in his funereal architecture. Egypt was a land associated with wisdom and mystery, where the grandest architecture was that of the tomb. The emotions that Egyptian architecture could arouse put it firmly in the Sublime category. Sir John Soane referred to Egyptian architecture, pointing out its immense grandeur and its 'colossal', 'awful', and 'majestic' properties.[34] Soane's contemporaries also made similar remarks about ancient Egyptian architecture. Grandeur, massiveness, and a certain ponderous quality were characteristics of Egyptian architecture, and indeed Sublime reactions conveying awe, gloom, and a sense of permanence, began to be valued. Hubert Robert conveyed an idea of the Sublime possibilities of Egyptian architecture in his paintings (Pl. 47). Louis-François Cassas (1756–1827) also produced Boullée-like images of Egyptian temples and pyramids 'restored'.[35]

During the second half of the eighteenth century, however, a much more full-blooded and inventive Egyptian Revival got under way, prompted by the inventive genius of Piranesi, and it is to this period that we now turn.

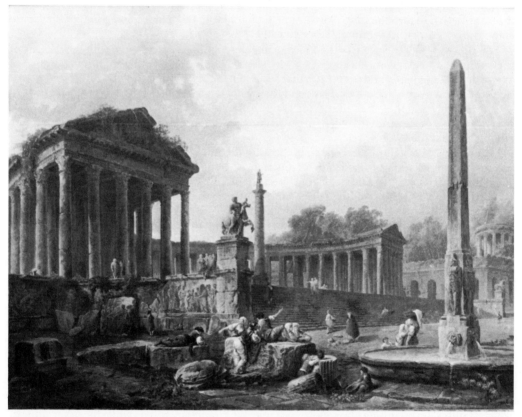

Plate 47 Architectural composition by Hubert Robert (1733–1808) featuring an Egyptian obelisk and a base incorporating the telamoni from the Villa Adriana. This is one of a number of Capricci that show Egyptian and Egyptianising elements as part of architectural compositions (*Reproduced by permission of The Bowes Museum, Barnard Castle, Co. Durham*).

5

Egyptian elements in Europe in the latter half of the eighteenth century from the time of Piranesi

Egyptian architecture appears here for the first time; I want to stress that because people always believed that there was nothing more than pyramids, obelisks, and giants, neglecting the parts that would be adequate to adorn and support this architectural style.

G. B. PIRANESI (1720–1778): Letter of 18 November 1768
to Thomas Hollis that accompanied the copy of the plates of *Diverse Maniere*

The inventor of the fashion for Egyptianising forms used in a Rococo manner was Giovanni Battista Piranesi. His *Vedutista* often include Egyptian or Egyptianising objects, but the most promiscuous array of exotic elements can be found in the *Antichità Romane* (Pl. 48). His engraving of an ancient burial chamber in *Prima Parte di Architetture e Prospettire* of 1743 includes a sphinx and a pyramid. The ruins of antiquity that Piranesi drew provided his basic material for later fantasies. The most important work by Piranesi that affected the Egyptian Revival, however, was the *Diverse Maniere d'adornare i Cammini,* published in 1769 (Pl. 49), a considerable proportion of which was devoted to the Egyptian style. As John Wilton-Ely has pointed out, Piranesi's interest in the Egyptian style, rather than the 'use of random motifs such as obelisks and pyramids in his imaginary compositions',[1] is demonstrated in an architectural fantasy showing an ancient school in the Egyptian style in the *Opere Varie:* the Egyptianising portal and frieze clearly were to influence Playfair at Cairness. Piranesi saw the possibilities in the austerity and monumentality of Egyptian architecture, and broadened his Egyptian architectural vocabulary by studying printed sources and the objects on view in Rome itself. Gradually he evolved a fusion of elements that led to a synthesis in which Graeco-Roman-Egyptian and other styles can be detected, yet the result is a satisfactory whole, as in *Parere su l'Architettura.* During the 1760s he was one of the first designers to apply Egyptian motifs to contemporary interiors, and produced a complete Egyptianising interior (of *c.* 1768) for the Caffè degl'Inglesi in the Piazza di Spagna in Rome (Pls. 50-51). This Caffè does not survive. It was described in 1776 by Thomas Jones as a 'filthy vaulted room the walls of which were painted with Sphinxes, Obelisks and Pyramids from capricious designs by Piranesi, and fitter to adorn the inside of an Egyptian Sepulchre, than a room of social conversation.'[2] Soane did not approve either, and accused Piranesi of mistaking 'Confusion for Intricacy, and undefined lines and forms for Classical Variety'.[3] Two plates in the *Diverse Maniere* show two walls from this curious interior, and there are also several designs for Egyptian chimneypieces that were completed by November 1767 when Piranesi sent a proof copy of the book with fifty-seven plates to Thomas Hollis (Pls. 52-61). Piranesi emphasised his originality as a pioneer of Egyptian taste in his covering letter to Hollis.[4] There is no doubt that the Mensa Isiaca, or more probably published descriptions and illustrations of it, influenced Piranesi in his fireplace designs. There is a very detailed account (1767) of the Mensa Isiaca in Caylus' *Recueil.*[5] In 1769 James Barry wrote to Edmund Burke to say that Piranesi would go down to posterity with a deserved reputation, 'in

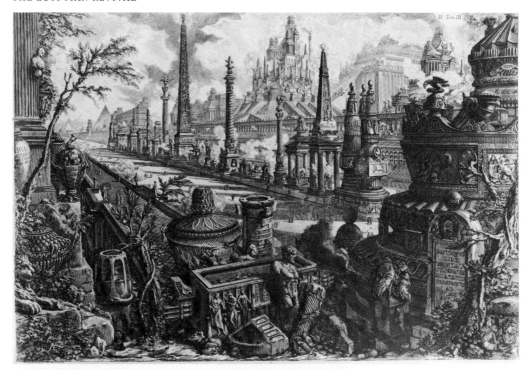

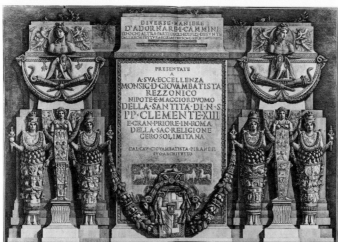

Plate 48 (above) The second frontispiece of Volume III of Piranesi's *Antichità Romane*, with several Egyptianising forms in evidence. Note the pyramids, obelisks, and fantastic pyramidal compositions (*Society of Antiquaries of London*).

Plate 49 (left) The title page of Piranesi's *Diverse Maniere d'Adornare i Cammini*. Note the figures of Diana of Ephesus, identified with Isis (*Society of Antiquaries of London*).

spite of his Egyptian and other whimsies, and his gusto of architecture flowing out of the same cloacus as Borromini's and other hairbrained moderns.'

Piranesi clearly aimed his *Diverse Maniere* at potential clients as well as designers and he wrote at length on the variety of Egyptian ornament. Certainly the eclectic possibilities had not escaped him, and he used Egyptian motifs in the book in the manner of capricci. Piranesi's designs are in a Rococo spirit that was to be found in Strawberry Hill Gothick or in the Chinese Pagoda at Kew. French writers had noted that the coldness of Greek and Roman forms caused a reaction, and that the spirit of Rocaille was perhaps caught by the 'bissarrerie' of Chinese and Egyptian ornaments. Gothic Revival was anticipated as a further attraction for jaded palates. Pevsner and Lang[6] quote Blondel's reaction to the Piranesi type of Rococo-Egyptianising: he did not altogether approve, and he saw clearly the connexion with a Rococo he thought had been left far behind. Sir

80

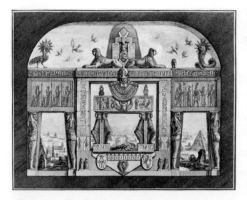 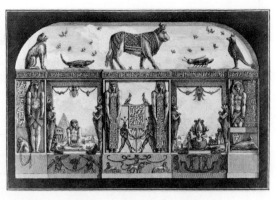

Plate 50 The Caffè degl'Inglesi in the Piazza di Spagna in Rome, by Piranesi from *Diverse Maniere* . . . One of the first great Egyptian Revival interiors (*Society of Antiquaries of London*).

Plate 51 Another wall of the Caffè degl'Inglesi by Piranesi, from *Diverse Maniere* . . . Note the telamoni based on the Villa Adriana figures, the Apis bull, crocodiles and sphinxes (*Society of Antiquaries of London*).

William Chambers used the example of the Villa Adriana as precedent for the use of Chinese elements in his work on Chinese Buildings of 1757. Cornelius Pauw in his *Recherches Philosophiques sur les Egyptiens et les Chinois* also linked Egypt and China. It is quite clear that the Rococo idea of using ornament from any source – Gothic architecture, Chinese forms, Egyptian art and even Moresque buildings – creates problems for the purist. The age of Piranesi was one of eclecticism, however, and there is no doubt that the somewhat bizarre possibilities of Egyptianising forms were quickly spotted by designers of Piranesi's calibre. Piranesi can be identified as the architectural theorist who provided arguments used by designers such as Adam, who, like many architects since, have sought to justify a philosophy relating to modern design that would be respectable. His use of a wide variety of motifs derived from his archaeological works lent his designs an integrity. Horace Walpole recognised the sublime genius of Piranesi when he wrote that the 'delicate redundance growing into our architecture' would be stopped if man would study 'the sublime dreams of Piranesi'. Walpole recognised that Piranesi had 'imagined scenes that would startle geometry, and exhaust the Indies to realize.'[7]

Yet Piranesi was certainly fascinated by Fischer von Erlach's *Entwurff*. . . , and made sketches of many of the Egyptianising plates around 1743. Piranesi's drawings are now in the Pierpont Morgan Library, New York. Fischer's extraordinary plate that purports to show royal tombs at Heliopolis clearly influenced Piranesi in his later designs, and was noted in the page of sketches. In the collection of the Duke of Devonshire at Chatsworth House is a book of sketches by Filippo Juvarra which has a number of imaginary scenes with Egyptianising motifs. Two drawings (fol. 21, 22) have specific Egyptian elements: fol. 21 shows a sarcophagus resting on the backs of reclining sphinxes with heads turned to one side; fol. 22 shows a reclining statue of Nilus with sphinx, and in the background are tall obelisk-pyramids, one of which has a band of bogus hieroglyphs around it. Juvarra's sketches pre-date Piranesi's work, and came from Lord Burlington's collection. There are elements of the capriccio as well as of stage-design for operatic sets in Juvarra's work, but the scale is altogether less fearsome than in the drawings of Piranesi. The latter has Rococo aspects to his Egyptianising capricci, yet his influence on later theorists and designers was profound. Piranesi accepted that the hardness and simplicity of Egyptian architecture were not due to ignorance but were deliberate. Taste of the day saw non-naturalistic styles as primitive or inferior: Piranesi insisted that Egyptian art was highly sophisticated. The bridge between a Rococo attitude to design forms and those of a later period was provided by a change of philosophy. The gap between the philosophy of the Enlightenment and that of Romanticism was narrowed by Johann Gottfried Herder (1744–1803), who was one of the first in the eighteenth century to point out what Egyptian art might contribute to the period. Herder wrote that the first monuments in the world were those of Egypt, and that lasting buildings, using squares, spheres,

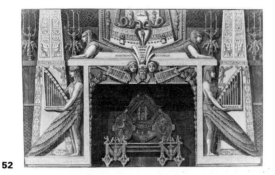

52

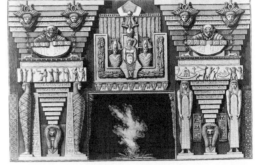

56

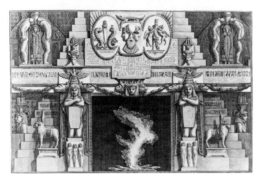

53

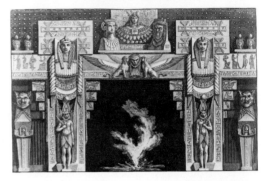

57

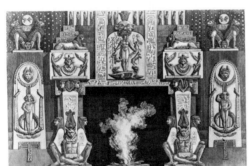

54

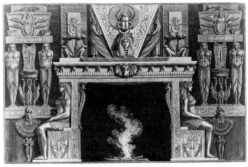

58

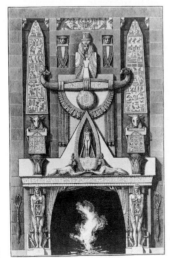

55

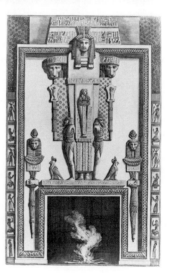

59

Plates 52-61 Fireplace designs by Piranesi from *Diverse Maniere . . .* Note the corbelled form (Plate 56) that were to become usual in Egyptian Revival work and in Art-Déco designs. Also compare Plate 60 with Plate 79 (*Society of Antiquaries of London*)

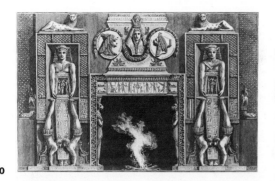

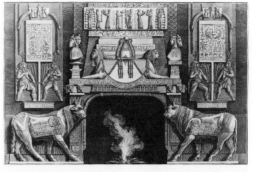

and points, became the pyramids or obelisks. The simple idea in building, giving an impression of permanence, and without any images, statues, or ornament, was achieved by the Egyptians. Herder thus realised the possibilities of a stark, simple architecture, a severe expression of basic form, in the buildings of ancient Egypt. The primitiveness of nineteenth-century Egyptian Revival stems from the philosophical ideas of Burke and Herder, and from the *architecture parlante* of Boullée. The search for simple forms that was to be such a feature of the eighteenth and early nineteenth centuries had begun. The philosophy is Herder's, and the stripped-down, Sublime images are Piranesi's. The latter's prisons, views, tombs, and Egyptianising forms were to mix with a demand for simplicity by the German Herder and the Frenchman Laugier. Père Laugier's *Essai sur l'architecture* of 1753 also argued for simplicity, but it was a simplicity based on columns and beams only. French architects of the last quarter of the century were not slow to connect Laugier's ideas of simplicity with those of Herder and Piranesi.

One of the best of the 'Rococo' phase of Egyptianising interiors is that of the Sala dei Papiri, decorated for Pius VI by Anton Raphaël Mengs (1728–79) around 1776, but probably commissioned by Clement XIV in 1772 (Pl. 62). While Mengs was unquestionably influenced by Piranesi, his most important mentor was Winckelmann, whom he met in 1755: there is a fine portrait of Johann Joachim Winckelmann by Mengs in the Metropolitan Museum of Art in New York. Mengs won European renown as a leading exponent of Neoclassicism. He had previously studied the works of Michelangelo and Raphael. The *Allegory of History* that is the subject of the main composition of the decorations in the Camera dei Papiri has iconography relating to the function of the Camera. Genius carrying manuscripts is heralded by Fame, and advances towards History, who is attended by Time and by Janus. The latter points to a picture of the Museo Pio-Clementino. The Egyptian figures by Mengs in the corners of the ceiling owe much to the telamoni painted in the Stanza dell' Incendio by Raphael and Giulio Romano (Pl. 34), and ultimately to the two telamoni of red granite from the Villa Adriana that now flank the entrance to the Museum Pium in the Vatican in the Sala a Croce Greca (Pl. 29). In the same room there are two sphinxes of red granite, also of the first to third centuries AD, and Roman work in the Egyptian style.

Justine, Countess Orsini-Rosenberg, authoress of *Alticchiero,* describes the Villa Alticchiero which had a Canopus, a Chinese pavilion, and other features. Justine Wynne (as she once was) had been a mistress of Casanova, and had been loved by Andrea Memmo, a Venetian Freemason. Memmo had been introduced to Freemasonry by Casanova (who was himself initiated in Lyon in 1750), and was the cause of the latter's imprisonment. The importance of Freemasonry in the history of the Egyptian Revival is considerable. The idea of Egypt as the source of knowledge of building and of all wisdom enshrouded in the Hermetic mysteries was known to Freemasons. The craft of Masonry itself was traced to Egypt, and the Israelites were supposed to have learned the skills of building in stone from the Egyptians. According to Waite,[8] however, the Freemasons did not develop any special 'Egyptian' rites. Yet Rosicrucianism owed much to the Hermetic Tradition, and there seem to have been some remarkably Egyptianising facets to that Order.

Freemasonry in the latter half of the eighteenth century reflected many of the philosophical, moral, political, artistic, and intellectual currents of the Enlightenment. Liberalism was implicit in

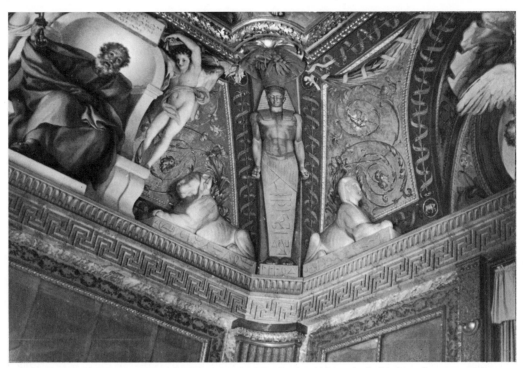

Plate 62 The corner of the ceiling of the Sala dei Papiri by Raphaël Mengs in the Vatican. Compare with Pl. 51 and 60.

Masonic ideals of the brotherhood of Man, and Continental Masons held little brief for the Roman Catholic hierarchy in its most reactionary forms. The Egyptian influence on one of the most sublime works associated with Freemasonry, Mozart's *Die Zauberflöte,* needs to be stressed. In 1731 the Abbé Jean Terrasson (1670–1750) published *Sethos, histoire ou vie tirée des monumens anecdotes de l'ancienne Egypte. Traduite d'un manuscrit grec.* This tedious work by a man who had translated Diodorus Siculus into French concerns an Egyptian Prince Sethos who was initiated into ancient mysteries, and who, after many travels and adventures, retired to a temple of initiates. Despite the tedium of this text, a second edition came out, and English and German translations appeared in 1732. An Italian translation was published in 1734, and another German version was printed in Breslau in 1777–8. During the eighteenth century the book was popular in Masonic circles, and was cited by French historians as if it were a standard work on ancient Egyptian mysteries. Thomas Moore's romance *The Epicurean* of 1827 has certain ideas borrowed from *Sethos,* and the connexion between *Sethos* and Mozart was first noticed by Thomas Love Peacock in his review of *The Epicurean.* Like other works of the period, Terrasson's book is Rococo, in the sense of its central idea being dressed up in exotic garments. Yet the description of the Isiac mysteries in *Sethos* is very long and detailed, and Egypt is stressed as the fount of wisdom and of the Hermetic Tradition. The playwright Gebler knew *Sethos* in its German translation, and was undoubtedly influenced by it when he wrote his play *Thamos, König in Ägypten. Thamos* was given in Salzburg in 1773 with specially composed incidental music by the young Wolfgang Amadeus Mozart who thus came into contact with mystical ideas of initiation, Hermetic religion, and Freemasonry. Doubtless Mozart, who loathed at least one prince of the Church, Hieronymus Colleredo, Archbishop of Salzburg, began to be influenced by Masonic ideals at this time. Mozart's impressive and solemn music was later re-cast and expanded for a new production of the play given by the troupe of Emanuel Schikaneder in Salzburg in 1779 that included some Egyptianising sets.

Indeed Egyptian theatrical sets seem to have appeared in the last third of the eighteenth

century, a fact not unconnected with the influence of Freemasonry. Otto Jahn observes of the choral writing in *Thamos* that it is grander, freer, and more imposing than that of any of the Masses of the period. He also points out that a 'solemn act of worship was represented on the stage,' and that the 'expression of reverence to the Supreme Being was heightened in effect by the Egyptian surroundings.' Mozart's endeavour was to 'render the consequent emotions with all possible truth and force.'[9] Here is a reference, then, to an Egyptian Revival stage-set north of the Alps, and probably not uninfluenced by the stage designs of Tesi of the previous decade. Mozart's Masonic music, including the cantata *Dir, Seele des Weltalls* (K. 429), *Zerfliesset Heut', Geliebter Brüder* (K. 483), *Ihr Unsre Neuen Leiter* (K. 484), *Die Ihr des Unermesslichen Weltalls Schöpfer Ehrt* (K. 619), *Die Maurerfreude* (K. 471), *Die Ihr Einem Neuen Grade* (K. 468), and *Laut Verkünde Unsre Freude* (K. 623), as well as *Thamos* and *Die Zauberflöte,* had a literary background that was Egyptian, or were connected with Egyptian wisdom and with Hermetic Tradition. The elegiac *Maurerische Trauermusik* (K. 477), written for the Masonic commemoration of Duke Georg August of Mecklenburg-Strelitz and Count Franz Eszterházy von Galantha in 1785, has a dark atmosphere, the musical equivalent of the Desprez designs for tombs. In this respect the dark colouring of the *Maurerische Trauermusik,* with its characteristic basset-horns, resembles the opening pages of the *Requiem* (K. 626), in the chorus *Requiem aeternam dona eis Domine, et lux perpetua luceat eis.* Perhaps more startling in the Mozartian context is the fact that his *Graduale ad Festum B.M.V., Sancta Maria, Mater Dei* (K. 273), composed in 1777 before he left for Mannheim and other Protestant (or *in partibus infidelibus*) places, was a favourite with Austrian Freemasons. That a hymn to the Virgin Mary should be included in the musical repertoire of Freemasonry points to an oecumenical reality that was worthy of Isis herself.

In 1786 the Emperor ordered the amalgamation of the Viennese Lodges, and Mozart's Lodge *Zur Wohltätigkeit* (Benevolence) was joined with the *Gekrönte Hoffnung* to become the *Neugekrönte Hoffnung* (New-crowned Hope). The reference in Mozart's Masonic works to 'our hope being newly crowned' is, of course, a reference to the birth of a new Lodge. In 1738 Pope Clement VIII condemned Freemasonry and excommunicated all Roman Catholics who insisted on continuing their Masonic connexions. Despite Papal disapproval, however, Freemasonry prospered, although many heretical Lodges sprang up that were formed by intriguers, revolutionaries, alchemists, frauds, and confidence tricksters. The Society of Jesus even sent its members to join Lodges in order to be able to denounce Freemasonry to the Holy Inquisition. Masonic influence was so great in Vienna that the Papal Bull was not published there, although Maria Theresia suppressed Freemasonry in 1764, despite the fact that her husband was a Mason. Nevertheless, Freemasonry survived in the Austrian capital, and enjoyed some protection under Joseph II (1780–90). In 1794 Freemasonry in the Empire was suppressed by Francis II and many Freemasons, including Giesecke, fled abroad. The multiplicity of German Lodges led to a congress being called at Wilhelmsbad in 1782 that regularised German Freemasonry and reduced the number of Lodges. Heretical sects were denounced. Interestingly, some of the décor for ceremonies in the Vienna Lodges in the 1780s and 90s appears to have had Egyptian elements. The title-page of a German Masonic song-book, *Auswahl von Maurer Gesängen, mit Melodien der vorzüglichsten Componisten in zweij Abtheilungen getheilt,* published in Berlin in two parts in 1798 and 1799 (Pl. 63), shows a circular Pantheon-like temple with a Doric portico, the pediment of which contains Egyptianising symbols. Sphinxes and obelisks complete the picture.[10] Early published versions of *Die Zauberflöte* also had Egyptianising frontispieces.

We know that Haydn was a Freemason and that the Eszterházy family had Masonic connexions. The opera house at Eszterháza had some Egyptianising productions, and there were also some Egyptianising sets prepared for the stage of the theatre at Kismarton.[11] Mozart and Schikaneder were familiar with Egyptianising ideas from the time of *Thamos,* and *Sethos* was a powerful stimulus to designers. Desprez became a stage-designer in Sweden, and never lost sight of his powerful visual images as previously exploited in the extraordinary watercolours of Egyptianising tombs. All the evidence shows that the authors[12] of the Singspiel, *Die Zauberflöte,* were very well acquainted with *Sethos,* and indeed large sections of the libretto of *Die Zauberflöte* are lifted from it.[13] One of the authors of *Die Zauberflöte,* C. L. Giesecke, had previously written a

Plate 63 The title page of a German Masonic song book, *Auswahl von Maurer Gesängen mit Melodien der vorzüglichsten Componisten in zweij Abtheilungen getheilt; gesammlet und herausgegeben, von F. W. Böheim,* published in Berlin in 1798 and 1799. Note the Pantheon-like temple, the Doric columns, the sphinxes, and obelisks (*By permission of the United Grand Lodge of England*).

libretto for Paul Wranitzky's *Oberon,* first produced on 7 November 1789 by the impresario Schikaneder. *Oberon* is also a 'magic' Singspiel, full of spectacular effects and exotic imagery. Even the score is liberally spattered with 'Turkish' and other musical ideas, clearly derived from Mozart's colourful *Die Entführung aus dem Serail.* Giesecke's *Oberon* contains ideas that also occur in *Die Zauberflöte,* and Giesecke was himself a Freemason, as were Schikaneder and Mozart. Giesecke died in Dublin in 1833, a respected scientist and intellectual. It is likely that he had to leave Vienna after Freemasonry was proscribed in the 1790s. Schikaneder was interested in Egyptian mysteries, and clearly found *Thamos, Oberon,* and *Die Zauberflöte* much to his taste. Wranitsky, too, was a Freemason. Interestingly, R. S. Acerellos, in *Die Freimaurerei in ihrem Zusammenhang mit den Religionen der alten Aegypter, der Juden und der Christen*[14], quotes an alleged ancient Egyptian ritual passage that was also supposed to be inscribed on the tomb of Hiram, and that was read aloud at Masonic ceremonies. The passage is similar to the words of the duet sung by the two Men in Armour in Act II of *Die Zauberflöte.*

English ideals of Freemasonry took a strong hold in Germany and France. Francis I, husband of Maria Theresia, was a Mason, as were Frederick II of Prussia, Voltaire, Goethe, Herder, Lessing, Haydn, and Mozart, who was initiated in 1784. Herder's appreciation of the simple forms of Egyptian architecture is particularly interesting in this context. Jefferson, Washington, Franklin, and many other figures of the American Revolution were Masons. The 'Liberator' of Venezuela, Bolívar, was a Mason, and there were many Masons associated with liberal movements throughout the eighteenth century. Famous figures of the French and American Revolutions, as well as those associated with political events in Ireland, Germany, the Netherlands, and Italy, were Masons.[15] There had been an earlier 'Egyptian' opera, *Osiride,* by J. G. Naumann, with words by the celebrated librettist Mazzolà, who knew Lorenzo da Ponte at Dresden. The general story is not unlike that of *Die Zauberflöte,* and may also have derived from *Sethos.*[16] Significantly, the first temples to appear on the stage in Act I of *Die Zauberflöte* are those of Weisheit, Vernunft, and Natur. The Egyptian setting is reinforced by the Palmenwalde of the first scene of Act II, and by the celebrated prayer:

> O, Isis und Osiris schenket
> Der Weisheit Geist dem neuer Paar!

The Egyptian atmosphere is further emphasised in Mozart's work by the dark vault, with its Piranesian and Egyptian overtones. The ceremonial setting of Egypt would seem to be logical, given Masonic belief in Egypt as the source of skill and wisdom, yet despite *Sethos* an Egyptianising

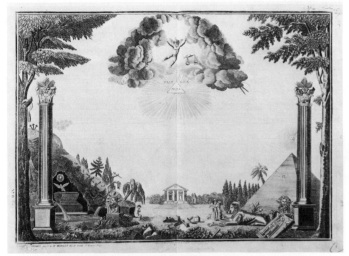

Plate 64 A typical standard design for a Masonic certificate for Lodges under the Grand Orient of France, from a nineteenth-century printer's sample book. Note the sphinx, Egyptianising deity, serpents, pyramids, and features recalling the Isiac lotus crown in shape on top of the Corinthian columns (*By permission of the United Grand Lodge of England*).

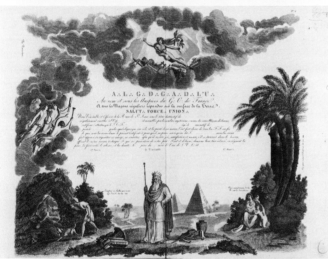

Plate 65 As above. Note the palm trees, pyramids, Isiac Madonna-like figure, and Egyptian capitals (*By permission of the United Grand Lodge of England*).

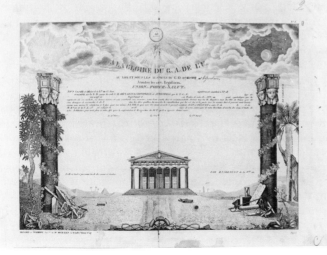

Plate 66 As above, but with the heading altered to suit the Grand Orient of Egypt. Note the pyramid, obelisk, winged disc in the tympanum, and Hathor-headed columns (*By permission of the United Grand Lodge of England*).

force in Freemasonry does not appear to have surfaced until after 1750. According to orthodox Masonic sources the emphasis on Egyptian décor and ceremonial was somewhat heretical, and can be regarded as foreign to Britain. Continental Lodges, however, notably those in France and in central Europe, became Egyptianised. The main influences in this transformation were Count Alessandro Cagliostro (1743–95) and Carl Friedrich Köppen. Cagliostro's real name was Giuseppe Balsamo, and he appears to have been an unscrupulous charlatan. He passed a dissolute and criminal youth and studied alchemy in the East. In Europe he peddled drugs and potions,[17] and became a Mason in London in 1777. He later became Grand Master of a Lodge in Paris to which a temple of Isis was attached. Although Cagliostro was in reality the Grand Master, he claimed to be the deputy of the Grand Kophta who had not been seen by anyone. In 1785 Cagliostro was implicated in the affair of the diamond necklace, in which Jeanne de St Rémy de Valois obtained possession of a diamond necklace by duping Cardinal de Rohan. Although Cagliostro was acquitted in connexion with the necklace affair, he was imprisoned on other frauds. Goethe's play *Der Grosskophta* was based on this unsavoury story. British Freemasons regarded Cagliostro and his 'Egyptian' rites as fraudulent,[18] but nevertheless Cagliostro's rituals were speedily adopted in French and German Lodges, especially in Vienna. C. F. Köppen of Berlin published a curious work[19] on the rites of initiation of Egyptian priests in 1778, and this became influential in Continental circles of the craft.[20]

It is clear from early nineteenth-century printers' samples of typical standard designs for Masonic certificates for Lodges under the Grand Orient of France that the Egyptian element was strong. Pyramids, Egyptian columns, palm trees, sphinxes, and Egyptian Isis- or Hathor-headed capitals are much in evidence (Pls. 64-66). A French Master Mason's apron of *circa* 1800, printed from an engraved plate, shows Egyptian features, with busts of Camberces, Duke of Parma, Second Consul of France in 1799, and Napoleon, on pedestals (Pl. 67). Initiation rites of Freemasonry, given an appropriately Egyptian setting in *Die Zauberflöte,* seem to owe a great deal to Isiac ceremony. A Graeco-Roman mosaic pavement from Antioch shows the *mors voluntaria* when the initiate goes fearlessly towards the unsheathed sword, the important moment of initiation in the Home of the Mysteries of Isis. The idea of a trial, even a voluntary death, where faith triumphs, is found in the trial by fire and water in *Die Zauberflöte.* Parallels can be found in the lives of Christian saints and martyrs.

We know that when Mozart moved to Vienna he became acquainted with eminent men of science, probably through the friendship with Baron van Swieten and through Anton Mesmer and his family. Mozart was also friendly with Gottfried von Jacquin and the Greiner family, and from 1783 he knew Ignaz von Born, one of the leading scientists of his day and an important Freemason. Von Born, who is said to be the model for Sarastro in *Die Zaubeflöte,* founded the Lodge Zur Wahren Eintracht in 1781,[21] the primary objects of which were scientific research and religious enlightenment. He published many scientific papers, but his most significant contribution to the subject of this study was contained in his Journals for the Lodge beginning in 1783. Born printed an important article on ancient Egyptian mysteries in *Physikalische Arbeiten* that is quoted in C. P. Moritz's work, *Die Symbolische Weisheit der Aegypter* of 1793.

The gradual search for architectural expression led away from Rococo and on to simple forms, with clear geometrical shapes exposed. The theories of Laugier and Herder, and the fecund imagination of Piranesi, together with the latter's drawings of ancient buildings at Paestum and at Rome, led to an appreciation of the possibilities of Greek Doric and Egyptian architecture. The eighteenth century discovered Greek Doric forms through Piranesi, the Dilettanti, and finally through the ambitious project by Stuart and Revett that gave birth to *The Antiquities of Athens.* The latter was intended as an accurate survey of Greek buildings as well as an architectural treatise. Like Piranesi's *Cammini* the *Antiquities* was aimed at patrons as well as architects. Richard Payne Knight (1750-1824) visited the Sicilian temples in 1777 and found them picturesque: Doric began to be acceptable. The dawning respectability of Doric pushed the frontiers of taste further towards even greater ruggedness, massiveness, and the primitive. Egyptian architecture could be even more desirable as the search for simplicity gained momentum.

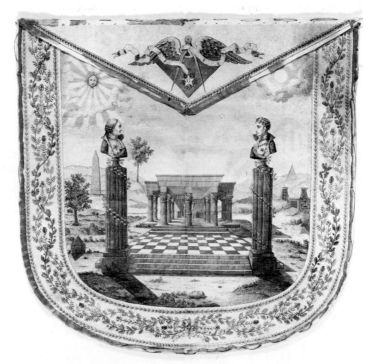

Plate 67 French Master Mason's apron of *c.* 1800, printed from an engraved plate. The busts on pedestals are those of Napoleon and of Camberces, Duke of Parma, Second Consul of France, 1799. Note the Egyptianising architectural forms (*By permission of the United Grand Lodge of England*).

Young French architects from the middle of the eighteenth century began to experiment with huge forms, simple massing, and symmetry at the Academies in Paris and Rome. Usually, public buildings, monuments, cemeteries, and vast civic structures were the subjects chosen. Etienne-Louis Boullée (1728-1799) was the visionary architect and leader of a whole generation of architects who remained moderates in political terms, while expressing the revolutionary spirit in the arts in pre-revolutionary France.[22] The drawings by Boullée in the Cabinet des Estampes of the Bibliothèque Nationale in Paris provide an astonishing array of supremely confident designs, many of which are projects associated with death. Boullée's designs for cenotaphs and cemeteries show buildings in which Egyptian motifs play no small part (Pl. 68). Huge blank walls emphasise the terror and finality of death, expressive of Boullée's ideas of *architecture parlante* (architecture that speaks clearly of its purpose), and have a powerful image that could be read easily.[23] Boullée visualised funerary monuments as temples of death, designed to chill the heart. He insisted that such buildings should be built to withstand the ravages of time, while incorporating what he called 'the Poetry of Architecture'.[24] Boullée's cemeteries incorporate a surrounding wall with the main monument in the centre. He sought 'perfect symmetry' and included features such as gigantic Neoclassical sarcophagi (which themselves became huge buildings), enormous pyramids, and 'funerary triumphant arches'. By cutting decoration to the minimum, Boullée gave his buildings 'a character of immutability'. The cone-shaped cenotaphs incorporate ideas based on both domes and pyramids, with obelisks and cypresses much in evidence. Boullée could conceive of nothing more appropriate or melancholy than a monument consisting of a flat surface, bare and unadorned, 'absolutely stripped of detail, its decoration consisting of a play of shadows, outlined by still deeper shadows.'[25] 'No gloomier images exist', he asserted, 'and if we make abstraction of all the beauty of art, it would be impossible not to appreciate, in such a construction the mournful effect of the architecture.'[26] To Boullée, the Egyptians had very grand ideas, and he could admire 'avec raison leurs Pyramides; l'ordonnance d'architecture qui règne dans leurs Temples offre l'image du grand.' The project by Boullée for a cenotaph[27] to be erected in memory of a national military hero shows a gigantic building in the shape of a huge sarcophagus set on a podium (Pl. 69). The frieze consists of a line of Egyptian figures in relief. These figures are clearly derived from

89

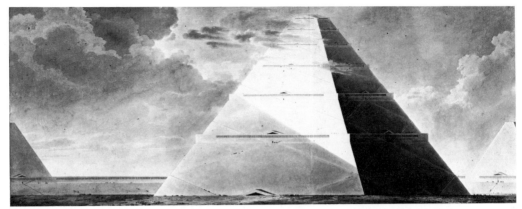

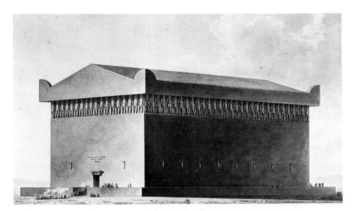

Plate 68 (*above*) A design for a gigantic pyramid by Boullée. (Cénotaphe Dans Le Genre Égiptien). Note the ramps, and compare them with Fischer von Erlach's ramps on his pyramids shown in Pl. 43 (*Bibliothèque Nationale, Paris. HA55. No. 26*).

Plate 69 (*left*) A project by Boullée for a cenotaph for a national military hero. The building is in the shape of a huge sarcophagus. The frieze consists of repeated Egyptianising telamoni based on the Villa Adriana figures in the Sala a Croce Greca in the Museo Vaticano (see Pl. 29) (*Bibliothèque Nationale, Paris, HA57. No. 27*).

the telamoni of the Villa Adriana at Tivoli. Boullée probably drew them from one of the many sources that illustrated them. Another cenotaph[28] by Boullée is like a gigantic 'funerary triumphant arch' set in a truncated pyramid. The arch is a huge coffered hemi-dome, and there are massive steps up the sides of the pyramid. The obelisks on bases add to the Egyptianising flavour of the design. Another design[29] by Boullée for a mortuary chapel set in the wall of a cemetery has a raised hemi-dome as the entrance to the chapel. In this design the terror and desolation of death are expressed in the blank walls that are devoid of all features save narrow vertical slit windows. The Chapelle des Morts was a chapel where funeral services could be held, and where bones could be stored (Pl. 70).

Even more overtly Egyptianising were the designs of Jean-Jacques Lequeu (1757–1825), one of the three architects described by Emil Kaufmann as 'Revolutionary', the other two being Boullée and Ledoux. Lequeu's 'House in the Egyptian Style' has two pylons capped by a somewhat incongruous hemispherical dome. Bogus hieroglyphs form bands of friezes on the pylons. There is also a startling design for an Egyptian Bridge by him, and many other *esquisses* that employ Egyptianising forms.

These powerful French designs were part of the revolt against the delicate Rococo of the previous generation. Such architectural dreams need not necessarily have any chance of realisation, but it was certainly with these Sublime designs for buildings associated with death that the French architects achieved their greatest heights. It was hardly surprising that the man who seduced the young architects away from the delicacies of the Rococo was Piranesi, for the Venetian engraver was obsessed by pyramids, Greek Doric columns, and other elements such as obelisks, ash-chests, urns, columbaria, and tombs. Piranesi's exaggerated sense of scale, and his powerful ideas and images started something of a cult among the students at the French

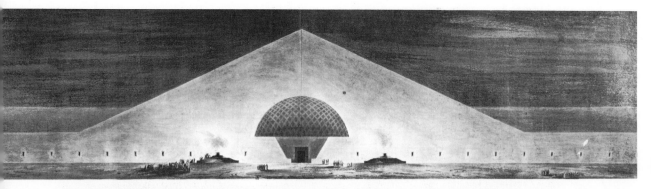

Plate 70 A design by Boullée for a Chapelle des Morts. Note the blank walls emphasising the terror and desolation of death, and the very low pyramidal form, the opposite extreme compared with the Cestius type of pyramid (*Bibliothèque Nationale Paris. HA55. No. 28*).

Academy in Rome. Peyre's 1765 publication, *Oeuvres d'architecture,* clearly demonstrates Piranesian influences in the overblown scale and repetition of Neoclassical motifs. These *Oeuvres* contained works by many young designers which show Egyptianising features.

Louis-Jean Desprez (1743–1804) began his architectural training in France, and went to Rome in 1776 as winner of the Grand Prix. During the 1760s he had produced a funerary temple with Egyptianising features. In Italy he studied painting and drawing as well as architecture, and contributed illustrations to the Abbé de Saint-Non's *Voyage pittoresque ou description des royaumes de Naples et de Sicile.* He became interested in stage-design, and as a theatrical designer was employed by Charles II of Sweden in 1784, living there until his death. The works of Desprez have an intensely dramatic character with strongly Romantic effects despite the apparent Classical nature of the drawings. When in Rome, Desprez produced a number of watercolours of imaginary tombs that incorporate Egyptianising ideas; the sombre funereal character is enhanced by the semicircular and segmental arches of ashlar beneath which the tombs are set. In one design, a crouching lion (suggestive of those Egyptian lions in the Vatican that Desprez must have known) lies below a simple monolithic sarcophagus that is carried on four stumpy plain columns. Instead of a formal effigy on top of the sarcophagus, the sculptured form is a naked figure, lying as though on a mortuary slab or in the anatomy lecture-theatre. Two heavily robed Egyptian figures support the massive pointed structure behind (Pl. 71). Another tomb has a segmentally-topped sarcophagus under a segmental arch. The sarcophagus has an Egyptianising 'inscription' of the hieroglyphic type, and rests on four stumpy piers. A robed skeleton with an Egyptian head-dress sits in front of the tomb (Pl. 72). Desprez, then, was moving away from the Piranesian use of Egyptian motifs, although the gloomy, dungeonesque pictures suggest Piranesi's *Carceri* and other fantasies (Pl. 73). The qualities of Egyptian architecture were starting to be exploited. Antiquity was not being slavishly copied, for the Neoclassical architects were to use antique forms and motifs with eclectic verve. Plain walls, a careful selection of elements, and a daring stripped-down approach to decoration were characteristics of the greatest Neoclassical architects, including Boullée and Ledoux in France, Soane in England, and Gilly and Karl Friedrich Schinkel in Prussia. As the engravings of the *Grand Prix* of the French Academy of Architecture show, the Neo-classicists were highly successful in adapting eclectic motifs from antiquity. The use of obelisks, pyramids, and blank walls created a suitably funereal image for much of the monumental work. For instance the designs of 1788 for the memorial for Lapeyrouse and his sailors in a scheme by Vien are set in a wild landscape by the seashore. The drama of the composition is enhanced by the colouring. Egyptian forms, such as the battered doorway, contrast with the heavy sarcophagus-like form of the tomb itself (Pl. 74). The whole composition, however, is essentially pyramidal, and enhances the Egyptian element of the design.[30] Indeed Egyptianising forms were used to achieve a noble and solemn theatrical appearance. The *Grand Prix* drawings also contain an extra-ordinary *chapelle sépulchrale* by de la Barre (1764–1833). The central building is clearly based

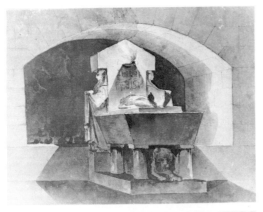

Plate 71 A design for an Egyptian tomb by Louis-Jean Desprez (1743–1804). Pen and ink, water-colour over black chalk. Note the segmental arch, which seems to have been a powerfully evocative idea among Neoclassical designers (*Courtesy of the Cooper-Hewitt Museum, the Smithsonian Institution's National Museum of Design. No. 1938–88–3950*).

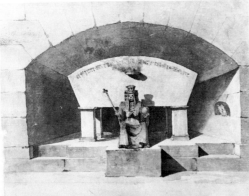

Plate 72 A design for an Egyptian tomb by Louis-Jean Desprez. Pen and ink, water-colour over black chalk. Note the hieroglyphs in segmental form on the segmental sarcophagus under the massive segmental arch of masonry. Segmental shapes seem to have been regarded since Roman times as having an Egyptian significance. The seated figure has an Egyptian head-dress, but is skeletal (*Courtesy of the Cooper-Hewitt Museum, the Smithsonian Institution's National Museum of Design. No. 1938–88–3951*).

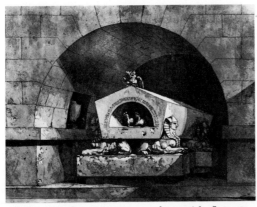

Plate 73 A design for an Egyptian tomb by Louis-Jean Desprez. Pen and ink and water-colour. The sarcophagus rests on sphinxes with large breasts, and hieroglyphs follow the semi-circular arched entrance on which the body rests (*Bibliothèque Nationale, Paris. No. HA52 fo.*)

on the Pantheon in Rome, but with four Doric porticos instead of one Corinthian, looking forward to a pure Neoclassicism. The Pantheon sits within a huge circular enclosure linking four pyramids. Sphinxes, sarcophagi, and urns complete the familiar vocabulary of an architecture of death (Pl. 75).[31]

Another influence on these young French architects was Antoine-Chrysostome Quatremère de Quincy (1755–1849) whose prize essay submitted to the *Académie des Inscriptions et Belles-Lettres* in 1785 is likely to have been known to Boullée and others, although it was not published until 1803. The Egyptians had grandiose ideas, Boullée tells us in his *Essai:* their pyramids are rightly admired; the architectural order of their temples gives an impression of greatness. The pyramids are characteristic of monuments that are designed to withstand the ravages of time; they conjure up the melancholy image of arid mountains and immutability. Quatremère de Quincy analysed

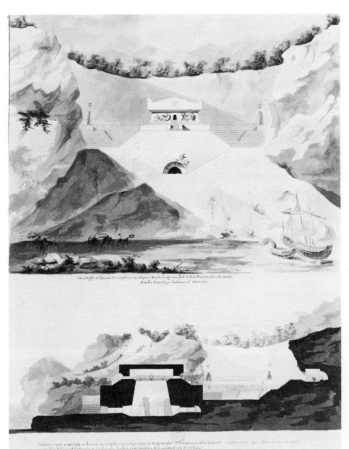

Plate 74 (*left*) Elevation and section of the Tombeau Lapeyrouse by Vien. Note the pyramidal composition of Egyptianising forms. From *Prix* (*Bibliothèque Nationale, Paris. HA75 fol. Pl. 64*).

Plate 75 (*below*) Section and elevation of the Chapelle Sépulchrale designed by La Barre (1764–1833), from A. P. Prieur and P.-L. Van Cléemputte. *Collection des prix que la ci-devant Académie d'Architecture proposoit et couronnoit tous les ans*. Paris, 1787–*c*. 96. Note the characteristic Neoclassical use of pyramids (*Bibliothèque Nationale, Paris. HA75 fol. Pl. 119*).

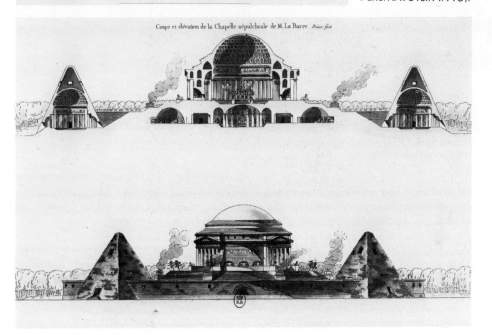

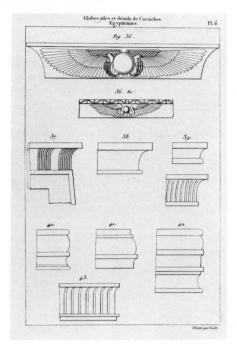

Plate 76 (left) Engraving by Gaitte in Quatremère de Quincy's *De L'Architecture Egyptienne*...(Pl. 6) showing Egyptian details (*Trustees of Sir John Soane's Museum*).

Plate 77 (above) A stepped pyramid by Ledoux, for *L'Architecture Considerée* of 1804, known as the Maison des Boucherons (Pl. 102) (*Trustees of Sir John Soane's Museum*).

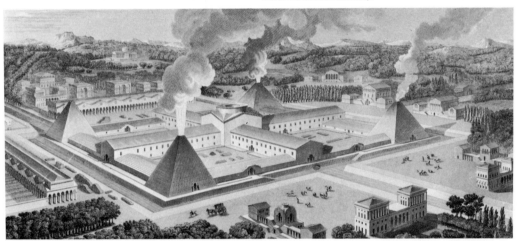

Plate 78 A perspective view of the Forge à Canons from Ledoux's *L'Architecture Considerée*...(Pl. 125) (*Trustees of Sir John Soane's Museum*).

Egyptian architecture and compared it with that of ancient Greece. His work dwells on the massiveness and brooding grandeur of Egyptian architecture, and it grants that Egyptian architecture contained much that was admirable. The views expressed in Quatremère de Quincy's *De L'Architecture Egyptienne, Considérée Dans son origine ses principes et son goût et comparée Sous les mêmes rapports à L'Architecture Grecque. DISSERTATION Qui à remporté, en 1785, Le Prix proposé par L'Académie des Inscriptions et Belles-Lettres* of 1803 are very near those of Boullée and other architects of the last quarter of the eighteenth century, so it would seem reasonable to suppose that their influence was felt in architectural circles long before publication. The illustrations by Gaitte in Quatremère de Quincy's work show considerable detail (Pl. 76). Werner Oechslin has provided some interesting comments in his 'Pyramide et Sphère. Notes sur l'Architecture Révolutionnaire du XVIIIᵉ Siècle et ses Sources Italiennes', published in the *Gazette des Beaux-Arts* for April 1971. Although

94

Boullée, Ledoux, and the younger generation of architects associated with primeval forms and with Egyptianising are often described as 'Revolutionary', the term is largely misleading, as many of the designers were servants of the Ancien Régime, and flourished in the reign of Louis XVI. Of these, perhaps the most interesting is Claude-Nicolas Ledoux (1735–1806) whose work is best known through his own book *L'Architecture considérée sous le rapport de l'art, des moeurs, et de la législation.* Ledoux was deeply interested in Masonic and mystical ideas.[32] William Beckford met Ledoux in 1784 and was somewhat put out by an occult meeting at the French architect's house.[33] It would seem that Ledoux was more involved in the type of heretical Masonry of Cagliostro than in the more orthodox Freemasonry of England and Scotland. A drawing of an eye, with the theatre at Besançon reflected in the pupil in Ledoux's book recalls Alberti's device, the winged eye, and was probably inspired by Masonic ideas. Ledoux used blank walls, removed ornament, and simplified architectural form (Pl. 77). In his book, the possibilities of Egyptian architecture are exploited, as in his celebrated gun foundry for Chaux, where the pyramid is used as the casing for the furnaces (Pl. 78). There is a similar design (not by Ledoux) in a private collection where the building is a crematorium. Again, the designer was French. After Ledoux had remodelled the château at Maupertuis for the Marquis de Montesquiou, Alexandre-Théodore Brongniart (1739–1813) designed the celebrated ruined pyramid in the gardens. This pyramid has a recess on one side containing a Doric portico that supports a segmental pediment. The pyramid dominates the lake in the garden known as the Elysée, where Montesquiou held Masonic meetings. Now the choice of the ruined pyramid (emphasising antiquity) and the Isiac segmental pediment is unquestionably Masonic, and it is significant that Brongniart and Montesquiou also dignified their Elysée at Maupertuis with a monument to the Protestant hero, Admiral Coligny, in defiance of Roman Catholic persecution. Montesquiou was appointed General-in-Chief of the Republican Army of Savoy during the Revolution.[34] Interestingly too, Mozart used a Protestant chorale in the scene with the two Men in Armour (undoubtedly telamoni-inspired) in *Die Zauberflöte,* to emphasise the unorthodox and Masonic character of the beginning of initiation.[35]

Piranesi made a collection of eleven plates in 1750 that included six of his own works under the title *Camere Sepolcrali degli Antichi Romani le quali esistono dentro a di fuori di Roma.* These plates are much more than archaeological records; they convey something of a theatrical atmosphere. Somewhat different is Mauro Tesi's (1730–66) etching called *Camera Sepolcrale Egiziana* that is not based on archaeological investigation, but is a theatrical interpretation (See Pl. 92), with something of the atmosphere of Piranesi's *Camere,* but with a domed chamber superimposed on Egyptian engaged columns – a most unhistorical notion. The circular form of the building is not Egyptian: only the columns, figures, and 'hieroglyphs' are.

The use of primeval Egyptian forms indicated a 'progressive' approach to architectural design. Two terracotta statuettes by Claude François Michel Clodion (1738–1814) survive in a private collection, one of which is clearly derived from Piranesi's *Cammini* Egyptian designs (Pl. 79). These may be modelled from the large Egyptian figures made for the mortuary chapel of Count d'Orsay in the church of d'Orsay (Chevreuse) in 1773 which was destroyed during the Revolution. A relief from the chapel was exhibited by Clodion in the Paris Salon of 1773 (250 in the Catalogue), and a drawing survives in the National Archives.[36] These statuettes are signed Clodion An XII, meaning 1804, but they are probably derived from figures originally designed in 1773.

The factory of Josiah Wedgwood at Etruria in Staffordshire was producing 'Canopic' vases by the 1780s, made of black basalt painted with red encaustic colour. The vase differs from Egyptian originals in that it did not have a removable lid, and seems to have been based on the pictures in Montfaucon's work, *L'Antiquité Expliquée . . . ,* or on Kircher's *Oedipus Aegyptiacus.* Another possible source is Michel-Ange de la Chausse's *Museum Romanum,* published in Rome in 1746. A later Wedgwood 'Canopic' vase of 1868, of blue 'jasper-dip' with white reliefs, has a lid in the form of a head of Am-Set, and this lid can be removed. Other 'Canopic' figures carved in marble and other materials (Pl. 80) were produced as ornaments in several countries, notably France, and usually did not have lids. Thus, by the last quarter of the eighteenth century the Egyptian style embraced three distinct attitudes. The first was essentially Rococo, where effects were sought not unlike those where Romantic ruins, Chinoiserie, and Gothick were used. The second was a more severe

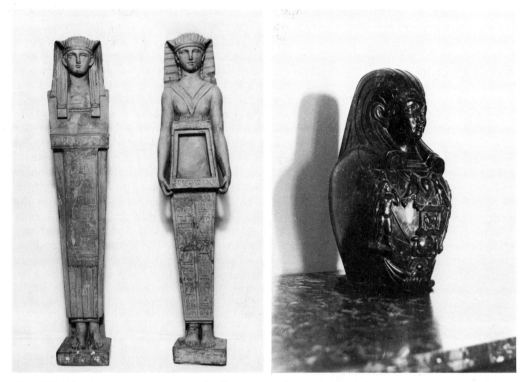

Plate 79 (left) Two terracotta statuettes by Clodion, one of which is clearly derived from Piranesi's *Cammini* . . . (Compare with Pl. 60) (*A Private Collection*).

Plate 80 (right) A 'Canopic' figure of red, grey, and black marble, dating from the early nineteenth century. The figure is carved with hieratic ornament in relief. A heart-shaped motif is suspended between two birds whose feet rest on an aedicule within which is the Apis Bull. Below, the lunar disc with uraei is supported by a scarab-like creature backed by a ribbed crescent. On either side of the central ornament are Egyptianising figures. This ornament is probably French (*Reproduced by permission of The Bowes Museum, Barnard Castle, Co. Durham*).

view of Romantic Classicism, where picturesque effects were still evident, but where Egyptian-isms were becoming part of the language of Neoclassicism. The last phase was archaeological, where correctly measured detail, available after the French had measured and drawn Egyptian buildings, much in the same way in which Stuart and Revett had recorded Greek antiquities, was used in architecture.

The use of Egyptianising elements for novelty became part of le style Louis Seize and clearly derived from Piranesian prototypes. There was a salon in the Place Vendôme decorated with Egyptianising motifs in 1786, but rather more important was the series of garden pavilions and Egyptian ornaments in the park at Etupes, designed by J.-B. Kléber (1753–1800)[37] for the Prince de Montbéliard in 1787. In the garden at Etupes, Kléber designed an Egyptian island, perhaps suggested by the Isiac buildings at Philae, approached by a bridge. On this island were a swing, benches, ornaments, and a bath-house, all in the Egyptian manner. The swing, bridge, and ornaments were delightfully eclectic examples where motifs (culled from Montfaucon and Caylus) are used in the manner of Piranesi's *Cammini* designs, but the bath-house was much more correctly based on archaeological observation. Indeed, the design for the bath-house is some-thing of a curiosity, for it has a battered podium on which sits a temple-like structure, distyle in antis at both ends, with eight square piers down each of the longer sides. Symmetrical steps at either end lead up to the podium, and these steps are carried on segmental arches. Now this design clearly recalls the Mammisi (Isiac) temple on the island of Elephantine that had not been

96

adequately recorded in 1787, so Kléber must have developed his design from studies
or Pococke, or both.[38] Indeed Norden and Pococke were standard source-books for E
ideas (Pl. 81), and Quatramère de Quincy used plates from both in his *De L'Architectu*
Kléber's work at Etupes was greatly admired as being in the true Egyptian manner w
of decoration arrayed in an harmonious fashion.[39] J.-B. Kléber was, of course, the
was assassinated in Egypt, and after whom many avenues, boulevards, and places
France today. His own bronze statue, in the square named after him in Strasbourg, was des
by Grass, and erected in 1840. It consists of an heroic figure of the General standing in front of a
reclining Egyptian sphinx.

In 1788 Desprez was to design with Egyptianising elements at Haga Castle in Sweden, and
certainly used Egyptianising motifs in his stage-sets.[40] He also designed Egyptian capitals for the
Botanical Institute at Uppsala. A design of 1782 for a monument by Carl August Ehrensvärd in
Stockholm shows a pyramid with a Doric interior. According to Rosenblum,[41] Doric buildings
were called 'Egyptian' in eighteenth-century Scandinavia. Ehrensvärd also produced a fascinating
work entitled 'Egyptian Architecture in a Nordic Landscape' which is now in the National-
museum, Stockholm (Pl. 82). The 'Egyptian' architecture is, in fact, very stocky, stumpy Doric.

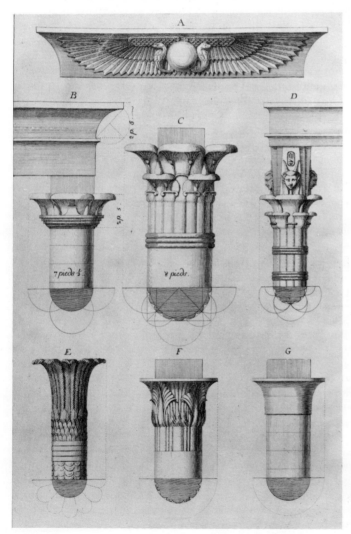

Plate 81 Plate 144 of
F. L. Norden's *Travels in Egypt and
Nubia,* showing typical Egyptian
details (*Trustees of Sir John
Soane's Museum*).

Ehrensvärd also produced (in Berlin in 1782) a similar design for an 'Egyptian' temple to be erected in Gustav Adolfs Torg, Stockholm. More overtly Egyptian, and doubtless influenced by Piranesi, was le Théâtre Feydeau by Amant-Parfait Prieur, of 1789. The decoration of the entrance and the foyer was in the Egyptian style.

Pyramids, with their starkly simple geometry, were felt to indicate progressiveness in architecture. The pyramid of Cestius in Rome was well known, and publications from the end of the Middle Ages had shown pyramids that clearly fascinated western commentators. By the eighteenth century architects not only began to exploit the iconographical suggestions of pyramids, but saw the possibilities of using these forms as expression. Boullée, Ledoux, Desprez, and others did this. Both Caylus and de Quincy had commented on the expressive power of simplicity, grandeur, solidity, massiveness, and uniformity found in ancient Egyptian architecture. Hawksmoor and Vanbrugh used pyramids, and some pyramidal mausolea have already been mentioned,[42] for the funereal possibilities of the form were obvious. John Harris has drawn attention to a pyramidal sepulchral temple by H. H. Jardin of 1748,[43] and there was a pyramid in the Parc Monceau of 1773.[44] In 1777 John Carter (1748–1817) published a design for an Egyptian Pyramidal Dairy in the *Builder's Magazine or Monthly Companion for Architects,*[45] and, according to Emil Kaufmann,[46] 'found pleasure in putting sphinxes on top of the classic entablature of a temple.' In 1778 John Soane (1753–1837) published a pyramidal design for a garden temple with a simplified Doric distyle in antis portico and flanking sphinxes in his *Designs in Architecture, consisting of Plans, Elevations and Sections for Temples, Baths, Casines, Pavilions, Garden-Seats, Obelisks, and Other Buildings,* a work that he subsequently tried to suppress. Soane also exhibited a 'Design for a Mausoleum to the Memory of James King' at the Royal Academy in 1777. It has a central domed building set on a heavily rusticated podium that was joined by diagonal wings to four pyramids. This design was also published in *Designs in Architecture.*

The 1780s were important for the development of Neoclassicism in Scandinavia. In common with architects from France, Germany, and England, many Scandinavians made their ways south to Italy where they came into contact with the international revival of classical antiquity. The Swedes Eric Palmstedt (later designer of the royal theatre at Gripsholm), Olof Tempelman, and Carl August Ehrensvärd, and the Dane Peter Meyn are among the most important of the Scandinavians to travel to France and Italy at the time. In 1779–80 Eric Palmstedt copied a design for a mausoleum by Claude-Thomas Lussault of about 1770. The Lussault design survives in Palmstedt's drawing now in the Konstakademien, Stockholm, and consists of a pyramid of the 'ideal' type (that is with the section of an equilateral triangle) with a domed Pantheon-like interior, four hexastyle Doric porticoes, four cupolas at the corners, and a subterranean vault. Lussault's project is one of the earliest designs for ideal pyramid mausolea that were to become so popular in the next decade. Peter Meyn also designed several funerary projects using the pyramid as a main component in 1780, five of which are preserved in the Kunstakademiets samling, Charlottenburg, Copenhagen. Meyn's designs are influenced by Peyre and by the works of Nicolas Jardin, his professor at the Academy in Copenhagen. Jardin had designed a pyramidal Castrum Doloris for King Frederik V, a design that appears to be the first stereometrically pure pyramid of Neoclassicism. Indeed, the designs by Meyn, Jardin, and other architects for pyramids follow the prototype of the Cestius pyramid because the 'ideal' (that is equilateral triangle section) form was more in accordance with Neoclassical taste than was the Giza type of Egyptian pyramid. Geometrical logic and purity were potent forces in the eighteenth century, and their importance must not be overlooked. Ehrensvärd designed his remarkable 'Egyptian' (i.e. stumpy Doric) temple with a Castrum Doloris in the centre for the funeral of the Queen Dowager Lovisa Ulrika of Sweden in 1782, and later placed the Castrum Doloris within a segmental vault. The final design (not executed, but now in the *Uppsala universitetsbibliotek*) incorporates the Castrum Doloris within a huge pyramid that was to be clad in black and was to stand in Gustav Adolfs Torg in Stockholm, in front of the Royal Palace (Pl. 83). Ehrensvärd's 1782 pyramid design was far more revolutionary than those of his contemporaries, for it was an ideal stereometrical pyramid sitting directly in the square, with no podium and no base.[47]

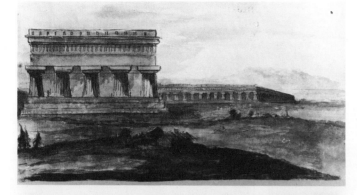

Plate 82 'Egyptian Architecture in a Nordic Landscape', by Carl August Ehrensvärd, showing how very primitive Doric was thought to be 'Egyptian', even in the 1780s. The 'Egyptian' architecture is very similar to that proposed by Ehrensvärd for his 'Egyptian Temple' in Gustav Adolfs Square, Stockholm, of 1782 (*Statens Konstmuseer, Stockholm, Teckning och Grafik, No. NMH 179/1866*).

Plate 83 The visionary design by C. A. Ehrensvärd for a black pyramid in Gustav Adolfs Torg, Stockholm. The proposal was for the funeral of the Dowager Queen Lovisa Ulrika of Sweden in 1782, and shows an 'ideal' pyramid of stereometrically pure shape based on the Cestius model (*Ulf Cederlöf: Uppsala universitetsbibliotek*).

James Wyatt (1746–1813) designed a mausoleum for the fourth Earl of Darnley at Cobham Park, Kent, in 1783–4, which incorporates a Roman Doric Order, sarcophagi at the corners, an attic storey above the entablature with segmental openings, and a pyramidal roof. The designs were exhibited at the Royal Academy in 1783, and survive at the Sir John Soane's Museum in London.[48] Boullée also designed a gigantic pyramid, with ramps on its sides,[49] dating from *c.* 1785. Friedrich Gilly (1771–1800) projected a pyramid, with a Doric portico on each face flanked by sphinxes. This project is undoubtedly a logical extension of the symmetrical planning of the Villa Capra at Vicenza by Palladio (1518–80), also used by Vanbrugh at Castle Howard, by Burlington at Chiswick, and by Colen Campbell at Mereworth Castle, Kent. This Palladian exercise in formal symmetry was greatly influential throughout Europe in the eighteenth century. The Gilly design was more severely in keeping with the Neoclassical search for purity of form expressed by Boullée, Ledoux, and others.[50] Joseph Bonomi (1739–1808) built a pyramidal mausoleum with domed interior and recesses for the second Earl of Buckinghamshire in 1794 (Pl. 84). The designs were exhibited at the Royal Academy in that year and survive at Blickling.[51] The pyramid appears with frequency in a funereal connexion, and other examples include Peter Josef Krahe's (1758–1840) design for General Marceau's monument at Koblenz of 1799, surrounded in the manner of the Boullée monuments by cypresses.[52]

The obelisk, too, was much used. Mention has already been made of the impact of obelisks in Roman town-planning. There is an extraordinary obelisk set on a formally conceived grotto-like base at Stillorgan, Co. Dublin, designed by Sir Edward Lovett Pearce (1699–1733).[53] There are obelisks in plenty in the South Park Street Cemetery in Calcutta,[54] some of which are, in fact, very steeply pointed pyramids (Pl. 85). In Egypt obelisks were usually placed in pairs flanking the axis of processional ways in temple complexes, but in Europe this was not the case. Obelisks were used as

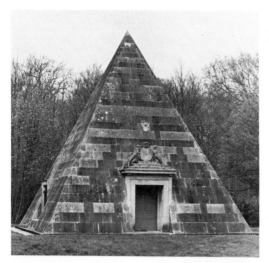

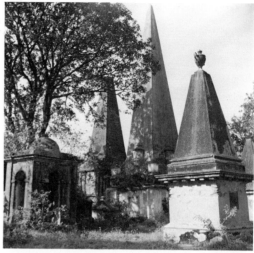

Plate 84 (*left*) The Mausoleum at Blickling, Norfolk, designed by Joseph Bonomi for the Earl and Countess of Buckinghamshire, 1794.

Plate 85 (*right*) Tombs in South Park Street Cemetery, Calcutta, showing varieties of obelisk and obelisk-pyramids (*Theon Wilkinson, lent by the British Association for Cemeteries in South Asia*).

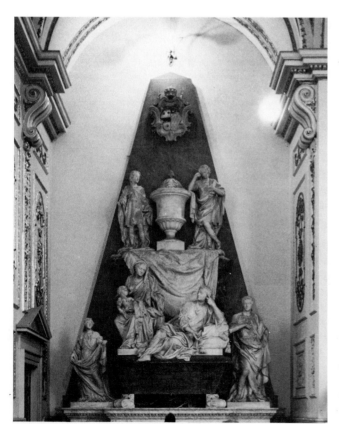

Plate 86 (*left*) The tomb of Thomas Foley in the Church of St Michael, Great Witley, Worcestershire, by J. M. Rysbrack.

Plate 87 (*below*) An entrance gateway for Sherborne Castle, Dorset, designed by Sir William Chambers in *c.* 1758. Note the Egyptianising figures in the niches (*RIBA British Architectural Drawings Collection*).

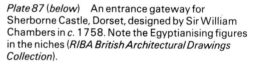

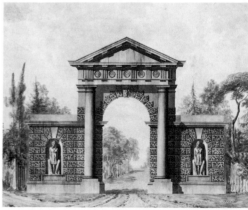

eye-catchers in parkland, as monuments alone or in cemeteries, as central foci of Baroque spaces, as crowning features of buildings or monuments, or as backgrounds to funerary monuments. J.-N. Sobre projected an Egyptian obelisk for the Place des Victoires in 1795 (Pl. 93) that was to be carried on the backs of stone elephants, and that was to be incised with symbols of victory. Boullée and other contemporaries used obelisks to embellish their buildings, and this French influence was marked in the work of Friedrich Gilly. When Frederick the Great died in 1786 the Berlin Akademie der Wissenschaften proposed that a monument should be erected to his memory. To this end, Karl Ludwig Fernow designed a pyramid without decorations, but inscribed with the word 'Frederico'. The prototypes of Cestius and of Boullée's ideas are immediately suggested. Heinrich Gentz (1766–1811) proposed a rotunda on a raised podium, with obelisks, that suggested he was acquainted with French designs, probably from Peyre's *Oeuvres*. Gilly's design, however, was startlingly original, and consisted of a Greek Doric temple on a high podium set in an enclosure, or sanctuary, entered by a triumphal arch. There were several pairs of obelisks set in the enclosure.[55] The qualities of the Egyptian style appealed to Romantic Classicists. Massiveness and bareness could contribute to Sublime effects. Simple geometry, bare unadorned walls, and severity, combined with enormous scale to give the required reaction. Both Herder and Kant understood this, and Kant, in his *Critique of Judgement,* mentions the pyramids at Giza as mathematically Sublime. Gentz also proposed a huge obelisk set in a rocky base as a monument to Luther in 1804.

The student of funerary monuments will be familiar with the pyramidal composition and with the obelisk. Crowning obelisks on tombs of the sixteenth and seventeenth centuries have already been mentioned, yet the large obelisk as a background to sculptural groups became common from the seventeenth century, largely as a result of the influence of Bernini. Markland[56] tells us that:

> Descending to later days, we approach that favourite ornament, the pyramid, which, for a series of years, was the prevailing characteristic. This appears to have originated with Bernini, and, for this violation of taste and judgement, Flaxman has bestowed upon him a well merited censure. The representation of a building, intended from its immense size, and its solid base, to last thousands of years, indicated by a little slab of marble, an inch thick, 'to be the back ground of sculpture, belonging to none of the ancient classes, foisted into architecture, with which it has neither connection nor harmony',[57] does appear to be the very climax of absurdity, were it not heightened by making the pyramid rest upon four round balls, or, as we have already seen, upon four skulls.

Markland, of course, was confusing his 'pyramid' with an obelisk, although the pyramidal form of such memorials derives from Bernini. In England the tomb of the Earl of Exeter in the Church of St Martin in Stamford by Peter Stephen Monnot (1657–1733) of Rome is one such example of the group set against an obelisk. It dates from 1704 and consists of vigorous, confident sculpture in white marble. The tomb of Thomas Foley by John Michael Rysbrack (1694–1770) in the Church of St Michael, Great Witley, Worcestershire, consists of a base, a sarcophagus, sculptured figures, a large urn, and a crowning cartouche, the whole being placed against a background of a large obelisk (Pl. 86). Similar compositions can be found in the tombs of Stanislaus I Leszynski and his consort in the Church of Bon Secours in Nancy, and in the monument of John, Duke of Argyll and Greenwich, of 1748-9, by Louis-François Roubiliac (1705-62).[58] The pyramid also appealed to designers like J.-B. Tuby, Michelange Slodtz, N. S. Adam, and J.-B. Pigalle. The latter's mausoleum of the Maréchal de Saxe (1696–1750) in the Church of St Thomas, Strasbourg, includes a steeply pitched pyramid, almost an obelisk, on the background. The pyramid motif in funerary design thus varied from the obelisk to the Cestius form, and from Cestius to the very flattened, wide-angled cemetery entrances of Boullée. Slodtz's pyramidal monument in the Church of St Maurice, Vienne, of 1740-7 should also be noted. An early use of the stepped pyramid as part of a tomb structure is found at the Contarini tomb, Il Santo, Padua, of 1544-8, designed by Sanmicheli.

Sir William Chambers (1723–96) produced an unexecuted design for an entrance gateway to Sherborne Castle, Dorset, that dates from the second half of the eighteenth century, in *c.* 1758.[59] The interest for purposes of this study lies in the Egyptian figures set in the niches on either side (Pl. 87). Johann Heinrich Müntz (1727–98) designed an 'Egyptian Room' (actually a Gothick room with Egyptianising figures – an odd and unnerving mixture) for the Earl of Charlemont at Marino, near Dublin, in 1762. In 1773 Robert Adam (1721–92) built the entrance-screen for Syon House, Middlesex, with sphinxes as terminal features of the flanking walls. The first catalogue issued by Wedgwood in 1773 included sphinxes, lotuses, Egyptian deities, a Cleopatra, Canopic vases and figures, and hieroglyphs.[60] Wedgwood's factory continued to produce Egyptianising figures well into the nineteenth century, and Egyptian motifs appear in some numbers in later eighteenth- and early nineteenth-century English furniture,[61] especially in the work of Thomas Sheraton (1751–1806), as is apparent from his *The Cabinet Maker's and Upholsterer's Encyclopaedia* published in London, 1804–6.

A delightful piece of Egyptianising, reminiscent of the contents of the Villa Adriana, is the English marble bust, 'Mrs. Freeman as Isis', carved by Anne Seymour Damer (1749–1828), and now in the Victoria and Albert Museum. Mrs Freeman sports a lotus bud on her head, and the pedestal is adorned with a sistrum. George Dance Junior (1741–1825) designed an Egyptian chimney-piece for the first Marquis of Lansdowne in 1788–91, and was later commissioned by Benjamin West to design a monument to George Washington in 1800. The latter consists of a low central pavilion with two flanking giant pyramids that recall the work of Ledoux. In fact Dance had met Piranesi in Rome and was clearly influenced by the Venetian master.[62] James Playfair (1755–94) designed Cairness House, Aberdeenshire, for Charles Gordon in 1791–7, with primitivist Doric columns and an Egyptian billiard room,[63] doubtless influenced by his visit to France in 1787. Playfair's design for this Egyptian room anticipates Hope's Egyptian Room at his house in Duchess Street, with its segmental ceiling, hieroglyphic friezes, and chimney-piece (Pl. 88). Playfair also met Canova in Italy, and his work is clearly influenced by Neoclassical ideas from the Continent. His interest in Neoclassicism, and especially in the French Neoclassicism of the Peyre, Boullée, and Ledoux schools, is brought out by the sale catalogue of his library, which included Winckelmann's *Histoire des Arts Anciens.* John Nash set a sphinx on the centre of the attic storey of Southgate Grove, Middlesex, of 1797. The north front, showing the sphinx (which faces to the left, or east), appears in Richardson's *New Vitruvius Britannicus* of 1802. Egyptianisms were rare in Nash's work, however, and Southgate Grove is one of his very few buildings with an overtly Egyptian feature.

Plate 88 The design for the Billiard Room at Cairness House, Aberdeenshire, by James Playfair, 1793. Note the hieroglyphs on the frieze, architraves and chimney-piece. The ceiling is described 'as Nero's Baths at Baia' (*Miss M. V. Gordon and Aberdeen University Library, MS. 1160/28/6/2*).

One of the last architects to make a pilgrimage to Rome, before the study of Egyptian antiquities was systematised by the Napoleonic scholars in Egypt itself, was Charles Heathcote Tatham (1772–1842).Tatham arrived in Rome in 1794, and stayed for two years, during which time he made many drawings of architectural details, including much Egyptian work in the Vatican and elsewhere[64] (Pls. 89-90). In Rome he met Canova, Angelica Kauffmann, Sir William Hamilton, and the Earl Bishop of Derry.[65] However, Tatham's chief *oeuvre* was in his provision of exemplars for Neoclassical furniture and décor. His *Etchings of Ancient Ornamental Architecture drawn from the Originals in Rome and other Parts of Italy during the years 1794, 1795 and 1797* was published in 1799–1800. This was indeed a major source-book of the Egyptian Revival and of Neo-classicism as a whole, based on the results of excavations at Pompeii, Tivoli, Herculaneum, and Rome. It was a great success and went into further editions. A German translation appeared in Weimar in 1805. The line engravings derived from Flaxman, and influenced Thomas Hope, Percier, and Fontaine. His *Etchings, representing the best examples of Grecian and Roman Architectural Ornament,* etc., contains a tribute to the influence of Piranesi, but also notes that Piranesi 'rejected with disdain the restraints of minute observation', and that he 'sacrificed accuracy' to conceptions that were 'the richer products of a more fertile and exuberant mind'. Tatham designed candelabra and other ornaments of fine quality with Egyptianising influences, and through the leading cabinet-makers Linnell and Thomas Tatham (both relations) he had a profound effect on contemporary furniture.[66] Tatham designed a pair of candelabra for Henry Holland that were originally in Carlton House. The Drawings Collection of the RIBA British Architectural Library contains two books of drawings by Tatham. These include a beautiful sketch of an Egyptian Term on a 'French Chimney piece' of 'statuary marble with gilt or-moulu ornaments' at Carlton House, Pall Mall[67] (Pl. 91).

Two sketches, dated Rome 1796, show an 'Egyptian Sepulchre' and an 'Egyptian Temple dedicated to the God Anubis' that are clearly based on the theatrical designs of Mauro Tesi[68] (Pl. 92). The drawing by Tatham of a 'Monument projecté pour le centre de la place des Victoires, à Paris',[69] is clearly the design by J.-N. Sobre of 1795, and shows a large obelisk adorned with Neo-classical motifs, resting on the backs of elephants (Pl. 93). Tatham also drew a pyramid mausoleum, with tetrastyle in antis entrances, and corner pavilions with heavily rusticated walls and segmental cappings protecting sarcophagi. Sphinxes flanked the openings at the corner pavilions[70] (Pl. 94). He also copied Vien's drawing of the Lapeyrouse monument. Rather more interesting are two sets of designs by Tatham: one for an Egyptian temple proposed to be used as a Greenhouse for Trentham Hall, Staffordshire, dated 1804 (Pl. 95), and one for a 'Table executed for the Earl of Carlisle at Castle Howard' of 1800 (Pl. 96). The Egyptian temple is ingeniously adapted for use as a greenhouse, and is more consciously Egyptian than is the well known mausoleum at Trentham Park which Tatham designed and built in 1807–8 in a more severe Neoclassical style that nevertheless suggests pylons under the heavily battered cornice.[71] The table for Castle Howard is more catholic in its eclecticism.

Among the last eighteenth-century manifestations of the steeply-pointed pyramid (almost an obelisk) that it has been possible to discover occurs in the parish churchyard in Knockbreda in County Down, near Belfast.[72] Above the crowning cornices are curious superstructures composed of domes, pyramids, obelisks, and urns. Parallels can be found, especially in the steeply pitched pyramidal forms, in the South Park Street Cemetery in Calcutta, and the Knockbreda tombs may have been suggested to Ulstermen returning home from India. A further connexion may be that with France, and with Scotland, where there were traditional ties through the 'Auld Alliance'. However, the curious Neoclassical Egyptianising of tombs in Ulster and France may owe not a little to Freemasonry.[73] There is an interesting painting in the Musée Municipal in Brest by Jacob-Henri Sablet (1749–1803) known as *Double portrait dans le cimetière des Protestants à Rome,* painted in Rome in 1791. The picture shows a new Neoclassical monument, the Cestius pyramid, and several Masonic symbols, including the acacia branches covering the pyramid (which had then, and has now, no covering vegetation) and the lightning in the storm-tossed sky. The acacia on the pyramidal tomb signifies hope in the afterlife, and the storm is an allusion to the trials of initiation. French taste and scholarship were to stimulate the next and perhaps most con-

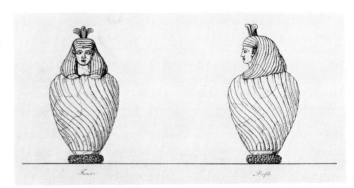

Plate 89 (top) 'Canopus, an Egyptian Idol, executed in dark oriental marble from the Collection in the Museum of the Vatican'. An illustration from Charles Heathcote Tatham's *Etchings representing the best examples of Greek and Roman Architectural Ornament* and based on his drawings of 1794–6.

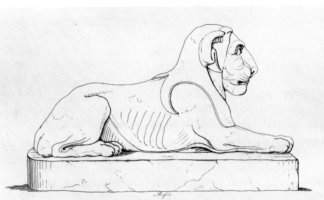

Plate 90 (centre) 'Antique Egyptian Lion executed in green Basalt, now placed at the feet of the grand flight of Steps leading to the Capitol in Rome'. An illustration from Tatham's *Etchings . . .*, of 1826.

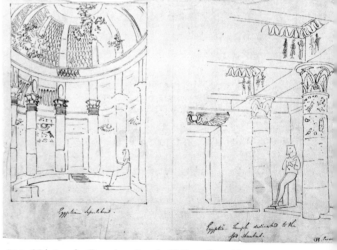

Plate 91 (below) A drawing by Tatham of 'Therm of a french Chimney-piece statuary marble with gilt or-moulu ornaments – at Carlton House Pall Mall', from his 'A Collection of Manuscript Drawings from Various Antique and other models made in Rome in 1794, 95 and 96' (*RIBA British Architectural Drawings Collection*).

Plate 92 (above) Two drawings by Tatham from his 'Collection of Manuscript Drawings of 1796', showing an 'Egyptian Sepulchre' and an 'Egyptian Temple dedicated to the god Anubis'. These were based on theatrical designs by Mauro Tesi. The Tesi etching Camera Sepolcrale Egiziana of 1762 was obviously copied by Tatham (*RIBA British Architectural Library Drawings Collection*).

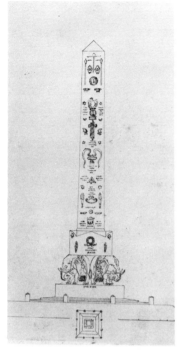

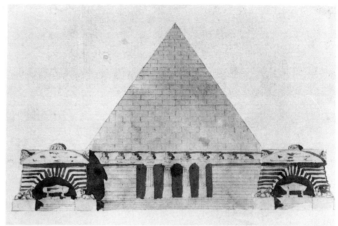

Plate 93 (left) A drawing by Tatham of 'Monument projeté pour le centre de la place des Victoires, à Paris' from his 'Collection of Manuscript Drawings'. This is a design by J.-N. Sobre of 1795 (*RIBA British Architectural Library Drawings Collection*).

Plate 94 (right) A pyramidal mausoleum drawn by Tatham and in his 'Collection of Manuscript Drawings'. Note the sphinxes flanking the corner pavilions in which the sarcophagi rest. Note also the segmental caps to the pavilions. This may be an original design, or it may be influenced by work of the French Academy in Rome (*RIBA British Architectural Drawings Collection*).

Plate 95 (below) 'A Design for an Egyptian Temple proposed to be used as a Greenhouse' for Trentham Hall, Staffordshire. From 'A Collection of Manuscript Drawings' by Tatham, dated 1804 (*RIBA British Architectural Library Drawings Collection*).

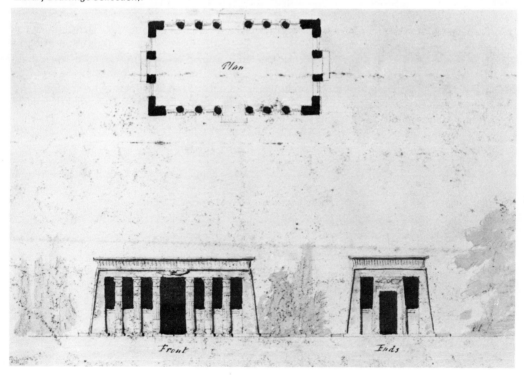

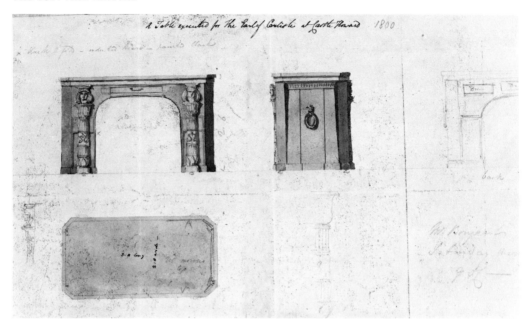

Plate 96 'A Table executed for The Earl of Carlisle at Castle Howard'. From 'A Collection of Manuscript Drawings' by Tatham, dated 1800 (*RIBA British Architectural Library Drawings Collection*).

centrated phase of the Egyptian Revival, although there had been an important book published in Parma in 1786 by Count Jacopo Belgrado before the French led the field. This was *Dell' Architettura Egiziana, dissertazione d'un Corrispondente dell' Accademia delle Scienze di Parigi.* The other important source-book for the Egyptian Revival published in Italy at the end of the eighteenth century was *Monumens Égyptiens, consistant en obélisques, pyramides, chambres sépulchrales, statues, etc., le tout gravé sur deux cens planches avec leurs explications historiques,* which came out in Rome in 1791. The significance of these two books has been largely overshadowed by the huge works of Denon and of the *Commission* that followed in the next century, but their impact on design is obvious from their contents. *Monumens Égyptiens . . .* is one of the most interesting Revivalist publications, and this point needs emphasis. The monumental achievements of the French scholars who recorded the Nile styles with accuracy came after the Napoleonic campaigns in Egypt, and it is to that singularly important and fecund period for the Egyptian Revival that we now turn.

6

The Egyptian Revival after the Napoleonic campaign in Egypt

Soldats, du haut de ces Pyramides quarante
siècles vous contemplent.

> NAPOLEON BONAPARTE (1769–1821): *Proclamation
> to His Army* before the Battle of the Pyramids
> 21 July 1798.

In the popular imagination, the Egyptian Revival is usually thought to begin with the Napoleonic campaigns in Egypt in 1798–9, but this, as we have seen, was not the case. Similarly, architects like Boullée and Ledoux have been designated as though they were 'of the Revolution'. Again, this is a false conception, for many successful Neoclassical designs that incorporated stripped-down Classical elements, Egyptianising motifs, vast blank walls, and an exaggerated scale were, in fact, known and influential during the Ancien Régime. During the Republic and Empire, Egyptian elements were still used, but became more archaeologically correct. This correctness was based on the very important publications that appeared in France after the Egyptian campaign and the French occupation of Egypt.

The French applied the method of scientifically exact measurement to the remaining buildings of Egyptian antiquity, and made detailed notes of the condition of the buildings. Scholarly reconstructions, full records of surveys, and precise descriptions by artists, architects, scientists, and historians were commissioned by Napoleon. This work was collected and published in twenty volumes (nine of text and eleven of plates) of folio size, and included details of the topography, natural history, geography, and antiquities of Egypt. The precise measurements and the beautiful accurate engravings of the buildings were of the highest quality and in the best traditions of scholarship. The work was published as *Description de l'Egypte, ou, Recueil des observations et des recherches qui ont été faites en Egypte pendant l'expédition de l'armée française, publié par les ordres de Sa Majesté l'empereur Napoléon le Grand* in Paris between 1809 and 1828 (Pl. 97). Hereafter, this work of the Commission des Monuments d'Egypte will be referred to as *Description*. Some authorities disagree on the number of volumes, but the second edition of 1821–9, including an atlas, runs to twenty-four volumes.

Before the *Description* started to appear, however, an account of the campaign in Egypt was published that included views of Egypt and pictures of its buildings. This was Baron Dominique Vivant Denon's *Voyage dans la Basse et la Haute Egypte pendant les campagnes du général Bonaparte* which came out in Paris in 1802. As Denon's work was published some years before the colossal *Description* began to appear, it can be said to be the first really reliable attempt to provide comprehensive and accurate surveys with descriptions of Egyptian architecture (Pl. 98). Denon's *Voyage* (as it will be called from now on) had an extraordinary impact. It came out in English in 1803,[1] and an abridged version was published in New York in the same year. Several editions in English were in existence by the end of the first decade of the nineteenth century, most of them American.[2] It is clear that Napoleon's Egyptian campaign, and the exact archaeological surveys of buildings

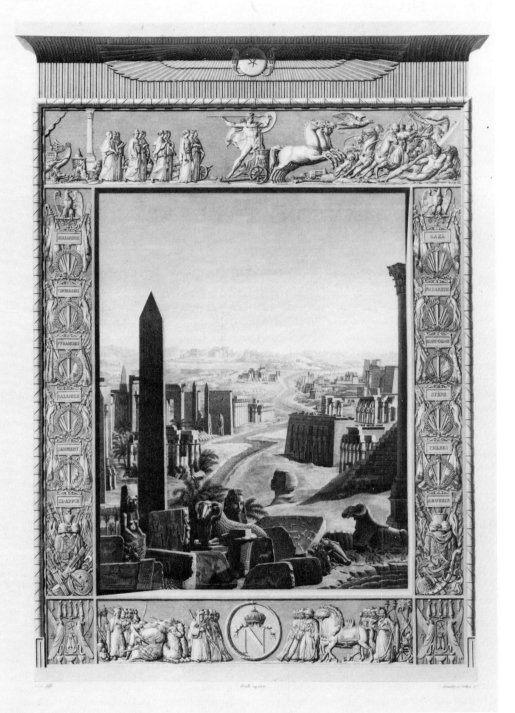

Plate 97 The frontispiece of *Description de L'Egypte . . .* of 1809. A, vol. 1 (*Trustees of Sir John Soane's Museum*).

Pl. 39

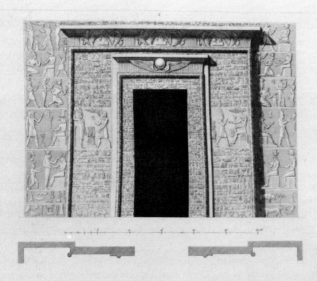

Porte intérieure du Temple de Tentyris.

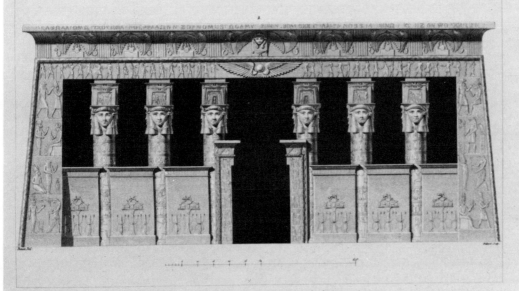

Vue géométrale du Portique du Temple de Tentyris.

Plate 98 Entrance and portico of the temple at Tentyris (Dendera) from Denon's *Voyage dans la Basse et la Haute Egypte* of 1802 (*Trustees of Sir John Soane's Museum*).

carried out as part of that campaign, began the serious, scholarly side of the Revival, as well as focusing attention on Egypt. Denon and the Commission des Monuments d'Egypte (Pls. 99-100) were to the Egyptian Revival what Stuart and Revett were to the Greek Revival.[3]

In 1800 or thereabouts P.-F.-L. Dubois designed ice-houses and a bridge for M. Davelouis at Soisy-sous-Etoile.[4] The ice-house was described as a temple égyptien, and had a distyle in antis portico flanked by obelisks. The obelisks and the temple façade were decorated with hieroglyphs, and there was an Egyptianising winged motif in the triangular pediment. At the time, these buildings were praised for their 'novel' and 'picturesque' forms,[5] yet the design is not really a scholarly work of archaeological correctness. J. C. Krafft, in his *Recueil d'Architecture Civile,* illustrated this ice-house (Pl. 101). Another ice-house based on a pyramid stands in the gardens known as the Désert de Retz, at Chambourcy. These gardens were certainly inspired by Hubert Robert, as Osvald Sirén has pointed out, but date from 1771.

Denon had mentioned in his *Voyage* the order and simplicity that could be found in Egyptian architecture, raising it to the Sublime. Herder and Kant also understood the Sublime qualities of Egyptian architecture, and Soane and his contemporaries noted how Egyptian elements could be used to induce Sublime effects. Charles Kelsall (1782–1857) mentioned 'a specimen from Egyptian Tombs' in his design for the College of Mathematics. The 'Egyptian' elements used were capital-less Greek Doric columns and heavily battered openings. The search by Neoclassical architects for a primitive style led them to Egyptian architecture as even more pure than that of Greece.

Wedgwood also began to manufacture a greater range of Egyptianising ornaments inspired by the Egyptian campaigns. An inkstand of 1805, made of black basalt with red decorations in relief, has the winged sun-globe, ram's head, and dog couchant, clearly derived from B. de Montfaucon's book, *L'Antiquité Expliquée* . . . A Wedgwood teapot, cover, and stand set, also of 1805, made of unglazed red stoneware, known as rosso antico, with reliefs in black basalt, and now in the Victoria and Albert Museum, has sitting sphinxes derived from the Mensa Isiaca and other motifs in Montfaucon.

It was Thomas Hope (1769–1831) who took Piranesi's ideas and merged them with archaeologically based designs for furniture. In his *Household Furniture and Interior Decoration*[6] Hope tells us that his sources for Egyptianising objects were from his own collection, and from those in the Vatican, in the Capitoline Museum, and in the Egyptian Institute at Bologna. For his writings on the Egyptian taste, Hope used Norden, Piranesi, and Denon,[7] yet he had visited Egypt himself and had made extensive drawings while there. His plate of the Egyptian Room at his house in Duchess Street in *Household Furniture* is of particular interest. The ceiling is a segmental vault; a form, as we have already noted, associated with Egypt from Roman times. The walls and friezes of figures were from Egyptian scrolls, and the lunettes were painted to resemble drapery. The colours of the furniture and ornaments were pale yellow and blue-green relieved by black and gold.[8] Materials used in the ornaments were granite, porphyry, basalt, and serpentine. Between the double doors was a table carrying two stumpy obelisks that supported Canopic vases. Two statuettes stood on a table opposite the chimney-piece. The latter was of black marble, and was a monumental composition to suggest permanence: Hope was critical of imitations using inferior materials.[9] On the chimney-piece were the couchant lions on short obelisks flanking an Egyptian statuette. The furniture was of some splendour. The chairs were adorned with the cow on a panel at the back, and two seated Egyptian figures supported the arm-rests. Two Canopic figures surmounted the back-rails. The couch had panels with representations of Anubis and Horus and the feet had panels with scarabs. A scorpion motif appears on the sides beneath the lions that grace the terminal blocks. Black and gilt are the dominant finishes. Indeed, the black rail decorated with gilt rosettes, and the brackets beneath do tend to suggest Greek forms, and recall Piranesi's eclecticism in the *Diverse Manière.* The chairs, couch, Isis clock, torchères, and other items can be seen together today at Buscot Park, near Faringdon. (In the grounds of Buscot, incidentally, are other Egyptianisms, including copies of the *Villa Adriana* Antinoüs and several sphinxes.) The room also contained a mummy and a cinerary urn (Fig. 2). The owning of a mummy was certainly fashionable. Thomas Rowlandson (1756-1827), in his watercoloured drawing of 'The Antiquary', ridiculed the curiosity aroused by the mummy in the collection of the Duke of Richmond. The

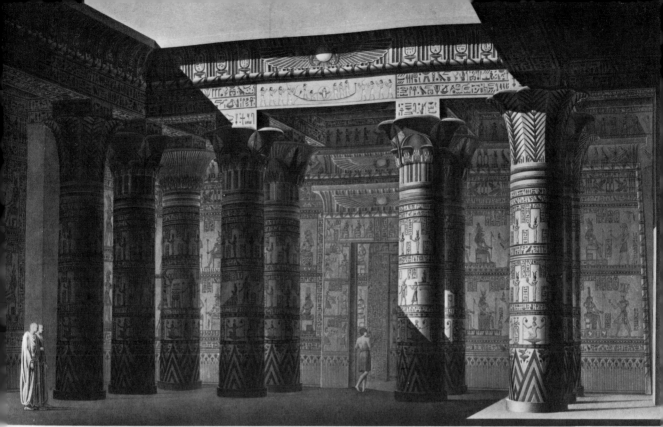

Plate 99 Perspective view of the painted interior under the portico of the large temple on the Island of Philae, from *Description . . .* A, vol. 1, pl. 18 (*Trustees of Sir John Soane's Museum*).

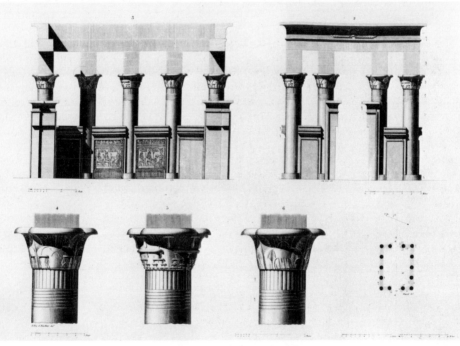

Plate 100 Plan, section, elevation, and details of the eastern Kiosk at Philae, a Trajanic structure, from *Description . . .* A, vol. 1, pl. 26 (*Trustees of Sir John Soane's Museum*).

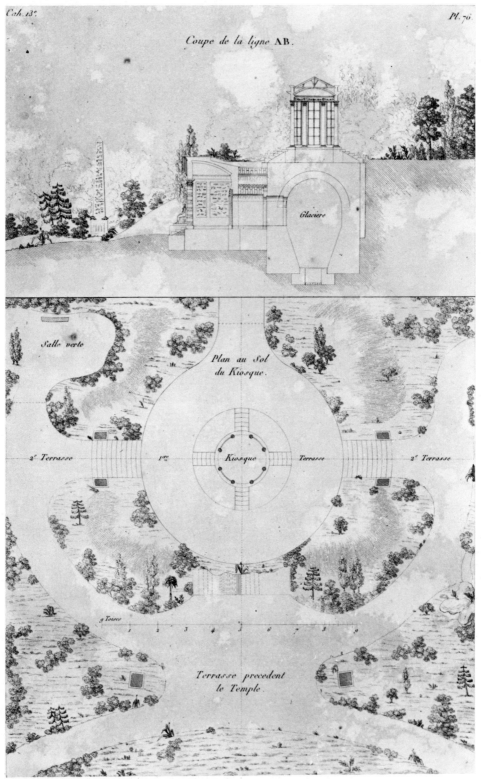

Coupe de la ligne AB.

Glacière

Salle verte

Plan au Sol
du Kiosque.

2ᵉ Terrasse

1ᵉʳ Terrasse

Kiosque

Terrasse

2ᵉ Terrasse

9 Toises

Terrasse precedent
le Temple.

Plate 101 P.-F.-L. Dubois' design for an ice house for M. Davelouis at Soisy-sous-Etiole, with Egyptian obelisks and portico from J. C. Krafft's *Recueil d'architecture* of 1811, pl. 76 (*Trustees of Sir John Soane's Museum*).

drawing shows a hideously ugly 'Antiquary' quizzing a smiling mummy at the feet of which is a bemused sphinx.

The *Lararium* of Hope's house was perhaps even more Egyptian. Again a segmental ceiling roofed the room. The chimney-piece was derived from temple-pylons, with a coved cornice, and had a stepped upper section for the display of the idols. The chimney-piece was set against a mirror. Seated Egyptian figures flanked the fireplace, and winged discs were used to decorate the front of the fire-basket and the lintel of the chimney-piece. Twin figures of the many-breasted Diana of Ephesus stood on the steps. Two Egyptian Canopic figures stood in aedicules above the pylons (Fig. 3).

The remodelling of the Duchess Street interiors began in 1799 and was complete by 1804. As Dr Watkin has pointed out, this period was also the time of the Consulate of France, when Percier and Fontaine began their work to redesign the furnishings of the old royal palaces.[10] Dr Watkin reminds us that Percier and Fontaine began to issue *Recueil de décorations intérieurs* in 1801, and that, according to Dr Watkin, this work influenced Hope's published work,[11] although the 1801 version had only about half the illustrations of the 1812 edition. It must be emphasised nevertheless (as Dr Watkin has remarked) that the overall style adopted by Hope at Duchess Street differs considerably from that favoured by French designers, and John Gloag has also noted that Hope's work and English Regency styles can be seen as independent developments when compared with French work, although there are clearly cross-currents and common influences.[12]

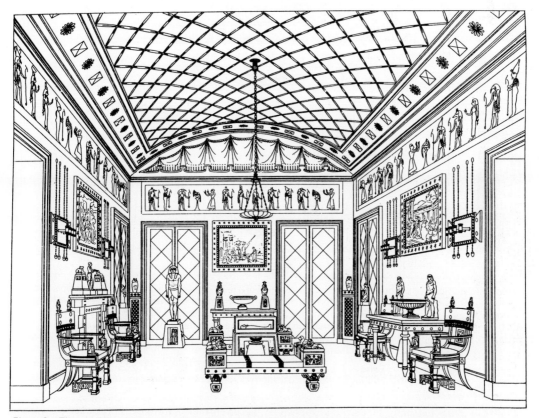

Figure 2 Thomas Hope's 'Egyptian Room' in his home in Duchess Street, from his *Household Furniture and Interior Decoration, Executed from Designs by Thomas Hope*, plate VIII. Note the chairs, with seated Egyptian figures on arm-rests, and the Canopic figures surmounting the backrails. Note the Egyptian statuettes, the mummy, the Canopic jars on stumpy pedestals, and the friezes. The wall lights should be compared with Pl. 143.

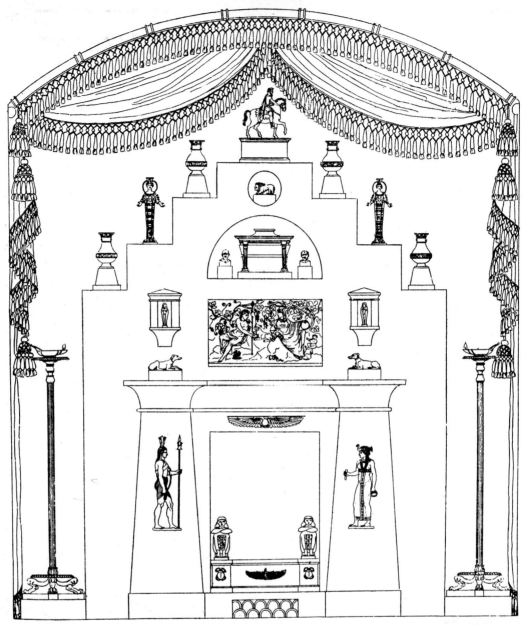

Figure 3 'The closet or boudoir fitted up for the reception of a few Egyptian, Hindoo, and Chinese idols and curiosities. The sides of this Lararium are formed of pillars, and the top of laths, of bamboo. Over these hangs a cotton drapery, in the form of a tent. One end of this tabernacle is open, and displays a mantle-piece in the shape of an Egyptian portico, which, by being placed against a background of looking-glass, appears entirely insulated. On the steps of this portico are placed idols, and in its surface are inserted bas-reliefs'. From Thomas Hope's book, *op. cit.,* plate x. Note the Dianas of Ephesus.

Figure 4 (*opposite, top left*) (1 and 2) Tables in the Lararium. (3) A table dedicated to Aurora, with the clock, designed by Hope, and incorporating a statue of Isis adorned with her cow's horns and moon-disc. Plate XIII from Hope, *op. cit.*

Figure 5 (*opposite, top right*) (1) Black marble chimney-piece from the Aurora room. (2) Table in the Egyptian Room, with lion and cup of basalt. On either side of the cup are Egyptian aediculae with idols, supporting Canopuses. From Hope, *op. cit.*, plate xvi.

Figure 6 (*opposite, below left*) (1 and 2) Front and end of a glazed case containing a mummy. The case stands on a battered pedestal within which is an alabaster urn. (3 and 4) Front and end of the settee in the Egyptian Room (See Fig. 2). (5) Bronze tripod. Plate XVII from Hope's book *op. cit.*

Figure 7 (*opposite, below right*) Various items of furniture from Hope's book, *op. cit.*, plate xix. The bottom pictures show the front and side views of a stone seat adorned with sphinxes and lotus flowers.

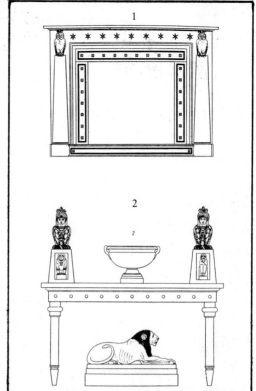

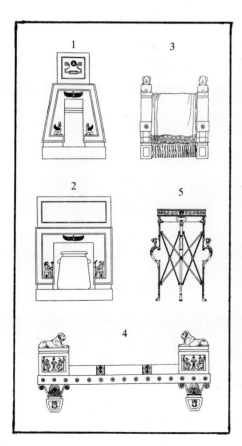

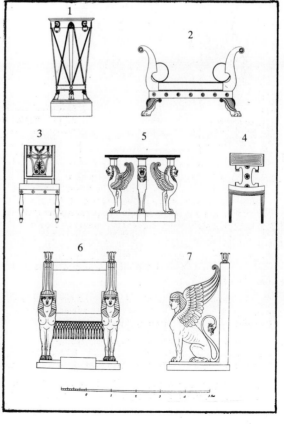

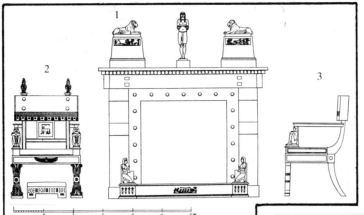

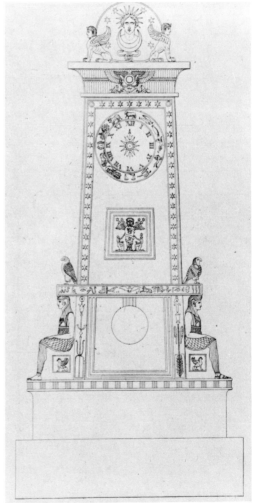

Figure 8 Plate XLVI for Hope's book, *op. cit.*, showing the 'mantle-piece of black marble, copied from the facade of a sepulchral chamber'. Hope says the ornaments on the shelf and fender were copied from Egyptian items in the Capitol and Vatican and from Denon. The chair has crouching priests, and the winged Isis placed in the rail is borrowed from the Egyptian mummy case in Bologna. The Canopuses on the back rail are copied from the one in the Capitol, and 'other ornaments are taken from Thebes, Tentyris, &c.'

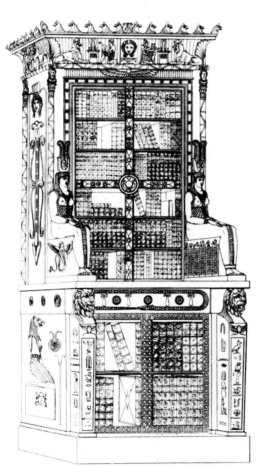

Plate 102 Plate 28 from Percier and Fontaine's *Recueil de décorations interieurs* of Paris, 1801, showing an Egyptianising secretaire (*Trustees of Sir John Soane's Museum*).

Plate 103 Plate 8 from Percier and Fontaine's *Recueil . . .* showing an Egyptianising clock. The Isiac crescent moon at the top should be noted (*Trustees of Sir John Soane's Museum*).

There is, however, one connexion with Percier that should be mentioned here. Percier knew Flaxman in Rome during the last decade of the eighteenth century, and Flaxman was also friendly with Hope. Letters survive in the Fitzwilliam Museum in Cambridge to demonstrate that Flaxman's friendship with one of Napoleon's architects lasted for a considerable time.[13] The plates for Hope's book show an astonishingly inventive range of Egyptianising motifs (Figs. 4-8).

Hope's main sources have already been noted. The Egyptianising material from the Villa Adriana was known to him, while the contents of the Vatican and Capitoline Museums and the plates in Denon provided him with detail. Some of his Egyptianising came from buildings at Thebes and Tentyris.[14] As has been previously stated, James Playfair's Egyptian Room at Cairness House, Aberdeenshire, looks forward to Hope's room at Duchess Street, with such features as the segmental ceiling, double doors set in a battered architrave with hieroglyphic inscriptions, and blocky chimney-piece. Percier and Fontaine, who were much favoured by Napoleon, used certain Egyptianising features. The *Recueil de décorations intérieurs* of 1801 includes an Egyptianising secretaire and an Egyptian clock. The secretaire has seated Isiac figures, hieroglyphs on the lion-headed piers (Pl. 102) and other Egyptian ornament, while the clock has seated male figures, an Isiac crescent moon, and an Egyptian cornice crowned with winged sphinxes (Pl. 103). Percier and Fontaine also illustrate a Canopic Bonne Déesse with four breasts in Plate 14 of their book. Thomas Hope designed an Egyptian clock for his Flaxman Room at Duchess Street that consisted of a statue of Isis carrying a clock flanked by panels with obelisks and hieroglyphs (Fig. 4). The cows' heads on the short obelisks on either side of the goddess emphasise the Isiac attributes, although the deity appears to have lost her cow's horns and moon disc head-dress (Pl. 104). This exquisite clock, now in the Royal Pavilion at Brighton, is made of bronze, ormolu, and rosso antico marble. Hope's scholarly use of coherent iconographic programmes ensured that his work was altogether more severe and less wild than that of Piranesi in the Egyptian taste. Indeed, Hope's display of vases, urns, and statuary in a series of tomb-like interiors emphasises his narrative approach to the settings of art. Sir John Soane was to achieve certain resemblances to Duchess Street in his house at Lincoln's Inn Fields. The use of mirrors, segmental sections for ceilings, and other devices recall Hope, although there are few overt Egyptianisms. Soane's sarcophagus of Seti I in his house was the centre-piece of his extraordinary and somewhat funereal Museum. The Bank of England interiors display some feeling by Soane for Piranesi's approach to an eclectic use of antique motifs. In the forty-five years during which the Bank of England was reconstructed from 1788, Soane, possibly influenced by the ideas of his master Dance, produced a number of interiors which incorporate an architectural expression that was original yet a development from some of the spatial notions of Piranesi, especially in the Carceri drawings. The Soane use of segmental lunettes, battered architraves, somewhat sinister figures as caryatides to support low domes, and a cunning subdivision of space suggest Piranesian ideas, although from 1806 Soane tended to denounce the Venetian's licence and extravagancies.

Thomas Hope's Egyptianisms were robust yet refined, scholarly and imaginative, bold yet delicate. They represent a high point in Regency design, and were beautifully realised. Hope emphasised the need for good craftsmanship to encourage the manufacture of objects that would last. He was particularly anxious to promote the use of long-lasting materials. Hope's furniture was influential, and copies were made of some of his designs. George Smith (1783–1869) produced a work on *Designs for Household Furniture* in c. 1808, and his *Cabinet-Maker's & Upholsterer's Guide, Drawing Book, and Repository of New and Original Designs for Household Furniture and Interior Decoration in the most approved and modern taste: including specimens of the Egyptian, Grecian, Gothic, Arabesque, and French, English and other schools of the art* contained some Hopeian ideas. Indeed, the popularisation of the Egyptian taste was very largely due to Smith's pattern-books that, though lacking Hope's scholarly approach, had a considerable influence on the furniture trade. *Household Furniture* was 'studied from the best examples of Egyptian, Greek, and Roman styles.' Fully developed Regency Egyptian taste can be found in the painted, bronzed, and gilt armchair with cane seats and sides, probably made in 1806 from a design dated 1804 in *Household Furniture*. The rectangular back has a Medusa head flanked by anthemion scroll-work. The sides are carved with leopard masks, and the supports are in the form of leopard's legs. Examples of this design can be

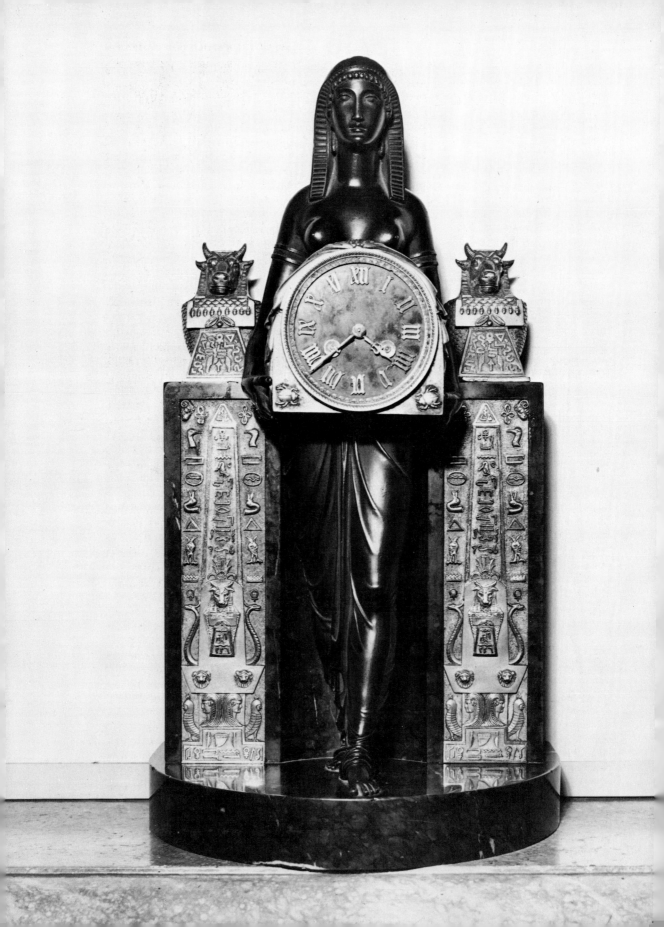

Plate 104 (opposite)
Egyptianising clock designed by
Thomas Hope for the Duchess
Street Mansion. The statue of Isis
as originally designed was
crowned with cow's horns and a
moon-disc, but there is no sign of
the fixing. See Fig. 4 (*Royal
Pavilion, Art Gallery, and Museums,
Brighton*).

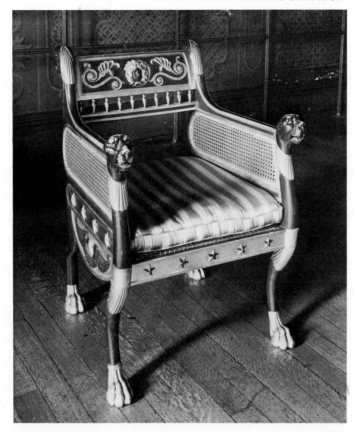

Plate 105 A chair based on a
design found in George Smith's
Household Furniture. Note the
Medusa mask on the back, and the
leopard masks and legs (*Royal
Pavilion, Art Gallery, and Museums,
Brighton*).

found in the Royal Pavilion at Brighton, and in the Victoria and Albert Museum (Pl. 105). Somewhat odder, Gaetano Landi's *Architectural Decorations: a Periodical Work of Original Designs invented from the Egyptian, the Greek, the Roman, the Etruscan, the Attic, the Gothic, etc., for Exterior and Interior Decoration and whatever relates to furniture* included a design for a Grand Egyptian Hall (Pl. 106) that owes more to Piranesi than to Hope, although there are segmental lunettes, and friezes of figures from scrolls. The fireplace in Landi's book is also Egyptianising (Pl. 107). In the same year as the first (and only) instalment of Landi's work, John Buonarotti Papworth or Samuel Pepys Cockerell designed an Egyptian room for the Duke of Marlborough at Whiteknights, Reading, Berkshire. This was decorated with hieroglyphs, murals, and statues. Francis Bernasconi may also have worked at Whiteknights.[15] A certain amount of confusion reigns as to who did what at Whiteknights. We know that Papworth designed the garden structures, and that Cockerell and Bernasconi worked at Whiteknights in 1810. Hofland's *A Descriptive Account of the Mansion and Gardens of White-Knights, A Seat of His Grace the Duke of Marlborough* refers to 'The Anti Room' having 'Egyptian Idols', while the drawing room chimney-piece was also in the Egyptian taste. The second room of the Library was ornamented in the Egyptian manner.

In 1805, J. M. Gandy, the gifted pupil of Soane, published 'Lodges after the model of the Egyptian entrances to their temples' in *The Rural Architect*. One pair was set as inhabitable pyramids, and the other as pylon towers, though in miniature, with obelisks (Pls. 108–109). Gandy specifically mentions that they were 'after the model of the Egyptian entrance of their temples'. In his *Designs for Cottages, Cottage Farms, and other Rural Buildings*, dedicated to Thomas Hope, Gandy shows one design (Plate XXXIX) that incorporates a circular pavilion with a short and a long obelisk as gate-posts. Egyptian elements also occur in Dublin, notably in St Andrew's Church and in Smirke's Wellington Testimonial obelisk.

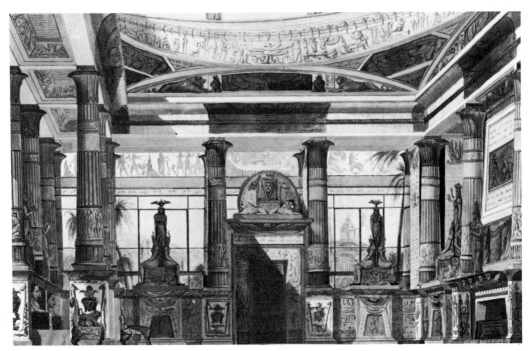

Plate 106 (*above*) The Grand
Egyptian Hall in Gaetano Landi's
Architectural Decorations . . . of
1810 (*Trustees of Sir John Soane's
Museum*).

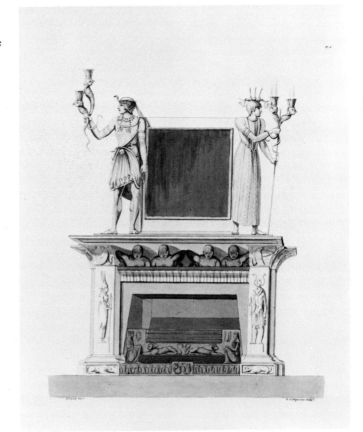

Plate 107 A fireplace in the
Egyptian taste from Landi's
Architectural Decorations . . .
(*Trustees of Sir John Soane's
Museum*).

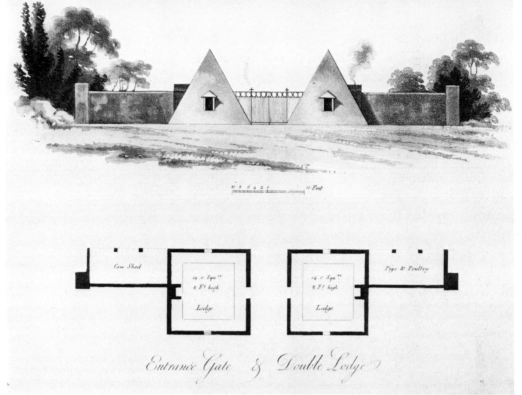

Plate 108 A design for an 'Entrance Gate and Double Lodge' from Joseph Gandy's *The Rural Architect Consisting of Various Designs for Country Buildings, Accompanied With Ground Plans, Estimates, and Descriptions.* Plate XXXIX (*RIBA British Architectural Library*).

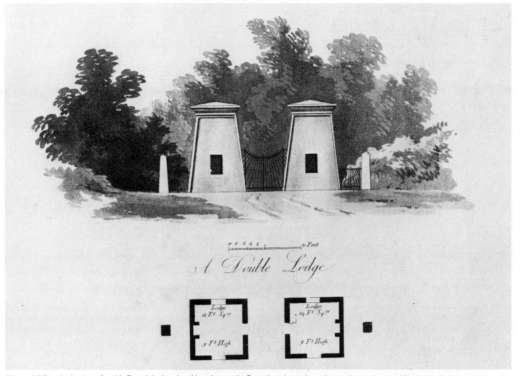

Plate 109 A design for 'A Double Lodge' by Joseph Gandy, showing the pylon-shaped lodges, and stumpy obelisks as gate posts. From *The Rural Architect . . . op. cit.*, plate XLII (*RIBA British Architectural Library*).

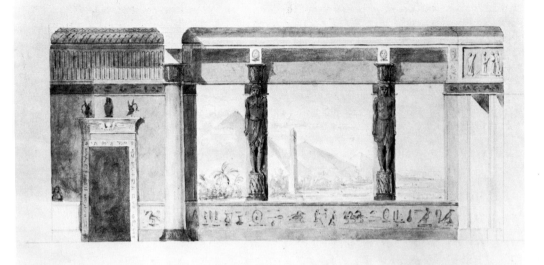

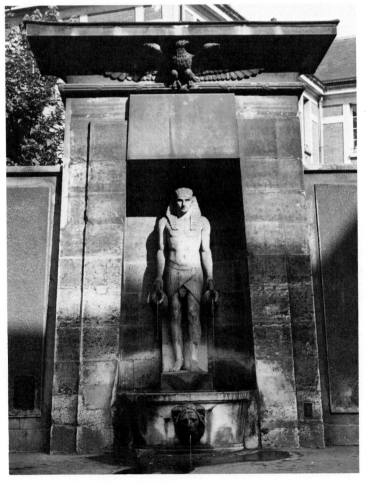

Plate 110 (*above*) Robert Smirke's drawing (pencil and water-colour) of an interior in the Egyptian style of *c.* 1801. The telamoni are based on those from the Villa Adriana (*RIBA British Architectural Library Drawings Collection CC12/72. No. 2*).

Plate 111 The Egyptian fountain in the Rue de Sèvres, Paris, by J.-M.-N. Bralle with the figure by P.-N. Beauvallet, of 1808, based on the figure of Antinoüs from the Villa Adriana (See Pl. 5) (*James Austin*).

Egyptian motifs appear in George Smith's work, usually for library fittings, perhaps a piece of architectural association with the library of the Serapeion at Alexandria, and with Egypt as the fount of wisdom and learning. Thomas Chippendale (1749–1822) designed some Egyptianising furniture for Stourhead[16] (1802) possibly based on Denon's publications. George Dance (1741–1825) designed Egyptianising elements for Lansdowne House and for Stratton Park[17] and, according to Professor Richard G. Carrott,[18] Nathaniel Dance designed Egyptianising caryatides for the library at Lansdowne House in 1794. Egyptianising fireplaces occur in numbers in England, but most of these designs are really attempts to give variety. The conscious iconography of Hope is missing. Egyptian detail appears in chimney-pieces at Southill (1800), the Gallery at Attingham Park (1807), and at Bayfordbury (1812). The dining room at Goodwood was also based on Denon, as was the Egyptian Hall under the north portico at Stowe, which was based on the interior of one of the small temples at Dendera, as illustrated by Denon. The library at Barnsley Park, Gloucestershire, of 1806–10, also includes some Egyptianising elements.

Curiously, the lull in hostilities between England and France led many Britons to France. Tourists visited the museums and galleries, and bought artefacts in the latest taste. One of the most fashionable shops was that of Martin-Eloy Lignereux, whose partner, Daguerre, had had a shop in London until 1796.[19] Geoffrey de Bellaigue has quoted a bill of the Prince of Wales. Items include 'Une paire de girandoles avec figure de femme Egyptienne' and two cabinets with gilt-bronze Egyptian figure enrichments set on inverted obelisks, the whole dans la forme antique. As Mr de Bellaigue has pointed out, the use of the phrase forme antique usually applied to Greek and Roman art, but by 1803 the respectability of Egypt as a source of antique art was becoming established after the Napoleonic discoveries in that land. Georges Jacob (1739–1814), the most celebrated of all Parisian furniture suppliers of the Louis Seize period, used Egyptianising features, while his sons Georges II and François-Honoré Georges Jacob, produced many splendid Egyptianising pieces in the Directoire and Empire periods. Between 1801 and 1805 Robert Smirke (1780–1867) and his brother Richard visited Italy and Greece. While in Italy he produced a drawing in pencil and water-colour, presumably topographical, of a delightful room in the Egyptian taste that incorporates telamoni clearly derived from the Villa Adriana examples in the Vatican. The wall behind shows a view of the pyramids (Pl. 110). This drawing is in the RIBA British Architectural Library Drawings Collection.

In 1806 James Randall published a design for a country mansion in the Egyptian style in his *Architectural Designs for Mansions, Villas, Lodges, and Cottages.*[20] This odd design had battered corner piers, Hathor-headed columns, and hieroglyphic decorations, all apparently derived from Denon. J.-A. Renard (1744–1807) built a garden room for the Prince de Bénévant at Valançay in 1805 in the form of a small Egyptian temple, square on plan, that did not come from Denon. Three years later, in 1808, J.-M.-N. Bralle (1785–1863) built a fountain in the Rue de Sèvres consisting of an Egyptian gate, sealed, forming an aedicule for a male Egyptian figure by P.-N. Beauvallet (1750–1818) that was based on an Egyptianising statue of the Antinoüs removed from the Capitoline Museum by Napoleon. Bralle's fountain was one of several erected by order of Napoleon in Paris. Bralle also designed a fountain with Egyptian attributes for the Place du Châtelet, consisting of a palm shaft with four sphinxes at the base,[21] that doubled, as did the fountain in the Rue de Sèvres, as a memorial to the Egyptian campaign. The aedicule at the Rue de Sèvres comes from Denon. One curious feature of the latter fountain is the use of the Imperial eagle with outstretched wings replacing the winged disc of Egyptian work (Pl. 111). Thus a Napoleonic campaign was suggested by architectural motifs throughout Paris. M. Bataille added an Egyptian porch to the Hôtel de Beauharnais in the Rue de Lille in Paris in 1806 on Napoleon's orders. Here, palm columns, set distyle in antis (the antae being battered), possibly derives from Denon's view of the Esna temple, but lightened by the wide spacing of the columns.

A rare and strange piece of Egyptiana found its way to St James's Park in 1803 after the Egyptian campaign. This was the Great Egyptian Gun, apparently a Turkish cannon captured at Alexandria in 1801. It was of fluted make, with raised work of hieroglyphs. It sat on a new carriage, carved by a Mr Ponsonby, and had a panel on the side showing Britannia pointing towards the pyramids. The barrel of the cannon rested on a sphinx[22] (Pl. 112). One of the longest-

lived pieces of Egyptianising furniture appeared in Europe at this time, and is still in use today. This was the metronome, as designed by Johann Nepomuk Maelzel (1772–1838), and consisting of a clockwork mechanism set in a stumpy obelisk, rather like a steep pyramid with an obelisk top. An Egyptianising form of the Neoclassical period was thus familiar to all musically inclined households. Egyptianising furniture varied from the purism of Hope and other scholars to a more popular interpretation after the publication of Smith's pattern-books. Lion or leopard-supports became common: Egyptian heads and feet were often used as terminations on bookcases, commodes, and other furniture (Pl. 113); desks often had pylon supports (as did fireplace surrounds); and other Egyptian decorative motifs appeared in profusion.

The Sèvres Egyptian Service, now in the Victoria and Albert Museum, is of singular interest in the story of the Egyptian Revival. Involved in its creation were Denon, Alexandre Brongniart (administrator of the Manufacture Impériale at Sèvres), Jean-Baptiste Le Peyre, Théodore Brongniart, and Jean-François-Joseph Swebach-Desfontaines. In 1802 Denon became Director of the Musée Napoléon, and, in 1803, of the Monnaie des Medailles.[23] In 1805 he had become artistic adviser to the porcelain factory at Sèvres, where Brongniart as administrator had improved the process of manufacture and glazing. Brongniart built up the Musée Ceramique at Sèvres, and developed an interest in design as well as in technicalities. Denon proposed to Brongniart that an Egyptian Service should be manufactured at Sèvres, to the designs to be derived from plates in Denon's *Voyage*. It was Denon who had control of the design of the whole project, while Brongniart dealt with the problems of manufacture.[24] The plates were painted by Swebach-Desfontaines with a different scene on each, in a sepia monochrome. Théodore Brongniart designed the borders with blue and gold. The centrepiece was designed by Jean-Baptiste Le Peyre, who had been on the Nile expedition. This *surtout* of biscuit porcelain is set on imitation porphyry, and consists of models of the temples of Philae, flanked by the Luxor obelisks from Denon (Pl. 114); two temples based on those at Edfu and Dendera; pylons from Edfu; four seated male figures; and avenues of sacred rams (Pl. 115). The whole ensemble is decorated with bogus hieroglyphs. J.-F.-J. Swebach-Desfontaines (1769–1823) painted the service after Denon; Claude-Antoine Depérais (1777–c. 1825) painted the signs of the Zodiac; Jean-Nicolas-Alexandre Brachard (1775–c. 1830) modelled the biscuit porcelain and the architectural parts of the surtout. This *Service Egyptien* was intended as a present for Czar Alexander of Russia, and the original set is now in Moscow. However, the Empress Josephine was so charmed by the Service that she asked for another set. The second set was delivered at Malmaison in 1812, but the Empress found it *trop sévère*. After the Battle of Waterloo, Wellington remained in Paris at the head of the occupying army. In 1818 Louis XVIII, anxious no doubt to show his gratitude to the man who had restored him to his throne, instructed Brongniart to send the Service to the Tuileries, and it remained in the possession of the Dukes of Wellington until 1979 when it was bought for the nation.[25] The Service consisted of 66 *assiettes avec vues*, 12 *assiettes à monter*, 12 *compotiers*, 2 *sucriers à figure égyptienne*, 2 *glacières forme égyptienne*, 4 *figures avec vasques*, 2 *corbeilles à palmes*, and 2 *confituriers à boules-griffes*.[26]

William Bullock opened his Egyptian Hall at what is now Nos. 170–173 Piccadilly in 1812. This was to house a collection of curiosities, and was designed by Peter Frederick Robinson (1776–1858), who had a reputation as a connoisseur of styles, and who had advised the Prince of Wales on Chinese furnishings for the Royal Pavilion. This was an early design alleged to be based on archaeology to revive the Egyptian style, and was supposed to be modelled on plates from Denon's *Voyage*, with some considerable freedom. The immediate ancestor of the Egyptian Hall was said to be the great temple at Dendera. The central façade was crowned by a cornice carried by a sphinx and by two colossal nude statues of Isis and Osiris in Coade stone carved by Sebastian Gahagan[27] (Pl. 116). Short lotus columns flanked the entrance, and the architraves were liberally decorated with bogus hieroglyphs. Elmes, master of John Haviland (who, according to Professor Carrott, was the 'greatest of the American Egyptian Revival architects'),[28] wrote that the 'elevation' was 'completely Egyptian, that is supposing the ancient Egyptians built their houses in storeys. The details are correctly taken from Denon's celebrated work, principally from the great

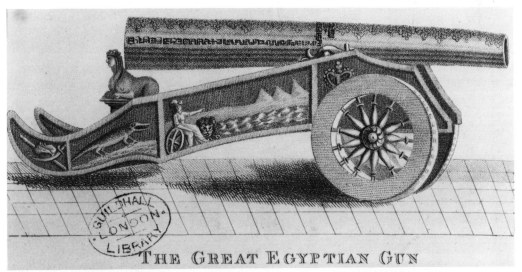

THE GREAT EGYPTIAN GUN

Plate 112 'The Great Egyptian Gun in St James Park 16 feet 1 in. long'. From *Kirby's Wonderful & Scientific Museum, or the Magazine of Remarkable Characters*, vol. I, p. 173 (*Guildhall Library, City of London*).

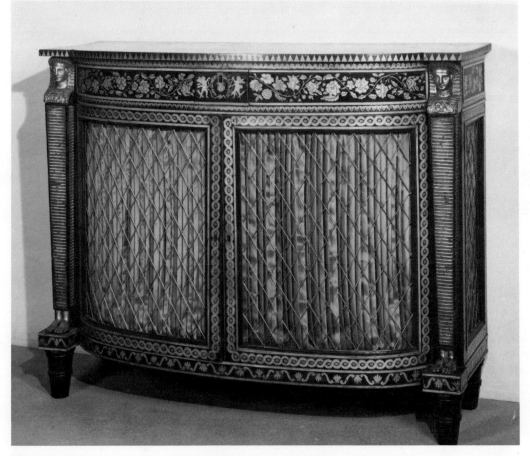

Plate 113 Typical use of Egyptian heads and feet as terminal features in furniture design (*Victoria and Albert Museum*).

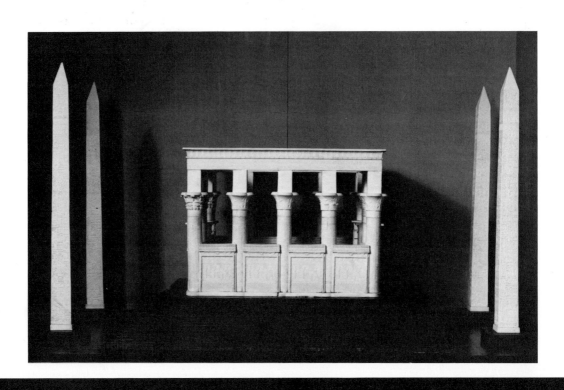

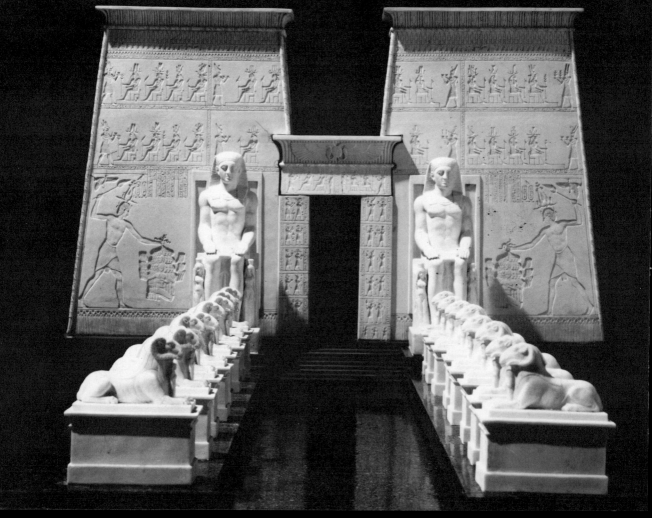

temple' at Dendera. The two 'colossal figures that support the entablature of the centre window are novel in idea and application; picturesque in effect; and add variety to the composition; while the robust columns beneath them seem built exactly for pedestals to the sturdy Ethiopians above.' Haviland also felt that the large projection of the superior cornice rising from the colossal sculptured torus that bounds the entire design, was 'grand and imposing'.[29] Hugh Honour has pointed out that the claim of the Egyptian Hall to derive from Dendera has no foundation on truth. The temple of Hathor at Dendera bears no resemblance to Robinson's confection. Professor Carrott has amusingly referred to buildings like the Egyptian Hall, probably erected for advertising purposes to appear novel, picturesque, and different, as belonging to a genre that might be described as 'Commerical Picturesque'.[30]

Sebastian Gahagan's 'Egyptian' figures owe more to representations of Red Indians than to Egyptian deities. Leigh Hunt disliked the building, and said Egyptian architecture should remain in Egypt, as in England it was an 'uncouth anomaly'.[31] Nevertheless, from this time features such as chimney-pots, chimney-pieces, and even cast-iron details began to be manufactured with a pronounced Egyptianising flavour. Chimney-pots, especially, in the form of a pylon, square on plan, with a cavetto cornice, and often with a battered panel on each face, were made by builders' suppliers in enormous quantities, usually in a yellow or biscuit clay, and can still be found in plenty in many English cities and towns. Manufacture of them continued for the best part of eighty years. Many Egyptianising chimney-pieces, with pylon-like pilasters on either side of the fireplace, and with cavetto cornices, were put into houses in the Winchester, Cheltenham, and Leamington Spa areas (among others) in considerable quantities from the second decade of the nineteenth century. These were made as standard items by dealers in marble components. Although many

Plate 114 (*opposite above*) The Kiosk from Philae (compare with Pl. 100) with the obelisks from Luxor as part of the surtout from the Sèvres Egyptian Service (*Victoria and Albert Museum*).

Plate 115 (*opposite below*) The centrepiece of the Sèvres Egyptian Service, designed by Le Peyre, showing the pylons from Edfu, seated male figures, and avenues of sacred rams, all of biscuit porcelain (*Victoria and Albert Museum*).

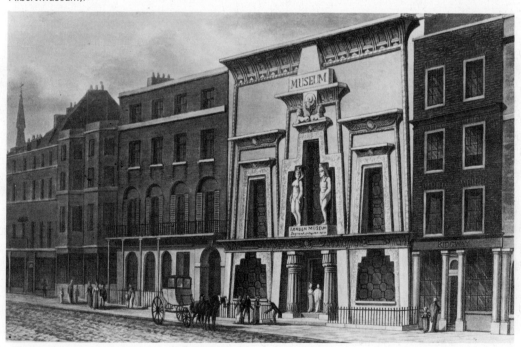

Plate 116 Bullock's Museum, Piccadilly, designed by P.'F. Robinson. A print of 1815 by Ackermann (*Guildhall Library, City of London*).

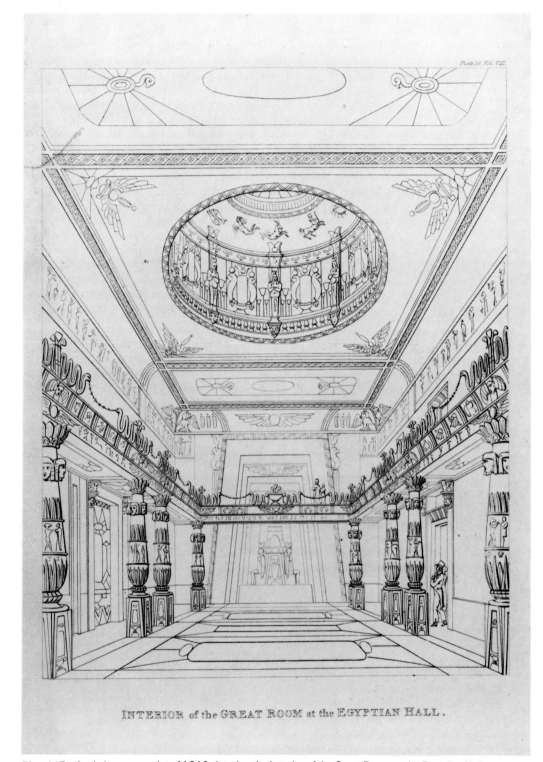

Plate 20. Vol. VIII.

INTERIOR of the GREAT ROOM at the EGYPTIAN HALL.

Plate 117 An Ackermann print of 1819 showing the Interior of the Great Room at the Egyptian Hall, as modified by Papworth (*Guildhall Library, City of London*).

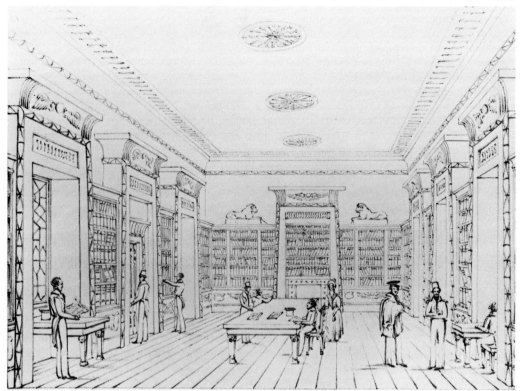

Plate 118 The interior of Foulston's 'Civil and Military Library, Devonport,' showing the Egyptian interior. From Foulston's *Public Buildings* ... (*RIBA British Architectural Library*).

Egyptian chimney-pots have survived, chimney-pieces have suffered from the vagaries of taste, and have been ripped out of houses in this century with a zeal that perhaps matches the enthusiasm they provoked in the last.

In 1821 a curious twist of fate determined that the Egyptian Hall should house a magnificent exhibition of Egyptian art. Giovanni Battista Belzoni appealed to British patriotism to support explorations of Egypt in reply to the stream of scholarly publications being produced in France. Details of Belzoni's excavations and discoveries were brought to London in 1820, and Belzoni published his *Narrative of the Operations and Recent Discoveries within the Pyramids, Temples, Tombs, and Excavations, in Egypt and Nubia; and of a Journey to the Coast of the Red Sea, in Search of Ancient Berenice; and Another to the Oasis of Jupiter Ammon* to extol his discoveries. The exhibition which followed at the Hall was an immediate success, and featured replicas of two of the finest chambers in the tomb of Seti I. For the first time in London a major exhibition of Egyptian objects, including idols, scarabs, papyri, statues, and all sorts of artefacts could be seen by the public. Interest in ancient Egypt was thus quickened in England. Soane himself acquired the sarcophagus of Seti I that Belzoni had tried to sell to the British Museum in 1824.

The setting for Belzoni's exhibition was admirable, for J. B. Papworth had restyled the 'great apartment' into an Egyptian Hall in 1819. Papworth, of course, had been commissioned by Bullock to lay out Hygeia, a model town, for his estate in America. Papworth's Egyptian Hall had Hathor-headed columns carrying a gallery, and was top lit. There was a plethora of Egyptianising ornament. The original 'great apartment' had not been styled in an Egyptianising manner, and the only 'Egyptian' architectural feature was the front to Piccadilly (Pl. 117).

One of the most spectacular examples of Egyptianising was carried out to designs by Giuseppe Valadier (1762–1839) for the reforming of the Piazza del Pòpolo in Rome from 1816 to 1820 for Pope Pius VII. Using the central obelisk, the twin churches of Carlo Rainaldi, the church of Santa

Maria del Pòpolo, and the gate as his points of reference, Valadier created an elliptical space with ramps to give access to the high ground. Valadier fused the park and the buildings in a supremely confident act of urban planning. His ramps were crowned with sphinxes to complement the Egyptian obelisks (Pl. 10). Even before 1800 Valadier produced a sketchbook with Egyptianising elements, according to Dr Eva Brues.

Egyptianisms also often occurred mixed with other Neoclassical elements. For example, Elim Chapel at Brighton, of 1810, has Egyptianising architraves, but a correct Doric pediment. Egyptianising architraves with a strong batter can be found in many places in Europe and America. At the corner of High Street and Southgate Street in Winchester are some architraves in a prominent position with a pronounced batter, and on the east side of Southgate Street are some houses with fine Egyptianising fireplaces in otherwise Italianate buildings. Of all English Egyptianisms of the early part of the last century, Thomas Harrison's (1744–1829) unexecuted design for a monumental pyramid of 1814 is the most Egyptian version of the pyramid with four porticos. The hexastyle in antis columns are set in wide battered pylon-porticos each flanked by a pair of sphinxes.

Designs by Giuseppe Martelli (1792–1876) dating from the second decade of the nineteenth century contain some Egyptian elements. His Tempio of 1815 has a massive pylon-like centre-piece with a coved cornice and a winged globe over the distyle in antis entrance.[32] Another Italian, Luigi Cagnola (1762–1833), produced a remarkable building called La Rotonda at Inverigo near Milan in 1813. Egyptian figures and a caryatid porch are found in this strangely eclectic design.[33]

The former library at Devonport, built to designs of John Foulston (1772–1842) in 1823, is somewhat more correctly Egyptianising than Robinson's curious offering. Yet Foulston's work at Devonport was part of a group of buildings: a range of houses in Roman Corinthian; a Greek Doric town hall and column; an Oriental chapel; and an Egyptian library. This historicism, giving a wide stylistic choice, was justified by Foulston himself. He said that if

> edifices, exhibiting the various features of the architectural world, were erected in conjunction, and skilfully grouped, a happy result might be obtained . . . (Foulston) . . . was induced to try an experiment (not before attempted) for producing a picturesque effect, by combining in one view, the Grecian, Egyptian, and a variety of the Oriental . . .[34]

Foulston was therefore working within the picturesque tradition. However, his Egyptian library reminded critics more of Piccadilly than of Egypt,[35] and can be compared unfavourably with Regency Greek Revival work, which was far more scholarly (Fig. 9). The interior of the Library had cavetto cornices, torus mouldings, winged discs, and other Egyptian features (Pl. 118).

Much wilder than Foulston's work is the Egyptian House in Penzance (c. 1835), a design rather closer to Bullock's Egyptian Hall in Piccadilly (Pl. 119). This has corbel-arched windows, cavetto cornices, torus mouldings, winged discs, and much coarse Egyptianising. The Egyptian House in Penzance was acquired by the Landmark Trust and restored in 1973. It was built in Chapel Street for George Lavin as a museum and geological repository. This building comes into Professor Carrott's 'Commercial Picturesque' tradition, as did No. 144 Fore Street, Exeter, which acquired Egyptian features around 1830, mentioned by Pevsner in South Devon.[36] Also from the 1830s (or possibly 1825) is an Egyptian façade applied to a house in Hertford (No. 42, Fore Street), with architraves, cornice, and a shop front in the Egyptian style, but this is merely applied ornament to a standard late-Georgian façade (Pl. 120).

Much more correctly archaeological, but firmly within the 'Commercial Picturesque' tradition, is the extraordinary Flax Mill in Leeds of 1842, designed by Joseph Bonomi, Jr (not his brother Ignatius).[37] Joseph Bonomi, Jr (1796–1878) was a distinguished Egyptologist and was the second curator of Sir John Soane's Museum. His mother was a cousin of Angelica Kauffmann. According to the Companion to the Almanac of 1844, and the Transactions of the Society of Biblical Archaeology of 1879, Joseph Bonomi designed the 'Temple Mills, Leeds' in association with the architect James

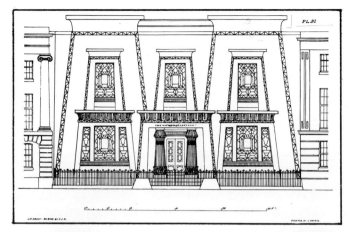

Figure 9 The main elevation of Foulston's Egyptian Library at Devonport, of 1823, from his *The Public Buildings Erected in the West of England* (*RIBA British Architectural Library*).

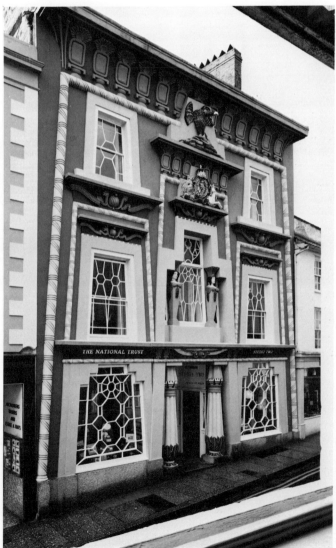

Plate 119 The Egyptian House in Penzance (*National Trust*).

Plate 120 (*left*) The Egyptian House at No. 42, Fore Street, Hertford.

Plate 121 (*below*) The Egyptian 'Temple Mills' in Leeds, of 1842, by Joseph Bonomi, and James Combe of Leeds. The building is based on the Temple of Antaeopolis from the *Description*, and on the Temple of Horus at Edfu.

Plate 122 (*opposite*) Isambard Kingdom Brunel's Clifton Suspension Bridge at Bristol, of 1831. Note the pylon-piers, with winged globes, cavetto cornice, and sphinxes. The massive blocks anchoring the cables resemble sarcophagi (*City of Bristol Museum & Art Gallery*).

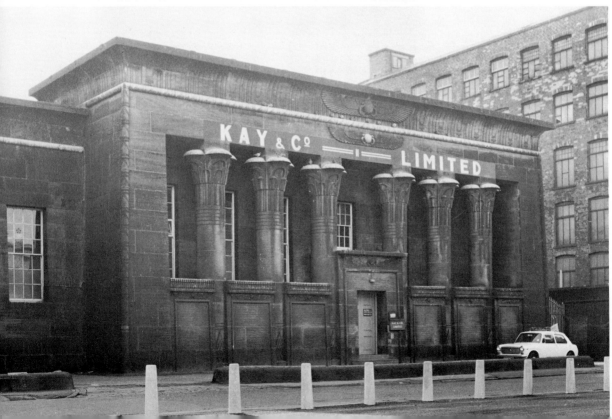

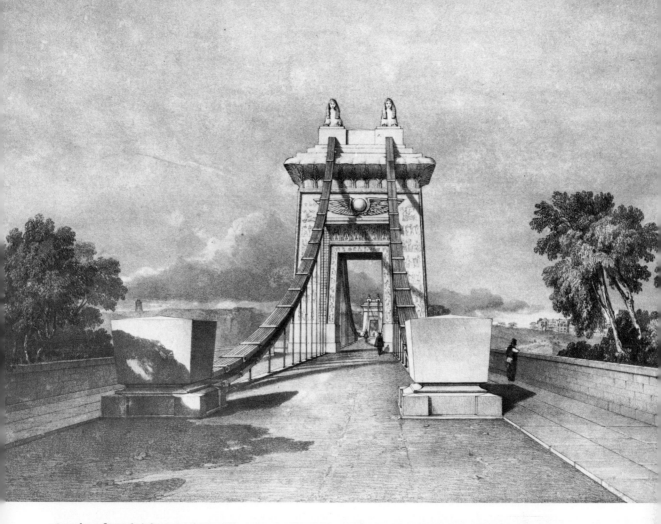

Combe of Leeds (Pl. 121). This mill has two buildings: an office block, and the factory. Bonomi had been to Egypt, and so had David Roberts (1796–1864), whose drawings appear to have been known to Bonomi. The sources for the office building are the temple of Antaeopolis as recorded in the *Description,* and the temple of Horus at Edfu. The factory block is clearly derived from the 'Typhonium' at Dendera, published in the *Description.* The detail of both the office and factory blocks is so scholarly that much of the information must have come from the records of actual buildings in the *Description* by the Commission des Monuments d'Egypte and from first-hand observation by Bonomi and Roberts. The latter produced a number of imaginative pictures, notably the 'Departure of the Israelites from Egypt' of 1829, that show correctly observed Egyptian architecture on a scale worthy of Martin.

Again, like libraries and learning, there was an association of the Egyptian style with Egypt in that flax and linen were produced there, but the buildings must have been primarily intended to draw attention to the firm. When first built, the flat roof of the mill provided grazing for animals, and the cast-iron columns also doubled as drainage channels. According to W. H. Smyth, in *Aedes Hartwellianae,* 1851, Bonomi also designed an Egyptian building over a spring at Hartwell House, Buckinghamshire, in 1851.[38] The idea of Egyptian architecture to suggest strength, solidity, and durability could mean that it would be appropriate to structures such as mills, railway stations, bridges, and so on, and therefore was ideal for a factory. Two early suspension bridges with Egyptianising aspects have been identified. They are Brighton Chain Pier of 1823 by Captain Samuel Brown, and the Clifton Suspension Bridge, designed in 1831 (but started in 1836 on site), by Isambard Kingdom Brunel (Pl. 122). The pylons were ready in 1840, and work was only

133

resumed in 1861 under Hawkshaw and Barlow, to be completed in 1864. The Brighton Pier had four pylons that were built out into the sea, and Brunel's scheme for Clifton had pylons with sphinxes on top of them, hieroglyphs, and winged orbs over the pylons. The design was 'quite extravagantly admired by all',[39] although it was never carried out quite as originally intended. The pylon was thought to be an ideal form for suspension bridges, and so many bridges have Egyptianising elements, like that at Anzio with lotus columns and sphinxes.[40] Henry-Russell Hitchcock has reported another Egyptian suspension bridge near Leningrad.[41]

The Egyptian Revival in the nineteenth century seems first of all to have sought novel motifs for decoration and architecture in a search for the picturesque. After the Napoleonic campaigns a more scholarly approach prevailed, and the scholarly archaeological qualities contributed to the cult of the picturesque. The possibilities of Sublime effects and of associational ideas in Egyptian forms were explored: as previously noted, Charles Heathcote Tatham, in his *Etchings, representing the best examples of Grecian and Roman Architectural Ornament; Drawn from the Originals, and chiefly collected in Italy, before the later revolutions in that country,*[42] pays tribute to Piranesi.

Egyptianising elements occur in Germany too, in much the same way as in France. The bridge at Monbijou by Carl Gotthard Langhans (1732–1808) and Johann Gottfried Schadow (1764–1850) had paired sphinxes, and Schadow used sphinxes to embellish the entrance to Steinhöfel Park.[43] The palace at Kassel had an Egyptian Room of 1830, and Egyptianisms occurred in Vienna, where they were already known from the time of Fischer von Erlach. A synagogue of 1798 at Karlsruhe designed by Friedrich Weinbrenner (1766–1826) had pylons at the gate,[44] and the same architect used a pyramid of black stone for his monument to Margrave Karl-Wilhelm of 1823 near the intersection of the Karl-Friedrich Strasse with the Kaiser-Strasse. Pyramids were also used in designs for the Prince von Schwarzenberg at Leipzig of 1815,[45] and for the 'Pyramid of Austerlitz' which was erected by Marmont's troops in honour of Napoleon's coronation, and which lies between Utrecht and Arnhem, near the Moravian settlement of Zeist.[46] It is today somewhat eroded and shapeless. The design by Gilly for the monument to Frederick the Great has been mentioned, but its pyramidal composition and use of obelisks need to be emphasised. More overtly Egyptianising were Karl Freiherr Haller von Hallerstein's (1774–1817) first designs in 1814–15 for Walhalla near Regensburg that included a propylaeum with pylons. Although the Walhalla itself was a Greek temple set on a series of mighty platforms, a type of composition clearly inspired by Gilly's 1797 design for the monument to Frederick the Great,[47] the great propylaeum was daringly Egyptian, with a central pylon-gate higher than those on either side. The lodges, and the platforms themselves, are similar in shape to Egyptian mastaba tombs. Haller von Hallerstein was the most Egyptian-minded of the great German Romantic Classicists in his architectural works, as can be seen from his Walhalla project and in the designs for the Munich Glyptothek of 1814, which is probably[48] derived from Denon, and based on the Dendera temples. The Glyptothek design embraces both Egyptian and Greek elements.

Among the most imaginative schemes where Egyptian Revival forms were used in the German-speaking countries, the stage-designs must take pride of place, and perhaps of all inspirations of Egyptianising stage-sets, Mozart's *Die Zauberflöte* proved the most potent. Only three years after the death of Mozart, Giulio Quaglio III (1764–1801) designed stage-sets for *Die Zauberflöte* that were shown at the Nationaltheater, Mannheim, in 1794. Quaglio was official painter to the Court Theatre in Mannheim, where he specialised in flat, realistic architectural and landscape scenery. Although he was primarily a user of Roman motifs, he was not averse to exotic styles, including Gothic, and he used a design for a vault inside a pyramid for Act II, Scene 20, of *Die Zauberflöte* (Pl. 123).[49] The libretto states that the Scene is *'Ein seltsames Gewölbe',* or 'a strange vault'. The term 'Gewölbe' in German also means 'a family vault', so the funereal character can be suggested by the pyramid with a vault inside it, a favourite Neoclassical device.

At Kismarton *Die Zauberflöte* was given on 10 August 1804 under the direction of Johann Nepomuk Hummel, with sets by Carl Maurer, who was engaged by Prince Miklós III in 1802 as Hofkammermaler. Maurer's designs are preserved in a sketch-book 'Handzeichnungen Zum Theater Gebrauch von Carl Maurer, Fürstlich Esterhazyscher Hof Theater Decorateur', dated

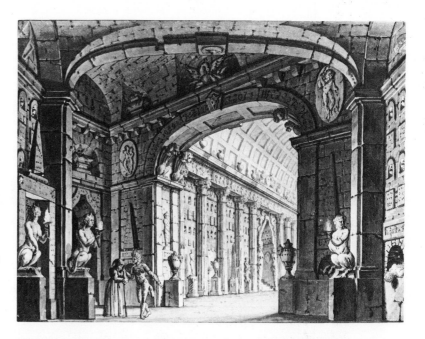

Plate 123 A design by Giulio Quaglio III (1764–1801) for the Nationaltheater, Mannheim, production of Mozart's *Die Zauberflöte*, in 1794. The subject is a Vault inside a Pyramid, a favourite Neoclassical device, used in Act II, Scene 20. Here in *Ein seltsames Gewölbe*, the priests sing the chorus *O, Isis und Osiris welche Wonne* (*Deutsches Theatermuseum, Munich. Früher Clara Ziegler-Stiftung, No. 5. Qu. 44/11*).

Eisenstadt 1812, and now in the Caplovic Library. The sets were strongly Egyptianising, with pyramids, very unauthentic and ill-observed hieroglyphs, sphinxes, obelisks, a Bernini-Poliphilus elephant with an obelisk on its back, a Piranesian Carceri-like interior, a many-breasted bust over a fountain, and corbelled openings. Maurer's designs were fairly typical of late eighteenth- and early nineteenth-century Egyptianising sets, and, for the most part, are somewhat bucolic in appearance[50] (Pls. 124–6).

Far more professional, and of a quality that is outstanding, are the sets by Karl Friedrich Schinkel (1781–1841) for *Die Zauberflöte*. They were designed in 1815, when Schinkel became responsible for the stage-décor under the general management of Count Brühl at the Berlin Königliche Schauspiele-Opernhaus. The Singspiel was given on 16 January 1816 to celebrate the coronation of the King of Prussia as well as the peace after the Napoleonic Wars, and the production set a standard for the next few years, during which Schinkel produced designs for over thirty productions. Schinkel chose the Egyptian style for historical correctness as well as for the grandeur of the occasion, and produced a masterpiece of Neoclassical theatre decoration in which architectural and historical accuracy were achieved. Yet the designs are magnificent without being slavish to archaeological correctness. They were certainly much admired at the time: the *Dramaturgisches Wochenblatt* of Berlin praised the starry skies, the dark vaults, the super-natural atmosphere, the splendid sphinxes, the colossal temple of the sun, and the contrasts of light and dark. The 'Hall of Stars of the Queen of the Night' (Act I, Scene 6), as conceived by Schinkel (Pl. 127), is a dark vault in the form of a hemi-dome, illustrated by stars that follow the structure of the dome. In the centre floats the Königin der Nacht, standing on a bright crescent moon that appears above the clouds.[51] The Isiac allusions will be obvious, as well as the image of the Immacolata from Baroque and Rococo ceilings of the previous two centuries. The identification in such a startling manner of the Queen with the Immacolata emphasises the inner meaning of *Die Zauberflöte*. The Queen and her forces represent Roman Catholicism, 'Blendwerk und Aber-glauben' (Trickery and Superstition), and anti-Masonic elements. The final triumph of Reason, Wisdom, and Love in the Great Temple dispels the forces of darkness, unreason, and hatred.

Schinkel's gouache drawings are superb. The 'Garden with Sphinx'[52] in the moonlight (Act II Scene 7) is one of his most unforgettable compositions (Pl. 128). The set represents the gardens of the Temple, and is a splendid design, illumined by the moonlight of a clear southern sky. The enormous sphinx on a high podium is placed on an island in a lake, and suggests stillness and solemnity.

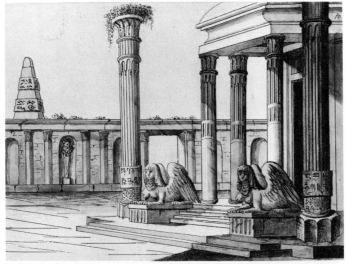

Plate 124 A design for Mozart's *Die Zauberflöte* by Carl Maurer, from the 'Handzeichnungen Zum Theater Gebrauch von Carl Maurer, Fürstlich Esterhazyscher Hof Theater Decorateur' dated 'Eisenstadt, 1812'. The design is page 10 of Maurer's sketch-book, and shows decorations for the theatre at Kismarton. Note the winged sphinxes, fake hieroglyphs, steep banded pyramid, and segmental top to the portico (*Čaplovičová Knižnica, 026 01 Dolný Kubín. Matica Slovenská*).

Plate 125 A design for Mozart's *Die Zauberflöte* by Carl Maurer from his sketch-book of 1812, page 15. The scene is a moonlit garden. The obelisk and the many-breasted figure over the fountain should be noted (*Čaplovičová Knižnica, 026 01 Dolný Kubín. Matica Slovenská*).

Plate 126 A design for Mozart's *Die Zauberflöte* by Carl Maurer from his sketch-book of 1812, page 16. The scene is that of the Trial by Fire and Water (Act II, Scene 27). Note the corbelled arches that were to become a feature of the Egyptian Revival and of Art-Déco work (*Čaplovičová Knižnica, 026 01 Dolný Kubín. Matica Slovenská*).

Plate 127 (above) The Queen of the Night, with crescent moon and stars. Compare with pl. 44. The 1815 gouache design by Karl Friedrich Schinkel for Act I, Scene 6, of Mozart's *Die Zauberflöte* produced at the Berlin Königliche Schauspiele-Opernhaus in 1816 (*Staatliche Museen zu Berlin. Kupferstichkabinett und Sammlung der Zeichnungen No. 22C. 121. X*).

Plate 128 Sarastro's Garden, with lake and Sphinx. The 1815 gouache design by Karl Friedrich Schinkel for Act II, Scene 7, of Mozart's *Die Zauberflöte*, produced at the Berlin Königliche Schauspiele-Opernhaus in 1816 (*Staatliche Museen zu Berlin. Kupferstichkabinett und Sammlung der Zeichnungen No. 22C. 102. Pass.*).

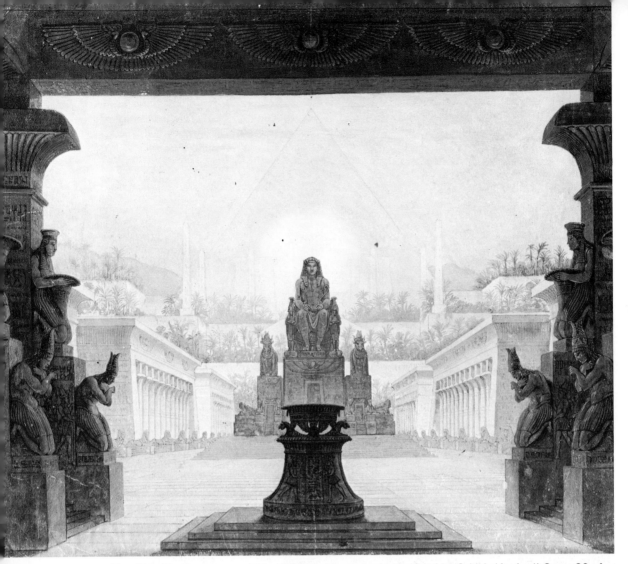

Plate 129 The Sonnentempel. The 1815 gouache design by Karl Friedrich Schinkel for Act II, Scene 30, of Mozart's *Die Zauberflöte,* produced at the Berlin Königliche Schauspiele-Opernhaus in 1816. Note the Egyptian frame, the winged orbs, the colossal statue of Osiris, the avenus of sphinxes, the temple colonnades, the pylons, obelisks, and huge pyramid (*Staatliche Museen zu Berlin. Kupferstichkabinett und Sammlung der Zeichnungen Th. 3.*).

The 'Temple of the Sun',[53] the last set of *Die Zauberflöte,* has an Egyptian architectural frame, with Egyptian colonnades flanking a colossal statue of Osiris. In the background is a vast pyramid (Pl. 129). The splendour of this set owes much to its historical connexions, but the quality of colour and of light lift it above archaeology to a work of original genius.[54] Schinkel's designs were published by Thiele in Berlin in 1823. Some of the sets were luxuriantly tropical, possibly suggested by Humboldt's travels, as in the 'Palmenwald' for Act II, Scene 1, where a distant view of a Philae-like complex of temples appears in the centre. The Queen of the Night's star-crowned hemi-dome appears again in the background of the set for Act I, Scene I, but the architectural centrepiece is a menacing colonnaded building representing the Palace of the 'Sternflammende Königin'. The columns and crowning cornice are Egyptianising, yet Schinkel transformed the archaeological aspects with crouching figures suggestive of modern illustrations to science-fiction futuristic tales (Pl. 130). More correctly Egyptianising is the set for Act II, Scene 28, which shows the exits from the tunnels of fire and water through which Pamina and Tamino pass to reach the temple above (Pl. 131).

138

Simon Quaglio (1795–1878) produced pen and water-colour designs of sets for *Die Zauberflöte* to grace the opening of the Nationaltheater in Munich in 1818. These sets herald his work for later Romantic operas, including Carl Maria von Weber's *Der Freischütz* and *Oberon* of 1822 and 1826 respectively. The magnificent 'Vault inside a pyramid'[55] (Act II, Scene 20) (Pl. 132) has a deep air of mystery, and the inspiration is Egyptian. Dr Manfred Boetzkes has said that 'Quaglio's stage sets are fully equal in authority to those of Schinkel . . . Quaglio, like Schinkel, seeks inspiration from Egyptian architecture, and his success in doing so may be seen from impressive studies like the Temple Forecourt and imaginative works like the Egyptian Interior'.[56] The 'Egyptian Interior' is, of course, the Prächtiges Zimmer in Sarastros Palast of the libretto. The Forecourt of the Temple[57] (Act II, Scene 2) (Pl. 133) is a distinguished Egyptianising design, as is the Egyptian Interior[58] (Act I, Scene 9)[59] (Pl. 134).

There were other instances of Egyptianising designs for the stage. Norbert Bittner (1786–1851), the Viennese architectural painter and etcher, produced etchings of stage-designs after Josef Platzer and Antonio di Pian, including an 'Egyptian Room'[60] (Act I, Scene 9) (Pl. 135) and 'Vaults between the Pyramids'[61] (Act II, Scene 20), for the Kärntnertortheater, Vienna, production of *Die Zauberflöte* in 1818[62] (Pl. 136).

Friedrich Christian Beuther (1777–1856) worked first at Darmstadt as a stage-designer, and later moved to Wiesbaden, Bamberg, and Würzburg. In 1815 he moved to the Hoftheater at Weimar, and in 1818 to the Theater August Klingemann in Brunswick. His work was influenced by his teacher, Giorgio Fuentes, and Klingemann himself was impressed by his archaeologically

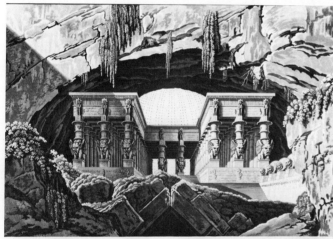

Plate 130 Schinkel's set for Mozart's *Die Zauberflöte*, Act I, Scene 1, in the 1816 production at the Berlin Königliche Schauspiele-Opernhaus. This was the entrance to the domain of the Queen of the Night, and the Egyptianising building has been made more menacing by the use of crouching, sinister figures. From the published version of the designs by Thiele, Berlin, 1823 (*Deutsches Theatermuseum, Munich. Früher Clara Ziegler-Stiftung, No. A 1627*).

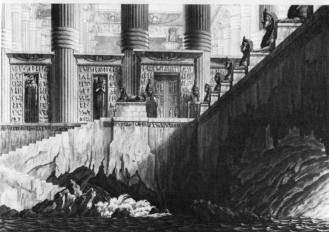

Plate 131 Schinkel's set for Mozart's *Die Zauberflöte*, Act II, Scene 28, in the 1816 production at the Berlin Schauspiele-Opernhaus. This was the penultimate scene in which Pamina and Tamino arrive at the entrance to the Temple of the Sun having passed their Trials by Fire and Water. From the published version of the designs by Thiele, Berlin, 1823 (*Deutsches Theatermuseum, Munich. Früher Clara Ziegler-Stiftung. No. A. 1398*).

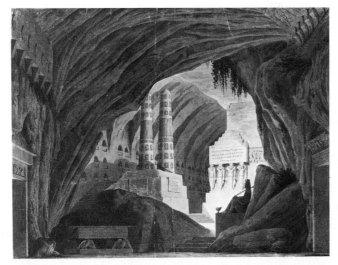

Plate 132 A pen and water-colour design by Simon Quaglio (1795–1878), featuring a Vault inside a Pyramid in Mozart's *Die Zauberflöte* (Act II, Scene 20), for the production at the Nationaltheater, Munich, in 1818 (*Deutsches Theatermuseum, Munich. Früher Clara Ziegler-Stiftung. No. 5. Qu. 530*).

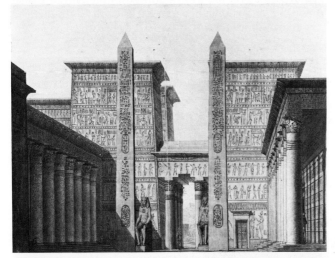

Plate 133 A pen and water-colour design by Simon Quaglio, featuring the Forecourt of the Temple in Mozart's *Die Zauberflöte* (Act I, Scene 2), for the production at the Nationaltheater, Munich, in 1818 (*Deutsches Theatermuseum, Munich. Früher Clara Ziegler-Stiftung. No. 5. Qu. 532*).

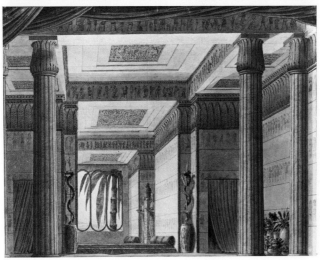

Plate 134 A pen and water-colour design by Simon Quaglio, featuring an Egyptian Interior in Mozart's *Die Zauberflöte* (Act I, Scene 9), for the production at the Nationaltheater, Munich, in 1818 (*Deutsches Theatermuseum, Munich. Früher Clara Ziegler-Stiftung. No. 5. Qu. 525*).

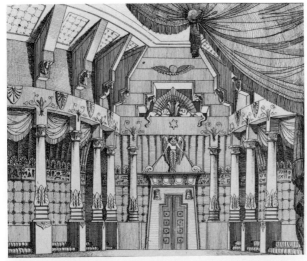

Plate 135 Etching after Josef Platzer and Antonio di Pian by Norbert Bittner (1786–1851) of the Egyptian Room, known as the Prächtiges Zimmer in Sarastros Palast, for the 1818 production of Mozart's *Die Zauberflöte*, at the Kärntnertortheater, Vienna, Act I, Scene 9 (*Theatermuseum des Institutes für Theaterwissenschaft der Universistät Köln. No. G. 16939a*).

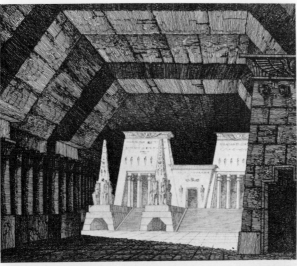

Plate 136 Etching after Josef Platzer and Antonio di Pian by Norbert Bittner of the Vaults between the Pyramids for the 1818 production of Mozart's *Die Zauberflöte*, at the Kärntnertortheater, Vienna, Act II, Scene 20 (*Theatermuseum des Institutes für Theaterwissenschaft der Universistät Köln. No. G. 16939b*).

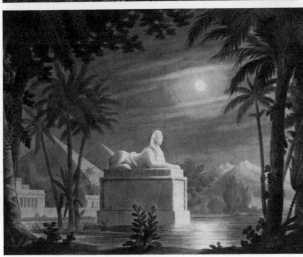

Plate 137 The tempera and water-colour design by Friedrich Christian Beuther (1777–1856) showing the Garden with Sphinx at Night for the 1821 production of Mozart's *Die Zauberflöte* (Act II, Scene 7) at the Kurfürstliches Hoftheater, Kassel. The scene is described as 'Ein Garten, worin Pamina schläft' in the Libretto (*Theatermuseum des Institutes für Theaterwissenschaft der Universistät Köln. No. G. 16928a*).

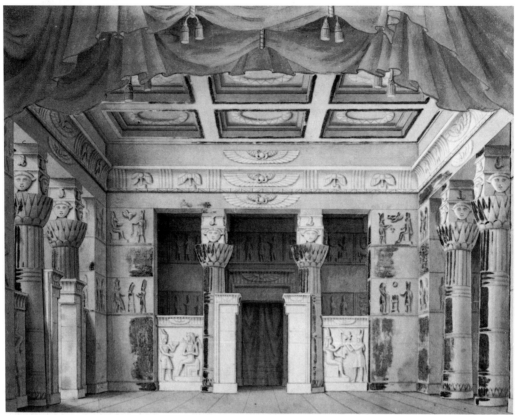

Plate 138 The tempera and water-colour design by Friedrich Christian Beuther for the Egyptian Room, the Prächtiges Zimmer in Sarastros Palast, for the 1817 production of Mozart's *Die Zauberflöte* (Act I, Scene 9) at the Grossherzogliches Hoftheater, Weimar, and for the 1821 production at the Kurfürstliches Hoftheater, Kassel (*Theatermuseum des Instituts für Theaterwissenschaft der Universität Köln. No. G. 16927*).

correct Classicism. From 1823 until his death in 1856 Beuther worked at Kassel. His designs for the 1821 production of *Die Zauberflöte* at the Kurfürstliches Hoftheater in Kassel demonstrates his interest in geography, history, and aesthetic beauty. He had a high regard for his own calling, and emphasised the importance of stage-design as the art which combined all the visual arts in one totality. He published (1822) *Bemerkungen und Ansichten über Theatermalerei* in which his ideas (and many of Goethe's) are expressed. The 'Garden with Sphinx at Night'[63] from the 1821 Kassel production for Act II, Scene 7 (Pl. 137), is not as powerful an image as Schinkel's design mentioned earlier; nor is his 'Egyptian Room'[64] for Act I, Scene 9 (Pl. 138) of *Die Zauberflöte,* originally produced for the Grossherzogliches Hoftheater, Weimar, in 1817, and re-used in the Kassel production of 1821.[65] Paolo Landriani (1755–1839) designed a portico in the Egyptian style for La Scala, Milan, that is now in the Museo Theatrale alla Scala, Milan; but by 1836, when Jakob Orth (1780–1861) produced his 'Temple of the Sun'[66] design for Act II, Scene 30 of *Die Zauberflöte* at the Grossherzogliche Nationalbühne, Mainz, designs were becoming less Egyptian. Orth's manner adheres to strict Classical motifs, but occasionally influences from Beuther can be detected in his work.

The importance of the Egyptian taste in furniture design cannot be stressed too strongly. Rudolf Ackermann (1764–1834) published the *Repository of Arts, Literature, Commerce, Manufacturers, Fashions and Politics* in monthly instalments between 1808 and 1828, most numbers of which include plates showing furniture and interior decorations. From 1812, the *Repository* carried plates showing furniture in the French Empire style, based on Percier and Fontaine's *Recueil de Décorations Intérieurs.* One of the plates, a secretaire-bookcase, is described as being 'after the style

so exquisitely perfected by M. Persée (sic), the French Architect to Buonaparte'.[67] During 1812 and 1813 several Egyptianising items are described. Something of an archaeological approach to furniture design appears in Sheraton's *The Cabinet Dictionary* of 1803,[68] although Sheraton's designs do not show a particularly good comprehension of the style. In his *The Cabinet-Maker, Upholsterer and General Artist's Encyclopaedia* of 1804-6, Sheraton illustrated the Egyptian taste with sphinx heads and feet used as capitals and bases on pilasters. These motifs were to be developed by Henry Holland (who, however, retained much Classicism, so that his Egyptianisms do not really convince), and by Thomas Hope, who designed the most archaeologically correct furniture.[69] Hope's house in Duchess Street that included many items with Egyptianising elements was opened for public inspection in 1804, three years before the publication of his book that illustrated the interiors and furnishings. Wyatt Papworth, Editor of the Architectural Publication Society's *Dictionary of Architecture,* states that the extraordinary influence of Percier and Fontaine in France 'was paralleled' in England 'by that of Tatham. To him perhaps more than to any other person, may be attributed the rise of the "Anglo-Greek style" '.[70] Tatham's publications, including his *Etchings of Ancient Ornamental Architecture Drawn from the Originals in Rome and other Parts of Italy* of 1799 and his *Etchings* volume of 1806, inspired many precise pieces of furniture as well as the details, including monopodia supports, lions' masks, leopards' heads, and terminal figures, that became features of the Neoclassical style, and that included items based on Egyptian or Egyptianising antiquities.

The Egyptian Revival in nineteenth-century English furniture design sprang from an archaeological interest and the popularity of Egyptian motifs after Nelson's victories at the Nile. Yet, as we have seen, the vogue for things Egyptian went back much further, and many Egyptian features were familiar in the vocabulary of Classical taste. The opening of the gallery, which included Egyptian antiquities, in the Capitoline Museum in Rome in 1748, stimulated further interest in Egyptian objects, and Tatham's drawings of Egyptian antiquities which he sent to Henry Holland from Rome clearly influenced design in England. At Southill, Holland used Egyptianising elements, including lotus pedestals and an Egyptian fireplace.[71] The translation by F. Blagdon of Denon's *Voyage dans la Basse et la Haute Egypte* in 1802 aroused further interest among the English cognoscenti. Sheraton's publications attempted to include some of the new trends, and Chippendale the Younger made two writing tables for Stourhead in 1804 that featured Egyptian heads.[72] The scholarly use of Egyptianising features in English furniture achieved new heights in Thomas Hope's *Household Furniture and Interior Decoration, Executed from Designs by Thomas Hope.* With Hope's designs, 'Canopic' vases, winged globes, Egyptian figures, monopodia, leopards' heads and feet, lotus plants, couchant lions, Egyptian deities, hieroglyphs, rosettes, palms, and other motifs became established and clarified. Hope's Egyptian furniture indicates the tendency towards simplicity of form, robustness of construction, and the 'emphasis on unbroken surfaces marked by straight lines, which distinguishes the best Regency furniture'.[73] George Smith's *Household Furniture* influenced the furniture trade, and the Egyptian taste became more widely available to the general public. Lion supports, monopodia, and Egyptian heads and feet as caps and bases on pilasters for bookcases and cupboards, were popular. The association of Egypt with learning ensured that Egyptian heads or masks were often used in library furniture, while pylon motifs appeared in fireplaces, doorcases, gateposts, and writing tables. Griffins with eagle-wings and the bodies of lions, serpents, scarabs, and other motifs appeared in abundance. The lotus flower and the lotus bud were used as capitals and bases, as feet, as ornaments dividing columns or pilasters in two, and as the decorative element on the crossing of supports in cross-framed stools.[74]

The Royal Pavilion at Brighton contains a number of items with Egyptianising motifs well to the fore, although most of these have been introduced in recent years, and were not there originally. There was, however, a room described as 'An Egyptian Gallery' in the Royal Pavilion, dating probably from the 1802 reconstruction. No accurate conception of how this room appeared exists at present, but Attree's *Topography of Brighton* of 1809 described it as 'the Egyptian Gallery . . . the walls of which are covered with a historical paper'. It occupied the site of the present North Drawing Room.

Some of the Egyptianising furniture at present in the Royal Pavilion deserves mention here.

The Anteroom and King's Bedroom has a pair of elbow chairs in wood grained to resemble rosewood; the back and back legs with gilt reeding, pine-coned finial, and ball-foot; the reeded arm-rests terminate in leopards' heads supported on Egyptian columns with lotus caps (Pl. 139). A variant of this design appears in Thomas Hope's *Household Furniture* of 1807, Plate 22. The seat-rail has studs derived from doorbolt designs, and the legs have gilt ribbing. One of the chairs in the Royal Pavilion has the label of James Newton, upholsterer and cabinet-maker,[75] while the other has names recorded in pencil on the underside, one of which is Albert Rawlins, and the date 1806, October 6, an interesting point when one remembers that Hope's book appeared in 1807.[76]

The South Drawing Room at the Royal Pavilion contains the Dolphin Furniture, presented in 1813 to Greenwich Hospital by the widow of Mr John Fish in memory of Lord Nelson, and currently the property of the Admiralty. The gilding, dolphins, acanthus leaves, sphinxes, cornucopiae, and other ornament render it one of the most interesting suites of Regency furniture in England. The centrepiece,[77] or *torchère,* is a pedestal surmounted by an urn. The upper part is supported by three dolphins and is of bronze, partly gilt, and decorated with sphinxes and crocodiles (a favourite Nilotic motif from Classical times) (Pl. 140). The suite was intended for ceremonial use at Greenwich Hospital. There were several designs of this type, with motifs of dolphins, anchors, and cables, in Sheraton's *Cabinet Dictionary* of 1803. The torchère is signed by William Collins of London (perhaps a relation of the cabinet-maker William Collins of Tothill Fields, who died in 1793), but appears to be quite distinct from the rest of the set, which was probably by a different maker.

The Saloon of the Royal Pavilion[78] contains a couch in the form of a river boat, on crocodile feet, in green-painted wood with carved gilt reeding and gilded enrichments featuring reeds, serpents, shells, and dolphins (Pl. 141). It dates from *c.* 1806–10,[79] and is a handsome piece even for its period. The ground-floor suite comprising the Anteroom, Library, and King's Bedroom contains the clock, designed by Thomas Hope, of bronze, ormolu, and rosso antico marble (Pl. 104). This clock is illustrated in two plates of Hope's *Household Furniture,*[80] and he describes it as 'carried by a figure of Isis, or the moon, adorned with her crescent.' In fact, it was never 'adorned with her crescent', but was shown with the cow's horns holding the moon disc, now missing.[81] There is no sign of any attachment to the head, although this may be due to skilful repair work. The King's Apartments also contain a pair of torchères in gilt wood based on those in Plate 28 of Thomas Hope's *Household Furniture* (Pl. 142). The parts derive from the Egyptian lotus and the bolts in the doors of a Greek temple.[82] In the same section of the Royal Pavilion is a pair of wall-lights in carved, ebonised, and gilt woods, with carved and gilt decorations of Graeco-Roman form based on door-bolts.[83] Again, these are based on the illustrations in Thomas Hope's *Household Furniture.*[84] The shields beneath with lotus decoration are similar to those in Plate 6 of Hope's book. The apartments also contain two other Egyptianising torchères in carved, ebonised gilt wood, consisting of columns supported by three female Egyptian figures. The circular tops are decorated with palm and acanthus motifs; the circular drum-like base stands on three carved lion-paw feet. The Egyptian figures have heads and feet exposed, and elongated inverted obelisks sheathing the bodies; the chests and shoulders are clad in the Greek *peplos*[85] (Pl. 143). Egyptian heads occur on the supports for candleholders as part of candelabra in the South Drawing Room of the Royal Pavilion (Pl. 144). The candelabra stand on torchères of carved wood and gilt *gesso,* in the form of the Three Graces, the figures derived from Germain Picon's monument for the heart of Henri II, of 1560. The torchères are signed 'Robt. Shout', and dated 1803.[86]

Perhaps even more remarkable is the settee in the Egyptian taste, of about 1815, in mahogany with brass inlay, the arms and feet in lotus form, in the Anteroom and King's Library of the Royal Pavilion[87] (Pl. 145). This fine piece of furniture shows the Egyptian Revival in its most refined and delicate phase. The King's Library has an ornamental mirror with pilasters by Robert Jones which are also Egyptianising (Pl. 146).

One of the finest Egyptianising pieces can be found in the Royal Collections. It is a magnificent centrepiece, described in a catalogue of gold, silver, and gilt bronze objects published by Garrards in 1914 as a large 'Egyptian Temple or incense burner with figures supporting branches for eight lights.' According to Mr Geoffrey de Bellaigue, this centrepiece[88] was bought by George IV in

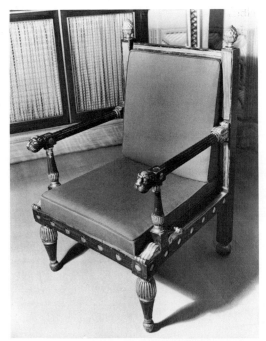

Plate 140 A detail of the centrepiece of the Dolphin Furniture in the Royal Pavilion, showing the sphinxes and a crocodile. These allude to Nelson's campaign in Egyptian waters (*Reproduced by kind permission of the Trustees of Greenwich Hospital*).

Plate 139 An elbow chair in wood grained to resemble rosewood. Note the Egyptian columns with lotus caps and the leopards' heads (*Royal Pavilion, Art Gallery and Museums, Brighton*).

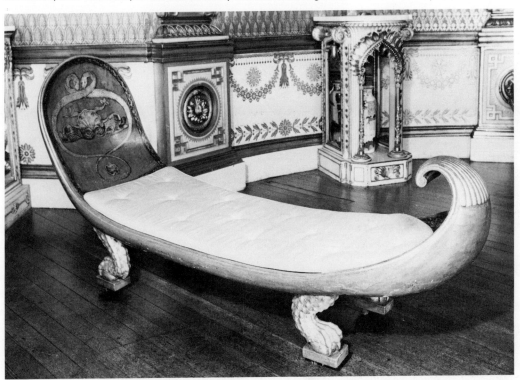

Plate 141 A couch in the form of an Egyptian river boat, on crocodile feet, of green-painted wood with carved gilt reeding and gilded enrichments, featuring reeds, serpents, and other motifs. The date is about 1806–10 (*Royal Pavilion, Art Gallery and Museums, Brighton*).

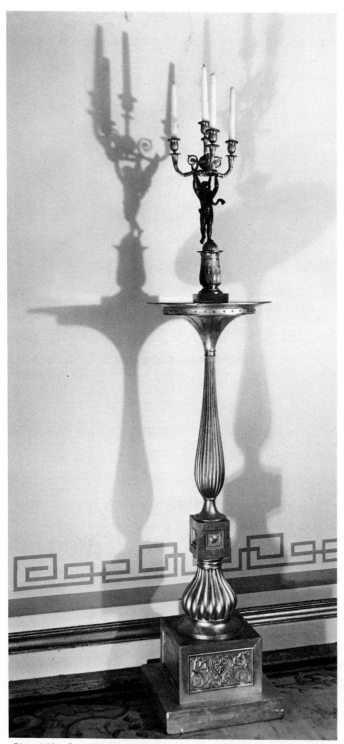

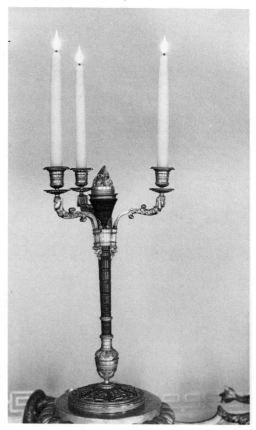

Plate 143 (*opposite right*) Wall light of carved, ebonised, and gilded woods, with carved and gilt decorations of Graeco-Egyptian form. The door-bolt portion is based on Plate 8 in Hope's *Household Furniture*. Compare with Fig. 2. On the *Left* is one of a pair of torchères in carved, ebonised, gilt wood, with a column supported by three female Egyptian figures. The circular tops are decorated with palm and acanthus motifs (*Royal Pavilion, Art Gallery and Museums, Brighton*).

Plate 144 (*below*) Egyptianising heads on the supports for candleholders (*Royal Pavilion, Art Gallery and Museums, Brighton*).

Plate 142 One of a pair of torchères in gilt wood based on Hope's design for Duchess Street (See Plate 28 in Hope's *Household Furniture*) (*Royal Pavilion, Art Gallery and Museums, Brighton*).

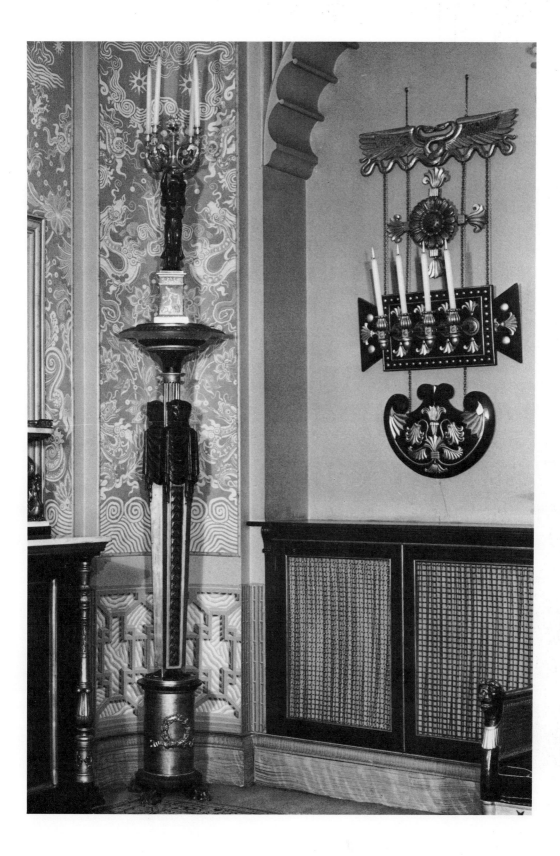

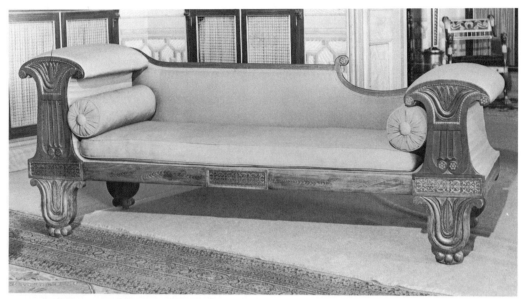

Plate 145 (*above*) Settee in the Egyptian taste in mahogany with brass inlay, of about 1815. Note the lotus forms of the arms and feet (*Royal Pavilion, Art Gallery and Museums, Brighton*).

Plate 146 (*below*) Details of a mirror-surround in the King's Library in the Royal Pavilion at Brighton, showing Egyptianising detail (*Royal Pavilion, Art Gallery and Museums, Brighton*).

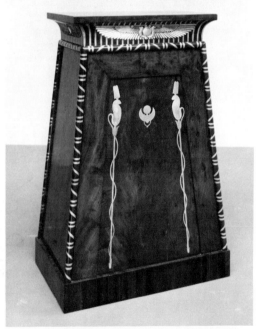

Plate 148 A medal cabinet of mahogany with silver inlay and silver mounts, part of a set of furniture in the Egyptian taste commissioned by Dominique Vivant Denon, and executed by François-Honoré-Georges Jacob-Desmalter (1770–1841). The mounts are by Martin-Guillánne Biennais, and the design was by Percier. The pylon is derived from the illustration of Apollonopolis in Denon's *Voyage dans la Basse et la Haute Egypte* (*Metropolitan Museum of Art, New York. Bequest of Collis P. Huntington, 1926. No. 26.168.77*).

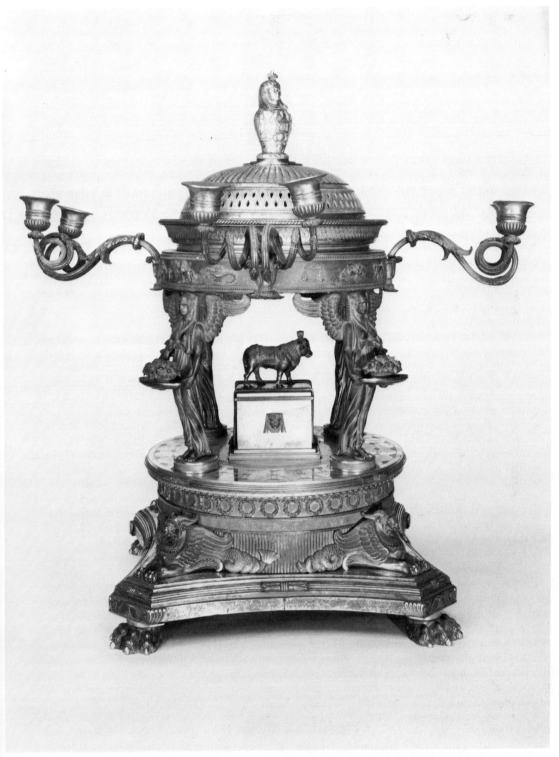

Plate 147 A centrepiece of gold, silver, and gilt bronze, with Egyptian figures, Apis bull, and Canopus surmounting the whole (*By Gracious Permission of Her Majesty the Queen. R. 508144*).

1811 for £504.19s.-0d (Pl. 147). Of particular interest in the context of this study is the 'Canopic' figure capped by an Isiac lotus bud similar to that on the head of Isis in Plates 7 and 8. Figures with Egyptian head-dresses carry the canopy, on the frieze of which are scorpions and other Nilotic fauna. In the centre, under the canopy, is an Apis bull on a podium decorated with Egyptian masks.[89]

Sphinxes, of course, were commonly found as part of the vocabulary of designers in the early part of the nineteenth century. Particularly interesting in this respect are the winged sphinxes on the state chairs designed for Prince Karl of Prussia by Karl Friedrich Schinkel in 1828, and based on the model in a wall-painting from Herculaneum.[90] Similar sphinxes, but without wings, sitting up in an alert position, are found supporting the circular backs of chairs designed by Leo von Klenze (1784–1864) for the Queen's throne room in the Residenz in Munich.[91] Large council chairs incorporating winged sphinxes in the sides were made by Tatham and Bailey in 1813, and are recorded as gracing the Throne Room in Carlton House.[92] They are clearly based on the forms recorded by C. H. Tatham from the throne in S. Gregorio Magno in Rome,[93] and from seats in the Vatican. Winged sphinxes are not especially Egyptian, however, but the winged variety sometimes occurs with Egyptian heads.

François-Honoré-Georges Jacob-Desmalter (1770–1841), son of Georges Jacob, manufactured a set of furniture decorated with Egyptian motifs for Denon. He made an extraordinary medal cabinet based on designs by Percier, with mounts by Martin-Guillaume Biennais (Pl. 148). The cabinet is in the form of a pylon from Apollonopolis that was illustrated in Denon's *Voyage*,[94] and the front and back were decorated with the scarab motif, the crescent moon of Isis, and serpents on lotus stalks.[95]

In 1777 Laurent Pecheux (1729–1821) painted a portrait of the Marchesa Gentili Boccapaduli in her Cabinet of Curiosities that shows a table in the Egyptian taste.[96] This is similar to a late eighteenth-century Italian table of wood, painted red and mottled green and black to look like Egyptian granite, with a black marble top, now in the Metropolitan Museum of Art.[97] The corner terms are canted, and the frieze is decorated with bogus hieroglyphs. Similar tables by Giovanni Socci are in the Palazzo Pitti in Florence. The legs in the painting by Pecheux are Egyptian telamoni facing outwards, rather than canted at the corners, as in the specimen in the Metropolitan Museum.[98] A marble mantelpiece in the Palazzo Pitti is supported by telamoni similar to those on typical French and Italian furniture of the period, for example the console table in the Palazzo Pitti of *c.* 1810.[99] Even as early as 1782, chairs of walnut were being made in Italy, adorned with gilt ornaments freely adapted from Egyptian motifs, including serpents, scarabs, and scorpions. One late eighteenth-century chair, probably included as part of the furnishing of the Sala Egizia in the Villa Borghese, survives in the collection of the Galleria Borghese in Rome. It is clearly derived from the decorations of the Caffè degl'Inglesi and from other illustrations in Piranesi's *Diverse Maniere . . .*[100]

Egyptianisms recur in furniture, jewellery, and artefacts in profusion during the eighteenth and early nineteenth centuries. The silver-gilt Borghese table service of 1794–1814 by Martin-Guillaume Biennais and Jean-Baptiste-Claude Odiot includes a hot water urn, or samovar, which has a crescent-moon handle for the top.[101] Odiot made a similar urn that rested on three sphinx supports for the Russian Court.[102]

The obelisk motif enjoyed a long life. Vincenzo Coacci (1756–94) made an inkstand in the form of the Quirinal Monument in 1792 of silver, silver-gilt, and lapis lazuli on a base of rosso antico. The obelisk is guarded by sphinxes, the head-dresses of which conceal candle-sockets. Although this marvellous piece was made in the eighteenth century, its spirit is essentially that of the Neo-classical period, and it influenced many nineteenth-century designs for centrepieces and similar ornaments.[103]

There were parallels in architecture, where Egyptian elements were used in similar ways: obelisks, sphinxes, and other motifs appeared in stone just as they appeared in wood, silver, and gold. W. H. Playfair included sphinxes over his pediments at the Royal Scottish Academy of 1823–33 in Edinburgh, while the bases of some of the monuments in the New Town display definite Egyptianising with their pronounced batter. One of the strangest and most interesting

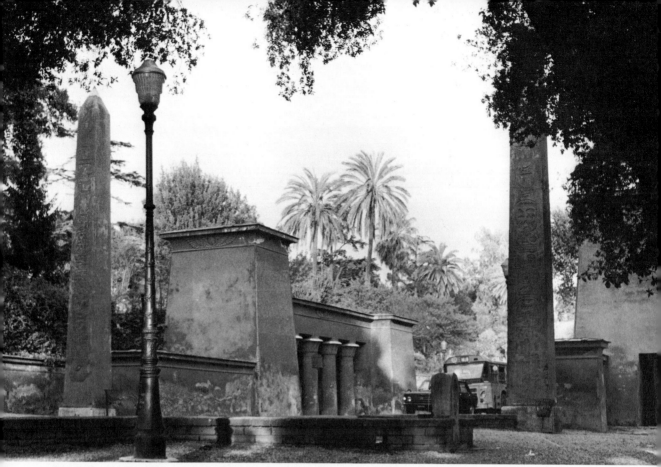

Plate 149 The Egyptian gate in the Borghese Gardens in Rome, of 1825, by Luigi Canina.

examples of the Egyptian Revival is Luigi Canina's Egyptian Gate in the Borghese Gardens in Rome, erected in 1823.[104] The Gardens were originally an attempt to encapture something of the atmosphere of the Villa Adriana. Canina bridged a road, using stone from Tivoli, and gave grandeur to his work by adding a superstructure in the Egyptian style. He built two great pylons flanking the entrance with stairs inside. On one side of the pylons are colonnades, with four columns each, to give shelter, and in front of the pylons is a pair of obelisks without pedestals decorated with hieroglyphs. Canina used brick covered with stucco to imitate Egyptian granite (Hope would not have approved). A picturesque technique combined with some archaeological expertise thus engendered architectural associations and identification with Tivoli. As evocative work the gate succeeds, but it is not a slavish copy (Pl. 149). Elements from an ancient architectural vocabulary were used, but new purposes and ideas were expressed.

Egyptian features as part of garden design, as we have seen, were not uncommon, but the full-blooded Egyptianisms of Canina were not usual. There are French parallels, of course, and the catacombs at Highgate Cemetery are an outstanding example of an Egyptian Revival building set in a consciously designed landscape. Perhaps the most captivating of all gardens where Egyptian motifs are used is that at Biddulph Grange in Staffordshire, an unexpected and exotic creation of James Bateman (1811–97) and his wife, Maria Warburton, who moved to Biddulph in 1838. The gardens were laid out mostly in the 1840s, with considerable assistance from the painter and designer Edward Cooke, and were described in detail in *The Gardener's Chronicle* of 1857–62. There is a charming section with Chinoiserie elements, but the strangest part of the garden is the Egyptian Court. There, two stone sphinxes of bucolic mien flank a path that leads to a battered pylon-like entrance, but the rest of the ensemble, consisting of two pyramids on pedestals, massive blocky Egyptian forms, and a great central truncated pyramid, is all of clipped yew. It is a

151

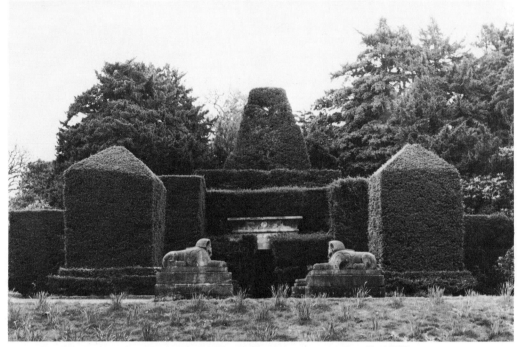

Plate 150 The Egyptian Garden at Biddulph Grange, Staffordshire, completed in 1856.

wonderfully effective idea, brilliantly rendered, and darkly mysterious. Here, one can imagine the two men in black armour standing guard in front of the sphinxes, in Mozart's *Die Zauberflöte;* it is a place where anything might happen; it is a marvellous design. The gloomy stone portico leads to a dark tunnel at the end of which is a grotesque statue of Bes. The whole ensemble was completed in 1856. (Pl. 150). Of course, Egyptomania gained ground through the drawings, paintings, and topographical views that were such a feature of the epoch. David Roberts (1796–1864) had visited Egypt in 1838–9, and later a great number of fine lithographs from his originals were produced by Louis Haghe in the 1840s, and these became very popular after they were published in *Egypt and Nubia* in 1846–9. Queen Victoria and the Archbishops of Canterbury and York subscribed. Artists including John Frederick Lewis, Edward and Frederick Goodall, Richard Dadd, and Edward Lear also drew ruins of ancient Egypt as well as modern scenes in Cairo and elsewhere. Later, when reconstructions of life in ancient Greece and Rome became fashionable subjects for painters, life in ancient Egypt was also depicted, especially when illustrations of Biblical scenes were required for educational purposes. Poynter's *Israel in Egypt,* exhibited in 1867, was immensely popular. Later, Sir Lawrence Alma-Tadema and Edwin Long became two of the most practised exponents of archaeological correctness in their reconstructions. Long's *The Gods and Their Makers* of 1878 has a wealth of Egyptological detail. Nineteenth-century eclecticism was not a simple matter nor was it merely an exercise in the copying of past styles, as has sometimes been suggested.

152

7

The Egyptian Revival in funerary architecture from the nineteenth century

Egypt had maimed us,
offered dream for life,
an opiate for a kiss,
and death for both.

HILDA DOOLITTLE: *Egypt*

The use of Egyptianisms in funerary and commemorative architecture has already been noted. Obelisks appear in profusion in Elizabethan, Jacobean, and contemporary Continental work in northern Europe, usually to cap memorial aedicules or free-standing canopies sheltering effigies. The mural-tablet of 1611 commemorating Jo. Osbaldeston in the Sylvester aisle of the Church of St John the Baptist in Burford, Oxfordshire, deserves note as a curiously rustic example of a pedimented aedicule flanked by scrolls, and supported on a strapwork base, in which male and female figures help to carry the entablature. The female figure, with bare breasts, and volutes instead of arms, is clothed from the breasts down in a casing of stylised foliage that is disturbingly reminiscent of a mummy case. Even more Egyptianising is the decoration on the frieze, which recalls the archaic Ionic caps from Neandria, and more especially the volute caps from Philae (Pl. 151). Pyramidal compositions, usually incorporating obelisks set flat against a wall, had been developed since the time of Bernini. Eighteenth-century funerary monuments in western Europe were often of the pyramidal type of composition, with an obelisk as the main background against which sculptural groups could be set. Neoclassical influences ensured that designs for commemorative sculpture and architecture tended to become more wide-angled, especially in the work of Boullée, whose low, wide pyramids are particularly awesome in quality. Canova designed a series of pyramid tombs of considerable excellence, using a flat pyramid as the main element in the composition.

J.-N. Durand designed an ideal pyramid with a domed circular interior surrounded by semi-circular-headed niches for urns that was published in his *Précis des Leçons d'architecture données à l'école polytechnique* of 1802. The same volume shows Egyptian telamoni at the first floor of the *Maison Particulière exécutée à Paris, Rue du Faubourg Poissonière*, garden elevation. The pyramid design (1805) owes much to projects by Boullée and Ledoux, and variations of it had been produced by Friedrich Gilly in his monument with four Doric porticos.[1] Similar designs to Gilly's can be found in the work of G. Selva (1751–1819) for his monument to Napoleon in 1813,[2] and in those of Harrison and Alferov, especially the latter's monument to the defeat of the Tartars at Kazan of 1830. This building had distyle in antis porticos on each face, and the pyramid was truncated. The sides of the porticos were battered.[3] The powerfully evocative possibilities of Egyptian architecture were exploited in these remarkable designs. Selva's scheme was the result of his appointment to a Milanese commission to erect a monument to Napoleon on Mount Cenis. The pyramidal design was set on three steps, with octastyle Greek Doric porticos on each face.

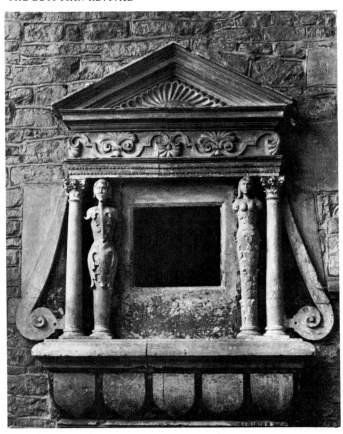

Plate 151 The Osbaldeston monument in the Church of St John the Baptist at Burford, of 1611. Note the female figure, clothed from the waist down in what is disturbingly like a mummy case. Note also the decorations of the frieze, which recalls the archaic Ionic caps from Neandria, and the volute caps from Philae. Compare the palmette and volutes with Pl. 25.

The exterior may have been suggested by Canova's monument to Titian, and Selva may also have known Boullée's designs. The interior was to have been a Pantheon-like coffered dome carried on a vast entablature supported on Doric columns. Light was introduced to the interior by lunettes set above the pediments. By 1814 the project was abandoned as Napoleon's star faded. Selva collaborated with his friend Canova on the Dieden Monument in the Eremitani in Padua, and was influenced by his studies in France and England.

According to Horsfield, Sir Robert Smirke designed the pyramidal mausoleum to 'Mad Jack' Fuller that stands in the churchyard of St Thomas Becket at Brightling in East Sussex. Although Fuller did not die until 1833, the mausoleum, which is of the Cestius type, was erected in 1812. The story that the MP sits inside, wearing a top hat and clutching a bottle of claret, is probably apocryphal.

The associations of Egyptian architecture with death and monumental celebration ensured that the Egyptian Revival would play no small part in the appearance of the new cemeteries that began to develop in Europe from the beginning of the nineteenth century. It is significant that in India and Louisiana, where Europeans found themselves in climates and conditions where a customary lack of fastidiousness in matters of hygiene played havoc with lives in a manner unknown in colder zones, cemeteries were formed by necessity in the mid eighteenth century. South Park Street Cemetery in Calcutta is one such example, and the New Orleans cemeteries are others. These cemeteries were the envy of visitors, and returning merchants and servicemen brought ideas of new cemeteries back with them.[4]

As with many great modern reforms, however, the aftermath of the French Revolution was the first real occasion when burial customs were revised. Under Napoleon, Brongniart laid out the great cemetery of Père-Lachaise in Paris, and this soon became established with many

154

distinguished monuments, many of them Egyptian in style. The beauty of the site, the design of winding paths, and the first monuments erected against a background of foliage soon attracted the public to these Elysian Fields. Much of the grandeur of Père-Lachaise can be attributed to the architect Godde who embellished the cemetery in the early years of its existence. It was he who designed the main gateway and the chapel, and who advised on the desirability of monuments.

A standard house-tomb was developed for Père-Lachaise that included a subterranean vault with a chapel above. Typical of this form are the tombs of the families Carette and Boscary (Pl. 152), the former in a severe Roman Doric, and the latter in Greek Doric with an Egyptianising entrance. The Boscary tomb was designed by Vincent Méry. 'La porte et les ornamens, composés dans le style égyptien, sont en fonte de fer.'[5] Many other Neoclassical tombs have Egyptian cornices or details similar to those of the Boscary tomb. More overtly Egyptianising, however, is the tomb of Gaspard Monge in Père-Lachaise, designed by M. Clochard, and erected by the pupils of L'Ecole Polytechnique in 1832 (Pl. 153).

> Ils en ont confié l'exécution à M. Clochard, architecte, qui, dans le style q'il lui a donné, a cherché à rappeler que Monge avait fait partie de cet Institut d'Egypte dont les travaux scientifiques ont été si riches en résultats.[6]

The Moricet family tomb, with its Egyptianising details can also be compared with more typically Neoclassical designs in the tombs of Monvoisin and Ruineau Fontaine. The latter two have no Egyptianising tendencies, although the Ruineau Fontaine tomb has a slight batter, whereas the Moricet tomb has pronounced Egyptian elements (Pl. 154).

The fact that Père-Lachaise became the desirable model for those who wished to form public cemeteries laid out on rational, hygienic lines, is borne out by the vast amount of literature that quotes it as the exemplar.[7] Not only was the idea of forming cemeteries as opposed to church-yards becoming attractive, but designs for mausolea and funerary monuments in Père-Lachaise were published and became widely available as copy-books for other countries to follow. Architectural ideas were widely publicised, and the eclectic climate encouraged repetition and variation of those ideas. Pugin produced a great number of engravings of tombs in Père-Lachaise, and the enterprising Normand Fils published a large volume of measured drawings of funerary architecture. The tomb of John Gordon of Newton, Aberdeenshire (1802–1840), in the General Cemetery of All Souls, Kensal Green, is clearly based on the design for a house-tomb in Père-Lachaise that was published by Pugin, and has Graeco-Egyptianising heads as acroteria (Pl. 155).

In the design of funerary monuments, the Berniniesque obelisk backing a pyramidal design had long been a favourite motif. Antonio Canova (1757–1822),[8] however, used the pyramid as a three-dimensional object in his funerary art. From 1780, when he became acquainted with Gavin Hamilton and other members of the international set of theorists, he developed a revolutionary severity and purity in his designs, and responded to Winckelmann's demands for noble simplicity. He studied antique works to attain an ideal, and many of his contemporaries thought he had excelled the ancients. Lord Byron felt that Canova was the one heir to Italy's lost greatness, and many contemporaries agreed with him. The monument to Provost Baldwin of 1784 by Christopher Hewetson in Trinity College, Dublin, has a tall, obelisk-like pyramid background against which are figures.[9] This 'piramid' as Hewetson (the most distinguished Irish sculptor of the eighteenth century) called it, here of red oriental granite, was the first to be made of that material since ancient times.[10] Hewetson worked in Rome, and Canova is known to have seen the monument in Hewetson's studios.[11] Canova's models of the monument to the Archduchess Maria Christina are similar to other funerary memorials of the pyramid-obelisk type. Canova originally designed a pyramid, with figures entering it, as a monument to Titian in 1790. The plan to build a monument to Titian failed to come to fruition, but in 1798 Duke Albert of Sachsen-Teschen asked Canova to design and make a monument to his Duchess, who had died that year. Canova adapted his Titian designs and reversed the composition (Pl. 156). The monument was built in the Augustinerkirche in Vienna in 1805, and shows the three ages of man moving slowly towards the open door of the marble pyramidal tomb, carrying a funerary urn. The monument is

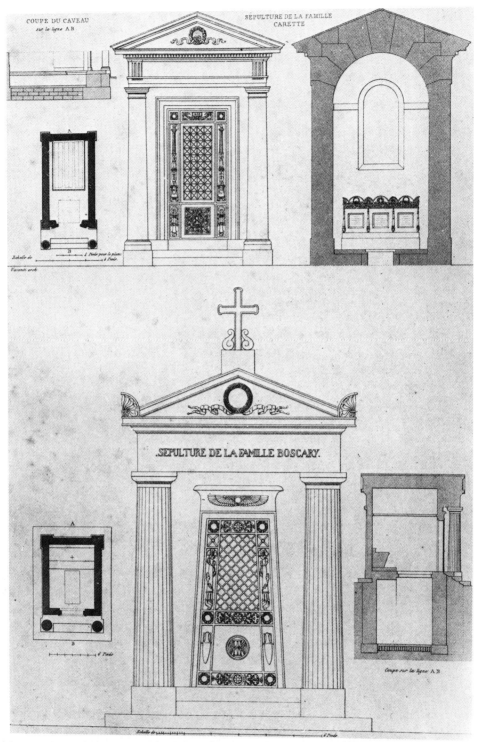

Plate 152 House-tombs in the Cemetery of Père-Lachaise, Paris. The Boscary tomb has an Egyptianising entrance, and was designed by Vincent Méry. From Normand Fils. *Monumens Funéraires* . . . (1832).

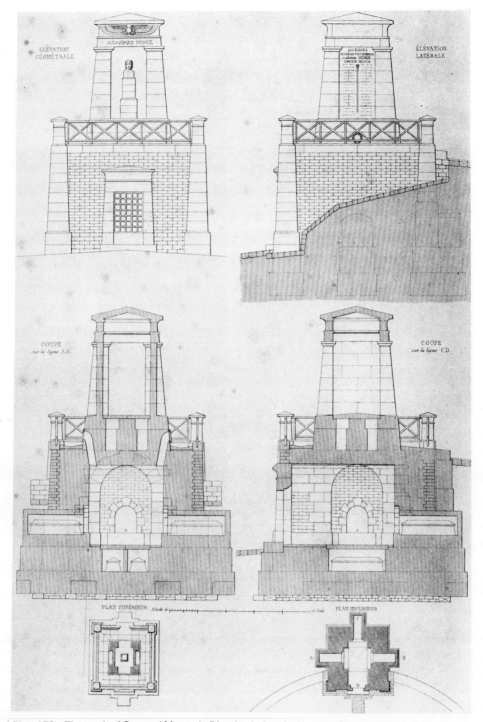

Plate 153 The tomb of Gaspard Monge in Père-Lachaise, designed by Clochard. From Normand.

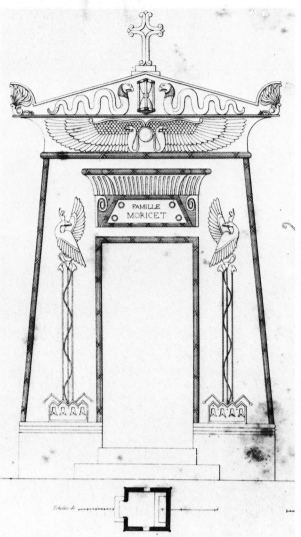

Plate 154 The Moricet tomb. From Normand.

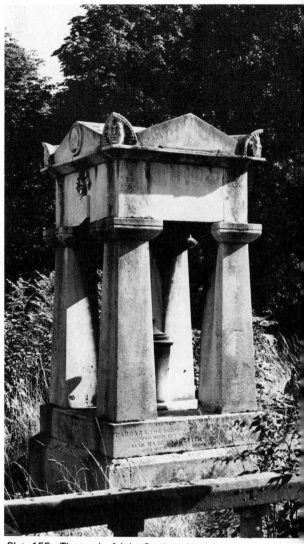

Plate 155 The tomb of John Gordon of Newton, of *c*. 1840, in Kensal Green Cemetery, clearly based on the tomb in Père-Lachaise published in Pugin. Note the Egyptianising heads.

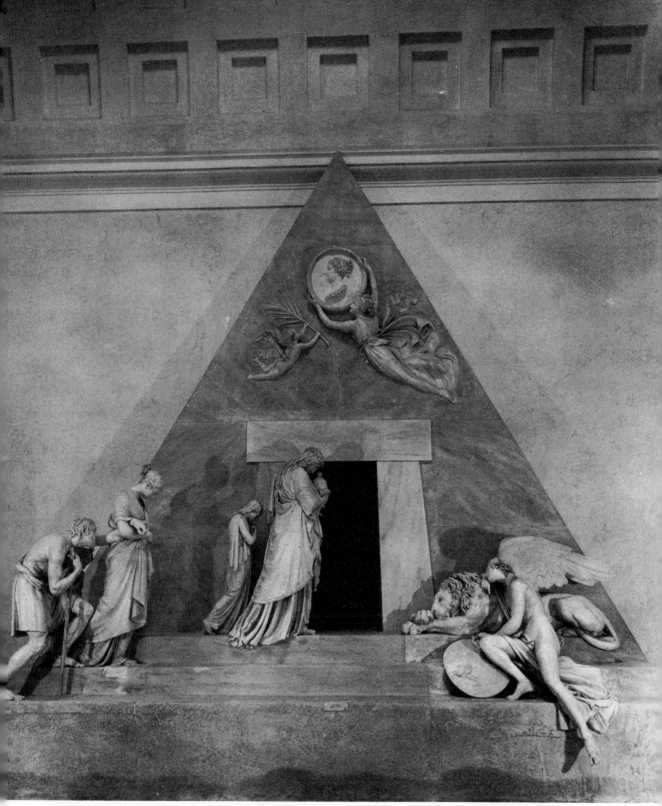

Plate 156 The model of the tomb of the Archduchess Maria Christina, now in the Gipsoteca Canoviana, by A. Canova (*Courtauld Institute of Art. B. 72/2219*).

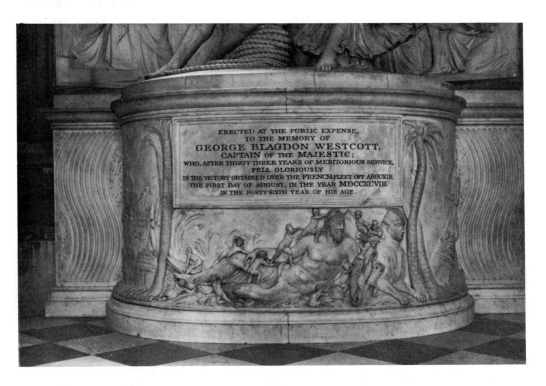

Plate 157 The monument to George Blagdon Westcott, in St Paul's Cathedral, London, by Thomas Banks, showing the Nile group. Compare with Pl. 12.

T. Allen. fecit.

MAUSOLEUM.

BRIXTON CHURCH YARD.

Pub.ᵈ by J.Allen. Kennington.

Figure 10 The mausoleum in Brixton Churchyard of Richard Budd, designed by R. Day. From T. Allen's *History of Lambeth* (*Guildhall Library, City of London*).

a cenotaph: the Archduchess lies in the Kaisergruft of the Kapuzinerkirche. The designs for the Titian monument were later revived by Canova's pupils for the tomb of Canova himself in the church of Santa Maria Gloriosa dei Frari, in Venice. The tomb was completed in 1827.

Sir Richard Westmacott (1775–1856) was a pupil of Canova and studied in Rome from 1793. His monument to Sir Ralph Abercomby (*ob.* 28 March 1801) of 1809 in St Paul's Cathedral in London has overt Egyptianisms in the two sphinxes that flank the heroic central group. Other Egyptian allusions can be found in Thomas Banks' (1735–1805) monument to George Blagdon Westcott, who fell at the Battle of Aboukir in 1798, also in St Paul's Cathedral. This monument was erected in the last year of Banks' life, and the pedestal shows the famous figure of the Nile, now in the Vatican, complete with the cubits, a sphinx, and palm trees (Pl. 157). Banks knew Italy, and stayed in Rome for seven years.[12] Agostino Aglio, the painter who exhibited at the Royal Academy from 1807–38, produced an imaginary design for a monument to Lord Nelson in 1805 that is very bold and arresting. Perhaps the choice of the pyramid for the basic form alludes to the Nile campaign, or perhaps the Egyptianising type of tomb can be seen as part of a great number of Neoclassical designs featuring pyramids that appeared in the latter part of the eighteenth century and the beginning of the nineteenth. The drawing, now in the Print Room of The British Art Center at Yale (No. B. 1977.14.4400), shows a huge pyramid with strange beasts in a fantastic landscape.

In the churchyard of St Matthew's, Brixton, stands an extraordinary monument, or mausoleum, in memory of Richard Budd (1748–1824). It was designed by R. Day, and is described by T. Allen in his *History of Lambeth* as 'without doubt the finest sepulchral monument in the open air in the metropolis, and perhaps not equalled by any one in the kingdom.' It is an eclectic mixture of Greek and Egyptian forms, of Portland stone on a granite base. The winged disc, the heavy battering, and the segmental pediments are all Egyptian in character (Fig. 10).

Egyptianising tendencies in funerary architecture began to be associated with the new cemeteries. The Gordon tomb at Kensal Green has already been mentioned, and there are several mausolea of an Egyptian type, cast in the form of stumpy pylons. Obelisks, too, are common. One of the oddest Egyptianising tombs in the General Cemetery of All Souls is that of Andrew Ducrow: 'erected by genius for the reception of its own remains' in 1837 (Pl. 158). Ducrow was the lessee of the Royal Amphitheatre, London, from 1793–1842. Sphinxes guard the entrance. Kensal Green also contains the tomb of Sir George Farrant of Northsted House, Kent (*ob.* 1844), and that of Major-General the Hon. Sir William Casement, KCB, of the Bengal Army (*ob.* 1844). The Farrant tomb is in the form of a miniature pylon, with panels of a characteristic battered shape, and a heavy cavetto cornice (Pl. 159). Casement's tomb has a vaguely Egyptianising canopy carried on four telamoni. Standard house-tombs, usually of granite, in a simplified Egyptian style, exist in many nineteenth-century cemeteries throughout Britain and America, and appear to be based on pattern-books derived from the French exemplars published by Normand and others.

A variant of the house-tomb can be found in Northern Ireland. In the old Clifton Graveyard, Belfast, established in 1774, there are examples of house-tombs surmounted by short obelisks. The best example in Belfast is the Luke family vault, a distinguished design in sandstone with battered Egyptianising sides (Pl. 160). Even more overtly Egyptianising is the Greer mausoleum in the tiny parish churchyard of Desertcreat, Co. Tyrone, dating from about 1830. The Greer tomb has sides with a pronounced batter crowned with an Egyptian cornice over which is a stepped base and a short obelisk. The influence of Egyptianising Neoclassical motifs in Protestant Ulster must be emphasised, and the connexion with rational, radical ideas born in France, carried partly through Freemasonry, and partly through pattern-books, must be stressed.[13]

The London Cemetery Company was one of the first Joint-Stock Cemetery Companies to employ Egyptian elements in the architecture of the cemetery buildings, as opposed to individual tombs erected by private interests. Stephen Geary (*ob.* 1854) designed and built the Circle of Lebanon Catacombs at the Cemetery of St James in Highgate in 1839. This range of house-tombs in terrace-form is circular on plan, and surrounds a great Cedar of Lebanon. It is in the Egyptian style, and is stucco-faced. The Egyptian Avenue and the entrance to it in the 'stern and

Plate 158 The mausoleum of Andrew Ducrow of 1837 in Kensal Green Cemetery.

Plate 159 The tomb of Sir George Farrant (died 1844) in Kensal Green Cemetery.

Plate 160 (*left*) The Luke vault in Clifton Old Cemetery, Belfast (*c.* 1830).

Plate 161 (*below*) The entrance to the Egyptian Avenue, Highgate Cemetery.

appropriate architecture of Egypt' was designed by James Bunstone Bunning between 1839 and 1842.[14] The entrance to the Egyptian Avenue has a corbelled arch, flanking engaged Egyptian columns, and guardian obelisks (Pl. 161).

The second instance when Egyptian forms were used by a cemetery company in England was at Abney Park Cemetery, Stoke Newington, in 1840, where Professor William Hosking provided gates and lodges in the Egyptian manner. The single-storey lodges have coved cornices decorated with winged discs, and the cast-iron gates incorporated Egyptianising motifs (Pl. 162). In 1980 these lodges and gates underwent restoration. An interesting West Country connexion with Egyptianising can be found in the cemetery in Exeter which was designed with Egyptian architectural features.

Mount Auburn Cemetery near Cambridge, Massachusetts, was one of the first large cemeteries to be laid out on the Père-Lachaise model in the United States. It was one of the earliest landscaped cemeteries in America and dates from 1831. It was conceived by Jacob Bigelow (1786–1879) who described the Egyptian Revival gates in an 1846 guide book as 'in imitation essentially of some of the gateways of Thebes and Denderah.' Bigelow himself states that the sources of his design were 'mostly taken from some of the best examples in Denderah and Karnac.' Certainly the relationship of the lodges at the gates at Mount Auburn is similar to that at Canina's gate in the Borghese gardens (Pl. 163). The main source of the gate at Mount Auburn would seem to be the north and south portals of the Temple of Karnak from the *Description de L'Egypte*. The use of the Egyptian style for Mount Auburn was noted by James Gallier in 1836.[15] Gallier singled out Mount Auburn as the

only remarkable display of (Egyptian) architecture . . . Too much praise cannot be given to those who originated this design, and selected the place . . . Its natural beauty is not equalled by that . . . of the . . . Campo Santo of Pisa . . . nor even Pere La Chaise . . . The most remarkable specimen of architecture . . . is the gateway. This is of Egyptian architecture; and, in imitation, the principal portion of the monuments are in the same style . . .

Plate 162 (*left*) The entrance gates to Abney Park Cemetery, London, by William Hosking, 1840.

Plate 163 (*below*) The entrance gates to Mount Auburn Cemetery, Cambridge, Massachusetts, by Bigelow (*Michael Haškovec*)

Gallier went on to note the 'great number of pyramids and obelisks, and tombs supported by Egyptian columns'. He was cautious, however.

> It is doubtful whether the Egyptian style is most appropriate to a Christian burial-place . . . It . . . reminds us of . . . paganism . . . solid, stupendous, and time-defying . . .

Yet he was aware of the powerful associations that a cemetery might bring to mind, and that the obelisk was 'by far the most beautiful form of Egyptian architecture, whose stern and severe proportions seem to speak of eternal duration . . .'[16]

A terrible fire in a theatre in Richmond, Virginia, in which seventy-two people were killed in 1798 prompted the design by Benjamin Henry Latrobe for his 'Theater Memorial' of 1812. This was to consist of a square blocky plinth with battered sides and two Greek Doric columns set in antis on each face; a stepped base; and a stepped pyramid of Cestius proportions to crown the composition. There is a fine watercolour perspective of this design among the Latrobe papers in the Library of Congress, and this is reproduced in Professor Carrott's book (Plate 25 in that work).

The first Egyptian Revival cemetery gate in the United States was that of Westminster Cemetery, Baltimore, by Maximilian Godefroy, of 1815.[17] Several other examples followed, for in America the Egyptian Revival was unquestionably an *architecture parlante* in the Boullée manner. One commentator observed that the expression of purpose should grow out of a quality that is connected in the mind with the use.[18] The style of a building should express the purpose for which it is built. In the United States the Egyptian style was popular for both cemeteries and prisons. Obelisks and pyramids were common in funerary architecture from Renaissance times, and obelisk-memorials were fashionable in the United States from the beginning of the nineteenth century. In 1833, the date when the Washington National Monument was originally designed by R. Mills, the United States could boast several memorials in the form of obelisks (quite apart from obelisks as grave-markers in burial grounds). These include the Columbus Memorial at Baltimore by the Chevalier d'Anmour, of 1792;[19] the Battle Monument at Lexington of 1799;[20] and many others set out in Appendix I of Professor Carrott's book.[21] Indeed, Professor Carrott has discussed Egyptian obelisks and cemetery entrances in America very fully, and it would be superfluous to go over the subject again here. It will be sufficient to mention the most important cemetery gates in the Egyptian Revival style. Apart from Godefroy's Westminster Cemetery in Baltimore (actually a church burial ground rather than a cemetery), the most distinguished examples in America of Egyptian Revival cemetery gates are those at Mount Auburn and the lodges by Jacob Bigelow, originally built of wood in 1831 and of granite in 1842; the fine competition entries for Laurel Hill Cemetery, Philadelphia, of 1836, by William Strickland (1788–1854) and Thomas U. Walter (1804–87);[22] the Mount Hope Cemetery gates at Rochester, by John McConnell;[23] the Cypress Grove Cemetery gates, New Orleans, by F. Wilkinson;[24] the Old Granary Burial-Ground gates at Boston of 1840 by Isaiah Rogers;[25] the identical gates at Touro Cemetery, Newport, Rhode Island, of 1843, also by Rogers;[26] the design for the entrance to Greenmount Cemetery, Baltimore, by Robert Cary Long of 1845;[27] the celebrated Grove Street Cemetery entrance at Grove Street, New Haven, by Henry Austin, of 1844–8, based on a mixture of the Temples of Esna and Hermopolis Magna;[28] the Forest Hills Cemetery gate at Roxbury by H. A. S. Dearborn, of 1848;[29] the Old Burying Ground at Farmington, Connecticut, of 1850;[30] the Mikveh Israel Burial-Ground entrance, Philadelphia, of c. 1845;[31] and the entrance to the Odd Fellows Cemetery, Philadelphia, of 1849 by Stephen Decatur Button (1803–97), a design of the propylaea type that is not unlike McConnell's design for Mount Hope Cemetery.[32]

Although advertisements were placed for plans for the Glasgow Necropolis in 1831, the cemetery was laid out by a superintendent[33] employed by the Merchants' House of Glasgow.[34] An obelisk with inscriptions was erected, and Egyptian vaults for temporary storage of bodies pending the erection of permanent tombs were built in 1837, probably to designs by David Hamilton. Several tombs with Egyptianising features stand in the incomparable Glasgow Necropolis. Other nineteenth-century British cemeteries, including those of Kensal Green, Norwood, Brompton, Bradford, and Brookwood contain tombs and mausolea with Egyptianising qualities (Pl. 164).

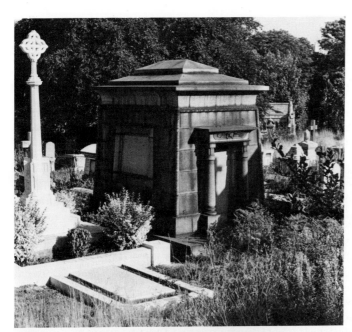

Plate 164 (left) Egyptianising tomb in Kensal Green Cemetery.

Plate 165 (below) Egyptianising tombs in the Parsee section of Brookwood Cemetery, Surrey.

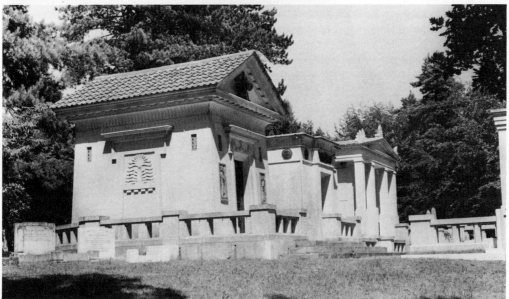

Undercliffe Cemetery in Bradford contains some fine Egyptian mausolea, the best of which is the tomb of Daniel Illingworth (*c.* 1854) which has battered sides, a cavetto cornice with winged globes, and sphinxes at the entrance.[35] Standard pattern-book Egyptianising mausolea or house-tombs can be found in many cemeteries in Britain, in Continental Europe, and in the United States of America. One of the oddest groups incorporating Egyptian elements stands in the Parsee section of Brookwood Cemetery, near Woking, in Surrey (Pl. 165).

One of the most bizarre schemes with Egyptian connotations was conceived by Thomas Willson 1824. He proposed a vast pyramid to hold five million bodies, a Sublime idea worthy of Boullée. The pyramid was to be constructed of brick, faced with granite, and would occupy an area the size of Russell Square. Willson wrote that his idea was 'practicable, economical, and

167

remunerative',[36] and that the pyramid (capped by an obelisk) would 'tower to a height considerably above' that of St Paul's Cathedral (Pl. 166). The pyramid would cost £2,583,552, and would contain freehold vaults selling at between £100 and £500 each, while other vaults could be let out to the various parishes in London. Willson estimated his scheme would bring in a profit of £10,764,800. 'This grand Mausoleum', he wrote, 'will go far towards completing the glory of London.' It was to contain ninety-four stages of catacombs, and would be compact, ornamental, vandal-proof, and hygienic. At the base, Willson proposed a normal cemetery for earth burial to surround the pyramid. In all, there would be 215,296 vaults. Although Willson published his designs in c. 1842, they had been exhibited much earlier, in 1824.[37] The idea of a monumental and Sublime structure, suggesting a place of sepulture, was tempered by the practical notion of multiplying the eighteen acres occupied by the base by the several stages to be erected over each other, thus, in effect, generating nearly a thousand acres for burial. An engraved version of the design is bound with C. H. Tatham's designs for a naval monument in the Royal Library at Windsor Castle. Charles Heathcote Tatham built a mausoleum for the Second Marquess of Stafford in 1807–8, the designs for which were exhibited at the Royal Academy in 1807. The heavy battering of the walls, of the piers, and of the upper works owes much to French Neo-classical designs, and Egyptian influences are detectable in the severity of the building.

Sir John Soane's design for a sepulchral chapel, although superficially Greek Doric, has Egyptianising elements in the reclining lions that are based on the Egyptian lions in the Vatican. C. H. Tatham had included these in his *Etchings,* published in 1826, but Soane would have been familiar with the originals in Rome. The bulbous urns that stand around the apses (and are embellished with caryatides) suggest the form of Canopic urns that Tatham and Soane also would have seen in Rome.

The wide pyramid favoured by Boullée in his 'funerary triumphal arch' also appears in a design of 1829 by Axel Nyström for the great cemetery outside the northern gates of Stockholm.[38] Although the pyramid and the obelisk in their various forms had entered into the Neoclassical vocabulary, more painstaking archaeological attempts to revive Egyptian architecture were

Plate 166 (*left*) 'The Pyramid to contain Five Millions of Individuals' by Thomas Willson, 1824. From *The Pyramid. A general Metropolitan Cemetery to be Erected in the Vicinity of Primrose Hill* (Guildhall Library, City of London).

Plate 167 (*opposite*) 'Entrance Gateway for a New Cemetery' from A. W. Pugin's *An Apology for the Revival of Christian Architecture in England* (Bodleian Library, Oxford).

made in funerary architecture. Such Egyptianising excited the ridicule of A. Welby Pugin in his *An Apology for the Revival of Christian Architecture in England*.[39] Pugin stated that the

> new Cemetery Companies have perpetrated the grossest absurdities in the buildings they have erected. Of course there are (*sic*) a superabundance of inverted torches, cinerary urns, and pagan emblems, tastefully disposed by the side of neat gravel walks, among cypress trees and weeping willows . . . the entrance gateway is usually selected for the grand display of the company's enterprise and taste, as being well calculated from its position to induce persons to patronise the undertaking by the purchase of shares or graves. This is generally Egyptian, probably from some associations between the word catacombs, which occurs in the prospectus of the company, and the discoveries of Belzoni on the banks of the Nile; and nearly opposite the Green Man and Dog public-house, in the centre of a dead wall (which serves as a cheap medium of advertisement for blacking and shaving-strop manufacturers), a cement caricature of the entrance to an Egyptian temple, $2\frac{1}{2}$ inches to the foot, is erected with convenient lodges for the policeman and his wife, and a neat pair of cast iron hieroglyphical gates, which would puzzle the most learned to decipher; while, to prevent any mistake, some such words as 'New Economical Compressed Grave Cemetery Company' are described in *Grecian* capitals along the frieze, interspersed with hawk-headed divinities, and surmounted by a huge representation of the winged Osiris bearing a gas-lamp.[40]

Pugin denounced architects. One 'breathes nothing but the Alhambra, – and then the Parthenon, – a third is full of lotus cups and pyramids from the banks of the Nile'. He rounded on what he described as a 'Carnival of architecture' . . . 'tricked out in the guises of all centuries and all nations; the Turk and the Christian, the Egyptian and the Greek.' The illustration Pugin produced was a cruel parody of the Egyptian style (Pl. 167). However, as Professor Carrott has shown,[41] the anti-Egyptian arguments of Pugin, although having some parallels in the United States, failed to prevail as they did in Britain. The enduring character of Egyptian architecture (constructed of

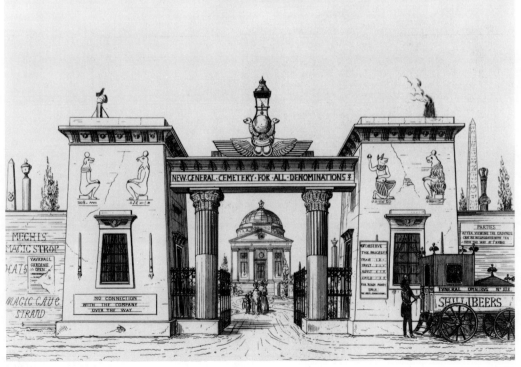

169

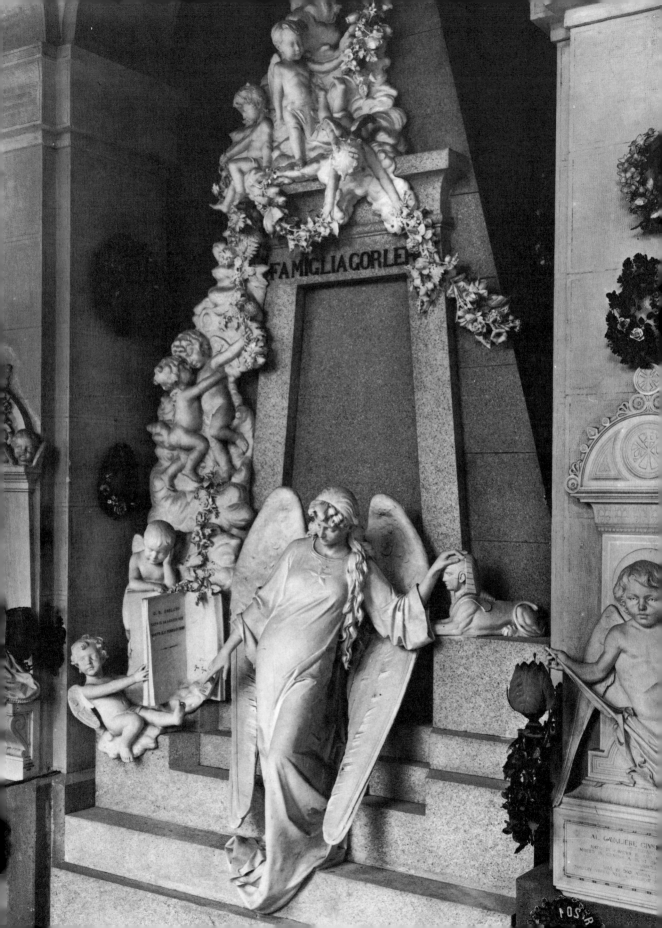

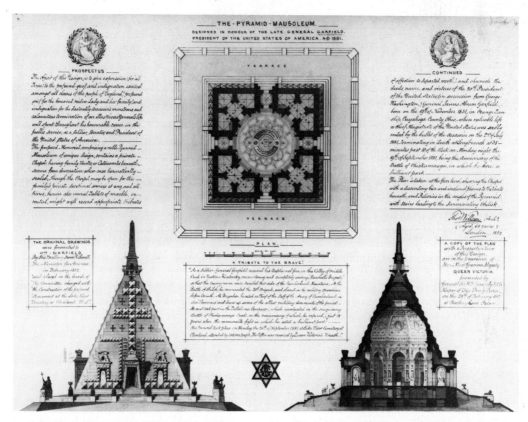

Plate 168 (*opposite*) The Gorlero tomb in the Cimitero di Staglieno, Genoa, by E. Sclavi (*Mansell-Alinari. No. 15103*).

Plate 169 (*above*) The pyramid mausoleum for President Garfield, by Thomas Willson, of 1882. Each entrance is Egyptian. Note the obelisk and the rows of Vatican Egyptian lions (*RIBA British Architectural Library*).

good, sound materials) was important for a Christian cemetery, despite the pagan overtones. It is likely that Masonic and Odd Fellow strength in America, with a Nonconformist tradition, helped to overcome the shrill pro-Gothic arguments of Pugin and the Gothic camp, at least for a while. Pugin's views had little effect in Italy. In the Cimitero di Staglieno, Genoa, the monument to the family Gorlero by E. Sclavi has an Egyptian doorway, and a pyramid is its main architectural element. A sphinx reclines on the podium (Pl. 168).

The sixty-eight-year-old Thomas Willson (possibly a son of the progenitor of the 'Pyramid Cemetery' of 1824) produced a design for the 'Pyramid Mausoleum' in honour of the assassinated President Garfield in 1882 (Pl. 169). The object was to 'give expression . . . for all Time . . . to the profound grief' felt as a result of the work of the 'dastardly assassin'. The mausoleum consisted of catacombs 'secure from desecration' over which was a pyramid surmounted by an obelisk – really the elder Willson's design for Primrose Hill. The form is similar to designs by Gilly and others, and each face of the pyramid had an entrance in the Egyptian style surmounted by a sarcophagus. Less overtly Egyptian, but still using the basic pyramid with a portico on each face, is the design of 1897 for a mausoleum for the Counts of Henckel-Donnersmarck, by Julius and Otto Raschdorff, now in the RIBA British Architectural Drawings Collection. The proposals by Peter Force for the Washington Memorial Competition in 1837 also rely heavily on the simple Egyptianising form of the pyramid set on a low podium. This, and the winning entry by Robert Mills, are reproduced in *Unbuilt America,* by Alison Sky and Michelle Stone.

The Egyptian style in funerary architecture had a long life. A memorial tablet to George Edge (*ob.* 1901) in St John's Church, Stamford, Lincolnshire, had an Egyptian cornice and a reclining

171

sphinx in a panel at the top. It would be pointless to attempt to list all the Egyptianising funerary monuments, for they were only variations on what had gone before. Obelisks, Egyptian cornices, pyramidal forms, and various other Egyptianisms continued to be used in funerary and commemorative work until well into the twentieth century. Stripped-down Classicism, where square columns recalling the Mammisi temples were used, occurred in the 1920s and 30s, and Adolf Hitler planned to erect gigantic pyramids, smoking cones, and obelisks to commemorate his victories. Wilhelm Kreis, the architect of much work favoured by the Third Reich, was a Classicist who owed a lot to the simplified designs of the late eighteenth and early nineteenth centuries, while Albert Speer has acknowledged his and his contemporaries' debts to the ideas of Boullée and Ledoux. French Neoclassicism, especially the designs of those architects who favoured the utter simplicity of pure forms, including Egyptian elements, was greatly admired by Speer and his colleagues. Had the forces of the Axis triumphed, the Egyptianising forms used by the so-called 'Revolutionary' architects of France might well have acquired a new and sinister significance than was already apparent when Reason gave way to the Terror. The chilling totalitarianism that is suggested by overblown scale and obsessional symmetry would have been well expressed by Wilhelm Kreis's designs. Simplified Classicism, the return to Doric and Egyptian forms as ideals, and the blank walls enlivened only by openings, had their sinister side, suggesting the awe and terror of death, and the final irrational, age-old demand for blood-sacrifice. The smoking pyramids of Ledoux's foundry had their successors in the flaming monumental Neoclassical beacons that would have celebrated the victory of Hitler's New Order.

8

Aspects of the Egyptian Revival in non-funerary architecture in the later part of the nineteenth century

Let me however . . . urge young artists never to adopt,
except from motives more weighty than a mere aim at
novelty, the Egyptian style of ornament

THOMAS HOPE (1769–1821): *Household Furniture
and Interior Decoration.*

The recommendation by Thomas Hope that young artists should never adopt the Egyptian style save from motives more 'weighty' than novelty was followed by an observation that hieroglyphs 'can afford us little pleasure on account of their meaning, since this is seldom intelligible: they can afford us still less gratification on account of their outline, since this is never agreeable; at least in as far as regards those smaller details, which alone are susceptible of being introduced in our confined spaces. Real Egyptian monuments, built of the hardest materials, cut out in the most prodigious blocks, even where they please not the eye, through the elegance of their shapes, still amaze the intellect, through the immensity of their size, and the indestructibility of their nature. Modern imitations of those wonders of antiquity, composed of lath and plaster, of callico and of paper, offer no one attribute of solidity or grandeur to compensate for their want of elegance and grace, and can only excite ridicule and contempt.'[1] This passage is also quoted in J. C. Loudon's *An Encyclopaedia of Cottage, Farm, and Villa Architecture and Furniture.*[2] Loudon dwelt at some length on the massiveness, gloom, magnitude, grandeur, solidity, and permanence of Egyptian architecture in the *Architectural Magazine.*[3] Yet Loudon always took considerable pains to stress fitness of purpose to legitimise style as appropriate to use.[4]

Richard Brown, the architect, published his *Domestic Architecture: Containing A History of the Science, and the Principles of Designing Public Edifices, Private Dwelling-Houses, Country Mansions, and Suburban Villas, with Practical Dissertations on Every Branch of Building, from the Choice of Site, to the Completion of the Appendages* in 1842. Brown appears to have come from Devonshire, and may have been influenced by Foulston, as his published works are, in the words of Howard Colvin, 'indiscriminately eclectic'.[5] Brown's book contains a most peculiar design for 'An Egyptian Pavilion' that deserves some attention (Pl. 170). Brown tells us that:

> Some country-houses appear to have been ornamented with propylaea and obelisks, like the temples themselves; it is even possible, that part of the building may have been consecrated to religious purposes like the domestic chapels in other countries; since we find in the sculptures a priest engaged in presenting offerings at the door of the inner chamber. And, indeed, were we not convinced to the contrary by the presence of women there, the form of the gardens and the style of the porch, we should feel disposed to consider this a temple rather than a place of abode. The entrances of large pavilions were generally through folding gates, standing between lofty towers, as in the propylaea of temples, with a small door on each side; and others had merely folding-gates with imposts surmounted by a cornice. A circuit wall

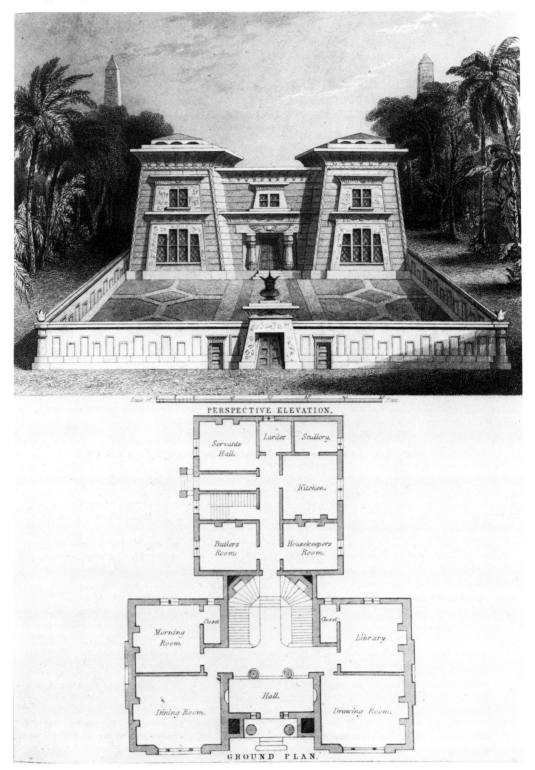

PERSPECTIVE ELEVATION.

GROUND PLAN.

Plate 170 'An Egyptian Pavilion' from Richard Brown's *Domestic Architecture* of 1842.

extended round the premises; but the courts of the house, the gardens, the offices, and all the other parts of the pavilion had each their separate inclosure. The walls were usually built of crude brick, baked in the sun, and in damp places, or when within reach of the inundation, the lower part was strengthened by a basement of stone. They were sometimes ornamented with panels and grooved lines, ... generally stuccoed, and the summit was crowned either with Egyptian battlements,[6] the usual cornice, a row of spikes, in imitation of spear-heads, or with some fancy ornament. The casinos belonging to the kings, which stood on the high road, where they were accustomed to pass either in their hunting or military expeditions, were small and simple, being only intended for their reception during the short stay of a few days. Those, however, in provinces at a distance from Egypt, were of very large dimensions, and had probably all the conveniences of spacious pavilions, like those erected in latter times by the Ptolemies on the confines of Abyssinia.[7]

Brown's design for 'An Egyptian Pavilion' owes more to Foulston or to Robinson than to ancient Egypt, however. It is a double-fronted house, with the servants' quarters in a distinct wing. The plan is spacious, and indeed the house could easily have become part of a terrace, as the side walls of the main block had no apertures, and the servants' wing was set back so that the windows to it could have been illuminated from a yard or small garden (Pls. 171-172). Brown also published a plate of 'Egyptian Columns, Walls, and Ceilings' that owe more to the 'Commercial Picturesque' tradition than to scholarly observation, despite the fact that by 1842 there were many accurate renderings of Egyptian architectural detail and décor to be found in published sources.

Brown wrote that

> Houses of a small size in the provincial towns were usually connected, and formed the continuous sides of streets; they rarely exceeded two stories, and many of them con-sisted only of a ground-floor and an upper set of rooms.[8]

His description of what he imagined to be the detail of ancient Egyptian houses was used as the basis of his design. He noted that chairs and stools of ancient Egypt

> were about the ordinary height of those now used in Europe, the seat nearly in a line with the bend of the knee, but some were very low, and others afford that variety of position which we seek in the kangaroo chairs of our own drawing-rooms. The ordinary fashion of the legs was in imitation of those of some wild animal, as the lion or the goat, but more usually the former, the foot raised and supported on a short pin; and what is remarkable, the skill of their cabinet-makers, even in the early era of Joseph, had already done away with the necessity of uniting the legs with bars. In many of the large fauteuils a lion, as the throne of Solomon, formed an arm on either side, but the back usually consisted of a single set of upright and cross-bars, or of a frame receding gradually, and terminating at its summit in a graceful curve, supported from without by perpendicular bars, and over this was thrown a handsome flowered pillow of coloured cotton, painted leather or gold and silver tissue ... The Egyptian tables were round, square, or oblong; the former were generally used during their repast, and consisted of a circular flat top, supported like the monopodium of the Romans on a single shaft in the centre, or by the figure of a man, intended to represent a captive. Large tables had usually three or four legs, but some were made with solid sides, broader at the bottom than at the top, and though generally of wood, many were of metal or stone, and they varied in size...[9]

There appears to have been a considerable interest in Egyptianising style in the provinces. Apart from Brown's design in his book, Foulston's work in Plymouth has been mentioned, as has the Egyptian House at Penzance. The model for these buildings appears to have been Robinson's Egyptian Hall in Piccadilly. The architect George Wightwick (1802–72), who was a partner of Foulston and succeeded to the practice, produced a number of designs, now in the RIBA British Architectural Library Drawings Collection, which display pronounced Egyptian influences. There

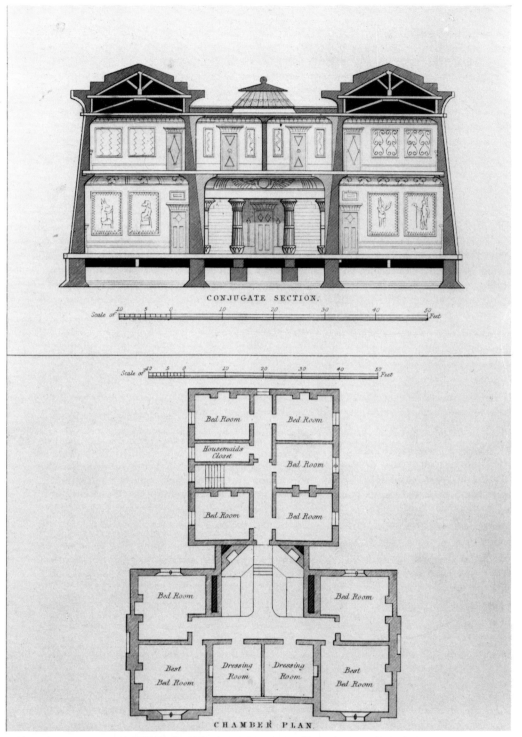

CONJUGATE SECTION.

Scale of 10 5 0 10 20 30 40 50 Feet

Scale of 10 5 0 10 20 30 40 50 Feet

Bed Room

Bed Room

Housemaids
Closet

Bed Room

Bed Room

Bed Room

Bed Room

Bed Room

Best
Bed Room

Dressing
Room

Dressing
Room

Best
Bed Room

CHAMBER PLAN.

Plate 171 A section of first floor plan of Brown's Egyptian house of 1842 and his *Domestic Architecture.*

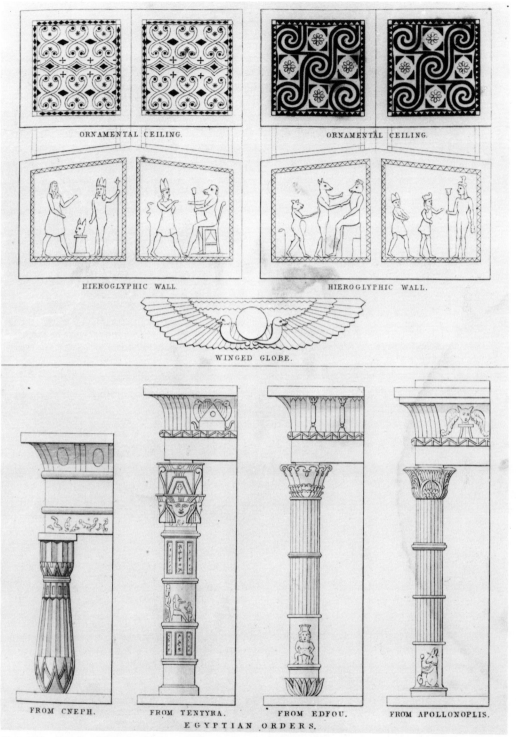

ORNAMENTAL CEILING.

ORNAMENTAL CEILING.

HIEROGLYPHIC WALL.

HIEROGLYPHIC WALL.

WINGED GLOBE.

FROM CNEPH.

FROM TENTYRA.

FROM EDFOU.

FROM APOLLONOPLIS.

EGYPTIAN ORDERS.

Plate 172 Details of Egyptian Orders and decorations from Brown's *Domestic Architecture* of 1842, which he produced despite the appearance of scholarly publications that featured accurately surveyed models.

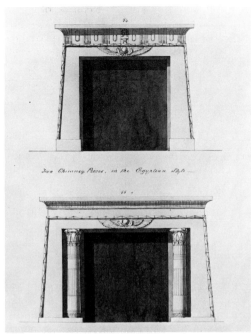

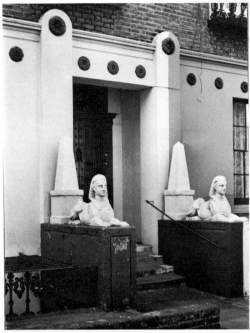

Plate 173 Chimney-pieces in the Egyptian style by George Wightwick (*RIBA British Architectural Library Drawings Collection*).

Plate 174 Egyptianising entrance to a house in Richmond Avenue, London.

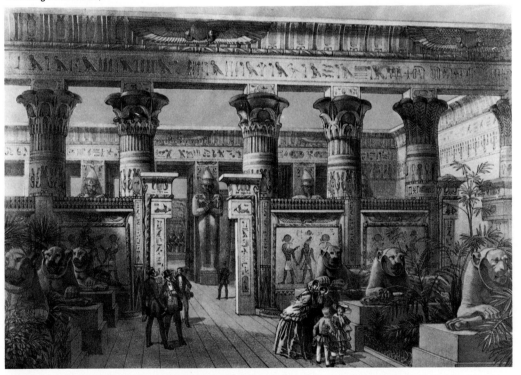

Plate 175 The Egyptian Court by Owen Jones and Joseph Bonomi at the Crystal Palace, Sydenham. Lithographed by Day & Son (*Guildhall Library, City of London*).

are shop-fronts with Egyptianising cast-iron columns, and designs for Egyptian fireplaces of some refinement by him (Pl. 173). Wightwick wrote an account of Foulston that is entertaining and informative[10] as well as *Nettleton's Guide to Plymouth, Stonehouse, Devonport and to the Neighbouring County,* published in 1836. Wightwick visited Italy in 1825[11] and later worked for Sir John Soane. In the west of England he built many houses, shops, terraces, and public buildings,[12] and often used Egyptianisms in his details.[13]

Many Egyptianisms recur in the domestic architecture of the first half of the nineteenth century. In Richmond Avenue, Islington, for example, there is a handsome terrace (Nos. 46–72) that is of a conventional London late-Georgian type except for the severe Greek detail of the ground-floor façade, and the Egyptian sphinxes and obelisks which flank the entrances (Pl. 174). Egyptian detail is found in surprising quantity, including such items as pylon-like clay chimney-pots, Egyptianising fireplaces, heavily battered architraves to window openings, gate-piers (again like pylons, or sometimes like short obelisks), and even door-knockers. A fine Egyptian door-knocker still exists at Rathmullan in Co. Donegal. At Great Glen Hall, Leicestershire, stands a large pylon of brick clad in stucco, with a pseudo-uraeus frieze. It houses the water tap for the garden.

Egyptian features were added to the Wellington Monument, Blackdown Hill, Somerset (originally designed by Thomas Lee in 1817–18),[14] by Charles E. Giles of Taunton in 1853–4. This is a lofty monument on a polygonal battered base decorated with the winged orb, cavetto cornices, and torus mouldings. Again, the Egyptian influence in the west of England should be noted.[15] A spectacular work of Egyptian Revival was designed by Owen Jones and Joseph Bonomi for the Crystal Palace[16] at Sydenham. This was the Egyptian Court (Pl. 175). It consisted of a series of rows featuring models of bas-reliefs, columns, deities, Graeco-Egyptian columns, hieroglyphs, Karnak lions, other Egyptian lions, Egyptian monarchs, Romano-Egyptian columns, the Rosetta Stone, statues, and a mock-up of the tomb of Abu Simbel (Pl. 176). The massive columns, based on the temple at Karnak, were particularly admired, 'on account of the beautiful manner in which the decorations' were executed. Such a public display of Egyptian architecture and sculpture (much of it actually designed by Jones and Bonomi in a scholarly manner) brought the Egyptian style before a wide public. Furthermore, the knowledge of the meaning of hieroglyphs illuminated by the discovery of the Rosetta Stone by a French engineer in Napoleon's army led to inscriptions being written in hieroglyphs. The Sydenham Egyptian Court contained hieroglyphs to signify 'Victoria' and 'Albert'.[17] The shedding of mystery through the discovery of the Rosetta Stone contributed to a more scholarly and scientific understanding of Egyptian art. Bogus hieroglyphs were used as decoration during the Rococo and 'Commercial Picturesque' phases of the Egyptian Revival, but by the 1840s such uses of hieroglyphs were unacceptable and too absurd to be countenanced. The Rosetta Stone was a tablet of basalt, bearing an inscription in hieroglyphic, demotic, and Greek characters, and so provided the key to an understanding of the meaning of Egyptian hieroglyphs. The Stone is of the Ptolemaic period, and was ceded to Great Britain under an article in the Treaty of Alexandria in 1801. It is now in the British Museum. The deciphering of the hieroglyphs on the stone, and the application of the knowledge gained to the construction of a basic skeleton of Egyptian philology, are due to J. F. Champollion (1790–1832) and the Somerset physician Dr Thomas Young (1773–1829). Dr Young translated the royal names on the Rosetta Stone, and on the granite obelisk that W. J. Bankes (c. 1787–1855) brought back from Philae to embellish his estate at Kingston Lacy near Wimborne in 1819. The obelisk was transported from Philae by Giovanni Battista Belzoni.[18]

The second half of the nineteenth century could boast several important theorists, including Gottfried Semper (1803–79) who was profoundly influenced by the 1851 Exhibition in London, and who designed some of the sections of that Exhibition himself. He later taught in Henry Cole's Department of Practical Art. Semper studied the applied arts, and in his book *Der Stil in den Technischen und Tektonischen Kunsten,* published in 1861 and 1863, he included researches into primitive, oriental, and European cultures, as did Charles Blanc, in his *Grammaire des Arts du Dessin* of 1867. Semper developed a theory of evolution in art, and stated that the history of architecture really began with a history of practical art. The characters of architectural styles, he

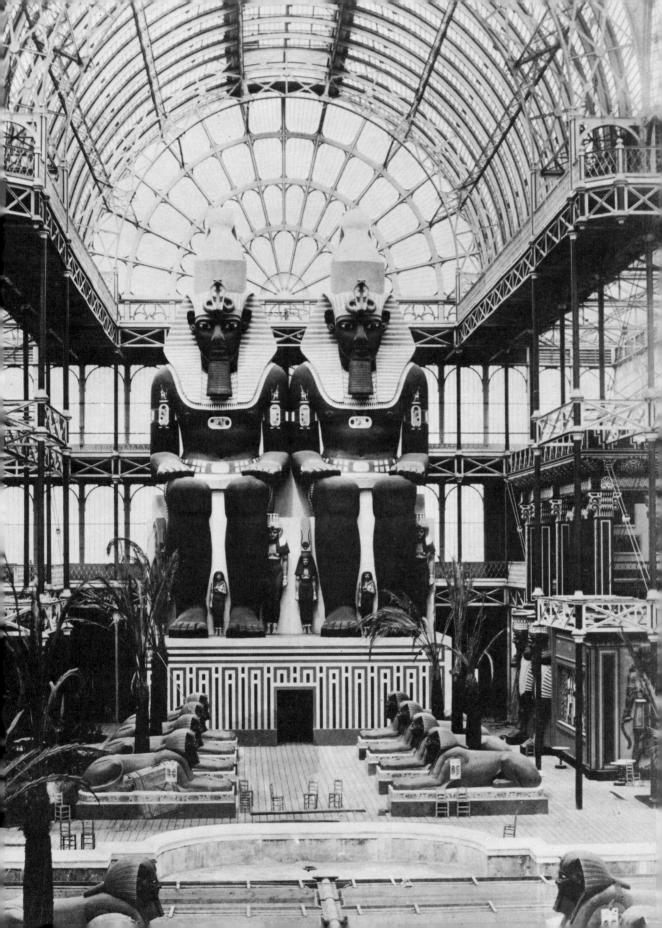

said, were expressed in certain forms of early industrial art, applied in necessary objects.[19] Semper proved his argument by comparing an Egyptian *situla,* or jug for drawing water from the river, with a Greek jar for collecting water from a spring, and pointed out that the form of each vessel expressed its function, not only as a container for water, but the method of carrying it. In *Der Stil* . . . Semper contrasted Doric temples with Egyptian examples, and found that the Egyptian architecture expressed the heaviness in the Egyptian character and spirit. Furthermore, Semper was one of the first theorists to argue that colour had been lavishly used in Greek architecture. He was closely involved professionally with Henry Cole, Owen Jones, and others, and was interested in the idea of providing exemplars. The Egyptian Court at Sydenham was a product of the high minded theories of educationalists by providing accurate, scholarly models of buildings that were so much a part of the ideas of the 1851 Exhibition. The example of the 1851 experiment encouraged a number of exhibitions on similar lines throughout the nineteenth century in Europe and America, and Jones and Semper were among the theorists who influenced the concepts of pavilions that would be related to aspects of applied art. There were several exhibitions where Egyptian objects, or Egyptianising objects, were given a suitably Nilotic architectural setting. Semper's studies of the primitive and the exotic led him to admire the sophistication of Egyptian architecture, and he certainly saw in the art and architecture of ancient Eygpt some profoundly expressive possibilities.

Despite the scholarly approach, and the new knowledge, there were occasional examples of Egyptian Revival work in the 'Commercial Picturesque' tradition, but often rendered more archaeologically correct. The Freemasons' Hall in Boston, Lincolnshire, of 1860–3, based on the portico of a Nubian temple of Dendur out of Denon's work,[20] is a late example, and is an unusually robust work of the Revival (Pl. 177). This Hall is situated in Mainridge, Boston, and consists of an entrance hall, kitchen, and banquet room, with the Lodge room above. The massive and spectacular façade is of gault brick with ashlar dressings, in the form of a pylon, with distyle in antis portico of columns with palm-caps. The cavetto cornice is adorned with a winged solar orb

Plate 176 (opposite) The Egyptian Court by Owen Jones and Joseph Bonomi at the Crystal Palace, Sydenham. A photograph of 1854 by Delamotte showing replicas of two figures from Abu Simbel (*Mansell Collection*).

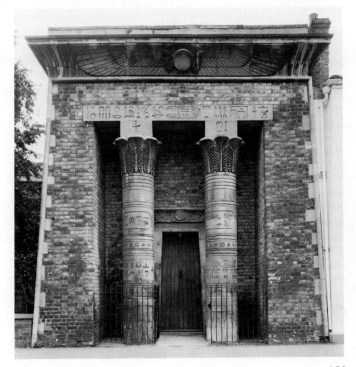

Plate 177 (right) The Freemason's Hall, Mainridge, Boston, Lincolnshire, of 1860–3 (*Addys (Boston) Ltd., No. 12168A*).

supported by cobras. The inscription in hieroglyphs on the lintel reads that 'In the 23rd year of the reign of Her Majesty the Royal Daughter Victoria, Lady Most Gracious, this Building was erected.' The building was dedicated on 28 May 1863 according to the hieroglyphic inscription. The interior was decorated with Egyptian motifs, including the winged globe with cobras, the scarab, the lotus, the eternal serpent, all embellished with strong colour. A Masonic doorcase of timber still exists at No. 3, High Street, Warwick, formerly the Masonic Lodge. It has Egyptianising columns supporting a somewhat heavy semicircular pediment, and the whole ensemble is richly embellished with lotus and papyrus emblems, although the original colouring is quite absent. Lincolnshire also acquired a Graeco-Egyptian Camera Obscura House in Stamford by Bryan Browning (1773–1856) in 1842,[21] but the latter was rather more Greek than Egyptian.

The Odd Fellows' Hall, Philadelphia, of 1846–7, is a strange design, with a vast cavetto crowning cornice, and tall giant pylon-like architraves with their own entablatures rising two storeys above a massive base. Above the window entablatures are corbelled or stepped openings.[22] The railway bridge at Harper's Ferry, West Virginia, of 1835–51, by B. H. Latrobe Junior and W. Bollman, was massively Egyptian,[23] as was J. B. Jervis' Croton Distributing Reservoir, New York, of 1842, a tremendous building worthy of Ledoux, with blank walls, massive pylons at the corners and centres, and a plain cavetto cornice.[24]

Synagogues, like Freemasons' and Odd Fellows' Halls, were often Egyptianising, but very much in the façadist manner of Robinson or of the Boston, Lincolnshire, Freemasons' Hall. The Synagogue at Hobart, Tasmania, of 1844 was designed with an enormous battered pylon-like façade crowned with a cavetto cornice.[25] There were also Egyptian synagogues at Launceston in Tasmania and in Sydney, Australia.[26] Professor Carrott mentions Friedrich Weinbrenner's Egyptian Synagogue at Karlsruhe of 1798, the Mikveh Israel Synagogue, Philadelphia, of 1822–5 by W. Strickland,[27] and the Beth Israel Synagogue in Philadelphia by T. U. Walter, of 1849.[28] Other splendid American Egyptian Revival buildings include the Downtown Presbyterian Church, Nashville, by W. Strickland, of 1848–51[29] (a massive concoction with huge pylon-shaped architraves set between a Giant Order of pilasters, and a distyle in antis porch); the First Baptist Church, Essex, Connecticut, of 1845 (Egyptianising clap-boarded);[30] the Whalers' Church, Sag Harbour, New York, of 1843 (a splendidly robust and delicately modelled wooden building);[31] the project for a church by A. J. Davis of 1845 (an Egyptianising version of the Classical churches evolved in England with a campanile set behind the 'west' front);[32] the same architect's project for an Athenaeum of Natural History, New York (almost Thomsonesque in its use of large areas of glass behind the Egyptian front);[33] T. S. Stewart's superb Medical College of Virginia, Richmond, of 1844 (one of the grandest and most monolithic of all Egyptian Revival buildings);[34] J. Haviland's New Jersey State Penitentiary, Trenton, of 1832–6 (massively robust, with large areas of blank walls, and a portico set between two pylons);[35] the 'Tombs', New York, by Haviland, of 1835–8 (influenced partly by Ledoux's prison at Aix-en-Provence, and partly by the Temple of Dendera);[36] Haviland's Essex County Courthouse, Newark, of 1836–8;[37] and the City Jail, Dubuque, Iowa, by J. F. Rague, of 1857–8.[38]

Perhaps the most splendid example of nineteenth-century Egyptianising, correct in the archaeological sense, complete with hieroglyphs telling us about the building and its date, can be found at Antwerp Zoo. This is the Egyptian Temple, designed by Charles Servais, and erected in 1856. It was based on the style of the temples of Philae and Dendera. Servais took infinite pains to ensure that his building was correctly Egyptian, and covered it with hieroglyphs that actually meant something. The building is described in E. Gens's *Promenade au Jardin Zoologique d'Anvers* of 1861. Servais visited Sydenham, and the Egyptian Court was his inspiration. He consulted Bonomi, who knew Egypt,[39] and who helped the Belgian architect with the hieroglyphs and with the correctly Egyptian forms of the building. Others involved in the design of the details were Sharpe and Dr Louis Delgeur (Pl. 178 and Fig. 11). The building is described in an article by W. van den Bergh.[40]

Considerable interest in ancient Egypt had been aroused by the publication in 1837 of J. G. Wilkinson's *Manners and Customs of the Ancient Egyptians,* which was one of the first attempts to provide a comprehensive account of the subject. It was very influential. David Roberts' *Egypt and*

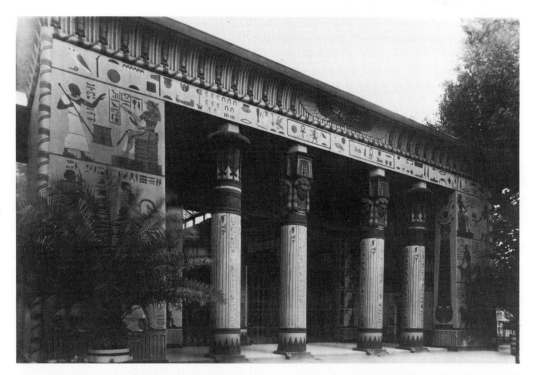

Plate 178 (above) The Egyptian Temple, Antwerp
Zoo, by Servais, of 1856 (*Michel L. Hoert. Koninklijke
Maatschappij voor Dierkunde van Antwerpen*).

eM TeR eNT piNouTeR eNTi NoHem MDCCCLVI KHaR Hon-eF
In het jaar van de God Verlosser 1856 onder Z. M.

SouKHeb Ra ONKH–Belgica Si Ra Leopold APe AiRiTOU
de Koning, Zon en leven van België, Zoon van de Zon, Leopold de Eerste. werd gemaakt

Pa TeN SchAlt eR Ou Het Antverpia Se-AKer RuT.
dit huis een boek om te verblijden Antwerpen en te onderwijzen zijn bewoners.

Figure 11 Hieroglyphs and their Flemish translation
at the Egyptian Temple, Antwerp Zoo (From *Zoo.
Uitgave van de Kon. Mij. voor Dierkunde van
Antwerpen*).

Plate 179 Egyptianising waterworks at East
Farleigh, Kent of 1860.

Nubia of 1846–9 enjoyed royal patronage and brought marvellous images of Egypt before the public. The importation of Egyptian cotton to Lancashire caused the naming of the Cairo Mill in Burnley, whilst Egyptian cigarettes became fashionable later in the century.

In 1860 James Pilbrow built the Egyptianising Maidstone Waterworks of stock brick and stucco dressings at East Farleigh in Kent beside the River Medway. It is a spectacular job, with battered buttresses and a heavy cavetto cornice (Pl. 179). The Egyptian style was also used for a commemorative obelisk and practical ventilator in Sydney, Australia, in 1857. There, under the enlightened mayoralty of George Thornton, the municipal authorities built a sewerage system that is ventilated through the cap of a fine obelisk which stands on a battered pylon-like base with cavetto cornice embellished with winged globes on all four faces. The cornice carries eight sphinx-like bodies that terminate in four heads at each corner of the obelisk. Dunore House, Aldergrove, in Co. Antrim, Northern Ireland, has four Egyptian terms supporting the cornice over the main door. Originally the doorway was covered with hieroglyphs, but these have been obliterated. An obelisk capped the crowning pediment, and the whole dated from *c.* 1860.

Some of the most interesting Egyptianisms of the second half of the nineteenth century occur in Christopher Dresser's work. Dresser (1834–1904) published his *Principles of Decorative Design* in 1873. He had designed a plate for Owen Jones's *Grammar of Ornament,* and was one of the first and one of the few Victorian designers of any standing who actually accepted the machine. Instead of nostalgia for handcrafts, Dresser produced designs suited to the new manufacturing processes. He drew particular attention in his works to the 'severity, rigidity of line, a sort of sternness'[41] in Egyptian ornament, and noted that with the severity there was always a dignity. He admired the nobility of Egyptian art as well as its massiveness and solidity. He mentioned the 'winged orb' or 'winged disc', and said he knew

> of few instances where forms of an ornamental character have been combined in a manner either more quaint or more interesting than in the example[42]

of the winged disc or globe. He identified this device as a symbol of protection. Dresser recommended the study of Owen Jones's *Grammar of Ornament,* the works of Sir Gardiner Wilkinson, and especially the Egyptian Court of the Crystal Palace at Sydenham.

In his book, *Principles of Decorative Design,* Dresser drew attention to the structural principles of an ancient Egyptian chair, and compared it very favourably with products of his own day. Indeed, Dresser designed several chairs based on Egyptian prototypes. One of his most delightful works is the sofa he designed for Bushloe House, Leicester, in 1880. This is of mahogany, with leather seat and back. Structural principles are well to the fore, as the back is further strengthened by being tied to cross-rails between the legs (Pl. 180).[43] Other examples of nineteenth-century Egyptianising furniture can be mentioned here, including the stool of 1870, made of wood, and painted with designs based on Jones's *The Grammar of Ornament* of 1856 (Pl. 181).[44] Even more spectacular is the splendid English wardrobe in the Egyptian taste of 1878–80, of oak and pine with Egyptian motifs, now in the Victoria and Albert Museum.[45] This is a very beautifully proportioned piece, and clearly owes much to both Jones and Dresser (Pl. 182). Dresser's influence in design was considerable, and his admiration for real Egyptian furniture from a design point of view is often expressed in his writings. Holman Hunt derived inspiration from New Kingdom furniture for his designs for chairs in the 1860s. One of his chairs was exhibited in London in 1862, and is now in Birmingham. By the 1880s many stools and tables in the Egyptian taste were being made.

There was an exhibition of Egyptian antiquities in New York in 1852, and this, with the permanent Egyptian Court at Sydenham, and the discoveries based on the archaeological excavations at Giza and elsewhere, helped a new Egyptian Revival. Brass lion's and leopard's feet, sphinx heads and feet, lotuses, palms, scarabs, and other motifs familiar from the Egyptian Revival of the early 1800s, began to reappear on furniture, especially in the United States of America (where Egyptianisms enjoyed a continuous vogue for the first half of the century) and in France.

Later in the century a further encouragement of Egyptianising was given by the opening of the

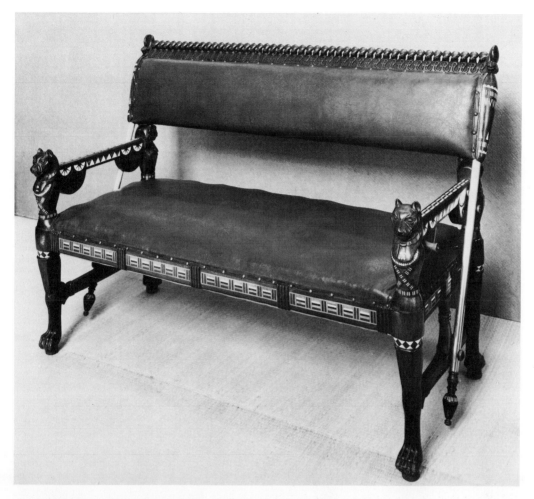

Plate 180 (*above*) Sofa of 1880 by Christopher Dresser with Egyptianising detail (*The Victoria and Albert Museum*).

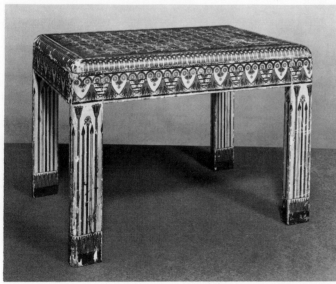

Plate 181 (*left*) Stool of 1870, made of wood, and painted with designs from Owen Jones' *The Grammar of Ornament* of 1856 (*Victoria and Albert Museum*).

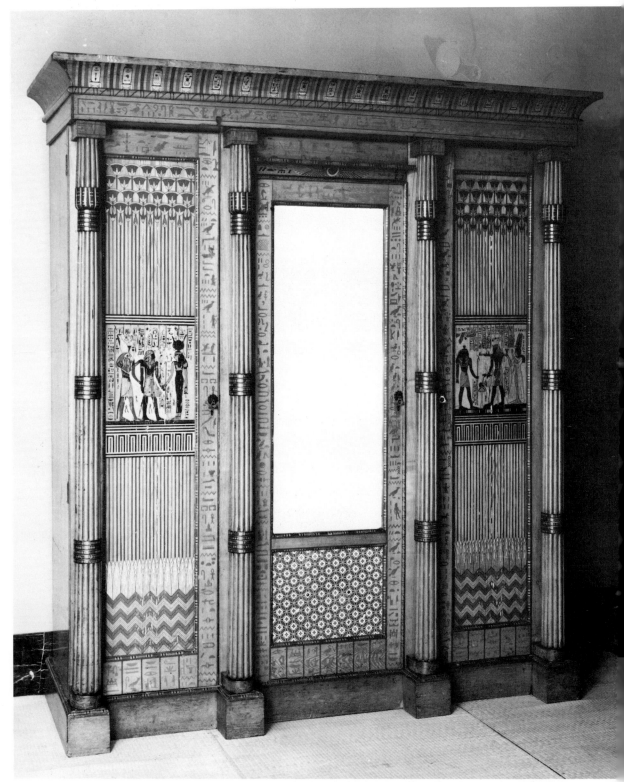

Plate 182 English wardrobe of 1878–80, of oak and pine with Egyptian motifs (*Victoria and Albert Museum*).

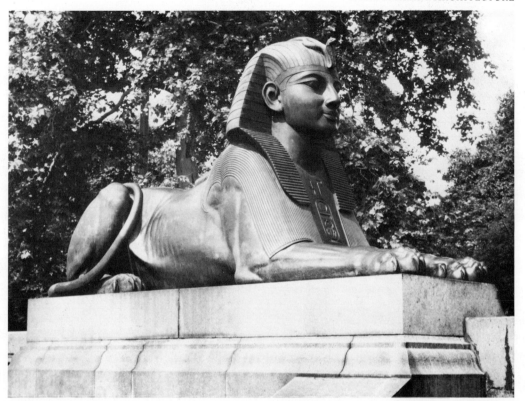

Plate 183 One of a pair of bronze sphinxes flanking the obelisk in London case by Young & Company and designed by G. Vulliamy.

Suez Canal in 1869. The Khedive of Egypt commissioned Verdi to write *Aida* at the same time to inaugurate the new opera house in Cairo, but *Aida* was not produced there until 1871, as costumes and sets were held up in France as a result of the Franco-Prussian War. The plot of the opera was suggested by the Egyptologist, Mariette Bey, and the original libretto was in the French of C. du Locle, translated into Italian by A. Ghislanzoni. *Aida* was set in ancient Egypt, the scenes being the Palace of the Pharaoh at Memphis, the Temple at Memphis, a Hall in the Apartments of Amneris (daughter of the Pharaoh), the Gate of Thebes, the Banks of the Nile, a Hall in the Palace of the Pharaoh, and a Dungeon with a Temple above. All these scenes were, and are, splendid vehicles for the most spectacular Egyptianising sets. The effects of the opera on taste were not dissimilar to the impact of the showy films of the twentieth century that featured Cleopatra and Egyptian décor. Contrary to often-stated belief, *Aida* was not commissioned to inaugurate the opening of the Canal.

The obelisk of red granite in London known as 'Cleopatra's Needle' lay in the sands of Alexandria for centuries before it was presented to the British Nation by Mahommed Ali, Viceroy of Egypt, in 1819, as a memorial to Nelson and Abercromby. Originally it stood at Heliopolis, where it was erected by Thothmes III in around 1500 BC, and was removed to Alexandria in 12 BC. It was brought to England in an iron cylinder, largely through the generosity of Dr Erasmus Wilson, FRS, and was erected on an Egyptianising base set with bronze ornament under the direction of John Dixon in 1878. The length of time between the making of the gift and the efforts to accept it is an indictment of nineteenth-century parsimony as well as of its technology, for it must be remembered that the Romans of Imperial times transported even larger obelisks by sea to their capital some 1,800 years before. Flanking the obelisk are two large bronze sphinxes by G. Vulliamy, cast by Young and Company (Pl. 183). The Egyptian Revival base and sphinxes provided

187

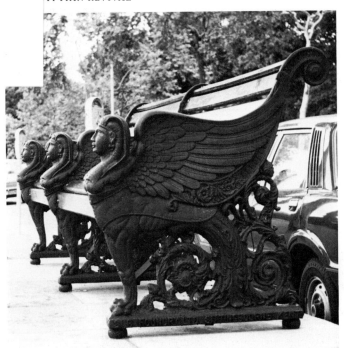

Plate 184 (left) Egyptianising cast iron seat-supports on the Embankment in London, by S.L.B. Foundry Ltd. of Sittingbourne.

Plate 185 (opposite) The Seventh Plague of Egypt by John Martin, engraved by Le Keux (Mansell Collection).

to set 'Cleopatra's Needle' on the Embankment were only part of further Egyptianising: all the public seats along the Embankment consist of cast-iron winged sphinxes (made by the S. L. B. Foundry, of Sittingbourne in Kent) supporting wooden slats (Pl. 184). 'Cleopatra's Needle' in London is not the obelisk of that name, but a second obelisk that stood beside the 'Needle' proper.[46] The real 'Cleopatra's Needle' is now in Central Park, New York, and was given by the Khedive of Egypt in 1880. The arrival of genuine obelisks in New York and in London, and the excavations at Tel-el-Amarna in 1887 gave further impetus to the Revival of the Egyptian style.

Throughout the nineteenth century the scholarly French publications previously mentioned had a considerable effect on architecture and design in Europe and in America. Masonic influence also played some part in the Egyptian Revival, while permanent exhibitions like the Egyptian Court at Sydenham influenced public taste. Napoleon's expedition gave a particular encouragement to the Egyptian Revival because the French went fully prepared for detailed study and surveys, while Nelson's victory over the French at the Battle of the Nile made Egyptianising popular in Britain. Even Nelson's funeral car was decorated with Nilotic palms for his burial on 9 January 1806.[47] Thomas Hope, Sheraton, Chippendale the Younger, George Smith, and others helped to make the Egyptian taste fashionable and familiar. Furniture in the Egyptian style was illustrated in Sheraton's *Cabinet-maker, Upholsterer, and General Artists' Encyclopaedia*, published in parts between 1804 and 1806, and Chippendale (1749–1822) made Egyptian furniture for Stourhead in Wiltshire in 1804–5.

There was another source for the popularisation of the Egyptian style in the paintings and engravings of John Martin (1789–1854), the English painter of large visionary and apocalyptic scenes with Biblical and Oriental settings. These paintings exerted a very great influence on Romantic taste in Europe and America. Martin became famous in 1816 with *Joshua Commanding the Sun to Stand Still,* and followed this with a series of enormous canvases. The most Egyptianising pictures were *The Destroying Angel, The Death of the First Born,* and *The Seventh Plague of Egypt* (Pl. 185). Prints were made of Martin's work by Ackermann, Le Keux, and others, although many were pirated, and the visionary compositions became familiar to a wide public. Martin was greatly

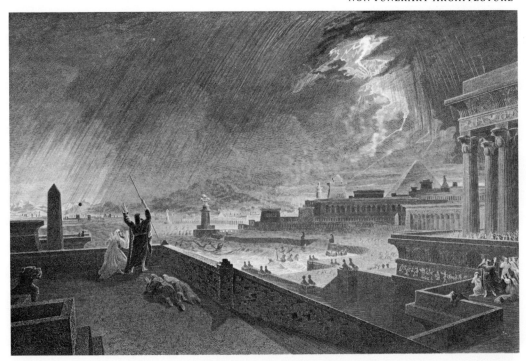

admired in France, and he was honoured by both Charles X and Louis-Philippe. His work attracted the attention of Sainte-Beuve, Victor Hugo, and Gautier, among others. Gustave Planche described Martin in 1834 as the 'poet's painter', and Bürger said in 1863 that of all English painters Martin had the highest reputation in Europe.[48] Martin was, in short, the master of Sublime terror. The opulence of the developments in Nash's London reminded Michelet of John Martin's visions, and the creations of Alexander Thomson in Glasgow also have a certain affinity with the grandeurs of Martin's paintings.

The individual contribution of the architect Alexander 'Greek' Thomson (1817–75), most of whose work was in the Glasgow area, cannot be underestimated in the context of this study. The term 'Greek' is misleading, for Thomson used Egyptian motifs with great assurance. He was much more than a revivalist, for he was a stylistic inventor of genius, although he was unquestionably influenced by Karl Friedrich Schinkel. The Prussian architect's use of bands of windows with square, squat mullion-columns linked in horizontal bands, as in the Berlin Schauspielhaus of 1819, was a favourite motif of Thomson. We also know that Thomson possessed Schinkel's *Sammlung Architektonischer Entwürfe,* and the motifs that occur in Thomson's and in Schinkel's work are too close to be unrelated.[49] However, the motif of horizontal bands of window separated by short columns square on plan is unquestionably Egyptian in origin, and can be traced to the Egyptian temples at Elephantine and other places illustrated in the *Description . . .* and other works.

Thomson's St Vincent Street Church in Glasgow of 1859 is one of his most amazing and dramatic compositions. As the land falls away sharply, a large podium had to be created, recalling Haller von Hallerstein's and Leo von Klenze's designs for *Walhalla,* or Gilly's project for the Frederick the Great monument. Thomson set his temple-church on this mighty plinth, with hexastyle Ionic porticos at each end, but with clerestory strips of windows down each side divided by short columns square on plan in the Schinkel manner. Below the clerestory lights are aisles with large areas of glazing divided by pairs of coupled columns again square on plan. Near the ends of the flanking aisle walls are two of Thomson's favourite Egyptianising devices: tall battered pylons rising above the cornice of the aisles. The tower of St Vincent Street Church has a

189

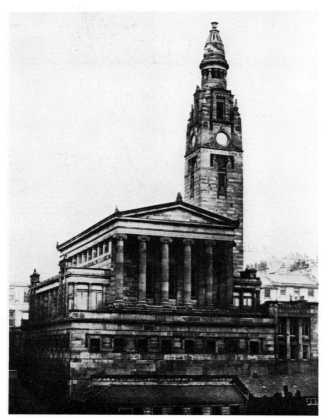

Plate 186 (*left*) Alexander Thomson's St Vincent Street Church in Glasgow of 1859. Note the Egyptian pylons in the tower and breaking through the side walls of the aisle (*Royal Commission on the Ancient & Historical Monuments of Scotland. No. GW/2017*).

Plate 187 (*below*) Alexander Thomson's Queen's Park Church, Glasgow, of 1867, with marked Egyptianising detail (*Mitchell Library, Glasgow*).

Plate 188 (*opposite*) The Egyptian Halls, Nos. 84–100, Union Street, Glasgow, of 1871–3, by Alexander Thomson (*Royal Commission on the Ancient & Historical Monuments of Scotland. No. GW/2020*).

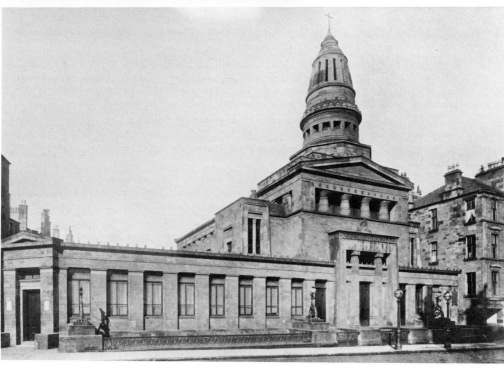

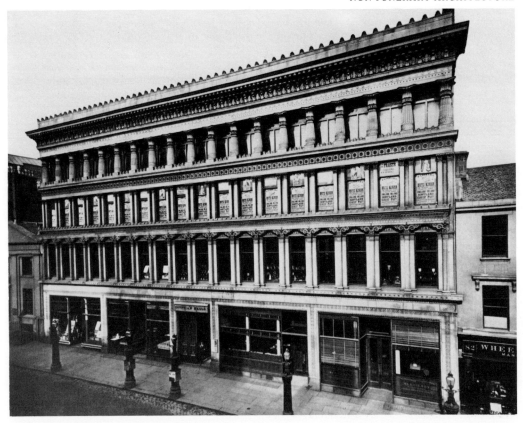

plain base with T-shaped openings near the top of the first stage in which Egyptianising figures face each other and support a lintel. Above, four battered pylons carry the drum that has a peristyle of stocky Egyptianesque columns (Pl. 186).

Even odder was Thomson's design for Queen's Park Church of 1867 (Pl. 187). The building was destroyed during the Second World War, and was one of Glasgow's great architectural losses. It had a high cupola not unlike that of St Vincent Street, but the front elevation was much more Egyptianising than that of the earlier church. The entrance was a huge pylon with two columns supporting the lintel and the Egyptian cornice. The temple-block had four squat columns set under a pediment, and again there were strips of clerestory windows with squat columns in the Schinkel manner. Two more battered pylons stood at the ends of the aisles. The Egyptian influence is particularly strong, and must have owed something to Denon or to the *Description de L'Egypte*...[50]

Thomson's 'Grecian' building (1865), of Nos. 336–56, Sauchiehall Street, has Egyptian free-standing columns with the glazing set well back on the top floor. The idea developed in his Egyptian Halls, of Nos. 84–100, Union Street, built in 1871–3. This is probably his most remarkable design for a warehouse, for the whole façade is exceedingly vigorous and inventive, with Egyptianising columns standing in front of a glass wall on the top storey beneath a gigantic entablature. In the Egyptian Halls Thomson erected a master-work of visual logic and cohesion (Pl. 188).

His villa at No. 200, Nithsdale Road, Glasgow, of 1871, is symmetrical, with Egyptian columns set in a plain stone wall. The chimney-pots, too, are splendidly Egyptianising, with palm-caps (Pl. 190). Thomson's work often shows a synthesis of Greek and Egyptian elements, although he always reinterpreted those elements with considerable élan and sureness of touch. Egyptianisms are also found in the interiors of his Great Western Terrace (1867). We know that Thomson knew

the works of J. G. Wilkinson, of David Roberts, and of James Fergusson.[51] He himself gave a lecture on 'The Development of Architecture – the Spirit of the Egyptian Style' in which he stressed the symbolic qualities:

> There are the pyramid, the obelisk, and the rudimentary temple forms, each having its sides sloped in greater or less degree and by this peculiarity suggesting common relationship. I have already spoken of the pyramid as expressing the simple idea of stability or duration. Suppose that idea to be distinctly impressed upon the mind; then look at the obelisk. The same idea is reproduced less strongly, but there is another element added, that of proportion, expressing the idea of justice or truth. And these two ideas readily combine.[52]

Thomson was interested in the Egyptian use of spatial sequences, of repetition, and of painted decoration. He made it clear in the Haldane Lectures[53] that he believed Greek architecture and design derived from Egyptian prototypes:

> The Egyptians sought to realise the idea of endless duration, and so all their works expressed that longing after immortality. The Greeks aimed at perfection, and all that they did bears evidence of the earnestness and ability with which they sought to realise their idea.

However, Thomson insisted that although the Greeks got their basic ideas from Egypt, they did not copy Egyptian work, but built on principles of design that had been established in Egypt.[54]

Thomson praised the architectural fantasies of John Martin, and also the paintings of Turner and Roberts for showing the 'mysterious power of the horizontal . . . in carrying the mind away into space.' Thomson particularly noted the 'repose' of Egyptian architecture and its expression of 'quietly waiting till all the bustle is over', in his 'Enquiry into the Appropriateness of the Gothic Style for the proposed Buildings for the University of Glasgow', now in the Mitchell Library, Glasgow.

With the works of Alexander Thomson the Egyptian Revival reached new heights of invention. Echoes of his work occur later, but without many overt Egyptianisms. The Schinkel-Thomson strip of horizontal window subdivided by means of columns on square plans recurs in a modified form in the works of Frank Lloyd Wright (Robie House, Larkin Building, and other structures), of J. M. Olbrich (Darmstadt Gallery), and of Otto Wagner (his own villa), among others. Obvious Egyptianisms occur at the Villa Hügel (completed in 1873 to designs by Schwarz and Rasch), home of the Krupps, near Essen, where large big-breasted guardian sphinxes of bronze flank the entrance (Pl. 189). These sphinxes were ordered from the sculptor Max Dennert in 1897, and cast between 1900 and 1904. They are discussed by Heinz Demisch in his *Die Sphinx,* in which he notes the masculine faces, the vigilant pose, and the massive, heroic breasts. The same villa also has strips of window subdivided by square columns in the Schinkel manner at clerestory level.

Jewellery accounted for much Egyptian Revival work in the course of the century. A pendant of 1865, with an enamel plaque depicting an Egyptian woman and her servant, was in the form of an aedicule flanked by seated figures.[55] Early Art-Nouveau designs often contained Egyptianising motifs: an American brooch with the profile of an Egyptian princess after Mucha of *c.* 1896 was made of twelve-carat gold, set with emeralds, seed pearls, and enamel;[56] and a brooch design by Paul Follot of *c.* 1900 had distinctly Egyptian antecedents in the papyrus motifs.[57]

The influential painting of Edwin Long (1821–91) known as *The Gods and their Makers* was exhibited at the Royal Academy in 1878 and shows the interior of an ancient Egyptian studio, where statues of deities are being made. Sir Laurence Alma-Tadema (1836–1912) had correct Egyptian Revival furniture made for his studio. His *Pastimes in Ancient Egypt* (1863), *An Egyptian Widow, Death of the First-Born,* and other paintings all contain correct Egyptianising detail of furniture. His sketch-books show how carefully Alma-Tadema studied his Egyptian taste. Further interest in Egyptian artefacts and design was stimulated by Joseph Mayer's Egyptian Museum in Liverpool which he presented to that city in 1867.

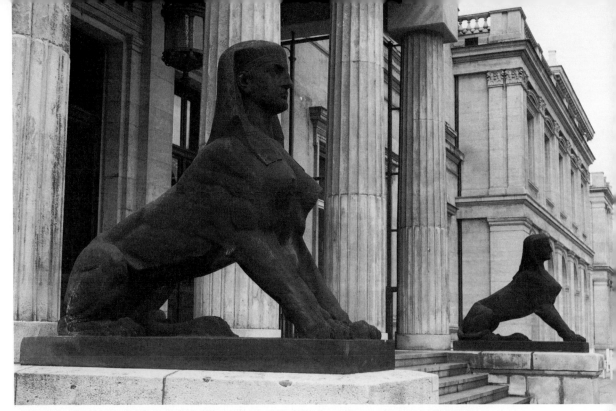

Plate 189 The bronze sphinxes by Max Dennert at the Villa Hügel, near Essen, designed 1897 and completed in 1904 (*Alan Spencer*).

Plate 190 No. 200, Nithsdale Road, Glasgow, of 1871, by Alexander Thomson (*Royal Commission on the Ancient & Historical Monuments of Scotland. No. GW/1432*).

Plate 191 Thebes stool patented and marketed by Liberty & Co. in 1884. It is made of mahogany, with a leather seat (*Victoria and Albert Museum*).

In 1884 Liberty and Company patented and marketed copies of a Thebes stool that was outstandingly in accordance with Dresser's principles of sound structural design, pleasing lines, and quality of materials. The stool is made of mahogany, and has a leather seat. It is now in the Victoria and Albert Museum (Pl. 191).[58] Liberty's was not the only firm to exploit a fashion for the Nile style: designs by E. F. Godwin were marketed by the Art Furnishers Alliance in Bond Street in the 1880s; the Grueby Pottery Company and Tiffany's began to produce objects with an Egyptian flavour; and the Symbolists from 1885 included Nilotic elements in their pictures. The Symbolists were eclectics interested in the expression of poetic ideas,[59] and in the occult. Painted and inlaid Egyptianising furniture was made for patrons like Alma-Tadema who used it as models. The Nile style had its enthusiasts in the latter part of the nineteenth century in America,

193

England, France, Russia, Germany, Italy, and Austria-Hungary. Periodicals like *Pléiade, Décadent, Vogue,* and *Symboliste* carried Symbolist ideas, while the shops of Liberty and Tiffany purveyed Nilotic objects to an eager public. Sarah Bernhardt's performances as Cleopatra in the 1890s also did much to popularise Egyptianising objects.

Throughout the 1880s, 1890s, and 1900s there are many examples of Egyptiana. Pharaonic head-brooches, gold cuff-links featuring hieroglyphics and Egyptian figures, scarab bracelets, brooches and rings, and statuettes occur in quantity. They are not confined to any one country, although the main centres of manufacture were Italy, the United States, France, and England. Some overt architectural Egyptianisms occur in the works of Arnold Böcklin (1867–1901) and his associates. Böcklin's celebrated *Toteninsel* of 1880, now in the Kunstmuseum in Basel, has eerie Egyptianesque entrances to rock-cut tombs in the Isle of the Dead.[60] Karl Wilhelm Diefenbach's (1851–1913) painting, *Isola dei morti,* of 1905, based on Böcklin's *Toteninsel,* and now in a private collection in Rome, has a full Egyptian cornice embellished with a winged globe over the entrance to the Isle of the Dead.[61] In both these paintings, Egyptian elements associated with permanence and death contribute to the disturbing images. The Villa Romana, San Gaggio, Florence, once occupied by the architect Henry Roberts (1803–76), became the centre for a group of artists associated with Böcklin. In the garden of the house are several terracotta sphinxes. The haunting works of the Böcklin circle were celebrated in an exhibition in Fiesole in 1980, and demonstrate why they were so greatly admired at the turn of the century. Böcklin's works especially had a profound effect on the composer Max Reger, who wrote some orchestral tone-poems inspired by his paintings.

Obvious Egyptianisms occur in the badges of regiments that had seen service in Egypt; in stamps issued in Egypt and printed by the firm of De La Rue showing ancient Egyptian architecture; and in *Old Moore's Almanac* (first published in 1791) where hieroglyphs are often in evidence. Indeed the latter publication still carries advertisements for ancient Egyptian charms. Even in Egypt itself hotels and other buildings erected to cater for European tourists were often in the Egyptian Revival style. Egyptian postage-stamps, cigarette boxes, and other ephemera exploited the art and architecture of the ancient Egyptians.

Egyptian papyrus heads and lotus flowers were introduced into designs for chintzes, wallpapers, and fabric design generally, especially in France, England, and America. Egyptian Revival had a vogue in the France of the Second Empire, where aspects of taste under the first Napoleon had a new lease of life. In England, designers including Walter Crane derived decorative motifs from the Egyptian lotus and other features.

In the last year of the nineteenth century an Egyptianising design for a Beacon of Progress was produced by Constant Désiré Despradelle (1862–1912) for Chicago. This monument, a gigantic obelisk that would have been nearly three times higher than the Washington Monument as built, and almost twice as tall as the Eiffel Tower in Paris, was intended to typify 'the apotheosis of American civilisation, to be erected on the site of the World's Fair at Chicago', as Despradelle himself described it in *The Technology Review* of October 1900. There was to be an esplanade leading to the access to the principal terraces and platforms, where sculptures representing eminent men and significant events would stand. In the 'place of honor, in the axis of the monument', the names of the original thirteen colonies were to be inscribed. Upon 'the "Stela", guarded by the eagle, is the goddess of the twentieth century, the modern Minerva, flanked by ranks of lions roaring the glory of America . . . In the interior, elevators conduct to different stories and balconies, as well as to the powerful beacon placed fifteen hundred feet above the ground.' So the proud architect described his scheme in *The Technology Review.*

Despite the influence of the Goths, and of all those who despised Egyptianising eclectic design, the Nile style survived, and indeed flourished in the nineteenth century.[62] It was to live on in the twentieth, and was to enjoy further Revivals.

9

The Egyptian Revival in the twentieth century

Real Egyptian monuments, built of the
hardest materials, cut out in the most
prodigious blocks, even where they please
not the eye, through the elegance of their
shapes, still amaze the intellect, through
the immensity of their size, and the
indestructability of their nature.

THOMAS HOPE: *Household
Furniture and Interior Decoration.*

We have seen how the Egyptian Revival persisted through the nineteenth century and that it was
not merely a phase after the Napoleonic campaigns in Egypt. The Egyptianising furniture of
Liberty's and other firms became popular, and even became associated in Italian minds with Art
Nouveau to the extent that Art Nouveau was named the Style Liberty in Italy. Egyptian elements
occur in Italian design of the early years of the present century, and are strongly represented in
the work of one of the most extraordinarily gifted designers of the time, Carlo Bugatti
(1856–1940). The astonishing room that Bugatti designed for Lord Battersea's house at No. 7,
Marble Arch, of *c.* 1903, is a strange and exotic amalgam of Egyptianising and other elements.
The room was designed and manufactured in Milan, and probably erected in London by a team of
Italian craftsmen sent over by Bugatti for the purpose. Although the Egyptian motifs had become
transformed in this design, their origins were unmistakable. Even the circular feature containing
the two mirrors had stepped 'corbels' that recalled Egyptian Revival openings of the 1800s, while
the fan-like feature between the two mirrors recalled the lotus flower (Pl. 192). The furniture had
echoes of Regency Hopeian designs mixed with the robust imagination of Dresser, and trans-
formed into something completely original by Bugatti. This room must be one of the richest and
most exotic designs in twentieth-century architecture.[1]

Bugatti returned to a more instantly recognisable Egyptian theme in his design for a War
Memorial of about 1919. The form is Neoclassical, recalling Desprez, Boullée, or Canova, and
consists of a pyramid set against a rugged wall. The pyramid supports an urn. In the centre of one
face of the pyramid is a circular opening (a motif used to great effect in Lord Battersea's room of
1903) at the back of which are ghastly figures suggesting the carnage of the battlefield and the
agonies of bodies in a slaughterhouse. This is a design of the utmost power, deeply moving, with
pronounced Egyptian Revival overtones (Pl. 193).[2] The Egyptianising of Bugatti did not occur in
isolation. In 1904 there was a rationalist congress held in Rome at which Giordano Bruno was
elevated to the position of a hero of his country, in clear defiance of clerical conservatism and in
direct opposition to the kind of papistical contortions enshrined in the works of obfuscators
like Cuomó and other crabbed apologists from the age of Pio Nono.

The Egyptian Revival received an impetus in 1922 through the opening of the tomb of
Tutankhamun that was second only to the tremendous stimulus provided by the publications of
the scholarly surveys of Napoleon's teams in Egypt. Furniture, jewellery, décor, and architecture

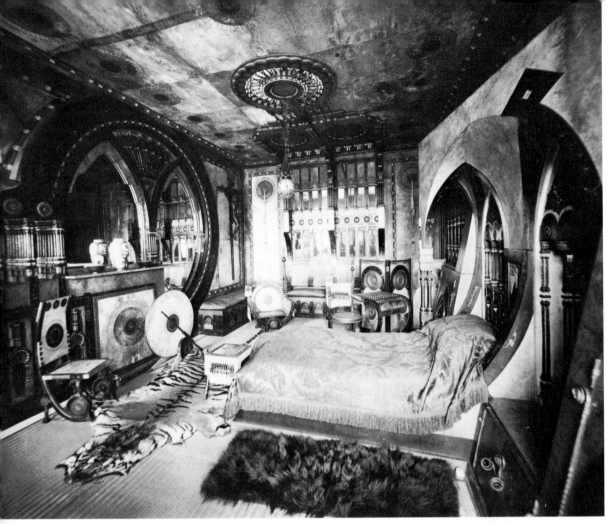

Plate 192 (*above*) A room designed for Lord Battersea at No. 7, Marble Arch, by Carlo Bugatti in *c.* 1903. Note the stepped 'corbels' over the mirrors on the left, and the fan-like feature between the mirrors that recall the lotus flower (*Collection of Christopher Wood*).

Plate 193 (*left*)) Carlo Bugatti's design for a war memorial of 1919 (*Collection of H. G. Conway*).

all were influenced by the finding of the tomb. The furnishings and other contents of the Pharaoh's mausoleum were of such superlative design and quality that they became models almost overnight, and not only for rare artefacts. Modern publicity ensured a widespread following for the Nile style. Fashionable ladies wore Egyptianising 'Cleopatra' earrings, while their aspiring sisters contented themselves with less perfect jewellery; designers like Pierre Legrain produced Egyptian chairs; and Egyptian motifs appeared on objects from ash-trays to cinemas.

Yet even before the discovery of the tomb and the publication of details of its marvellous contents, the Nile style had not died, although in architectural terms it had been somewhat out of fashion since the denunciations of Pugin in England. Nevertheless, Sir Frank Baines, the Director of H.M. Office of Works, was bold enough to propose a National War Memorial in the Egyptian style for a site at Hyde Park Corner. This proposal was not prepared officially on behalf of the government, but was entirely conceived and carried out by Sir Frank Baines as his own idea of a war memorial.[3]

Sir Alfred Mond, the First Commissioner of Works, gave permission for Baines's design to be exhibited in the tea-room of the House of Commons, where it 'aroused considerable discussion',[4] and 'excited extraordinary interest'.[5]

> The memorial, which is designed for a commanding position at Hyde Park Corner, is in the form of a gigantic pylon with two flanking temples. The style of the design is Egyptian.[6]

The Times noted that the architect had selected the Egyptian style 'evidently feeling that the Egyptian period is the most suitable for immense scale and grandeur. His ambition clearly is that the monument should be the most distinctive object in London.'[7] The Builder observed that the conception seemed to 'embody one great idea – that of sacrifice.' Clearly the design made a 'profound impression on the collective feeling of the House of Commons.' However, The Builder felt that a design for a national war memorial should be a subject for a national competition. The Builder went on to raise some cautionary points:

> No one would wish to do otherwise than welcome a well thought out scheme for such an object as that of a great National Memorial, but the announcement, apparently inspired, is launched in the most unfortunate terms. For such a proposal to command approval we should know to whom these 'immense bas-reliefs' are to be entrusted. But while no particulars are given such as could aid us, the phraseology employed is both grandiose and absurd. Will the public understand that such descriptions – we pluck a few of the flowers of speech – as 'immense', 'cloudy forms', 'gigantic symbol of immortality', 'immense scale and grandeur', and all the rest of it, are the merest moonshine? – that it is one thing to talk about these things, and quite another to do them?[8]

Sir Frank Baines was clearly thinking in the terms of the eighteenth- and early nineteenth-century architects. The blank incomprehension and hostility with which his scheme was greeted showed how well Pugin and others had done their work. The Sublime was definitely out of fashion. Members of Parliament

> were impressed that such a memorial should have been suggested for such a site by anyone who knew anything about the origin of the war, or its consequences.[9]

Some of the criticisms were not concerned with style, but only with getting jobs:

> with grief and indignation I learn of the proposal that H.M. Office of Works should design the National War Memorial . . . I protest very earnestly against employing a Government department to produce the monument which, above all others, should represent the finest art of our country . . .[10]

197

Other correspondents felt that Hyde Park Corner was 'unsuitable' for a memorial on such a large scale. The Egyptian style was regarded as:

> dreadful . . . What have we to do, now, with immense scale and grandeur – we who are not yet out of mourning, and two years ago were in terror of defeat . . . Of all the styles suited to London the Egyptian is the most unfit and alien; and the bigger it might be, the more vulgar it would be. It is heavy, passive, sulky; it is the style of a caste-ridden people; it requires the sunlight and the desert; it would show the dirt; it proclaims complete indifference to the hard estate of the poor.[11]

Mr Selwyn Image observed that he could only:

> characterise it as (a design) of pure pagan swagger. In every way it might have suited Berlin under the dominance of the ex-Kaiser.[12]

Some critics felt that the enormous dimensions of the proposed memorial would throw out of scale the areas of the surrounding parks and buildings, and suggested that such a memorial was only suited for the open country where it would not overpower and belittle its vicinity. Today it might be observed that a building such as that proposed might have filled the space and made it more coherent by its very site. The Egyptian style was regarded as

> commemorative of the despotism and conquests of the Pharaohs, and (was) unsuitable as a memorial of the recent struggle on behalf of human rights.[13]

At the Annual General Meeting of the Society for the Protection of Ancient Buildings Mr Thackeray Turner said he thought the design was 'monstrous' and should be 'opposed in every possible way'. Sir Thomas G. Jackson was opposed to any designs being adapted from any particular style. The symbolism, he said, was:

> as little suited to modern ideas as the Pylon itself. Symbolism belongs to the time when people could not read and had to be taught by pictures instead. It lost its meaning as knowledge spread, and was brushed aside by artists as art matured. The higher art really began when symbolism ended.[14]

In Jackson's opinion the design was an 'offence against reason and good taste', and he asked about the wisdom of 'spending tens or hundreds of thousands of pounds on such a scheme' when taxes were 'such a heavy burden on the community'.[15] A Mr Thomas Battenbury called the design a 'monstrous erection', and asked if the 'architect ever saw' Pugin's *Contrasts* (sic) in which there was a 'monstrosity in a pseudo-Egyptian style'.[16] It is interesting that a lampoon by Pugin was still enough to damn a style.[17]

Baines's scheme is an astonishing essay for its date. The great pylon was to be on the axis of Piccadilly at Grosvenor Crescent, and would have been visible from the east all the way down Piccadilly. There can be no question that the design would have been enormously impressive, and as a work of twentieth-century Egyptian Revival it is of considerable interest (Pl. 194).

Egyptianisms were well to the fore in the Peace and War Memorial scheme designed by Cass Gilbert (1859–1934) for New York City in 1919. 'A war memorial should be so designed and executed that it gives one the impression only, and that the impression should be one of sheer beauty, strongly suggestive of the ideals for which the memorial stands; namely, Courage, Bravery, Liberty, and Victory. It should be thought of only in relation to those who were most actively and intimately engaged in the war. I am speaking of those who not only gave their lives on the field of battle, but of the men and women alike who gave themselves entirely to the aid of the Government in helping the men on the battle line.' So wrote the architect himself in *The American Architect* of January 1921 (Vol. CXIX). The monument would have consisted of a massive stepped base approached from ramps, crowned by a huge stepped pyramid.

The discovery of the tomb of Tutankhamun and the publicity given to the marvellous furnish-

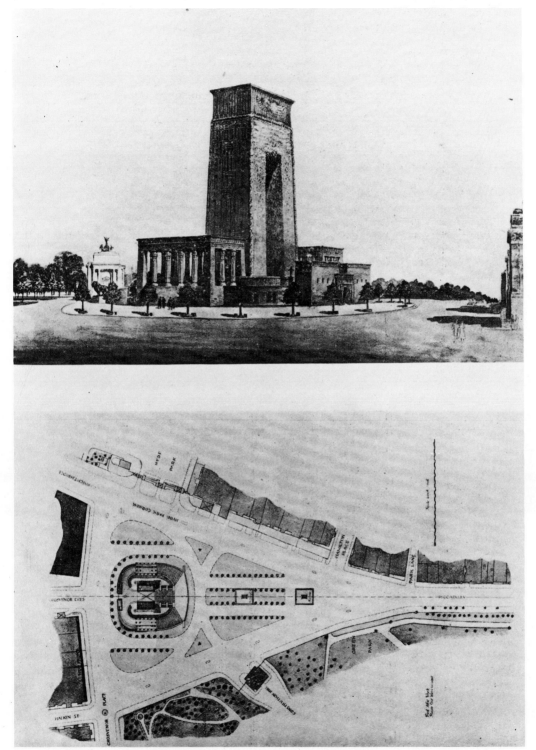

Plate 194 The design for a national war memorial at Hyde Park Corner by Sir Frank Baines, 1920, from *The Builder* (*RIBA British Architectural Library*).

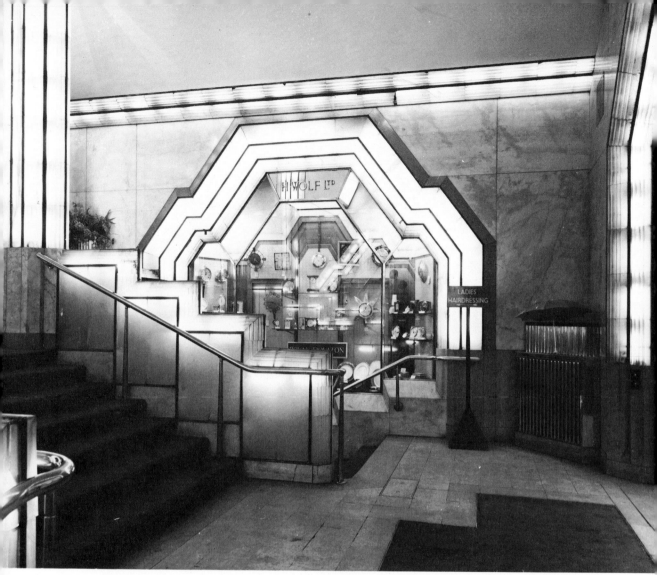

Plate 195 Oliver Bernard's Strand Palace Hotel Foyer of 1930, with the diagonal stepped motif. Compare with Pl. 116, 119, 126, and 161 (*Victoria and Albert Museum. No. GX1637*).

ings stimulated a new phase in the Nile style. The impact of film spectaculars also helped to popularise the style as never before. The great Paris Exposition Internationale des Arts Décoratifs et Industriels Modernes in 1925 also stimulated a new style now known as Art Déco that was unquestionably influenced by certain elements of the Egyptian Revival, notably the corbelled openings, the brightly coloured geometrical ornament, and the pyramidal composition. Bevis Hillier, in his *Art Deco of the 20s and 30s*,[18] draws attention to the influence of Mexican and Egyptian art and architecture on the Art Déco style. The Mexican influence was strong in the characteristic 'Aztec temple' or stepped shape so popular at the time, yet this stepped form is found in the pyramid at Sakkara and in Egyptian Revival work: the Egyptian House at Penzance, the Egyptian Halls in Piccadilly, and Maurer's designs for *Die Zauberflöte* are only three examples where the characteristic Egyptian Revival stepped form is found above openings in walls. Although Aztec temples were set on stepped pyramidal bases, stepped pyramids were also known in ancient Egypt, and the stepped shape is commonly found in Revival work. Stepped forms can be found in many designs of the 1920s and 1930s, notably in the work of F. Preiss, whose onyx clocks were sometimes themselves stepped, and often had stepped faces. Demetre Chiparus, who exhibited

200

at the Salon des Artistes Français between 1914 and 1928, frequently favoured the stepped Egyptianising or Aztec base, and made a number of nude Egyptianising figures. One such figure with arms upraised exists in bronze, and in ivory and bronze. The effect is perilously near that of Kitsch. Oliver Bernard's Strand Palace Hotel foyer of 1930 has the stepped motif with diagonals, thus adding a touch of 'Jazz Modern' to the basic Egyptian Revival form (Pl. 195).

Exotic coloured Egyptian Revival fronts, owing more to a straightforward Revival than to the Exposition, were erected during the 1920s and 30s. Bewley's Oriental Cafés Ltd built a splendid Egyptian Revival façade at 78 and 79, Grafton Street, in Dublin, complete with crowning cavetto cornice and winged solar globe with cobras. The colouring (red, blue, yellow, and green) adds to the richness. Round the corner, in St Stephen's Green, Egyptianising statuary enlivens the front of a celebrated hotel.

Adelaide House, London Bridge, of 1924–5, by Sir John Burnet, Thomas S. Tait, and D. Raeside, was one of the largest post-First World War buildings in London, consciously mannered, monumental, and Egyptian. As Vernon Blake pointed out in the *Architectural Review* when Adelaide House was nearing completion, English architects were 'attacking the problem of future building formulae contemporaneously with their brethren of the Continent and the two Americas'. Blake noted that modern designs had to face the problem of finding a new style 'at one with the aesthetic of the near future'. He continued:

> any valid aesthetic is an unconscious transcription of the mentality of its epoch, which mentality is the outcome of conditions; in this way there is coherence between the nature of the aesthetic and the conditioning of the movement. . . . no man stands apart, indebted neither to his epoch nor to his predecessors; though a genius both submits to his actual conditions and moulds those of the immediate future. But a great artistic production should only yield the secrets of its conception to intensive analysis, and then only in part. The first impression we should receive from it should be that of a homogeneous unity . . . The new unity is composed both of a novel organization of the inevitable elements of art, and of groupings of them already co-ordinated by predecessors. These are the conditions of a fully valid aesthetic innovation; it will perhaps be interesting to try and find out whether Adelaide House fulfils them.

Blake first studied the river front (Pl. 196), and found it 'distinctly Egyptian'. He went on to find many subtle features, and noted the just 'balance in the use of simplicity in alliance with the concave factor is found in Egypt.' Despite the criticisms of the entrance, which Blake felt was somewhat mausoleum-like and crushed by the weight above, Adelaide House was seen to be a 'genuine achievement'. 'Sir John Burnet and Partners have made history; they have given English commercial architecture a definite modern expression. It remains for us to make of Adelaide House and buildings like it the foundation for a modern tradition', wrote Blake. Once again, the Egyptian style and the bold, simple lines of the building were regarded as modern and forward-looking, just as the architects of the eighteenth century who used simple, blocky, Egyptian forms were regarded as modern. The ground floor of the main front to London Bridge has lines of square columns under a balcony, very much recalling Thomson's and Schinkel's works. The short stumpy piers immediately under the crowning Egyptian cornice are reminiscent of Thomson's works in Glasgow (hardly surprising since the firm had strong Glaswegian connexions), and also have echoes of the Chicago School. Adelaide House is one of the most distinguished Egyptianising buildings of the twentieth century.

Thomas S. Tait (1882–1954) was the consultant for the *Daily Telegraph* Building in Fleet Street, London, of 1928, designed by Elcock and Sutcliffe. This is another remarkable instance where Graeco-Egyptian elements fuse in a new synthesis. The building is a powerful work of architecture, and deserves more sympathetic treatment at the hands of the critics than it has received in recent times. The much-praised *Daily Express* Building, almost next door, by Ellis and Clarke in collaboration with Sir Owen Williams, of 1931, on the other hand has received almost unrestrained praise from the critics. The entrance-hall of the *Daily Express* Building, a sensational shining Expressionist work, has a cascade-like motif in the centre of the ceiling, designed by

Plate 196 (*above*) Adelaide House, London Bridge, of 1924–5 by Sir John Burnet, Thomas S. Tait, and D. Raeside, from the river.

Plate 197 (*left*) Ideal House (now Palladium House) at the corner of Argyle Street and Great Marlborough Street, by Raymond Hood and Gordon Jeeves, of 1929.

Plate 198 (*opposite*) The Arcadia Works Building of Carreras Ltd, between Hampstead Road and Mornington Crescent, London, by M. E. & O. H. Collins, with A. G. Porri of A. G. Porri & Partners as consultant, of 1927–8 (*Archives Collection of Carreras Rothmans Ltd*).

Robert Atkinson, that recalls the palm columns of the South Drawing Room at the Royal Pavilion at Brighton, the palm caps at Edfu, and the 'restoration' of the Egyptian temple by L.-F. Cassas of 1799.

An even more uncompromising building with Egyptian overtones went up at the corner of Argyll Street and Great Marlborough Street, completed in 1929. It was Ideal House (now Palladium House), designed by the American architect Raymond Hood, in collaboration with Gordon Jeeves. It is faced with black polished Swedish granite, with cast bronze frames around the window and door openings enamelled with yellow, gold, orange, green, and red. The window frames and glazing bars are treated with twenty-two carat English gold leaf. The crowning cornice and frieze, and the attic cornice, were of American green granite, with enamelled cast-bronze enrichments coloured yellow, gold, red, and green. The overall effect was, and is, exceedingly rich, in the manner of the lushly floral and Egyptianising motifs of the Paris Exhibition of 1925. The building attracted a great deal of attention, and was reviewed by A. Trystan Edwards as 'The Moor of Argyll Street' in the *Architectural Review*.[19] Edwards was critical of the building of unrelated structures in established streets, and emphasised the commercial and advertising aspects of the design in his critical review.

The entrances and ground-floor windows of this building have been sadly treated in recent years, and disfigured by inappropriate plastic signs. However, in the enamelled bronze enrichments we can find echoes of Pueblo pottery design from New Mexico; aspects of Art Déco from L'Exposition Internationale des Arts Décoratifs et Industriels Modernes of 1925; and the volute ornaments from ancient Egyptian wall-paintings, from tombs and vase-painting in Cyprus, and the Egyptian lotus. We can also find the stepped corbelled opening above doors that was part of the vocabulary of the Egyptian Revival of the early 1800s (Pl. 197).

The most spectacular of all Egyptian Revival buildings in the 1920s was the Carreras Building on Hampstead Road, backing on to Mornington Crescent. It was completed in 1928. *The Builder* described it as:

> a novel essay in architectural design. Constructed entirely in reinforced concrete, it is
> decorated in brilliant colours in the Egyptian style, which find a suitable background

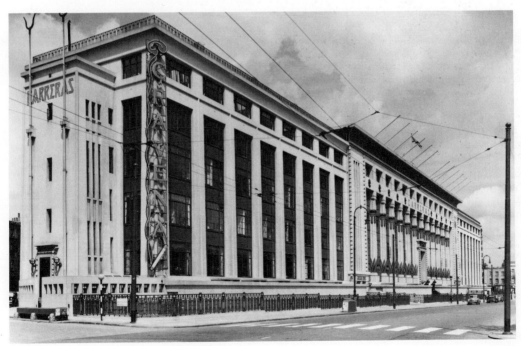

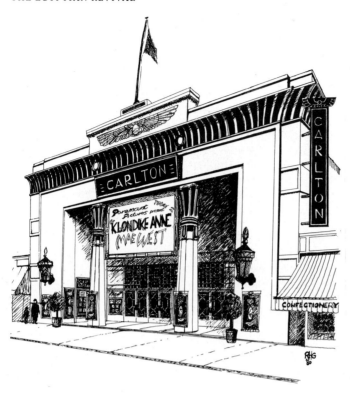

Figure 12 (*left*) The Carlton, Upton Park, Essex, of 1929, by George Coles (*Drawing by Richard Hamilton Gray, Cinema Theatre Association*).

Plate 199 (*opposite*) The Carlton, Essex Road, Islington, by George Coles, 1929–30 (*G.L.C. Department of Architecture and Civic Design No. 73/2542*).

in the rendering of white cement and sand which has been applied to the concrete surface. Cement mixed with ground glass provide the colouring for the Egyptian decorations ... The main front to Hampstead Road is in three sections, the wings depending for a great part of their interest upon the simple yet effective fenestration. The centre section, however, is most striking, with its range of 'lotus' columns. Above this rises the corona, with its gay decoration[20] (Pl. 198).

The architects were M. E. and O. H. Collins, while A. G. Porri was the architect who prepared the plans and a classical elevation. Collins submitted the Egyptian elevation which was accepted and adapted to suit Porri's plans. Unfortunately the columns have been squared up and the brilliant decoration has been removed. Only traces of Egyptianising remain. The Board Room was originally painted with Egyptian motifs in rich, glowing colours.

The choice of the Egyptian style was deliberately commercial, associated with the excitement of the Tutankhamun discoveries, with Hollywood spectaculars, and with the Black Cat trademark of the firm of Carreras. Indeed, the original intention, according to drawings by A. G. Porri & Partners, was to call the building Bast House, after the cat-goddess of Bubastis, but the somewhat unfortunate possibilities suggested in English by the name ensured that the structure became known as the Arcadia Works Building.

In 1929 the London Directory recorded for the first time another Egyptianising building: Museum House, later Britannia House, Nos. 231–3, Shaftesbury Avenue, a structure with a fully developed Egyptian coved cornice, and winged orbs. The architects were Hobden and Porri of 37A, Finsbury Square. The guiding partner in the Egyptianising of the design appears to have been Arthur G. Porri, and the plans are dated March 1927, in which year the architects applied for

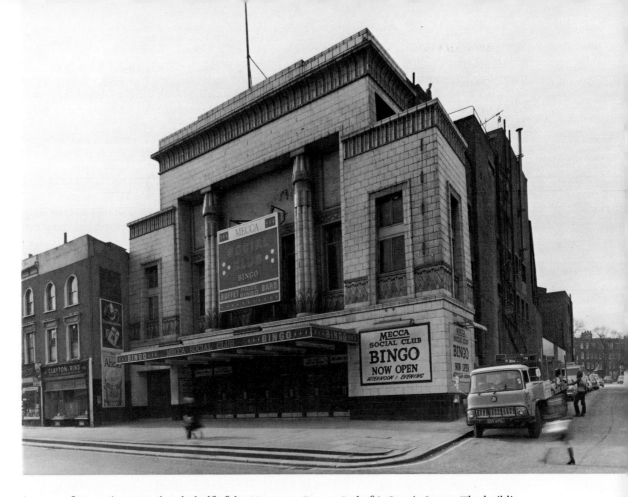

'means-of-escape' approval on behalf of the Museums Estates Ltd of 6, Coptic Street. The building was to be 'let in floors for the purposes of offices and showrooms'. In June 1929 Hobden and Porri had designed the internal partitions.[21]

The 1920s and 1930s produced a great number of Egyptianising objects and buildings. Bichara produced obelisk-shaped perfume bottles ornamented with hieroglyphs and made of acid-etched crystal. The cardboard case in which the bottle came was also an obelisk ornamented with Egyptianising motifs.[22] There were countless other examples of Egyptianising, including English furniture faced with embossed coloured leather that featured figures, hieroglyphs, winged discs, and the like.

There were quite a few Egyptianising cinemas erected at this time. One of the first was the Kensington Cinema, Kensington High Street, designed by Davis, Granger, and Leathart for Joseph T. Mears Theatres, and opened in 1926. The exterior was slightly Egyptianising, and reflected something of the manner of Adelaide House, with its two set-back pylons.[23] The *Architectural Review* described the Kensington Cinema as 'one of the most imposing as well as the largest' of the new cinemas with a 'great block' of a façade, 'solid and arresting as the front of an Egyptian temple. This appearance of strength and massiveness seems to have been deliberately accentuated by every possible means, from the predominance of horizontal lines throughout, to the spreading granite podium . . .' The ceiling of the auditorium was a segmental coffered vault. The New Gallery Kinema, Regent Street, was also partly Egyptianising,[24] with painted figure friezes by Gertrude Halsey. The architects were Nicholas and Dixon-Spain. The Carlton, Green Street, Upton Park, Essex, was opened on 29 September 1929. It was built for Clavering and Rose Theatres to designs by George Coles. The general contractor was Douglas Halse & Co. Only the entrance façade was Egyptian, and consisted of a wide pylon-like front with a cobra-frieze

surmounted by a wing and globe. Two columns with palm caps were set in antis (Fig. 12). In 1953 the Egyptian façade was severely cut down, following war damage, and what was left was covered in the late 1960s by a tiled fascia and an advertising display area. From 1979 the Cinema has been called the Ace.[25] The Carlton, Essex Road, Islington, was also built for Clavering and Rose Theatres by George Coles, and was opened in September 1930. The façade was Egyptian, of white faience, with multi-coloured embellishments. Mr Richard Gray, of the Cinema Theatre Association, holds that it is probably the most successful of the Egyptianising cinema façades[26] (Pl. 199). The Carlton is now a Bingo Hall, alas!

The Luxor, Cross Deep, Twickenham, was designed by J. Stanley Beard for Rialto (Twickenham) Co. Ltd, and was built by Minter & Co. It was opened on 18 November 1929. J. Stanley Beard designed several theatres influenced by the Egyptian style, but this was the only one to have the Egyptianising carried through to the auditorium. The interior still has the solar motifs over the proscenium. The façade is a mixture of Egyptian and Art Déco motifs. The Pyramid, Sale, Cheshire, was completed in 1930 to designs by Drury and Gomershall of Manchester, and is one of the better Egyptianising façades. The interior was Egyptianising with Art Déco overtones, and had a unique organ in the Egyptian style that was removed when the building closed as a cinema. The Riviera, Manchester, had an Egyptian front, with lotus-bud capitals.

Perhaps one of the most extraordinary of the great cinemas with an Egyptianising flavour was the Astoria at Streatham, built by Griggs and Son to designs by Edward A. Stone for the Astoria Theatre Co., and opened on 30 June 1930. The interior decoration was by Marc-Henri & Laverdet. There was no Egyptianising outside, but plenty within. The foyer had a semi-vaulted ceiling and an elaborate open plaster frieze supported by square piers with lotus capitals. The walls were red, with the frieze picked out in green, gold, and black. *The Bioscope* reported that:

> In no theatre in London can there be found such unique decoration as that designed for the ladies' rest room at the Streatham Astoria. The walls are cream in colour, the lighting soft and restful, this effect being obtained by means of a triple-coved cornice and ornamental glass shades unique in design. A coloured relief mural decoration of an Egyptian female figure, bathing in a lotus-filled pool, forms the background of a specially designed lounge-settee . . . In direct contrast to the cool decorative scheme of the entrance hall and foyer is the daring Egyptian decorative scheme of the auditorium, in which the brilliant colourings of that country have been introduced. The predominant colour is pure vermilion, while the mouldings and embellishments have been carried out in black and gold . . . The flank walls of the balcony are divided into three distinct panels, which have been made the base of what is claimed to be two of the most remarkable mural decorations ever introduced into a theatre. Each wall depicts a distinct tableau from ancient Egyptian history, the colouring being most strikingly vivid, even the helmets and spears of the ancient warriors being reproduced in gold and silver leaf.[27]

The effects of the use of Egyptian motifs must have been very rich indeed. *The Bioscope* described the decorative scheme as 'brilliant, and bizarre', an interesting use of the terms in the light of Piranesi's comments in the eighteenth century.

The modernistic, streamlined manner of cinema design of the 1930s found, for example, at the Odeon, Woolwich, was not guiltless of Egyptianising. The torchères by the yard entrance had simplified and slender palm shafts derived from Edfu and from the Choragic Monument of Lysicrates (where Egyptian palms are mixed with the Greek acanthus) (Pl. 200). There were many Egyptianising cinemas in the United States of America, one of the most spectacular being Grauman's Egyptian Theater in Hollywood. The style was particularly favoured for the lavish temples of popular entertainment. Factories, too, often had Egyptianising motifs mixed with Art Déco elements. In Britain the most spectacular Art Déco factory with Egyptianising centrepiece is the Hoover Building by Wallis, Gilbert & Partners, of 1931–2 (Pl. 201), possibly the finest example of the genre in western Europe. In the Hoover Factory influences from ancient Egypt, the Paris

Plate 200 (*right*) Detail from the Odeon at Woolwich, with Egyptianising ornament in faience (*GLC Department of Architecture and Civic Design No. 73/11290*).

Plate 201 (*below*) The Hoover Factory, by Wallis, Gilbert and Partners, on the Great West Road, London, of 1931–2.

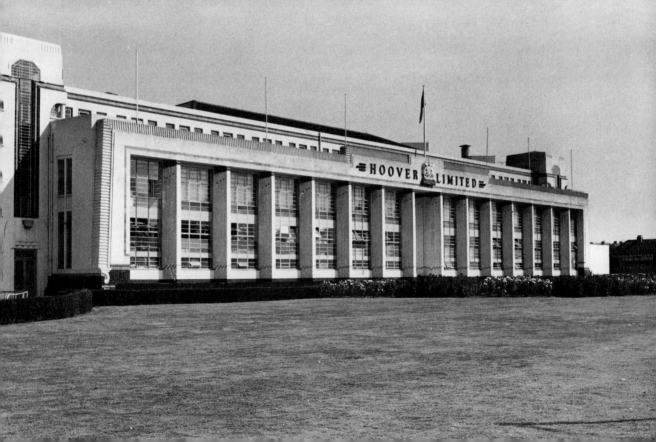

Exhibition of 1925, Cubism, and even the Russian Ballet can be detected. It is a marvellous synthesis of elements that were fashionable in the 1920s and 30s. The whole front has battered sides that recall the temples at Dendera and elsewhere, and the gate-posts were battered, like pylons. Wallis, Gilbert & Partners were also responsible for the Firestone Factory, Great West Road, London, of 1928–9, which had a superb Egyptianising centrepiece embellished with decorative ceramic tiles, demolished in 1980. Thomas Wallis, born in 1873, was a distinguished Neoclassical architect, who became interested in the possibilities of using Egyptian elements in his designs to create monumental buildings. Wallis exploited the possibilities of faience to make colourful façades, and his work was unquestionably in the first rank of distinguished inter-war buildings. It is tragic that recognition of his designs as part of a continuous Egyptianising Neo-classical tradition has been so delayed.

A fashion for things Egyptian seems to have been a constantly recurring theme in the history of taste. Sarah Bernhardt played Cleopatra in the 1890s and so encouraged a Revival in that decade; Theda Bara and Helen Gardner wore Egyptianising costumes in films in the second decade of the twentieth century; and Cecil B. de Mille's Egyptianising showpieces of the 1930s, especially the 1934 film with Claudette Colbert, ensured survival and revival of the Nilotic style. Other films in which Cleopatra was played by Vivien Leigh (1945) and Elizabeth Taylor (1962) encouraged mini-revivals of Egyptian jewellery and artefacts. None of these popular revivals can compare with the impact the publication of the *Description de L'Egypte* . . . or the opening of Tutankhamun's tomb had on Egyptian Revivals, however. The 1922 events were probably the archaeological triumph of the century, and had a tremendous impact on decorative arts throughout the world, especially in Europe and America. Egyptian motifs can be found in abundance in Art Déco work of the 1920s and 1930s. The furniture of Eileen Gray included Egyptianising elements, notably in her lovely table designed for Jacques Doucet in 1924, and recently adapted as 'lotus console' in 1978 by Vermilion, of Los Angeles.[28] Pierre Legrain was also greatly influenced by Egyptian art, and the Nile style was not confined to highbrow tastes. Egyptianising objects were produced in various cheap materials, like Bakelite and plastic, for ornaments. Egyptian motifs occur in Japanese enamels of the 1920s, and Egyptianising objects of exquisite quality from the inter-war years are almost as common as surviving Egyptianising artefacts for a less up-market public. Henri Sauvage (1873–1932) designed a series of massive stepped architectural blocks of flats not unlike the pyramid at Sakkara in the 1920s, but these were not realised.

The exhibition of masterpieces from the tomb of Tutankhamun that came to London and New York in the 1970s caused its own revival of interest in things Egyptian. The exhibition was an immediate success, and a new Egyptian Revival was launched. Not only were there expensive catalogues and books illustrating the 'unearthed royal treasure', but manufacturers produced Egyptianising objects in much the same way as they did in the 1800s. The Boehm Studio produced a collection of the treasures of Tutankhamun in porcelain, and Wedgwood brought out the mask of the king in gilt porcelain. Trinkets, items of clothing, ties, diaries, and books with the Egyptian motifs from Tutankhamun's tomb were produced in large quantities. Even a 'pop' song called 'Tutankhamun' was released in the late 1970s.

Richard Knapple produced an Egyptian Room, with furniture in hand-carved and painted wood for Bloomingdale's in 1977. The columns have painted bull-capitals with lotus-flower décor, and there is an Egyptian concave cornice painted with the lotus and papyrus. Ptolemy Designs of New York produced, in 1978, a magnificent Egyptian throne-chair in hand-carved wood, gilded and painted, based on Tutankhamun's throne. In the same year the Boehm Studio, of Treton, New Jersey, brought out a pair of Egyptian falcon emblems of painted porcelain; and Wedgwood issued a limited edition of their Canopic vase from a mould of 1800, in terracotta on black Jasperware, and brought out a smaller edition of a sphinx *couchant* in terracotta on black Jasperware. Philip Graf Wallpapers of New York produced a wallpaper called 'Nile Odyssey' in 1978 to designs by Bob Mazzini in which lotus flowers and other Nilotic motifs flourish.

The Glyndebourne Festival Opera produced *Die Zauberflöte* in 1978 with designs by David Hockney which are uncompromisingly Egyptian in manner. The colours are lighter and more pellucid than those of the Schinkel sets, and are perhaps nearer in spirit to those of Carl Maurer

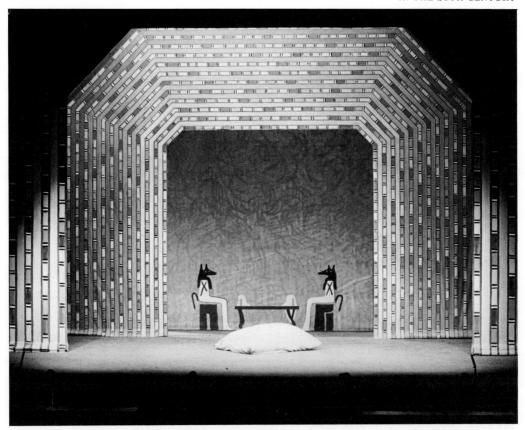

Plate 202 Design by David Hockney for the 1978 production of *Die Zauberflöte* for the Glyndebourne Festival Opera. Note the form of the arch (a favourite Art-Déco motif) *(Guy Gravett. No. 0968. 15)*.

(Pls. 202-203). A growing interest in the architecture and art of the 1920s and 30s will no doubt help to put the continuing influence of Egyptian motifs in perspective. Criticisms have far too often castigated the Egyptian Revival, and have looked on it as an aberration. Such comments have not created a sympathetic view of much Egyptian Revival work of the inter-war years. For example, the Carreras factory in Mornington Crescent has been described as 'abominable',[29] while work by the distinguished firm of Wallis, Gilbert & Partners has been denounced as 'offensive',[30] quite obviously because it did not fit into the category of the approved Modern Movement styles. 'Factories' in Middlesex, we are told in Pevsner's volume dealing with that county, 'are on the whole atrociously bad, Modernism at its showiest and silliest.'[31] By 1980 the Carreras Factory had been stripped of most of its gloriously colourful Egyptian centrepiece, while the marvellous centre of the Firestone Factory on the Great West Road had been destroyed. Official approval of buildings, reflected in the Listings of buildings of architectural and historic interest, has been lacking in respect of the period.

Now that Post-Modernism, especially Post-Modernist Classicism, is in the 1980s beginning to develop, some overt Egyptianisms are starting to appear in the works of younger designers who are reinterpreting ancient architectural vocabularies. Cornices of the Egyptian type, massive colonnades of the Temple of Hatshepsut kind, and battered walls and doorcases are returning as motifs in design. The invention of the Neoclassical architects of the eighteenth and nineteenth centuries was lively and fascinating, and might well have developed further if Gothic Revival and archaeological purity had not stifled it.

The revival of Egyptian forms had enjoyed a remarkably long life. Even in 1980 the Summer

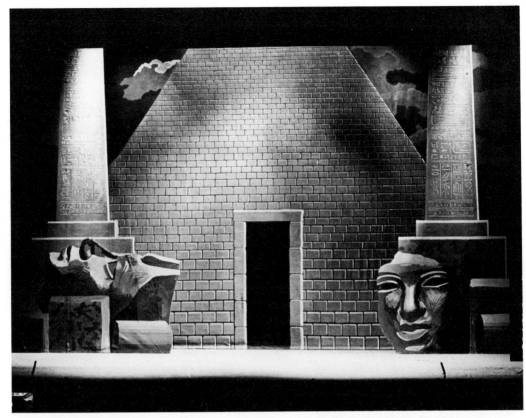

Plate 203 Design by David Hockney for the 1978 production of *Die Zauberflöte* for the Glyndebourne Festival Opera. Note the pyramid, obelisks, and colossal heads (*Guy Gravett No. 0969. 6*).

Exhibition of the Royal Academy of Arts included a pencil drawing for an obelisk at Harlow by Sir Frederick Gibberd & Partners,[32] and the elevations of Champagne Alley, King's Road, Chelsea, by Campbell, Zogolovitch, Wilkinson, & Gough at the same exhibition had curiously Egyptianising upper works[33] that recall the chimney designs of Alexander Thomson based on the palm capitals of Edfu. Cotton squares in a shop in Fiesole in 1980 had Egyptianising motifs in the border-friezes, coloured brown, white, red, blue, and green. In 1981 the Nile Valley style in female fashion was promoted by leading fashion designers. The graphic designer, Theodore Menten, has produced a number of stencil patterns based on ancient Egyptian painted decorations that are now[34] in use for interior décor. Many artists and craftsmen are now[35] using Egyptian design in fashion, jewellery, fabrics, needlework, wallpapers, and objets d'art. The inspiration lies in the Tutankhamun Exhibition as well as in a growing appreciation of the Art Déco style of the 1920s and early 1930s. It is quite clear that the potency of Egyptian design as an inspiration to the following centuries remains undiminished.

210

10

Epilogue

O'er Egypt's land of Memory floods are level,
And they are thine, O Nile!'and well thou knowest
That soul-sustaining airs and blasts of evil,
And fruits and poisons spring where'er thou flowest.

PERCY BYSSHE SHELLEY (1792–1822): *Sonnet. To the Nile.*

Throughout the ages, and especially in the eighteenth, nineteenth, and twentieth centuries, Egyptian art and architecture have inspired designers. The Nile style was particularly important in furniture design, and has been a highly significant element in the style known as Art Déco. The receptive observer will not fail to notice the recurring Egyptianisms in Western art and architecture, especially in Neoclassical works of the last two and a half centuries. Egypt has been a continuously attractive source of ideas, and a quarry from which designers have taken motifs from Classical times to the present. The brilliant colouring of Egyptian work, the superb crafts-manship, and the catholicity of the Isiac religion have been of considerable importance in the development of western European culture.

Beneath the conventional histories that deal with the Renaissance, Baroque, and later periods lurks a strange world that is only recently being uncovered in any systematic way. From the fifteenth century the Hermetic, or Egyptian, Tradition clearly played an important rôle in cultural affairs. What appears to lie beneath it all was nothing less than a radical reformation, perhaps far more interesting than *the* Reformation, that envisaged a reform of society, education, religion, and awareness, to take in every aspect of human activity. The idea of a future enlightenment, wherein all would be revealed through ancient wisdom, including Hermetic writings, the Cabbala, and alchemy, was a powerful force, and ultimately gave birth to movements that did indeed create an Enlightenment. Yet that *Aufklärung* had more of the darker, unimagined side of things within it than we sometimes care to admit. Like the clear meridian splendour of a day in the South, the Enlightenment, too, harboured, in the words of Bourget, *Le Démon de Midi,* although he suggested it meant the viciousness of the Middle Ages. As Psalm 90 puts it, *Non timebis a timore nocturno . . . ab incursu et demonio meridiano,* in the Vulgate. The demon of midday, unleashing untold horrors since Reason reasoned itself out of existence, was abroad. The balance, wherein every aspect, even the contradictions, was to be taken into account, was lost. Gone was that ancient equipoise. The Hermetic-Egyptian Tradition insisted that there were unseen, irrational forms that had to be recognised as part of the cosmos: by ignoring this the rationalists allowed the unthinkable to become not only thinkable, but terrifyingly real. To the minds of eighteenth-century men, bred in spiritual torpor and sceptic superiority, the Egyptianising in Italy must have seemed absurd. Hermes and Psammeticus had gone the way of incantations and lack of rigour in mental matters. The rain-bearing Madonnas were as foreign as the tearful Isis herself. The tenebrous realms of occultism and Egyptian studies that developed in sixteenth- and seventeenth-century Europe repelled the English Augustans, while all too often, notably in the nineteenth century, the aureole of the Madonna became a hard ring of bigotry. Yet

211

the delver into the ill-lit and fusty regions, where pre-scientific Egyptological writings lurk, may stumble upon doors that suddenly open onto enchantingly lovely landscapes that bask in an unspoiled clarity. Antiquarian controversies are often obscurantist, so it is as well to see the importance of the ancient Egyptian deities to explain much of European iconography, culture, religion, and art. The vigour of the Egyptian legacy has often been veiled, as though from the lands of Seth, for reasons that are difficult to respect. The treatment of Bruno points to a truth: orthodoxy could not admit its Egyptian origins, either in religion or in aspects of art and architecture.

The splendour of Egyptian design and the simplicity of basic Egyptian architectural forms suggest something of an eternal verity and an ageless serenity. An awareness of the persistence of Egyptian ideas in religion, art, and iconography creates fresh and enlightening perspectives. There is a sense of continuity. To consider the survival of the much loved goddess and so great a part of the objects and ideas familiar when she was omnipotent in ancient times is enough to emphasise the futilities and disagreeable dissonances of the present age. The sense of kinship with a robust and kindly past, in harmony with the moon, the earth, the waters, and the sun, is beneficent. In a southern evening, when the air is deliciously scented with fennel and rosemary, and tranquillity fills the soul, one can understand something of equilibrium, and of a golden dawn of European civilisation. In retrospect Graeco-Roman culture seems to be held in a meridian warmth, wherein the Great Goddess was universally revered. The pellucid landscapes of the Graeco-Roman world, and especially of the Mediterranean lands, suggest the simplest of forms, and a rejection of frippery. Probably no culture (even those of Central America) has produced such mighty works of architecture that are so stark, so basic, so grand, so instantly memorable, as did ancient Egypt. The pyramid, the obelisk, the pylon, and the symmetrical temple are pure shapes that are best seen within a luminously clear landscape, set amid Horatian verdure, where the colours are strong, and the light is not dissipated in mist or in haze. The unwholesome veiling and tepid winds blew from the lands of Seth: the clear light of the sun and the moon, the clean waters, and the calm blue heavens were presided over by Isis. The goddess spread her kindly and magical influence over the lands of the Nile, and subsequently over the known world. Her presence has been one of the most radiant and tranquil assets of the Christian Church, although she has undergone some subtle metamorphoses, not all of them for the better. Her enchantments have on the whole been benevolent and affectionate: Egypt is with us still, and we owe a very great deal to that ancient land. The architectural, iconographical, and decorative manifestations of ancient Egyptian culture are only some aspects of an influence which has gone deeply into western European civilisation and has not hitherto attracted the attention it so rightly merits.

Notes

CHAPTER 1

1 P. 11. Dr Witt's monograph offers a conspectus of the Isiac religion in its entirety in one scholarly volume, and builds upon early foundations set down by Lafaye, *op. cit.*

 Dr Witt has also incorporated findings by Tran Tam Tinh, Merkelbach, Bergmann, Grimm, and Münster, and has drawn especially on Hopfner's work, which is essential reading for any student of this fascinating subject. The author acknowledges his debt to Dr Witt, as well as to the studies of Hopfner, Lafaye, and Münster. Mr Peter Clayton has also been very helpful and sympathetic.

2 Hopfner, *op. cit.*, and Witt, *op. cit.* discuss this at length. The literary works quoted in Hopfner are detailed in full, and, although the distinguished German's book is more than half a century old, it is still a classic. The author acknowledges a considerable debt to Hopfner in the formation of the present study.

3 Witt, *op. cit.*, p. 15. See also Hopfner, *op. cit.*

4 *Ibid.* See also note 5 below, re Münster.

5 Münster, *op. cit.*

6 Seyffert, *op. cit.*, pp. 324–5.

7 *Ibid.*

8 *Ibid.*

9 See especially *Timaeus.* See also Hopfner, *op. cit.*, and Witt, *op. cit.*, pp. 15–16.

10 Witt, *op. cit.*, p. 16.

11 Nilsson, *op. cit.*, pp. 10–11 especially emphasises the point.

12 See Herodotus and Hopfner. See also Seyffert, *op. cit.*, entry on Isis. The author is greatly indebted to Seyffert's monumental work.

13 Herodotus, *Histories.*

14 Nilsson, *op. cit.*, pp. 10–11. Nilsson's book is singularly illuminating, and is indispensible in this field.

15 *Ibid.* Witt, *op. cit.*, also notes this point.

16 Seyffert, *op. cit.*, p. 663. According to Hesiod, Seth or Typhon was a giant of enormous strength, with a hundred snake-heads. He was the symbol of the fire and smoke in the interior of the earth, and of their destructive forces. He was the source of hurricanes. In Greek mythology Typhon was the father of the dogs Orthos and Cerberus, and of the Lernaean hydra. In Homer he lies beneath the earth.

17 Pliny describes the use of papyrus for decorating images in his *Natural History.*

18 Witt, *op. cit.*, pp. 16–17.

19 Seyffert, *op. cit.*, p. 38.

20 See Witt, *op. cit.*, p. 17; Seyffert, *op. cit.*, pp. 38, 324–5, 438–9.

21 Seyffert, *op. cit.*, pp. 438–9.

22 *Ibid.*

23 *Ibid.* See also Plutarch's Essay on Isis and Osiris (*De Iside et Osiride*).

24 Aelianus, *op. cit.*, pp. 10, 46. See also Seyffert, *op. cit.*, p. 439.

25 Seyffert, *op. cit.*, p. 439.

26 *Ibid.*

27 Plutarch, *De Iside et Osiride.*

28 Seyffert, *op. cit.*, p. 578.

29 *Ibid.*

30 *Ibid.*

31 *Ibid.*

32 *Ibid*, pp. 75–6.

33 *Ibid*, pp. 578–9.

34 Seyffert, under various entries, is most illuminating on this point.

35 Seyffert, *op cit.*, p. 324.

36 *Ibid.*

37 *Ibid.*

38 *Ibid.*

39 *Ibid*, p. 325. Serapis is sometimes spelled as Sarapis.

40 Seyffert, *passim.*

41 *Ibid.*

42 Apuleius, *Met.*, xi. 8–17. See also Firmicus Maternus, *De Err. Prof. Relig.*, 2. Apuleius gives detailed descriptions of the Isiac cult, the universality of which is proved by the existence of symbols in numerous finds of jewellery and of tomb reliefs.

43 Seyffert, *op. cit.*, p. 325.

44 *Ibid.*

45 Witt, *op. cit.*, p. 18.

46 Quoted in Witt, *op. cit.*, p. 18. See also Münster, *op. cit.*, p. 158.

47 Hopfner, *op. cit.*, p. 374. See also Witt, *op. cit.*, p. 19.

48 Information provided by Mr Peter Clayton, whose assistance is gratefully acknowledged.

49 Seyffert, *op. cit.*, p. 325.

50 Witt, *op. cit.*, p. 20.

51 Witt, *passim.*

52 See Xenophon of Ephesus.

53 Curl, *A. Celebration . . .* p. 48, 50.

54 Witt, *op. cit., passim.*

55 Leiden, 1972.

56 According to Nicander in his *Metamorphoses.* Nicander was, incidentally, an hereditary priest of Apollo as well as a physician. He was an expert on agriculture and on irrigation.

57 Brady, *op. cit.;* Witt, *op. cit.*, is also interesting on this point.

58 Curl, *European Cities . . .* p. 40.

59 Plutarch's *De Iside et Osiride.*

60 Witt, *op. cit.*, pp. 46–8.

61 *Ibid*, p. 48.

62 *Ibid*, p. 50.

63 Information provided by Mr Peter Clayton, to whom the author is indebted for help.

64 Witt, *op. cit.*, p. 87.

65 Vitruvius, book I, chapter VII.

66 Witt, *passim.* Esp. plates 54–67.

67 *Ibid*, pp. 240–2.

68 Information kindly provided by Mr Peter Clayton. Coin collections in various museums will testify to the widespread use of Isiac motifs.

69 Witt, *op. cit.*, p. 182.

70 *Carrus Navalis*, but probably from *Carnem Levare*, the putting away of flesh as food. See Witt, *op. cit.*, p. 183.

71 Witt, *op. cit.*, pp. 183–4 and notes, p. 310.

72 Described by Gaius Suetonius Tranquillus in *De Vita Caesarum.*

73 Suetonius, *op. cit.*, is again the source.

74 Witt, *op. cit.*, p. 234.

75 *Ibid.*, p. 235.

76 Aelianus Spartianus, *Scriptores Historiae Augustae.*

77 Paribeni, *op. cit.* See also Boëthius and Ward-Perkins, *op. cit.*

78 *Ibid,* esp. p. 237.

79 *Ibid,* p. 238.

80 *Ibid,* pp. 241–2.

81 *Passim.*

82 See Statham, *op. cit.,* pp. 15–16. See also Rosenblum, *op. cit.,* p. 148.

83 See Kurtz and Boardman, *op. cit.,* for many examples. See also Curl, *A Celebration . . .* pp. 11–41.

84 See Fletcher, *op. cit.,* pp. 102-31.

85 Curl, *A Celebration . . .* pp. 28–31.

86 Statham, *op. cit.,* p. 65.

87 Pijoan, Joseph, *op. cit.,* vol. i, p. 486.

88 *Ibid,* p. 488.

89 Baedeker, Karl., *Central Italy and Rome. Handbook for Travellers* (Leipzig, London, and New York, 1909), p. 178.

90 *Ibid,* p. 362.

91 Gestione Vendita Pubblicazioni Musei Vaticani. *Guida ai Musei Vaticani.* Città del Vaticano, 1979. The item is No. 4 in the *Braccio Nuovo.*

92 Toynbee, *op. cit.,* pp. 82–7, and 134–8. See also Curl, *A Celebration . . .* pp. 41–3.

93 Pp. 171–2.

94 Curl, *A Celebration . . .* pp. 60–2.

95 Pevsner and Lang, *op. cit.*

96 *Ibid,* p. 218.

97 Curl, *A Celebration . . .* pp. 21–68.

98 *Guida ai Musei Vaticani,* 1979.

99 *Naturalis Historia,* book xxxvi, 14.

100 Budde and Nicholls, *op. cit.,* no. 117.

101 Some frescoes of that date survive inside.

102 Pp. 23–6, with plans and photographs.

103 See Masson, Martin, and Nicholls, *op. cit.* The author is grateful to Mr Nicholls for discussing this stele in the Fitzwilliam Museum.

104 Pijoan, *op. cit.,* vol. I., p. 83.

CHAPTER 2

1 Curl, *European Cities . . .*

2 *The Epistle of Paul the Apostle to the Romans,* i, 23.

3 According to Plutarch. Decimus Junius Juvenalis also mentions the wrath of Isis, which could induce blindness by means of a blow from her sistrum.

4 Fr Clifford Carver shed valuable light on this matter.

5 See Hopfner, *op. cit.,* and Roscher, *op. cit.* See also the great work on Marian attributes by Hippolytus Marraccius in 1710.

6 Augustine comments on this point.

7 Witt, *op. cit.,* Dr Witt is particularly illuminating on the merging of Isis with the Blessed Virgin Mary. See especially pp. 269–281 and Notes. See also Jameson, Anna Brownell. *Legends . . . , op. cit.,* pp. 1–69.

8 See Bibliography.

9 Yates, *The Rosicrucian . . .*

10 *Ibid,* p. 216.

11 Roullet, *op. cit.,* pp. 67–93.

12 Witt, *op. cit.,* pp. 276–7.

13 *The Revelation of St John the Divine,* xii, 1; *Canticles,* vi, 10. These are also emblems of Isis.

14 *Canticles,* ii, 1.

15 *Ibid,* ii, 2.

16 *Ibid,* iv, 4.

17 *Ibid,* iv, 6.

18 *Ibid,* iv, 12.

19 *Ibid,* vii, 7.

20 Douglas, *op. cit.,* p. 272.

21 Smith, William, *op. cit.,* p. 268.

22 *Praefat. ad Ephes.*

23 Witt, *op. cit.,* pp. 269–81 is especially interesting on the parallels, and his admirable study should be approached by those wishing to pursue this topic. See also Fortescue, *op. cit.,* p. 308 and Steiner, *op. cit.*

24 See Smith, William, *op. cit.,* pp. 259–70.

25 Witt, *op. cit.,* p. 186.

26 Butler, Alban. *The Lives of the Principal Saints,* 1756–9. See also Eunapius, *Vit. Soph. Aedes,* 45.

27 See Baedeker for Roman examples.

28 For particularly illuminating information see Roscher, *op. cit.*

29 Roscher, *passim.* See also Witt, *op. cit.,* pp. 214–7.

30 *Ibid.*

31 *Ibid,* pp. 198–221 for development of this theme.

32 According to Chastel, *op. cit.,* pp. 165, 179.

33 Santa Maria in Trastévere is also discussed in *Architektonische Studien des Kais. Dtsch. Archaeol. Inst.,* III (1889), p. 77. See also Lanciani, R. in *Bulletino della Commissione Archeologica comunale di Roma,* 1883, pp. 35 and 56. See also Nibby, A., *op. cit.*

34 Yale, 1980.

35 Chastel, *op. cit.,* p. 179. Viterbo is also discussed in Venturi, *op. cit.* See also Noehles, K. in *Festschrift Werner Hager,* 1966. Esp. figures. See also Roullet, *op. cit.,* pp. 6–11.

36 Carré, *op. cit.*

37 Sbordone, *op. cit.*

38 Yates, *Giordano Bruno.* This is a particularly valuable contribution.

39 Thomson. E. A., *op. cit.,* Ammianus Marcellinus (*c.* 330–395) knew Egypt.

40 Burckhardt, *The Civilization . . .* p. 98.

41 Roullet, *op. cit.,* offers the fullest and most scholarly account of the subject. The author is indebted to Anne Roullet's work.

CHAPTER 3

1 Burckhardt, *The Civilization . . .* p. 90.

2 *Poggii Opera,* fol. 50, sqq. 'Ruinarum urbis Romae descriptio', written about 1430. See also Burckhardt, *op. cit., passim.*

3 Burckhardt, *op. cit.,* p. 98. See also Pevsner and Lang, *op. cit.,* p. 218. Burckhardt is especially useful on the rediscovery of the past.

4 *Vita Poggii.* See Burckhardt, *op. cit.,* pp. 93, 311.

5 Curl, *European Cities . . .* p. 90.

6 Burckhardt, *op. cit.,* p. 94.

7 *Ibid.*

8 *Ibid,* p. 95.

9 *Ibid.* See also Alberti, Leandro., *Descrizione di tutta L'Italia,* fol. 285. Burckhardt is particularly interesting on these points.

10 See his *Roma Instaurata* of 1446.

11 Pevsner and Lang, *op. cit.*, p. 246, note 46.

12 The author's italics.

13 The quotation is from the translations by Cosimo Bartoli and James Leoni in the London edition of 1955, chap. III, pp. 166–8.

14 A fine set can be seen in the Accademia Britannica in Rome. For more on destruction see Augustus J. C. Hare's *Walks in Rome* and Burckhardt, *op. cit.*

15 Tr. Bartoli and Leoni, *op. cit.*, p. 169.

16 Pevsner and Lang, *op. cit.*, p. 219.

17 Braham, *op. cit.*, p. 186.

18 *De Varietate Fortunae.* See also Burckhardt, *op. cit.* See also *Poggii Opera.*

19 Rosenau, *The Ideal City . . .* pp. 48–70.

20 See Rosenau, *op. cit.* See also the following: Spencer, J. R. (ed.), *op. cit.* pp. 152 *ff*; Lazzarini and Munoz, *op. cit.*; Firpo, L., 'La città ideale del Filarete', in *Studi in memoria di G. Solari* (Turin), 1954; and Onions, J., *The Journal of the Warburg and Courtauld Institutes,* xxxiv (1971), p. 96, *ff.*

21 Rosenau, *op. cit.*, p. 54.

22 See Rosenau, *op. cit.*, for details.

23 Gombrich, E. H. *Journal of the Warburg and Courtauld Institutes,* xiv (1951), p. 120.

24 See Murray, Peter, 'Bramante milanese: the paintings and engravings', *Arte Lombarda,* vii (1962). See also Pevsner and Lang, *op. cit.*, p. 220 and note 50.

25 As described in *The Civilization of the Renaissance in Italy.*

26 L. D. Ettlinger has described Vasari as the first art-historian worthy of the title.

27 Osborne, *op. cit.*, p. 876.

28 Hülsen, *Il Libro . . .* See also Roullet, *op. cit.*

29 Notably in work by Piranesi and Mengs.

30 Burckhardt, *op. cit.*, p. 95.

31 *Ibid.*

32 Baedeker, Karl, *Central Italy and Rome,* p. 448.

33 Yates, *Giordano Bruno . . .* pp. 115–6.

34 *Lectures at the Warburg Institute,* vol. 1 (1957), pp. 174 *ff.* Especially p. 184.

35 Burckhardt, *op. cit.*, p. 102.

36 *Ibid.*

37 *Ausgewälte Werke,* I (1938), p. 17.

38 *Musarion Ausgabe,* xx (1922), p. 158. For further discussion see E. Heller, *The Disinherited Mind,* Harmondsworth, 1961.

39 Also mentioned by Pevsner and Lang, *op. cit.*, p. 220, and note 51.

40 *Ibid.*

41 Golzio, *op. cit.* Pevsner and Lang, also mention this.

42 Giehlow, K., *op. cit.* See also Witt, *op. cit.*, pp. 87–8 and Godwin, *Athanasius Kircher,* p. 65. For more on Kircher see Bibliography.

43 Pignorius, *op. cit.*

44 Iversen, *The Myth of Egypt . . .* pp. 85, 158.

45 See, for example, Mandowsky and Mitchell, *op. cit.* and Roullet, *op. cit.*, pp. 10–11.

46 Osborne, *op. cit.*, p. 660.

47 Subtitled 'Eine Studie zur Frage über die Echtheit des Sienesischen Skizzenbuches', in *Jahrbuch der Kunsthistorischen Sammlungen des Allerhöchsten Kaiserhauses,* xxiii, Vienna (1902), esp. pp. 1–44 and fol. 47 v. See also Roullet, *op. cit.*, p. 87 and *passim.*

48 See especially Hülsen and Egger . . . *Heemskerck.* See also Roullet, *op. cit.*, cat. nos. 68, 73, 77, 94, 150, 271–6, 286–7 and 296–8; and Osborne, *op. cit.*, p. 528.

49 Giedion, Sigfried, *Space, Time and Architecture,* pp. 75–100. The author is indebted to the staff of the Biblioteca Apostolica Vaticana for permitting him to study this at close quarters, and for supplying an excellent photograph. For obelisks see also Roullet, *op cit.*, cat. nos 68–93.

50 Hartt, *op. cit.*

51 Pevsner and Lang, *op. cit.*, p. 222. For much more detailed discussion see Roullet, *op. cit.*, Catalogue Raisonné, plates lxxxvi, lxxxvii, lxxxviii, lxxxix.

52 Published in Manchester in 1921. Nos 32–7, p. 87 *ff.*

53 Pevsner and Lang, *op. cit.*, p. 247, note 53.

54 *Ibid.* For Anne Roullet's work see Bibliography.

55 Giehlow, K., *op. cit.*, p. 111. See also Roullet, *op. cit.*, cat no. 324.

56 Pevsner and Lang, *op. cit.*, p. 222. They also refer to A. Lhotsky's 'Apis Colonna, Fabeln und Theorien über die Abkunft der Habsburger', *Mitteilungen des Österreichischen Instituts für Geschichtsforschung,* vol. lv (1942). Mugnos *op. cit.*, is interesting on the Colonna clan, while Burckhardt, in *The Civilization . . .* is also illuminating on ancestor-searches and on the Egyptianising of the forebears of great Renaissance families. See also Giehlow, *op. cit., passim.* The ramifications are mind-boggling.

57 See Watkin, David and Lever, Jill. 'A Sketch-book by Thomas Hope', *Architectural History: Journal of the Society of Architectural Historians of Great Britain,* vol. 23 (1980), pp. 55–9, and plate 38b. The author is grateful to John Harris for drawing attention to the sketch book.

58 Davies, *op. cit.*, pp. 9, 146, 171, 179. Davies is excellent on the tombs of the period. See also Street, G. E. and Thompson, Stephen, *Sepulchral Monuments in Italy,* London, 1878.

59 Hay, *op. cit.*, pp. 187–91, 341.

60 Hay, *op. cit.*, p. 224. See also Harvey, Sir Paul (*Ed.*) *The Oxford Companion to English Literature,* Oxford, 1969, p. 652; and especially Hay, *op. cit.*, as note 59.

61 Curl, *English Architecture . . .*, pp. 21, 168–9.

62 For example Schéle, *op. cit.*, pp. 24, 145. See also Roullet, *op. cit., passim;* and Pevsner and Lang, *op. cit., passim.*

63 Canephorae (from the Greek κανηφορος, lit. 'bearing a basket') with baskets on their heads must not be confused with caryatides.

64 Schéle, *op. cit.*, p. 24. Jacques Androuet Ducerceau the Elder (*c.* 1520 – post 1584) produced *Les plus excellents bâtiments de France* (published 1576 and 1579), an important source on sixteenth century French architecture. His love of fantasy may suggest that he or his family had some influence on the design of the doorcase at Fontainebleau.

65 The author owes this item to his wife.

66 Pevsner and Lang, *op cit.*, p. 225 and notes 64–6. See also Hay, *op. cit.*, pp. 164–84. The device is on the *Impresa* inscribed *Enrico Secondo Re di Francia* and published by H. Ruscelli.

67 Yates, *The French Academies . . .* p. 135. The present author owes a considerable debt to the pioneering researches of Dr Yates.

68 For Diane de Poitiers see Orliac, *op. cit.*, also referred to by Pevsner and Lang, *op. cit.*, pp. 224–5 and note 68.

See also Hay, *op. cit., passim*. See also Jackson, Sir Thomas Graham, *The Renaissance of Roman Architecture*, pt iii, France and Cambridge, 1923, pp. 103–8.

69 In the collections in Siena.

70 Yates, *Giordano Bruno . . ., passim*.

71 Godwin, *Robert Fludd . . . passim*.

72 Yates, *The Rosicrucian . . . op. cit., passim*.

73 For further illumination on the study of this complicated business, Dr Yates' book on *The Rosicrucian Enlightenment* is invaluable. Her work has helped to clear the muddy waters of fact and fiction in the seventeenth-century context.

74 The Council of Europe Exhibition in Florence in 1980 featured works of an occult and magical nature in which designs that included Egyptianising motifs were much in evidence.

75 Yates, *The Rosicrucian . . .* p. 85.

76 *Ibid.*

77 *Ibid,* p. 136.

CHAPTER 4

1 De Quincey, Thomas. 'Historico-Critical Inquiry into the Origins of the Rosicrucians and the Freemasons', *The London Magazine,* 1824. The essay reappeared in De Quincey's *Collected Writings.*

2 See especially Yates, *The Rosicrucian . . .*

3 Knoop, Douglas and Jones, G. P., *The Growth of Freemasonry . . .* See also Dr Yates' work on *Giordano Bruno*

4 In her work on Bruno, *op. cit.,* pp. 274, 414–6, 423.

5 Yates, *The Rosicrucian . . .* p. 209.

6 *Ibid.*

7 Of the thirteenth and fourteenth centuries.

8 See Knoop and Jones on *The Growth of Freemasonry . . ., Genesis . . .,* and, (with Hamer), *Early Masonic Pamphlets,* Manchester, 1945.

9 Yates, *The Rosicrucian . . .* p. 212.

10 Anderson, *op. cit.,* pp. 24–5. The best working copy is that edited by L. Vibert, 1923.

11 *Ibid,* p. 39.

12 See Wittkower, R., *Architectural Principles . . .* pp. 91, 106.

13 Yates, *The Rosicrucian . . .* pp. 171–233.

14 See Esdaile, *op. cit.,* p. 90.

15 Pevsner and Lang, *op. cit.,* p. 227. See also Roullet, *op. cit.,* cat. no. 324.

16 *Ibid.*

17 For Kircher's works see Bibliography. See also Godwin, *Athanasius Kircher . . .* for a concise and digestible account of Kircher.

18 Pevsner and Lang, *op. cit.,* p. 228.

19 See Hibbard, *op. cit.,* pp. 118–123.

20 *Ibid,* p. 213.

21 See Stewart, Cecil, *op. cit.,* pp. 121–2.

22 Brinckmann, *Spätmittelalterliche . . .*

23 Stewart, *op. cit.,* p. 128.

24 Dempsey, *op. cit.,* pp. 109–19.

25 Aurenhammer, p. 153.

26 See Laugier, *op. cit.,* Blondel, *Discours . . . ;* and Pevsner and Lang, *op. cit.,* note 87.

27 Pevsner and Lang, *op. cit.,* p. 229. See also note 90.

28 Watzdorf, *op. cit.*

29 In seven volumes.

30 *Op. cit.,* p. 230. The author is grateful to Sir Nikolaus Pevsner and to Dr Lang for permission to quote.

31 Curl, *A Celebration . . .* pp. 140–5.

32 No. 590 in the *Catalogue.*

33 Burke, *op. cit.*

34 Soane, *Lectures . . .* pp. 20–1.

35 Cassas, *op. cit.*

CHAPTER 5

1 Wilton-Ely, *The Mind and Art . . .* p. 107.

2 Ford, B. (ed.), 'The Memoirs of Thomas Jones'. *Walpole Society,* XXXII (1946–8). Quoted in Wilton-Ely, p. 107.

3 Soane, *Lectures . . .*

4 The letter is in the possession of the Society of Antiquaries of London.

5 Caylus, *op. cit.,* VII, pp. 34–119, pl. xii.

6 Wilton-Ely, *The Mind and Art . . .* pp. 8, 47, 67, 76–80, 88, 107–9, 116.

7 In the Advertisement to the Fourth Edition of the *Anecdotes . . . op. cit.,* p. 398.

8 Waite, *op. cit.*

9 Quoted in Dent, *op. cit.,* p. 254.

10 The author is indebted to the librarian of the United Grand Lodge of England for help here. He is also indebted to the late Dr Hans Knappertsbusch who discussed Mozartian and eighteenth-century opera with him at Bayreuth in 1962.

11 Designs survive in the *Čaplovičová Knižnica, Dolný Kubín.* The author is indebted to Madame Edith Róth, Professor Mátyás Horányi, and Dr Štefan Krivuš.

12 C. L. Giesecke, Mozart himself, and Emanuel Schikaneder, according to Edward J. Dent, *op. cit.,* Dent's book is still a classic on this subject.

13 See Junk, *op. cit.,* and Dent, *op. cit.*

14 Leipzig, 1836.

15 For revolutionary connexions, see Curl, James Stevens, 'Mozart considered as a Jacobin', *The Music Review,* August, 1974.

16 Nettl, *op. cit.*

17 For this unsavoury character see Almeras, *op. cit.*

18 The author is most indebted to Mr Haunch, Librarian and Curator of the United Grand Lodge of England Library and Museum, for discussing Cagliostro with him.

19 Köppen, *op. cit.* and Acerellos, *op. cit.*

20 See Kneisner, F., *op. cit.,* and Friedel, J. G., *op. cit.,* for further information. See also Dent, *op. cit.,* pp. 26, 90, 211, 216, 219 *ff,* 231, 232 and 234.

21 Dent, *op. cit.,* p. 237. The contribution of Moritz Alexander Zille to an understanding of *Die Zauberflöte* and its meaning in 1866 must be stressed.

22 See Rosenau, *Boullée . . .*

23 Curl, *A Celebration . . .* p. 189.

24 *Ibid,* p. 190.

25 Rosenau, *op. cit.,* p. 106. The quotations are from Boullée's essay on 'Architecture', translated by Sheila de Vallée, and edited and annotated by Helen Rosenau. The author is grateful to Dr Rosenau-Carmi for her invaluable help.

26 *Ibid.*

27 Bibliothèque Nationale, Paris. HA 57, no. 27. References HA throughout are those of the Cabinet des Estampes..

28 *Ibid*, HA 57, no. 13.

29 *Ibid*, HA 55, no. 28.

30 For the *Grands Prix* see Rosenau, 'The Engravings . . .'

31 Curl, *A Celebration* . . . p. 194. For a full set of these designs, see Prieur and Van Cléemputte, *op. cit.*

32 See Braham, *op. cit.*

33 *Ibid*, p. 160.

34 *Ibid*, p. 216.

35 Curl on Mozart, *op. cit.* The author is also indebted to Mr Haunch and to Dr Knappertsbusch on these points, and acknowledges the encouragement of his former editor, the late Mr Geoffrey Sharp.

36 See Gallet, *op. cit.*

37 See Krafft and Dubois. *Production* . . . pp. 17 and 31–5.

38 Norden, *op. cit.*, and Pococke, *op. cit.*, Norden's work was published in French in 1755.

39 Krafft and Dubois, *op. cit.*, p. 33.

40 Wollin, *op. cit.*

41 Rosenblum, *op. cit.*

42 See Curl, *A Celebration* . . .

43 In *Essays in the History of Architecture presented to Rudolf Wittkower* (London, 1967), fig. 30.

44 Sirén, *op. cit.*, p. 125.

45 London, 1774–8.

46 Kaufmann, *op. cit.*, p. 50.

47 For a full description see Nilsson, Sten Åke, *op. cit.* Information also kindly provided by Herr Ulf Cederlöf of the Statens Konstmuseer, Stockholm.

48 Colvin, *op. cit.*, p. 952. See also Curl, *A Celebration* . . . p. 180.

49 HA 55, no. 26.

50 Oncken, *op. cit.*, Pl. 13.

51 Colvin, *op. cit.*, p. 125.

52 See Vogel, *op. cit.*, pp. 160–5.

53 The author is indebted to Dr Maurice Craig for showing him this.

54 See Curl, *A Celebration* . . . pp. 141–5.

55 Neumeyer, *op. cit.*, pp. 159–63. See also Rietdorf, *op. cit.*

56 Markland, *op. cit.*, pp. 59 *ff.*

57 Quoted from Flaxman's Address on the Death of Banks.

58 See Curl, *A Celebration* . . . for a discussion of the obelisk type of monument.

59 Harris, John. *The Architectural Review*, cxxii (1957), p. 2. This drawing was exhibited in the Neoclassical Exhibition at the RIBA Heinz Gallery in 1980.

60 Allen, H., *op. cit.*

61 Reade, *op. cit.* See also Johnson, J. Stewart, *op. cit.*

62 See Colvin, *op. cit.*, pp. 249–52. See also Pevsner, Nikolaus, *A History of Building Types* . . . p. 21. See Stroud, Dorothy, *op. cit.*, p. 245.

63 Drawings of Cairness House by Playfair survive in Aberdeen University Library. The author is indebted to Miss M. V. Gordon and to Mr McLaren.

64 Later published as *Etchings, representing the best examples of Grecian and Roman Architectural Ornament; Drawn from the Originals, chiefly collected in Italy, before the late revolutions in that country* (London, 1826).

65 Colvin, *op. cit.*, p. 808.

66 Colvin, *op. cit.*, pp. 808–10.

67 Tatham, C. H. Collection of Manuscript Drawings from Various Antique and other models made in Rome in 1794, 95, and 96.

68 *Ibid*, p. 15.

69 *Ibid*, p. 13.

70 ´ *Ibid*. Page not numbered.

71 *Ibid*, p. 11.

72 Curl, *A Celebration* . . . pp. 182–3.

73 Curl, *Mausolea* . . . See also Curl, *A Celebration* . . . pp. 169–76. These tombs are illustrated in both works.

CHAPTER 6

1 Published in London.

2 Carrott, *op. cit.*, is informative on this and on other matters, especially regarding the American connexion.

3 Stuart and Revett, *op. cit.*

4 Reed, Charles, 'A few remarks on ancient foundations and modern concrete', *The Architectural Magazine*, iii (1836), p. 80.

5 Dowson, J., 'Essay on the metaphysics of architecture', *The Architectural Magazine*, iii (1836), pp. 245–249.

6 London, 1807.

7 See Bibliography.

8 Westmacott, *op. cit.*, p. 214.

9 Watkin, *Thomas Hope* . . . pp. 115–6.

10 *Ibid*, p. 209.

11 *Ibid*, pp. 209–10.

12 Mr John Gloag has discussed this matter with the author. He also mentions it in his book *op. cit.* See also Watkin, *op cit.*, p. 292.

13 Watkin, *op. cit.*, p. 210 and 292.

14 Hope, *op. cit.*

15 See Papworth, *J. B. Papworth*; Hofland, *op. cit.*, and Watkin, *op. cit.*, pp. 211, 293. (Note 50).

16 Hussey, *English Country Houses*, vol. 2, p. 238.

17 Summerson, John, *Architecture* . . . A chimneypiece by Dance was illustrated in Hoffmann, *op. cit.* See also Colvin, *op. cit.*

18 Carrott, *op. cit.*, p. 32.

19 Bellaigue, *op. cit.* The author is most grateful to Mr de Bellaigue for help.

20 Published in London in 1806.

21 Hautecoeur, *L'histoire* . . .

22 *Kirby's Wonderful* . . . p. 173. Mr Ralph Hyde very kindly provided this reference.

23 Truman, *op. cit.*

24 *Ibid*. See also the Exhibition *Catalogue, Les Grands Services de Sèvres*, Musée National de Céramique Sèvres, 1951; Verlet, P., *Sèvres* (Paris, 1953), pp. 226–7. Grandjean, S., L'influence égyptienne à Sèvres', *Publicatie van het Genootschap voor Napoleonische Studien* (Aflevering, 8 September 1955), pp. 99–104; *Connaissance des Arts*, no. 118 (1961), pp. 124–33. See also Grandjean, S., 'The Wellington-Napoleon Relics', *The Connoisseur* cxliii (1959), pp. 223–30.

25 *Ibid*, p. 155.

26 Catalogue of *The Age of Neo-Classicism Exhibition* (London, The Arts Council of Great Britain, 1972). No. 1420.

27 Altick, *op. cit.*, pp. 235–52.

28 Carrott, *op. cit.*, p. 34.

29 Elmes, *Metropolitan* . . . See also Honour, Hugh. 'The Egyptian Taste'. *The Connoisseur* xxxv (1955), pp. 243, 245.

30 Carrott, *op. cit.,* p. 35.

31 Quoted in Altick, *op. cit.,* p. 237.

32 Wolfers and Mazzoni, *op. cit.,* p. 29.

33 Meeks, *Italian Architecture* . . . p. 149.

34 Foulston, *op. cit.*

35 Crook, *op. cit.,* p. 112.

36 *The Buildings of England,* p. 158.

37 See Bonser, *op. cit.,* pp. 280–2.
 See also Wood, G. B., 'Egyptian temple architecture in Leeds', *Country Life,* cxxviii (1960). The Mills were described in the *Penny Magazine* for 1843, and were credited to drawings by Bonomi and Roberts.

38 Carrott, *op. cit.,* p. 35.

39 Maré, *op. cit.,* p. 174.

40 Mentioned in Baedeker, *Southern Italy and Sicily* (1896), p. 18.

41 Hitchcock, *Architecture* . . . p. 58.

42 London, 1826.

43 Schmitz, *Berliner Baumeister* . . . pp. 166–81.

44 See Wischnitzer, 'The Egyptian Revival . . .' Quoted by Carrott, *op. cit.,* p. 43.

45 Vogel, *op. cit.,* pp. 160–5.

46 Baedeker, *Belgium and Holland including the Grand-Duchy of Luxembourg* (1910), p. 444.

47 Pevsner, *A History of Building Types,* pp. 17–18.

48 As Professor Carrott suggests.

49 No. S. Qu. 44/11 in the collection of the Clara Ziegler-Stiftung, Theatermuseum, Munich.

50 Horányi, *op. cit.* The author is indebted to Madame Edith Róth of the Akadémiai Kiadó, Budapest, to Professor Mátyás Horányi, and Dr Štefan Krivuš, Director of Matica Slovenská, for help with Maurer's sketchbook in the Caplovic Library, Dolný Kubín.

51 No. 22C/12 IX Pass. in the collection of the Kupferstichkabinett und Sammlung der Zeichnungen, Berlin.

52 No. 22C/102 Pass. in the collection of the Kupferstichkabinett und Sammlung der Zeichnungen, Berlin.

53 No. Th. 13. in the collection of the Kupferstichkabinett und Sammlung der Zeichnungen, Berlin. There is also an extraordinary design by Schinkel for the interior of the Temple in Jerusalem. This was produced for the 1817 production of the Opera *Athalia* by J. N. Poissl to a text (after Racine) by J. G. Wohlbrück. Schinkel's temple had coved Egyptian cornices set in antis, with palm capitals. The rest of the decorations derived from Assyrian, Persian and other periods. The massive room was illuminated by a clerestory supported on squat Egyptianising columns. The design is No. SM 22b. 104, numbered 131 in the Cat. of the 1980–1 Schinkel Exhibition in Berlin.

54 See The Arts Council for Great Britain. *The Age of Neo-Classicism.* The *Catalogue* of the Fourteenth Exhibition of the Council of Europe. (London, 1972).

55 No. S. Qu. 503. Clara Ziegler-Stiftung, Theatermuseum, Munich.

56 Dr Boetzkes in *The Age of Neo-Classicism, op. cit.,* p. 943. Item 755.

57 No. S. Qu. 532. Clara Ziegler-Stiftung, Theatermuseum, Munich.

58 No. S. Qu. 525. Clara Ziegler-Stiftung, Theatermuseum, Munich.

59 See also Skalicki, *op. cit.*

60 No. G. 16939a. Institut für Theaterwissenschaft der Universität Köln.

61 No. G. 16939b. Institut für Theaterwissenschaft der Universität Köln.

62 See *Theaterdekorationen nach den Original Skizzen des K.K. Hoftheater Mahlers Anton de Pian. Radiert und verlegt von Norbert Bittner* (Vienna, 1818). See also Rosenberg, *op. cit.*

63 No. G. 16928a. Institut für Theaterwissenschaft der Universität Köln.

64 No. G. 16927. Institut für Theaterwissenschaft der Universität Köln.

65 See also the *Catalogue* of the Düsseldorf Exhibition *Mozart und das Theater,* of 1970. See Jung, Niessen, and Beuther, *op. cit.*

66 No. G. 16172b. Institut für Theaterwissenschaft der Universität Köln.

67 April 1822.

68 See *The Cabinet-Maker and Upholsterer's Drawing Book* of 1802.

69 Joy, *op. cit.,* p. 27.

70 Published 1853–92. Vol. 3. E.G.

71 See Richardson, A. E. and others, *Southill: A Regency House* (London, 1951). Stroud, Dorothy, *Henry Holland, His Life and Architecture* (London, 1966).

72 Joy, *op. cit.,* p. 88.

73 *Ibid,* p. 90.

74 *Ibid,* p. 91.

75 Of 63, Wardour Street, London.

76 Higginbottom, *op. cit.* Item 272. The author is grateful to Mr John Morley for showing him these items and for discussing the furniture in detail.

77 Item 100 in Higginbottom, *op. cit.*

78 *Ibid.*

79 *Ibid,* item 116.

80 Plates 7 and 13.

81 The clock is numbered 244 in the *Catalogue* of the Royal Pavilion.

82 Higginbottom, *op. cit.,* no. 244.

83 *Ibid,* no. 249.

84 Plate 8.

85 Item 248 in Higginbottom, *op. cit.,* Mr John Morley has informed the author that he has recently seen two *torchères* of very similar design signed by a Scandinavian maker. Mr Morley has also drawn the author's attention to a remarkable Egyptianising *Biedermeier* sofa, very close to a design illustrated by Himmelheber, which has characteristics of the Schleswig-Holstein area. The ends of the arm rests are in the form of a simplified lotus flower.

86 *Ibid,* no. 107.

87 *Ibid,* no. 264.

88 No. 724 in the *Catalogue.*

89 The author is indebted to Mr John Morley and Mr Geoffrey de Bellaigue for drawing attention to this splendid piece.

90 Staatliche Schlösser und Gärten, Berlin. HM 7725 1–2.

91 Residenzmuseum, Munich, M. 932, 933. See also Thoma, *op. cit.*

92 Pyne, *op. cit.*

93 Tatham, *Etchings* . . . pls. 83, 81–2, 84–5.

94 Pl. 80, figs, 1 and 3.
95 The Metropolitan Museum of Art, New York. Collis P. Huntington Collection, 26.168.77. See also Dubois, *op. cit.*
96 Praz, *An Illustrated History* . . . fig. 134. The painting was No. 208 in the 1972 *The Age of Neo-Classicism* Exhibition in London.
97 Robert Lehman Collection, 41.188.
98 Johnson, J. Stewart, *op. cit.*
99 Noted by the author in Florence. See also *I mobile neo-classico italiano*, pl. clxxxviii.
100 No. 1647 in *The Age of Neo-Classicism* Exhibition in London in 1972, *op. cit.*
101 *The Age of Neo-Classicism*, no. 1719d.
102 *The Age of Neo-Classicism*, *op. cit.*, p. 816. See also Grandjean, S., *L'Orfèvrerie* . . . pl. IV.
103 The Minneapolis Institute of Art, Minnesota, Morse Foundation. 69.80a. See also Iversen, *Obelisks* . . . p. 125.
104 Canina, *op. cit.* See especially pp. 11–13.

CHAPTER 7

1 Rietdorf, *op. cit.* See figs. 25, 26, 43, 44, 138 and 139.
2 Bassi, *op. cit.* See also *The Age of Neo-Classicism* Exhibition Catalogue, item nos. 1234–5.
3 See Lukomskii, *op. cit.*
4 The story of burial reform is told fully in Curl, *A Celebration* . . .
5 Normand, *op. cit.*, pp. 4–5.
6 *Ibid*, p. 9.
7 See Loudon, *On . . . cemeteries* . . .; Strang, *op. cit.*; and Curl, *A Celebration* . . . for a full bibliography.
8 See Albrizzi, *op. cit.*
9 See Potterton, *op. cit.*
10 *Ibid.*
11 The Arts Council of Great Britain, *op. cit.*, p. 202.
12 Gunnis, *op. cit.*, pp. 37–40.
13 Curl, *Mausolea* . . .
14 Curl, *A Celebration* . . . p. 227.
15 Gallier, James, 'American Architecture', *North American Review*, xliii, 93 (1836), pp. 356–84. See also Bigelow, *op. cit.*
16 *Ibid.*
17 Carrott, *op. cit.*, p. 97.
18 Downing, *Cottage residences* . . .
19 Eckels, *op. cit.*
20 Hudson, *op. cit.*, pp. 215–9.
21 Carrott, *op. cit.*, pp. 139–41.
22 See Gilchrist, *op. cit.*
23 Parker, *op. cit.*
24 *Norman's New Orleans* . . . See also Wilson, Samuel, *op. cit.*
25 Lancaster, 'Oriental Forms . . .'
26 Carrott, *op. cit.*, p. 90.
27 Howland and Spencer, *op. cit.* See also Carrott, *op. cit.*, p. 90.
28 Discussed very fully by Professor Carrott, *op. cit.*, pp. 90–4.
29 *Ibid.*
30 *Ibid.*
31 *Ibid.*
32 See Plates 74 and 79 in Professor Carrott's book.

33 Blair, *op. cit.*, p. 26.
34 Curl, *A Celebration* . . .
35 For Undercliffe see Powell, Ken, 'Vandals in Valhalla', *Country Life*, 27 November 1980, pp. 2011–2. The Illingworth mausoleum is illustrated in this article.
36 Willson, *op. cit.*
37 Colvin, *op. cit.*, p. 899.
38 Illustrated on p. 152 of Curl, *A Celebration* . . .
39 London, 1843.
40 *Ibid*, p. 12.
41 Carrott, *op. cit.*, pp. 83–96.

CHAPTER 8

1 Hope, *Household Furniture* . . . p. 27.
2 London, 1834, p. 1016.
3 IV, 1837, p. 278.
4 *Ibid.*
5 Colvin, *op. cit.*, pp. 147–8.
6 *Sic!*
7 Brown, Richard, *op. cit.*, pp. 280–2.
8 *Ibid*, p. 281
9 *Ibid*, p. 282.
10 Papworth, *The Dictionary* . . .
11 Colvin, *op. cit.*, p. 888.
12 *Ibid.*
13 Drawings in RIBA British Architectural Library Drawings Collection. The author is indebted to Mr John Harris for suggesting an examination of Wightwick's work.
14 Exhibited at the Royal Academy in 1818.
15 Grinsell, *Guide Catalogue* . . . p. 9.
16 See *Routledge's Guide to the Crystal Palace, The Ten Chief Courts of the Sydenham Palace*, and the *Official Guide* of 1854, which includes a description of the Court by its designers. The author is indebted to Mr Ralph Hyde for this reference.
17 *Routledge's* . . . p. 35.
18 Grinsell, *op. cit.*, p. 9.
19 Semper, *op. cit.*
20 See Bibliography.
21 Colvin, *op. cit.*, p. 151.
22 Carrott, *op. cit.*, plate 77.
23 *Ibid*, plates 79–80.
24 *Ibid*, plates 86–7.
25 *Ibid*, plate 89.
26 *Ibid*, p. 18, note 4.
27 *Ibid*, plate 90.
28 *Ibid*, plate 91.
29 *Ibid*, plate 93.
30 *Ibid*, plate 94.
31 *Ibid*, plate 95.
32 *Ibid*, plate 96.
33 *Ibid*, plate 99.
34 *Ibid*, plates 102–3.
35 *Ibid*, plates 107, and 110.
36 *Ibid*, plates 111, 112, 114, 116, 118, 121, 122, 123, 124, 125, 127, 128, 134. Professor Carrott (*op. cit.*) is particularly useful on this.
37 *Ibid*, plates 129, 130, 131.
38 *Ibid*, plate 132.

39 For invaluable clarification of who was who in the Bonomi clan, see Colvin, *op. cit.,* pp. 122–5.

40 Bergh, W. van den. 'De Egyptische Tempel een Eeuw Oud'. *Zoo. Uitgave van de Koninklijke Maatschappij voor Dierkunde van Antwerpen.* January 1957, pp. 80–3. Heer Jan Geeraerts, Director of the Koninklijke Maatschappij voor Dierkunde van Antwerpen very kindly provided information about this extra-ordinary building.

41 Dresser, *op. cit.,* p. 5.

42 *Ibid,* p. 6.

43 Now in the Victoria and Albert Museum. *Circ.* 511, 1965.

44 Now in the Victoria and Albert Museum (GF 2443), on loan from Mr Raymond Hall, to whom the author is indebted.

45 *Circ.* 90, 1966.

46 Baedeker, *Londres et ses Environs* (Leipzig and Paris, 1907), p. 94.

47 Curl, *The Victorian Celebration . . .* pp. 4–5.

48 Osborne, *op. cit.,* pp. 695–6.

49 See McFadzean, *op. cit.,* pp. 216–8. Dr McFadzean is curiously unconvinced by the Schinkel connexion.

50 Gomme and Walker, *op. cit.,* pp. 128–9, also note this. The author is indebted to Mr Walker for discussing Thomson at length.

51 McFadzean, *op. cit.,* p. 214.

52 Thomson, Alexander, *The Haldane Lecture,* ii, pp. 11, 12.

53 See McFadzean, *op. cit.*

54 *The Haldane Lectures,* iii, p. 4. See McFadzean *op. cit.,* for full details of these.

55 Loring, *op. cit.,* pp. 114–21. See also the *Catalogue* of the Exhibition at the Metropolitan Museum of Art, 16 January–11 March 1979.

56 *Ibid.*

57 *Ibid.*

58 *Circ.* 439, 1965.

59 Osborne, *op. cit.,* p. 1117.

60 De Luca Editore, *op. cit.,* p. 103. Catalogue of the Exhibition at the Palazzina Mangani, Fiesole, 24 July–30 September 1980.

61 *Ibid,* p. 178.

62 Mr John Morley has informed the author of the existence (in store and in pieces) of a remarkable Egyptianising piano of *c.* 1880 that has fully modelled Egyptian figures as legs inlaid with mosaic.

CHAPTER 9

1 The author is indebted to Mr Christopher Wood, Miss Sylvia Katz, and the Design Council for information.

2 The author is indebted to Mr Hugh G. Conway and to Miss Sylvia Katz. See *The Amazing Bugattis.* A *Catalogue* of the Exhibition at the Royal College of Art, 8 October–18 November 1979.

3 *The Builder,* vol. 119 (23 July 1920), p. 93.

4 *Ibid.*

5 *Ibid.* vol. 119 (16 July 1920), p. 58.

6 *Ibid.*

7 Quoted in *The Builder,* vol. 119 (16 July 1920), p. 58.

8 *Ibid.*

9 *The Builder,* vol. 119 (23 July 1920), p. 93.

10 *Ibid.* John W. Simpson, PRIBA.

11 *Ibid.* The author is indebted to Mr Ralph Hyde for these references.

12 *Ibid.*

13 *Ibid.*

14 *Ibid.*

15 *Ibid.*

16 *Ibid.*

17 Pro-Gothic attitudes were well ingrained at the time.

18 London, 1968.

19 Edwards, A. Trystan, 'The Clash of Colour or The Moor of Argyll Street', *The Architectural Review,* June 1929, pp. 289–99.

20 *The Builder,* 16 November 1928, p. 799. Further information kindly provided by Mr T. Dimmick, of the Archives Collection of Carreras Rothmans. Mr L. A. Porri, of A. G. Porri & Partners, has also been most helpful.

21 Information kindly provided by Mr Peter Bezodis.

22 See the catalogue of the 'Egyptomania' exhibition at The Metropolitan Museum of Art in New York, 1979. See also Loring, *op. cit.,* pp. 114–21.

23 *The Architectural Review,* 59 (1926), pp. 212–21.

24 *The Builder,* vol. 129 (3 July 1925), pp. 2–5.

25 Information from Mr Richard Gray, archivist of the Cinema Theatre Association and Mr David Atwell.

26 A letter to the author of 14 June 1979.

27 The author is very grateful to Mr Richard Gray, Archivist of the Cinema Theatre Association, for generous help and information. See also *The Bioscope,* 18 June 1930.

28 *Catalogue* of the Metropolitan Museum of Art, New York, 16 January–11 March 1979.

29 Pevsner, *London Except the Cities of London and Westminster* (Harmondsworth, 1952), p. 371.

30 Pevsner, *Middlesex* (Harmondsworth, 1951), p. 130.

31 *Ibid,* p. 21.

32 No. 1363 in the *Catalogue.*

33 No. 1310 in the *Catalogue.*

34 In 1980–1.

35 In the 1980s.

The works cited in the chapter notes can be found in the Bibliography.

Bibliography

The stream of the river Nile
can water the earth, and the word
of the monk Nilus can delight
the mind.

GREGORY OF NAZIANUS: 'On Nilus the Great Hermit'
Greek Anthology. Book 1. Epig. 100.

Académie de France à Rome. Catalogue of the Exhibition, *Piranèse et les Français: 1740–1790.* Villa Medici, Dijon, and Paris, 1976.

Acerellos, R. S. *Die Freimaurerei in ihrem Zusammenhang mit den Religionen der alten Aegypter, der Juden und der Christen.* Leipzig, 1836.

Achen, Sven Tito. *Symboler omkring os.* Copenhagen, 1975.

Ackermann, Rudolf (*Ed.*). *Repository of Arts, Literature, Commerce, Manufacturers, Fashions, and Politics.* London, 1809–28.

Adams, Frank Dawson. *Birth and Development of the Geological Sciences.* New York, 1938.

Adams, W. Marsham. *The Book of the Master, or the Egyptian Doctrine of the Light born of the Virgin Mother.* London, 1898.

Aelianus, Claudius. *De Natura Animalium.*

Age of Neo-classicism, The. Catalogue of the fourteenth Council of Europe Exhibition. London, 1972.

Agnew, L. R. C. (*Ed.*). *Athanasius Kircher, 1602–1680.* Kansas City, 1958.

Alberti, Leone-Battista. *Ten Books on Architecture.* Translated by Cosimo Bartoli and James Leoni. Edited by Joseph Rykwert. London, 1955.

Albrecht, Theodor. *Freimaurers Weltreise.* Leipzig, 1914.

Albrizzi, Countess. *The Works of Antonio Canova.* London, 1824.

Alembert, d'. *See* Diderot.

Alexander, R. 'The Public Monument and Godefroy's Battle Monument', *Journal of the Society of Architectural Historians,* vol. xvii, 1958.

Alexander, R. *The Architecture of Maximilian Godefroy.* Baltimore, 1974.

Alföldi, A. *A Festival of Isis in Rome.* Budapest, 1937.

Algarotti, Count F. *Opere.* Venice, 1791–4.

Alison, Archibald. *Essays on the Nature and Principles of Taste.* Edinburgh, 1811.

Allais, L.-J., Détournelle, A., and Vaudoyer, A.-L.-T. *Grand Prix d'Architecture, projets couronnés par l'Académie d'Architecture et l'Institut de France.* Paris, 1806.

Allen, H. 'Egyptian Influences in Wedgwood Design', in *Seventh Wedgwood International Seminar.* Chicago, 1962.

Alméras, Henri d'. *Cagliostro.* Paris, 1904.

Alméras, Henri d'. *La Vie parisienne sous la Révolution et le Directoire.* Paris, n.d.

Altick, Richard D. *The Shows of London.* Cambridge, Mass., and London, 1978.

American Journal of Archaeology.

American Journal of Semitic Languages and Literature.

American Monthly Magazine, The. New York, 1833–8.

American Quarterly, The. Philadelphia, 1827–37.

Andersen, Aage, H. *Verdensfrimureri! Verdensrevolution!* Copenhagen, 1938.

Anderson, William J. *The Architecture of the Renaissance in Italy.* London, 1901.

Annali dell' Instituto di correspondenza archeologica. Rome, from 1829.

Annals of the British School at Athens.

Anonymous. *Geheime Figuren der Rosenkreuzer aus dem 16ten und 17ten Jahrhundert.* Altona, 1785–6.

L'Antiquité Classique.

Antoine, Jacques-Denis. *Plans . . . de l'Hôtel des Monnaies.* Paris, 1826.

Apuleius, Lucius. *Metamorphoseon libri XI.*

Archaeology. See References.

Architectural Magazine. See References.

Architectural Review. See References.

Architektonische Studien des Kais. Dtsch. Archaeol. Inst. III. 1889.

Armstrong. *See* Perrot.

Art Bulletin. See References.

Arts Council of Great Britain. See *Age of Neo-classicism.*

Aune, L. J. *Frimureriet. Dets Historie i Skandinavien.* Copenhagen, 1929.

Aurenhammer, H. *J. B. Fischer von Erlach.* London, 1973.

Axtell, H. L. *The Deification of Abstract Ideas in Roman Literature and Inscriptions.* Chicago, 1907.

Badenhausen, R. H. *Die Bildbestände der Theatersammlung Louis Schneider.* Berlin, 1938.

Baedeker, Karl. *Handbooks for Travellers,* but especially *Central Italy and Rome.* Leipzig, London, and New York, 1930.

Baege, Wernerus. *De Macedonum Sacris.* Halle, 1913.

Ballou's Pictorial Drawing-Room Companion. Boston, 1855–9.

Baltard, L.-P., and Vaudoyer, A.-L.-T. *Grands Prix d'Architecture, Projets couronnés par l'Académie Royale des Beaux Arts de France.* Paris, 1818.

Baltrušaitis, Jurgis. *La Quête d' Isis. Introduction à l'Égyptomanie. Essai sur la légende d'un mythe.* Paris, 1967.

Baltrušaitis, Jurgis, *Le Moyen-âge fantastique.* Paris, 1955.

Bandinelli, G. *Luigi Canina, le opere i tempi.* Alexandria, 1953.

Bapst, Constant. *Essai sur l'histoire du théâtre.* Paris, 1893.

Barfoed, Aage. *Tempelherrerne. Historisk Roman.* Copenhagen, 1934.

Barker, W. B. *Lares and Penates.* London, 1853.

Barry, James. *The Works of James Barry.* London, 1809.

Bartha, D. *Haydn als Opernkapellmeister.* Budapest, 1960.

Bartholdy, Paul. *Bericht über das Kaiserfest i. O. Strassburg i. E. am 12. September 1886.* Neuwied/Rhein, 1886.

Bassi, Elena. *Giannantonio Selva, architetto veneziano.* Padua, 1936.

Baumgarten, S. *Le Crépuscule Néo-Classique. Thomas Hope.* Paris, 1958.

Beauvallet, P.-N. *Fragmens d'architecture, sculpture, et peinture dans le style antique.* Paris, 1804.

Becker. *See* Thieme.

Bédarride, Armand. *Le travail sur la pierre brute.* Paris, 1927.

Beenken, H. *Schöpferische Bauideen der Deutschen Romantik.* Mainz, 1952.

Beer, G. R. de. *Sir Hans Sloane.* Oxford, 1953.

Begemann, Wilhelm. *Die Tempelherrn und die Freimaurer.* Berlin, 1906.

Belgrado, Jacopo. *Dell' Architettura Egiziana, dissertazione d'un Corrispondente dell' Accademia delle Scienze di Parigi,* etc. Parma, 1786.

Bell, H. I. *Cults and Creeds in Graeco-Roman Egypt.* Liverpool, 1953.

Bellaigue, Geoffrey de. 'Martin-Eloy Lignereux and England'. *Gazette des Beaux-Arts.* May-June, 1968.

Bellermann. Joh. Joach. *Geschichtliche Nachrichten aus dem Alterthume über Essäer und Therapeuten.* Berlin, 1821.

Belzoni, Giovanni Battista. *Narrative of the Operations and Recent Discoveries within the Pyramids, Temples, Tombs, and Excavations, in Egypt and Nubia; and of a Journey to the Coast of the Red Sea, in Search of the Ancient Berenice; and Another to the Oasis of Jupiter Ammon.* London, 1830.

Benincasa. *See* Orsini-Rosenberg.

Benyovszky, Károly. *Das alte Theater.* Pressburg, 1926.

Benyovszky, Károly. *Johann Nepomuk Hummel, der Mensch und Künstler.* Pressburg, 1934.

Benyovszky, Károly. *Theatergeschichtliche Kleinigkeiten.* Bratislava, 1929.

Benzon, S. *De tre Frimurere. Roman efter en afdød Frimurers efterladte Papirer.* Copenhagen, 1861.

Bergman, J. *Ich bin Isis. Historia Religionum 3.* Uppsala, 1968.

Berkenhout, John. *The Ruins of Paestum or Posidonia.* London, 1767.

Betancourt, Philip P. *The Aeolic Style in Architecture. A Survey of Its Development in Palestine, the Halikarnassos Peninsula, and Greece, 1000-500 B.C.* Princeton and Guildford, 1977.

Betbuch für Freymaurer in hochwürdigste Provinzialloge von Böhmen und allen Freimäurern dieses Sprengels. Prague, 1784.

Beuren, Otto. *Die innere Urwahrheit der Freimaurerei.* Mainz, 1884.

Beuther, R. See Jung, O.

Bible Myths and their Parallels in Other Religions: being a comparison of the Old and New Testament Myths and Miracles with those of Heathen Nations of Antiquity, considering also their Origin and Meaning. New York, 1883.

Bigelow, Jacob. *A History of the Cemetery of Mount Auburn.* Boston and Cambridge, Mass., 1860.

Biondo, Flavio. See Blondus, Flavius.

Bioscope, The. See References.

Bischoff, Oswald Erich. *Die Elemente der Kabbalah.* Berlin, 1913-14. Also the 1920 Edition.

Bittner, Norbert. *Theaterdekorationen nach den Original Skizzen des K.K. Hoftheater Mahlers Anton de Pian. Radiert und verlegt von Norbert Bittner.* Vienna, 1818.

Biver, M. L. *Le Paris de Napoléon.* Paris, 1963.

Blair, George. *Biographic and Descriptive Sketches of Glasgow Necropolis.* Glasgow, 1857.

Blavatsky, H. P. *Isis Unveiled.* New York, 1877.

Blondel, Jacques-François. *L'Homme du monde éclairé par les arts.* Amsterdam, 1774.

Blondel, Jacques-François. *Discours sur la nécessité de l'étude de l'architecture.* Paris, 1754.

Blondus, Flavius. *Roma ristaurata, et Italia illustrata.* Venice, 1558. The Roman edition of 1470, that of Verona in 1481, and the Venice version of 1510 are useful.

Blunt, Anthony. *The Drawings of G. B. Castiglione and Stefano della Bella in the Collection of H.M. the Queen at Windsor Castle.* London, 1954.

Blunt, Anthony. 'The "Hypnerotomachia Poliphili" in XVII Century France'. *Journal of the Warburg and Courtauld Institutes,* vol. 1, 1937–8.

Blunt, Anthony. *François Mansart and the Origins of French Classical Architecture.* London, 1941.

Boardman, John. *See* Kurtz, Donna C.

Boas, G. *The Hieroglyphics of Horapollo.* New York, 1950.

Boase, T. S. R. *English Art, 1800–1870.* Oxford, 1959.

Boëthius, Axel, and Ward-Perkins, J. B. *Etruscan and Roman Architecture.* Harmondsworth, 1970.

Böheim, F. W. von. *Auswahl von Maurer Gesängen mit Melodien der vorzüglichsten Componisten in zweij Abtheilungen getheilt.* Berlin, 1798.

Bolton, A. T. *Lectures on Architecture.* Sir John Soane's Museum Publications. No. 14. London, 1929.

Bonanni, Philippo, S. J. *Rerum Naturalium Historia . . . in Museo Kircheriano.* Rome, 1709.

Bonneau, D. *La Crue du Nil.* Paris, 1964.

Bonner, C. *Studies in Magical Amulets.* Ann Arbor and London, 1950.

Bonnet, H. B. C. *Reallexikon der ägyptischen Religionsgeschichte.* Berlin, 1952.

Bonser, K. J. 'Marshall's Mill, Holbeck, Leeds', *Architectural Review,* vol. cxvii. 1960.

Boor, J. *Masoneria.* Madrid, 1952.

Born, Ignaz von. *Physikalische Arbeiten der einträchtigen Freunde in Wien.* Vienna, 1783–8.

Botti, G. *Fouilles à la Colonne Théodosienne.* Vienna, 1897.

Bourgeois, Emil. *Le Style Empire.* Paris, 1930.

Bousset, W. *Die Offenbarung Johannis.* Göttingen, 1906.

Box, H. S. *See* Mascall, E. L.

Brady, T. A. *The Reception of the Egyptian Cults by the Greeks.* Columbia, 1935.

Braham, Allan. *The Architecture of the French Enlightenment.* London, 1980.

Bramsen, H. *Gottlieb Bindesbøll – Liv og Arbejder.* Copenhagen, 1959.

Brandon, S. G. F. *Jesus and the Zealots.* Manchester, 1967.

Brayley, E. W., and Britton, J. *A Topographical History of Surrey.* London, 1841–8.

Briffault, R. *The Mothers.* London, 1927.

Brinckmann, Albert Erich. *Die Baukunst des 17. und 18. Jahrhunderts in den romanischen Ländern.* Berlin, n.d.

Brinckmann, Albert Erich. *Spätmittelalterliche Stadtbau in Südlichen Frankreich.* Berlin, 1910.

Brindley, William (and Weatherley, W. Samuel). *Ancient Sepulchral Monuments Containing Illustrations of over Six Hundred Examples from Various Countries and from the Earliest Periods down to the end of the Eighteenth Century.* London, 1887.

Brion, M. *Pompeii and Herculaneum.* London, 1960.

Britton, J. *See* Brayley, E. W.

Britton, J. *History, etc., of the Deepdene. Seat of Thos. Hope, Esqre.* London, 1821–6.

Britton, J. *Illustrations of the Deepdene. Seat of T. Hope Esqre.* London, 1826.

Britton, J., and Pugin, A. C. *Illustrations of the Public Buildings of London.* London, 1825.

Brown, Glenn. *The History of the United States Capitol.* Washington, 1900.

Brown, Richard. *Domestic Architecture: containing a history of the science, and the principles of designing Public Edifices, Private Dwelling-Houses, Country Mansions, and Suburban Villas, with practical dissertations on every branch of building, from the choice of the site, to the completion of the appendages. Also, some observations on Rural Residences, their characteristic situation and scenery; with instructions on the art of laying out and ornamenting grounds; exemplified in Sixty-Three Plates, containing Diagrams, and Exemplars of the various Styles of Domestic Architecture, with a description, and wood-cuts of the appropriate furniture, garden, and landscape scenery of each.* London, 1842.

Brown, William. *The Carpenter's Assistant.* Worcester, 1857.

Brües, Eva. *Kunstchronik,* xviii. 1965. Pp 315 f.

Brunet, M. *See* Verlet, P.

Bubics, Zs. *Herczeg Esterházy Pál nádor.* Budapest, 1896.

Buck, J. D. *Symbolism of Freemasonry or Mystic Masonry and the Greater Mysteries of Antiquity.* Chicago, 1946.

Budde, Ludwig, and Nicholls, Richard. *A Catalogue of the Greek and Roman Sculpture in the Fitzwilliam Museum, Cambridge.* Cambridge, 1967.

Budge, E. A. T. W. *The Book of the Dead.* London, 1898.

Budge, E. A. T. W. *From Fetish to God in Ancient Egypt.* London, 1932.

Budge, E. A. T. W. *The Gods of the Egyptians.* London, 1904.

Budge, E. A. T. W. *Legends of the Gods.* London, 1912.

Builder, The. See References.

Bulletino della Commissione Archeologica comunale di Roma. Rome, from 1872.

Bullock, Edward. *A Companion to Mr. Bullock's London Museum and Pantherion . . . now open for public inspection in the Egyptian Temple . . . in Piccadilly.* London, 1812.

Burchard, J., and Bush-Brown, A. *The Architecture of America.* Boston and Toronto, 1961.

Burckhardt, Jacob. *The Civilization of the Renaissance in Italy.* Translated by S. G. C. Middlemore. Vienna and London, n.d.

Burckhardt, Jacob. *Die Zeit Constantins des Grossen.* Bern, 1950.

Burke, Edmund. *A Philosophical Inquiry into the Origin of Our Ideas of the Sublime and the Beautiful.* London, 1757.

Busby, C. A. *A Series of Designs for Villas and Country Houses, adapted with Economy to the Comforts and to the Elegancies of Modern Life.* London, 1808.

Butcher, E. L. *Story of the Church in Egypt.* London, 1897.

Butler, The Rev. Alban. *The Lives of the Fathers, Martyrs and other Principal Saints.* London, 1854.

Calcagnini, Celio. *De Rebus Aegyptiacis.* Basle, 1544.

Calcott, Wellins. *A Candid Disquisition of the Principles and Practices of the most Ancient and Honourable Society of Free and Accepted Masons; together with some Strictures on the Origin, Nature, and Design of that Institution.* London, 1769.

Cancellieri, F. *Il Mercato.* Rome, 1811.

Canina, Luigi. *Le nuova fabbriche della Villa Borghese denominata Pinciana.* Rome, 1828.

Caplat, Moran (*Ed.*). *Glyndebourne Festival Opera 1978.* Glyndebourne, 1978.

Cappe, August Wilhelm Heinrich. *Geschichte der Freimaurerei im Oriente von Hildesheim.* Hildesheim, 1812.

Carré, J. M. *Voyageurs et écrivains français en Egypte.* Cairo, 1932.

Carrott, Richard G. *The Egyptian Revival. Its Sources, Monuments, and Meaning. 1808–1858.* Berkeley, Los Angeles, and London, 1978.

Cassard, Andres. *Manuel de la masoneriá, ó sea el tejador de los rilos antiguo escoces, frances y de adopcion.* New York, 1860.

Cassas. L.-F. *Voyage pittoresque de la Syrie, de la Phénicie, de la Palestine, et de la Basse Egypte.* Paris, 1799.

Castells, F. de P. *The Genuine Secrets in Freemasonry prior to A.D. 1717.* London, 1930.

Caylus, Anne-Claude-Philippe de Thubières, Comte de. *Recueil d'Antiquités Egyptiennes, Etrusques, Grecques et Romaines.* Paris, 1752-67.

Cerceau, Jacques Androuet Du. *Livre d'Architecture.* Paris, 1911.

Černý, J. *Ancient Egyptian Religion.* London, 1952.

Chalon, J. *Aux Pyramides.* Verviers, n.d.

Chapouthier, F. *Les Dioscures au Service d'une Déesse.* Paris, 1935.

Chastel, A. 'L' "Etruscan Revival" du XVe siècle'. *Revue Arch.* 1 (1959), pp. 165, 179.

Chipiez, Charles. *See* Perrot.

Choukas, M. *Black Angels of Athos.* Brattleboro, Vermont, 1935.

Christine de Pisan. *Les cent histoires de troye.* 1499–1500.

Ciaceri, E. *Culti e Miti.* Catania, 1911.

Clark, R. T. Rundle. *Myth and Symbol in Ancient Egypt.* London, 1959.

Claridge, Amanda. *See* Ward-Perkins, John.

Clausen, Ernst. *Die Freimaurer. Einführung in das Wesen ihres Bundes.* Berlin, 1922.

Cléemputte, P.-L. van. *See* Prieur, A.-P.

Clemen, K. 'Der Isiskult und das Neue Testament'. *Heinrici Festschrift: Neuetestamentliche Studien.* Leipzig 1914, pp. 28–39.

Cochin, Charles-Nicholas. *Mémoires inédits.* Henry, Charles (*Ed.*). Paris, 1880.

Cole, W. P. *See* Montgomery, C. F.

Colombier, P. du (*Ed.*). *Lettres de Poussin.* Paris, 1929.

Colonna, Francesco. *Hypnerotomachia Poliphili.* Venice, 1499, and later editions.

Colvin, Howard M. *A Biographical Dictionary of British Architects 1600–1840.* London, 1978.

Commission des monuments d'Egypte. *Description de l'Egypte, ou Recueil des observations et des recherches qui ont été faites en Egypte pendant l'expédition de l'armée française, publié par les ordres de Sa Majesté l'empereur Napoléon le Grand.* Paris, 1809–28.

Commission des monuments d'Egypte. Another edition of 1821–9 in 24 volumes, with atlas.

Confalonieri, G. *Prigonia di un artista.* Rome, 1948.

Connaissance des Arts. See References.

Conner, Patrick. *Oriental Architecture in the West.* London, 1979.

Connoisseur, The. See References.

Cook, B. F. *Greek and Roman Art in the British Museum.* London, 1976.

Cooper, W. R. *The Horus Myth in its relation to Christianity.* London, 1877.

Country Life. See References.

Courgelon, J. H. F. *Protokoll am Tage der Installations – Feier der unabhängigen Grossloge des Königreichs Hannover, Die Freimaurerei im Orient von Hannover.* Hannover, 1828.

Craven, J. B. *Count Michael Maier.* Kirkwall, 1910.

Crawford, William. *Extracts from the Second Report of the Inspectors of Prisons for the Home District.* London, 1837.

Crawford, William. *Penitentiaries of the United States.* London, 1834.

Crook, J. Mordaunt. *The Greek Revival. Neo-Classical Attitudes in British Architecture 1760–1870.* London, 1972.

Csatkai, E. *Beiträge zu einer Eisenstädter Theatergeschichte.* Vienna, n.d.

Curl, James Stevens. *A Celebration of Death. An introduction to some of the buildings, monuments, and settings of funerary architecture in the Western European tradition.* London, 1980.

Curl, James Stevens. *Classical Churches in Ulster.* Belfast, 1980.

Curl, James Stevens. *English Architecture: an Illustrated Glossary.* Newton Abbot, 1977.

Curl, James Stevens. *European Cities and Society. The Influence of Political Climate on Town Design.* London, 1970.

Curl, James Stevens. *Mausolea in Ulster.* Belfast, 1978.

Curl, James Stevens. *The Victorian Celebration of Death.* Newton Abbot, 1972.

Dalton, O. M. *Byzantine Art and Archaeology.* Oxford, 1911.

Dannenfeldt, Karl H. 'Egyptian Antiquities of the Renaissance', in *Studies in the Renaissance,* vol. vi, 1959.

Davies, Gerald S. *Renascence: The Sculptured Tombs of the Fifteenth Century in Rome.* London, 1910.

Dawson, C. M. *Romano-Campanian Landscape Painting.* Yale, 1944.

Deissmann, G. A. *Paulus.* Tübingen, 1911.

Delafosse, Jean-Charles. *Nouvelle Iconologie historique.* Paris, 1768.

Delafosse, Jean-Charles. *Style Louis Seize. L'Oeuvre de Delafosse Iconologie historique. Reproduction intégrale de l'ouvrage du temps.* Guérinet, Armand (*Ed.*) Paris, n.d.

De Luca Editore. *Arnold Böcklin la Cultura Artistica in Toscana.* Rome, 1980.

Demetz, F.-A. *Lettre sur les système pénitentiaire.* Paris, 1838.

Dempsey, Charles G. 'Representations of Egypt in the Paintings of Nicolas Poussin'. *Art Bulletin,* xlv, 2, 1963.

Dennis, George. *The Cities and Cemeteries of Etruria.* London, 1883.

Dennis, J. T. *The Burden of Isis; being the laments of Isis and Nephthys.* London, 1910.

Denon, Dominique Vivant. *Voyage dans la Basse et la Haute Egypte pendant les campagnes du Général Bonaparte.* Paris, 1802. Also an English translation by F. Blagdon in the following year.

Dens, Ch., and Poils, J. *La Pyramide Cinéraire de Ladeuze, II*ᵉ *siècle de l'ère chrétienne.* Brussels, 1913.

Dent, Edward J. *Mozart's Operas. A Critical Study.* London, 1960.

Desroches-Noblecourt, Christiane. *Tutankhamen.* Harmondsworth, 1965.

Détournelle, A. *See* Allais, L.-J.

Diderot and d'Alembert (*Eds.*). *L'Encyclopédie.* Paris, 1777.

Dill, S. *Roman Society from Nero to Marcus Aurelius.* London and New York, 1904.

Dindorf, L. *Historici Graeci Minores.* Berlin, 1870.

Disher, M. W. *Pharaoh's Fool.* London, 1957.

Domaszewski, A. von. *Die Rangordnung des römischen Heeres.* Bonn, 1908.

Donnet, Alexis. *Architectonographie des théâtres de Paris.* Paris, 1857.

Doresse, J. *Des Hiéroglyphes à la croix.* Paris, 1960.

Doresse, J. *The Secret Books of the Egyptian Gnostics.* London, 1960.

Dorigny, P. W. *L'Egypte ancienne.* Paris, 1762.

Douglas, Norman. *Old Calabria.* Harmondsworth, 1962.

Downes, Kerry. *Vanbrugh,* in vol. xvi of *Studies in Architecture.* London, 1977.

Downey, R. E. G. *A History of Antioch in Syria.* Princeton, 1962.

Downing, A. J. *A Treatise on the Theory and Practice of Landscape Gardening.* New York, 1841.

Downing, A. J. *Cottage Residences.* New York, 1842.

Dresser, Christopher. *The Art of Decorative Design.* London, 1862.

Dresser, Christopher. *Modern Ornamentation.* London, 1886.

Dresser, Christopher. *Principles of Decorative Design.* London, 1873.

Dresser, Christopher. *Studies in Design.* London, 1876.

Drexler, W. *Der Isis – und Sarapis – Cultus in Kleinasien.* Vienna, 1889.

Drioton, E. *Le Théâtre Egyptien.* Cairo, 1942.

Dubois, L. *Description des objets d'art qui composent le Cabinet de feu M. Le Baron V. Denon.* Paris, 1826.

Dulaure, Jacques Antoine. *Histoire civile, physique et morale de Paris.* Paris, 1821.

Dumont, Gabriel-Pierre-Martin. *Recueil de plusieurs parties d'architecture de différents maîtres tant d'Italie que de France.* N.pl., 1767.

Dumont, Gabriel-Pierre-Martin. *Parallèle de plans des plus belles salles de spectacle d'Italie et de France.* N.pl., 1763.

Duponchel, Auguste. *Nouvelle Bibliothèque des Voyages anciens et modernes ...* etc. Includes *Voyage en Égypte (1761–1763),* by Carsten Niebuhr. Paris, 1841–2.

Durand, J.-N.-L. *Précis des leçons d'architecture données à l'école polytechnique.* Paris, 1802, 1805.

Düsseldorf. *Catalogue* of the Exhibition *Mozart und das Theater.* Düsseldorf, 1970.

Duval, Amaury, and Moisy, Alexandre. *Fontaines de Paris.* Paris, 1813.

Ebers, Karl Friedr. *Sarsena oder der vollkommene Baumeister, enthaltend die Geschichte und Entstehung des Freimaurerordens und die verschiedenen Meinungen darüber, was er in unseren Zeiten seyn könnte; was eine Loge ist, die Art der Aufnahme, Oeffnung und Schliessung derselben, in dem ersten, und die Beförderung in dem zweiten und dritten der St. Johannisgrade; so wie auch die höhern Schottengrade und Andreas-ritter.* Bamberg, 1817.

Eckels, C. W. 'The Egyptian Revival in America', *Archaeology,* vol. iii, 1950.

Edwards, I. E. S. *The Pyramids of Egypt.* London, 1972.

Edwards, R. *See* Macquoid, P.

Egger, Hermann. 'Entwürfe Baldassare Peruzzis für den Einzug Karls V in Rom. Eine Studie zur Frage über die Echtheit des Sienasischen Skizzenbuches', *Jahrbuch der Kunsthistorischen Sammlungen des Allerhöchsten Kaiserhauses.* Vienna, 1902.

Egger, Hermann. *Architektonische Handzeichnungen alter Meister.* Vienna, 1910.

Egger, Hermann. *See* Huelsen, C.

Elmes, James. *Lectures on Architecture.* London, 1821.

Elmes, James. *Metropolitan Improvements.* London, 1827.

Encyclopaedia of Religion and Ethics.

Enking, R. *Des Apisaltar J. M. Dinglingers.* Glückstadt, Hamburg, and New York, 1939.

Epinois, Henri de l'. *Les Catacombes de Rome.* Paris and Brussels, 1896.

Eriksen, Svend. *Early Neo-Classicism in France. The creation of the Louis Seize style in architectural decoration, furniture and ormolu, gold and silver, and Sèvres porcelain in the mid-eighteenth century.* Translated by Peter Thornton. London, 1974.

Erman, A. *The Literature of the Ancient Egyptians.* Translated by A. M. Blackman. London, 1927.

Erstling, Oskar. *Freimaurerische Aphorismen und Gedankenspäne.* Vienna, 1911.

Esdaile, Katherine A. *English Church Monuments 1510–1840.* London, 1946.

Fastnedge, R. *Sheraton Furniture.* London, 1962.

Fastnedge, R. See Jourdain, M.

Faulkner, R. D. *The Ancient Egyptian Pyramid Texts.* Oxford, 1970.

Feaver, W. *The Art of John Martin.* London, 1975.

Fels, Edmond Comte de. *Ange-Jacques Gabriel.* Paris, 1912.

Fesch, Paul. *Bibliographie de la franc-maçonnerie et des sociétés secrètes.* Brussels, 1976.

Findel, J. G. *Geschichte der Freimaurerei von der Zeit ihres Entstehens bis auf die Gegenwart.* Leipzig, 1861–2.

Firmicus Maternus, Julius. *De Errore Profanarum Religionum.* Brussels, 1938.

Fischer von Erlach, Johann Bernhard. *Entwurff einer Historischen Architektur, in Abbildung unterschiedener verühmter Gebäude, des Alterthums und fremder Völker.* French and German texts. Leipzig, 1725.

Fitzgerald, Edward. *A Hand Book for the Albany Rural Cemetery, with an Appendix on Emblems.* Albany, 1871.

Fleming, J. *Robert Adam and his Circle in Edinburgh and Rome.* London, 1962.

Fletcher, Sir Banister. *A History of Architecture on the Comparative Method for Students, Craftsmen & Amateurs.* London, 1954.

Floud, P. *The Complete Connoisseur Period Guides: Early Victorian Furniture*. London, 1968.

Fludd, Robert. *Tractatus Apologeticus Integritatem Societatis de Rosea Cruce defendens*. Leiden, 1617.

Fludd, Robert. *Apologia Compendiaria Fraternitatem de Rosea Cruce suspicionis & infamia aspersam, veritatis quasi Fluctibus abluens & abstergens*. Leiden, 1616.

Fludd, Robert. *Utriusque Cosmi majoris scilicet et minoris metaphysica atque technica Historia*. Oppenheim, 1617–9.

Focillon, H. *Giovanni Battista Piranesi, essai de catalogue raisonné de son oeuvre*. Paris, 1918.

Focillon, H. *Giovanni–Battista Piranesi*. Paris, 1928.

Fortescue, A. K. *Ceremonies of the Roman Rite*. London, 1943.

Foulston, John. *The Public Buildings Erected in the West of England*. London, 1838.

Fouquier, Marcel. *Paris au dix-huitième siècle*. Paris, n.d.

Fraser, Douglas, Hibbard, Howard, and Lewine, Milton J. *Essays in the History of Architecture presented to Rudolf Wittkower*. London and New York, 1967.

Frebault, M. *The Architectural Review*. CXXI. 1957.

Freedley, G. *Theatrical Design from the Baroque through Neo-Classicism*. New York, 1940.

Free-Mason's Melody, The. Brief and general collection of Masonic Songs . . . to which are added, the Royal Free-Masons' Charities, a List of the officers of the United Grand Lodge, with the remarkable occurrences in Masonry, and a list of lodges down to the present time. Bury, 1818.

Freymaurerliedern. Vollständige Sammlung von. Leipzig, 1791.

Frick, Karl, R. H. *Die Erleuchteten. Gnostischtheosophische und alchemistischrosenkreuzerische Geheimgesellschaften bis zum Ende des 18. Jahrhunderts*. Graz, 1973.

Friedel, J. G. *Geschichte der Freimaurerei*. Leipzig, 1861.

Gallet, M. *Demeures parisiennes: l'époque de Louis XVI*. Paris, n.d.

Gandy, Joseph. *Designs for Cottages, Cottage Farms, and other Rural Buildings; including Entrance Gates and Lodges*. London, 1805.

Gandy, Joseph. *The Rural Architect Consisting of Various Designs for Country Buildings, Accompanied with Ground Plans, Estimates, and Descriptions*. London, 1805.

Gandy, Joseph. *See* Gell, Sir William.

Gazette des Beaux-Arts. See References.

Geblin, François. *La Sainte Chapelle et la Conciérgerie*, Paris, 1931.

Geffcken, J. *Kaiser Julianus*. Leipzig, 1914.

Gell, Sir William, and Gandy, John P. *Pompeiana. The Topography, Edifices, and Ornaments of Pompeii*. London, 1852.

Giedion, Sigfried. *Space, Time and Architecture. The growth of a new tradition*. Cambridge, Massachusetts, and London, 1967.

Giedion, Sigfried. *Spätbarocker und romantischer Klassizismus*. Munich, 1922.

Giehlow, K. 'Die Hieroglyphenkunde des Humanismus in der Allegorie der Renaissance', *Jahrbuch der Kunsthistorischen Sammlungen des Allerhöchsten Kaiserhauses*, xxxii. Vienna, 1915.

Gilbert, P. *Chronique d'Egypte*, xvii, 1942.

Gilchrist, A. A. *William Strickland*. Philadelphia, 1950.

Gleason's Pictorial Drawing/Room Companion. Boston, 1851–4.

Gloag, John. *A Social History of Furniture Design*. London, 1966.

Godwin, Joscelyn. *Athanasius Kircher. A Renaissance Man and the Quest for Lost Knowledge*. London, 1979.

Godwin, Joscelyn. *Robert Fludd: Hermetic philosopher and surveyor of two worlds*. London, 1979.

Golzio, V. *Raffaello*. Città del Vaticano, 1936.

Gombrich, E. H. 'Vom Wert der Kunstwissenschaft für die Symbolforschung', in *Probleme der Kunstwissenschaft*. Berlin, 1966.

Gomme, Andor, and Walker, David. *Architecture of Glasgow*. London, 1968.

Gondoin, Jacques. *Description des écoles de chirurgie*. Paris, 1780.

Gorio. *See* Perrot.

Gonzales-Palacios, A. 'Il mobile nei secoli' in *Germania, Italia*. Milan, 1969.

Gonzenbach, V. von. *Untersuchung zu den Knabenweihen im Isiskult*. Bonn, 1957.

Goodenough, E. R. *Jewish Symbols in the Graeco-Roman period*. New York, 1953.

Gothein, Marie Luise. *A History of Garden Art*. New York, 1928.

Gould, Robert Freke. *The History of Freemasonry, its antiquities, symbols, constitutions, customs, etc.* London, 1884–7.

Graillot, H. *Le Culte de Cybèle, mère des dieux*. Paris, 1912.

Grandjean, S. *See* Verlet, P.

Grandjean, S. *Empire Furniture*. London, 1966.

Grandjean, S. 'The Wellington Napoleonic Relics', *The Connoisseur,* vol. cxliii, 1959.

Grandjean, S. 'L'Influence Egyptienne à Sèvres', in *Publicatie van het Genootschap voor Napoleontische Studien.* Aflevering 8, September 1955.

Grandjean, S. *L'Orfèvrerie du XIXè siècle en Europe.* Paris, 1962.

Greaves, John. *Pyramidographia: or, a description of the pyramids in Aegypt.* London, 1646.

Greenough, Horatio. *Form and Function.* New York, 1853.

Griesebach, A. *Karl Friedrich Schinkel.* Leipzig, 1924.

Griffith, G. T. *See* Tarn, W. W.

Griffiths, J. Gwyn. *The Conflict of Horus and Seth.* Liverpool, 1960.

Grimm, G. *Zeugnisse ägyptischer Religion und Kunstelemente im römischen Deutschland.* Leiden, 1969.

Grinsell, Leslie V. *Barrow, Pyramid and Tomb. Ancient Burial customs in Egypt, the Mediterranean and the British Isles.* London, 1975.

Grinsell, Leslie V. *Guide Catalogue to the Collections from Ancient Egypt.* Bristol, 1972.

Gromort, Georges. *Jardins d'Italie.* Paris, 1922.

Gromort, Georges. *Jacques-Ange Gabriel.* Paris, 1933.

Guêpière, De la. *Recueil d'esquisses d'architecture.* Stuttgart, n.d.

Guida ai Musei Vaticani. Città del Vaticano, 1979.

Guillaumont, Charles Axel. *Remarques sur un livre . . . de M. l'Abbé Laugier.* Paris, 1768.

Gunnis, Rupert. *Dictionary of British Sculptors 1660–1851.* New Revised Edition. London, n.d.

Gurlitt, Cornelius. *Geschichte des Barockstiles, der Rococo und des Klassizismus in Belgien, Holland, Frankreich, England.* Stuttgart, 1888.

Gurlitt, Cornelius. *Historische Städtebilder.* Berlin, 1903.

Guthrie, W. K. C. *Orpheus and Greek Religion.* London, 1950.

Gwilt, Joseph. *An Encyclopaedia of Architecture, Historical, Theoretical, and Practical.* Revised by Wyatt Papworth. London, 1903.

Hall, Manly Palmer. *The Secret Teachings of All Ages: An Encyclopedic Outline of Masonic, Hermetic, Qabbalistic and Rosicrucian Philosophy.* Los Angeles, 1928–1975.

Hamlin, Talbot. *Benjamin Henry Latrobe.* New York, 1955.

Hamlin, Talbot. *Greek Revival Architecture in America.* New York, 1944.

Hárich, J. *A kismartoni várkert története.* Budapest, 1937.

Harris, J. *Regency Furniture Designs.* London, 1961.

Hartland, Frederick D. *Tapographia, or A Collection of TOMBS of Royal and Distinguished Families. Collected during a Tour of Europe in the years 1854 and 1855.* Privately printed, 1856.

Hartt, F. *Giulio Romano.* New Haven, 1958.

Hatch, E. *The Influence of Greek Ideas and Usages upon the Christian Church.* London, 1888.

Hatfield, H. G. *The American House Carpenter.* New York and London, 1844.

Hautecoeur, Louis. *Rome et la Renaissance de l'antiquité.* Paris, 1912.

Hautecoeur, Louis. *L'art sous la Révolution et l'Empire en France.* Paris, 1953.

Hautecoeur, Louis. *L'histoire de l'architecture classique en France.* Paris, 1943–57.

Haws, F. L. *Monuments in Egypt.* New York, 1849.

Hay, Denys *(Ed.). The Age of the Renaissance,* London, 1967.

Heckscher, William. 'Bernini's Elephant and Obelisk', *Art Bulletin,* vol. xxix, 1947.

Hederer, Oswald. *Leo von Klenze; Persönlichkeit und Werk.* Munich, 1964.

Hemberg, B. *Die Kabiren.* Uppsala, 1950.

Hempel, E. *Geschichte der Deutschen Baukunst.* Munich, 1949.

Henne am Rhyn, Otto. *Die Freimaurerei in zwölf Fragen und Antworten.* Berlin, 1912.

Henne am Rhyn, Otto. *Die Freimaurer, deren Ursprung, Geschichte, Verfassung, Religion und Politik.* Leipzig, 1909.

Herald, J. Christopher. *Bonaparte in Egypt.* New York, Evanston, and London, 1962.

Herder, Johann Gottfried. *Älteste Urkunde des Menschengeschlechts.* n.p., 1774.

Herodotus. *Histories.* See especially the translation by A. D. Godley of 1920–4. The edition *De Aegyptiacis legibus et institutis e diversis historicis,* etc., in Greek and Latin, published in 1679 is useful.

Hersey, G. L. *Pythagorean palaces; magic and architecture in the Italian Renaissance.* Ithaca, 1976.

Hibbard, Howard. *Bernini.* Harmondsworth, 1965.

Higginbottom, David. *The Royal Pavilion at Brighton.* London and Bradford, n.d.

Hillier, Bevis. *Art Deco of the 20s and 30s.* London, 1968.

Himmelheber, Georg *(Ed.* Simon Jervis). *Biedermeier Furniture.* London, 1974.

Hinckley, F. L. *A Dictionary of Antique Furniture.* New York, 1953.

Hirschfeld, Gustave. *Arcs de triomphe et colonnes triomphales de Paris.* Paris, 1938.

Hitchcock, H.-R. *Architecture, Nineteenth and Twentieth Centuries.* Baltimore, 1958.

Hitchcock, H.-R. *Early Victorian Architecture in Britain.* New Haven and London, 1954 and 1972.

Hoffmann, A. *Der Landschafts-Garten.* Hamburg. 1963.

Hofland, Barbara, and Hofland, T. C. *A Descriptive Account of the Mansion and Gardens of White-Knights, A Seat of His Grace the Duke of Marlborough.* London, 1819.

Holberg, Ludvig. Epistola XI (Frimurerne), Epistola CDXVII (Tempelherrerne), *Den Danske Spectator,* No. 42, 26 February 1745.

Holland & Sons Day-Book. 1835–40. O-S. Victoria & Albert Museum.

Holtschmidt, Friedrich. *Licht und Schatten in der Freimaurerei.* Brunswick, 1903.

Honour, Hugh. 'Curiosities of the Egyptian Hall', *Country Life,* vol. cxv, 1954.

Honour, Hugh. 'The Egyptian Taste', *The Connoisseur,* vol. cxxxv, 1955.

Honour, Hugh. *Neo-Classicism.* Harmondsworth, 1977.

Hope, Thomas. *An Historical Essay on Architecture.* London, 1855.

Hope, Thomas. *Household Furniture and Interior Decoration, Executed from Designs by Thomas Hope.* London, 1807. A complete reprint of the 1807 edition was published in London in 1970 with a Preface by Clifford Musgrave.

Hopfner, T. *(Ed.) Fontes Historiae Religionis Ægyptiacae.* Bonn, 1922.

Horányi, Mátyás. *The Magnificence of Eszterháza.* London and Budapest, 1962.

Horsfield, Thomas Walker. *The History, Antiquities and Topography of the County of Sussex.* Lewes and London, 1835.

Howard, D. L. *John Howard; Prison Reformer.* London, 1958.

Howard, John. *The State of Prisons.* London, 1777.

Howland, Richard H., and Spencer, E. P. *The Architecture of Baltimore.* Baltimore, 1953.

Hudson, Charles. *History of Lexington.* Boston, 1868.

Hülsen, Christian. *Il Libro di Giuliano da Sangallo.* Leipzig, 1910.

Hülsen, Christian, and Egger, Hermann. *Die römischen Skizzenbücher von Maerten van Heemskerck.* Berlin, 1913–16.

Hussey, Christopher. *English Country Houses.* London, 1955–6.

Hussey, Christopher. *The Picturesque.* London, 1927.

Hutchinson, William. *The Spirit of Masonry in Moral and Elucidatory Lectures.* Carlisle, 1795.

Hytten, Sophus. *Mureriske Kantater og Sange.* Copenhagen, 1925.

Inwood, H. W. *Of the Resources of Design in the Architecture of Greece, Egypt, and other Countries.* London, 1834.

Irwin, D. *English Neo-Classical Art.* London, 1966.

Iversen, Erik. *The Myth of Egypt and its Hieroglyphs in European Tradition.* Copenhagen, 1961.

Iversen, Erik. 'Hieroglyphic Studies of the Renaissance', *Burlington Magazine,* vol. c, 1958.

Iversen, Erik. *Obelisks in Exile.* Copenhagen, 1968.

Ixnard, Pierre Michel d'. *Recueil d'Architecture.* Strasbourg, 1791.

Jahrbuch des kaiserlich deutschen archäologischen Instituts. Berlin, from 1887.

James, E. O. *The Tree of Life.* Leiden, 1966.

James, M. R. *A Descriptive Catalogue of the Manuscripts in the John Rylands Library.* Manchester, 1921.

Jameson, Anna Brownell. *Legends of the Madonna as represented in the Fine Arts.* London, 1907.

Janssen, Jozef. 'Athanase Kircher "Égyptologue" ', *Chronique d'Égypte,* vol. 18. Brussels, 1943.

Jansz, Jan de Witt. *Algemeen kunstenaars Handboek . . . geinventeerd . . . door J. Ch. de la Fosse.* Amsterdam, n.d.

Jardin, Nicolas Henri. *Plans, coupes et élévations de l'Eglise Royale de Frédéric V à Copenhague.* N. pl., 1765.

Jervis, J. B. *Description of the Croton Aqueduct.* New York, 1843.

Jidejain, N. *Byblos through the Ages.* Beirut, 1968.

Johnson, J. Stewart. 'Egyptian Revival in the Decorative Arts', *Antiques,* vol. xc, 1966.

Jones, Bernard E. *Freemasons' Guide and Compendium.* London, 1977.

Jones, G. P. *See* Knoop, Douglas.

Jones, Owen. *The Grammar of Ornament.* London, 1856.

Jouguet, P. *Histoire de la Nation Egyptienne,* Paris, 1933.

Jourdain, M., and Fastnedge, R. *Regency Furniture.* London, 1965.

Journal of Egyptian Archaeology.

Journal of Hellenic Studies.

Journal of Near Eastern Studies.

Journal of Roman Studies.

Journal of Theological Studies.

Journal of the Warburg and Courtauld Institutes.

Joy, Edward T. *English Furniture 1880–1851.* London and Totowa, New Jersey, 1977.

Jung, O., Niessen, C., and Beuther, R. *Der Theatermaler Christian Friedrich Beuther and seine Welt.* Emsdetten, 1963.

Junk, Viktor. *Goethes Fortsetzung der Mozartschen Zauberflöte.* Berlin, 1900.

Junker, H., and Winter, E. *Das Geburtshaus des Tempels der Isis in Philä.* Vienna, 1965.

Juvenalis, Decimus Junius, *Scholia.*

Kanzler, Theodor. *Maurerische Lieder als Anhang zum neuen Gesangbuch für die grosse National-Mutterloge zu den drei Weltkugeln.* Berlin, 1846.

Kaufmann, Emil. *Architecture in the Age of Reason. Baroque and Post-Baroque in England, Italy, and France.* New York, 1968.

Kaufmann, Emil. 'Three Revolutionary Architects. Boullée, Ledoux and Lequeu'. *Transactions of the American Philosophical Society,* Philadelphia, lxii, Part 3, 1952.

Kaufmann, Emil. *Von Ledoux bis Le Corbusier.* Vienna, 1933.

Kees, H. *Das Priestertum im ägyptischen Staat.* Leiden, 1953.

Kees, H. *Aegypten.* Tübingen, 1928.

Keller, Ludwig. *Die Freimaurerei. Eine Einführung in ihre Anschauungswelt und ihre Geschichte.* Leipzig, 1914.

Kempen, W. van. 'Die Baukunst des Klassizismus in Anhalt nach 1800', *Marburger Jahrbuch für Kunstwissenschaft,* vol. iv, 1928.

Kersaint, Armand-Guy de. *Discours sur les monuments publics.* Paris, 1792.

Kestler, Johann Stephan. *Physiologia Kircheriana Experimentalis.* Amsterdam, 1680.

Kinnander, Magnus. *Svenska frimureriets historia.* Stockholm, 1943.

Kirby's Wonderful & Scientific Museum, or the Magazine of Remarkable Characters, vol. 1. London, 1803.

Kircher, Athanasius. *Lingua Aegyptiaca Restituta.* Rome, 1643.

Kircher, Athanasius. *Obeliscus Aegyptiacus.* Rome, 1666.

Kircher, Athanasius. *Obeliscus Pamphilius.* Rome, 1650.

Kircher, Athanasius. *Oedipus Aegyptiacus.* Rome, 1652–4.

Kircher, Athanasius. *Prodomus coptus sive Aegyptiacus.* Rome, 1636.

Kircher, Athanasius. *Rituale Ecclesiae Aegyptiacae sive Cophtitarum.* N.p., 1647.

Kircher, Athanasius. *Sphinx Mystagoga, sive Diatribe hieroglyphica,* etc. Amsterdam, 1676.

Kircher, Athanasius. *Turris Babel.* Amsterdam, 1679.

Klapp, Ludwig. *Maurerische Reden.* Hamburg, 1905.

Klein, Rudolph. *Arnold Böcklin.* Berlin, 1901.

Klenze, Leo von. *Sammlung Architektonischer Entwürfe für die Ausführung bestimmt oder wirklich Ausgefürt.* Munich, 1847.

Kloss, Georg. *Bibliographie der Freimaurerei und der mit ihr in Verbindung gesetzten geheimen Gesellschaften.* Frankfurt a. M., 1844.

Kloss, Georg. *Die Freimaurerei in ihrer wahren Bedeutung aus den alten und ächten Urkunden der Steinmetzen, Masonen und Freimaurer.* Leipzig, 1846.

Kloss, Georg. *Geschichte der Freimaurerei in England, Irland und Schottland aus ächten Urkunden dargestellt (1685 bis 1784) nebst einer Abhandlung über die Ancient Masons.* Leipzig, 1848.

Kloss, Georg. *Geschichte der Freimaurerei in Frankreich aus ächten Urkunden dargestellt (1725–1830).* Darmstadt, 1852–3.

Kneisner, F. *Geschichte der deutschen Freimaurerei.* Berlin, 1912.

Knoop, Douglas, and Jones, G. P. *The Growth of Freemasonry.* Manchester, 1947.

Knoop, Douglas, and Jones, C. P. *The Genesis of Masonry.* Manchester, 1945.

Köberlein, E. *Caligula und die ägyptische Kulte.* Meissenheim, 1962.

Köppen, Karl Friedrich. *Crata Repoa, oder Einweihung der ägyptischen Priester.* Berlin, 1778.

Kongelige Kunst, Den. *Frimuriske Logetaler.* Copenhagen, 1929–33.

Körte, W. 'Giovanni Battista Piranesi als praktischer Architekt'. *Zeitschrift für Kunstgeschichte.* vol. II, 1932.

Krafft, J. C. (with Dubois, P.-F.-L.). *Productions de plusieurs architectes Français et étrangers.* Paris, 1809.

Krafft, J. C. *Recueil d'architecture civile.* Paris, 1812.

Krafft, J. C., and Ransonette, N. *Plans, coupes, élévations des plus belles maisons et des hôtels construits à Paris et dans les environs.* Paris, n.d.

Kristensen, Evald Tang. *Danske Sagn, som de har lydt i Folkemunde.* Copenhagen, n.d.

Kunoth, G. *Die Historische Architektur Fischers von Erlach.* Düsseldorf, 1956.

Kuntz, Edwin. 'Böcklins "Toteninsel" ', *Der Kunsthandel,* 66, H. 11. Heidelberg, 1974, p.7.

Kurtz, Donna C., and Boardman, John. *Greek Burial Customs.* London, 1971.

Lafaye, G. *Histoire du culte des divinités d'Alexandrie.* Paris, 1884.

Lafever, Minard. *The Beauties of Architecture.* New York, 1835.

Lafever, Minard. *The Architectural Instructor.* New York, 1856.

Lagrèze, G. B. de. *Les Catacombes.* Paris, 1872.

Lagrèze, G. B. de. *Les Catacombes de Rome.* Paris, 1889.

Lancaster, Clay. 'Oriental Forms in American Architecture, 1800–70', *Art Bulletin,* vol. xxix, 1947.

Lancaster, Clay. 'The Egyptian Style and Mrs Trollope's Bazaar', *Magazine of Art,* vol. xliii, 1950.

Lance, Adolphe. *Dictionnaire des architectes français.* Paris, 1872.

Lanciani, Rodolfo. *Wanderings in the Roman Campagna.* Boston and New York, 1909.

Lanciani, Rodolfo. *The Ruins and Excavations of Ancient Rome: A Companion Book for Students and Travellers.* London, 1897.

Landi, Gaetano. *Architectural Decorations: a Periodical Work of Original Designs invented from the Egyptian, the Greek, the Roman, the Etruscan, the Attic, the Gothic, etc., for Exterior and Interior Decoration and whatever relates to furniture.* London, 1810.

Lange, Albert J. *Bifrøst. Frimurerisk nytaarsgave.* Copenhagen, 1908.

Lassalle. *See* Marty.

Lauer, J. P. *L'Histoire Monumentale des Pyramides d'Egypte.* Cairo, 1962.

Laugier, Marc-Antoine. *Essai sur l'Architecture.* Paris, 1775.

Lavagnino, E. *L'Arte Moderna dai neoclassici ai contemporanei.* Turin, 1956.

Lavalée, Joseph. *Notice historique sur Charles Dewailly.* Paris, 1799.

Lawrence, John T. *The Perfect Ashlar and other Masonic Symbols.* London, 1912.

Lawrence, John T. *The Keystone and other essays on Freemasonry.* London, 1913.

Lawson, J. C. *Modern Greek Folklore and Ancient Greek Religion.* Cambridge, 1910.

Lazarides, D. I. *A Guide to Philippi.* Thessalonika, 1956.

Lazzarini, M., and Munoz, A. *Filarete.* Rome, 1908.

Leadbeater, C. W. *Ancient Ideals in Modern Masonry.* Los Angeles, 1919.

Leadbeater, C. W. *The Hidden Life in Freemasonry.* Adayar, 1926.

Lebegue, R. *Les Correspondants de Peiresc dans les anciens Pays Bas.* Brussels, 1943.

Lecreulx, François Michel. *Discours sur le goût.* Nancy, 1778.

Ledoux, C.-N. *L'architecture considérée sous le rapport de l'art, des moeurs et de la législation.* Paris, 1804–46.

Ledoux, C.-N. *L'architecture de Claude-Nicolas Ledoux.* (Ramée, D. Ed.) Paris, 1847.

Legrand, J. G. *Notice sur la vie et les ouvrages de J. B. Piranesi . . . Rédigée sur les notes et les pièces communiquées par ses fils, les compagnons et les continuateurs de ses nombreux travaux.* Paris, 1799.

Leipoldt, J. *Die Religionen in der Umwelt des Urchristentums.* Leipzig, 1926.

Leipoldt, J., and Morenz, S. *Heilige Schriften.* Leipzig, 1953.

Lemmonier, H. (*Ed.*). *Procès-Verbaux de l'Académie Royale d'Architecture.* Paris, 1911-12.

Leroy, Julien David. *Les Ruines des plus beaux monuments de la Grèce.* Paris, 1758.

Lessing, G. E. *Ernst et Falk. Dialogues maçonniques. L'éducation du genre humain.* Paris, 1946.

Levallet-Haug, G. *Ledoux.* Paris, 1934.

Levi, D. *Antioch Mosaic Pavements.* Princeton, 1947.

Lewine, Milton J. *See* Fraser, Douglas.

Liancourt-La Rochefoucault, Frédéric Alexandre Duc de. *Les Prisons de Philadelphia.* Paris, 1796.

Lindner, Erich J. *Die königliche Kunst im Bild. Beiträge zur Ikonographie der Freimaurerei.* Graz, 1976.

Lings, Martin. *Ancient Beliefs and Modern Superstitions.* London, 1965.

Lister, Raymond. *Edward Calvert.* London, 1962.

London Magazine, The. 1824.

Long, Robert Cary, Jr. *The Ancient Architecture of America.* New York, 1849.

Loring, John. 'Egyptomania: The Nile Style', *The Connoisseur,* vol. 200, no. 804, February, 1979, pp. 114–121.

Loudon, John Claudius. *Encyclopaedia of Cottage, Farm and Villa Architecture and Furniture.* London, 1833. The edition of 1846, enlarged by Mrs Jane Loudon, is particularly interesting.

Loudon, John Claudius. *The Architectural Magazine.* London, 1834–9.

Loudon, John Claudius. *On the Laying Out, Planting, and Managing of Cemeteries, and on the Improvement of Church-yards.* London, 1843.

Lowzow, M. A. *Anvendt Frimureri.* Copenhagen, 1930.

Lowzow, M. A. *En Frimurers Beckendelse.* Copenhagen, 1931.

Lowzow, M. A. *Frimureriet og Pythagoras.* Viby, 1975.

Lowzow, M. A. *Om Frimureri.* Copenhagen, 1928.

Lubicz, René Schwaller de. *Le Temple de l'Homme.* Paris, 1958.

Luca, De. *See* De Luca Editore.

Lucas, Paul. *Voyage du Sieur P. Lucas au Levant. On y trouvera entr'autre une description de la Haute Égypte, suivant le cours du Nil, depuis le Caire jusqu' aux Cataractes;* etc. The Hague, 1705. (A German edition was published in Hamburg in 1707).

Lucas, Paul. *Voyage fait en 1714 dans la Turquie, L'Asie, Sourie, Palestine, Haute et Basse Égypte, etc.* Rouen, 1719. (A German edition was published in Hamburg in 1722).

Lucius, E. *Die Anfänge des Heiligenkults in der Christlichen Kirche.* Tübingen, 1904.

Lucius, F. S. *Bundesgrüsse.* Grimma, 1838.

Lugar, Robert. *Architectural Sketches for Cottages, Rural Dwellings, and Villas.* London, 1805.

Lukomskii, G. K. *Monuments of Ancient Russian Architecture.* Petrograd, 1916.

MacBride, A. S. *Speculative Masonry. Its mission, its evolution and its Landmarks.* Kingsport, 1924.

McFadzean, Ronald. *The Life and Work of Alexander Thomson.* London, Boston, and Henley, 1979.

Maçonnerie. Adoption. Manuscrit français de 146 p., datant de la deuxième partie du 18ᵉ siècle, contenant les grades d'apprentie, compagnonne, maîtresse, maîtresse parfaite, élue et écossoise. Demi-veau de l'époque dos doré avec symboles maçonniques.

Macquoid, P., and Edwards, E. *The Dictionary of English Furniture.* London, 1954.

Mahan, D. H. *Civil Engineering.* New York, 1851.

Maier, Michael. *Arcana Arcanissima, Hoc est Hieroglyphica Aegyptio-Graeca.* Oppenheim, 1614.

Maier, Michael. *Symbola Aureae Mensae duodecim Nationum.* Frankfurt, 1617.

Major, Thomas. *The Ruins of Paestum, otherwise Posidonia, in Magna Graecia.* London, 1768.

Mandowsky, Erna, and Mitchell, Charles. *Pirro Ligorio's Roman Antiquities.* London, 1963.

Manthey, J. D.T. *Rede gehalten in der Loge Friedrich zur gekrönnten Hoffnung den 23sten Januar 1810.* Copenhagen, 1810.

Marbach, Oswald. *Arbeiten am rohen Steine.* Leipzig, 1862.

Marconi, P. *Giuseppe Valadier.* Rome, 1964.

Maré, Eric de. *The Bridges of Britain.* London, 1954.

Markland, J. H. *Remarks on English Churches, and on the Expediency of Rendering Sepulchral Memorials Subservient to Pious and Christian Uses.* Oxford, 1843.

Marraccius, Hippolytus. *Bibliotheca Mariana alphabetico ordine digesta . . .* Rome, 1648.

Marraccius, Hippolytus. *Polyanthea Mariana, in qua libris octodecim . . .* Köln, 1710.

Martin, Geoffrey Thorndike. See Masson, Olivier.

Marty (author) and Lassalle (lithographer) with Rousseau (architect). *Les Principaux Monuments Funéraires Du Père-Lachaise, de Montmartre, du Mont-Parnasse et autres Cimetières de Paris Dessinés et Mesurés Par Rousseau, architecte, et Lithographiés Par Lassalle, Accompagnés d'une Description succincte du monument et d'une Notice historique sur le personnage qu'il renferme, Par Marty.* Paris, n.d.

Marucci, O. *Gli Obelischi egiziani di Roma.* Rome, 1898.

Marucci, O. *Il Museo Egizio Vaticano.* Rome, 1899.

Marx, Jean. *La légende arthurienne et le graal.* Paris, 1952.

Mascall, E. L., and Box, E. S. *(Eds.). The Blessed Virgin Mary: appendix.* London, 1963.

Mascardi, V. *Festa fatta in Roma alli 25 di Febraio, MDCXXXIV.* Rome, 1635.

Masonic Record, The. London, 1947–55.

Masson, Oliver, with Martin, Geoffrey Thorndike and Nicholls, Richard Vaughan. *Carian Inscriptions from North Saqqâra and Buhen.* Egypt Exploration Society. London, 1978.

Matiglia, R. C. 'Giuseppe Jappelli, Architetto', *L'architettura,* 1, 1955–6.

Maurer, Carl. 'Handzeichnungen Zum Theater Gebrauch'. Unpublished manuscript, dated Eisenstadt, 1812.

Mayassis, S. *Le Livre des Morts de l'Egypte ancienne est un livre d'initiation.* Athens, 1955.

Mayes, Stanley. *The Great Belzoni.* New York, 1961.

Mayor, H. *Giovanni Battista Piranesi.* New York, 1952.

Meeks, Carroll, L. V. *Italian Architecture, 1750–1914.* New Haven, 1966.

Meeks, Carroll, L. V. *The Railroad Station.* New Haven, 1956.

Merkel, F. *Leibniz und China.* Berlin, 1952.

Merkelbach, R. *Roman und Mysterium in der Antike.* Berlin, 1962.

Mézières, Nicolas Le Camus de. *Le Génie de l'architecture.* Paris, 1780.

Mezzanotte, P. *Le architettura di Luigi Cagnola.* Milan, 1930.

Millin, Aubin-Louis. *Antiquités Nationales.* Paris, 1790–98.

Miltner, F. *Ephesos.* Vienna, 1958.

Missirini, M. *Tutte le Opere di Thorvaldsen.* Rome, 1832.

Mitchell, C. See Mandowsky, E.

Mitteilungen des kaiserlich deutschen archäologischen Instituts. Römische Abteilung. Rome, from 1886.

Moisy, Alexandre. *See* Duval, Amaury.

Mondain-Monval, Jean. *Soufflot.* Paris, 1918.

Montet, P. *Byblos et l'Egypte.* Paris, 1928–9.

Montfaucon, B. d. *L'Antiquité Expliquée . . .* Paris, 1719.

Montgomery, C. F., and Cole, W. P. (*Eds.*). Sheraton's *The Cabiner-Maker and Upholsterer's Drawing Book.* London, 1970.

Montgomery, C. F., and Cole, W. P. (*Eds.*). Sheraton's *The Cabinet Dictionary.* London, 1970.

Monumens Égyptiens, consistant en obélisques, pyramides, chambres sépulchrales, statues, etc., *le tout gravé sur deux cens planches avec leurs explications historiques.* Rome, 1791.

Morenz, S. *Die Geschichte von Joseph dem Zimmermann.* Berlin, 1951.

Morenz, S. 'Der Gott auf der Blume' *Artibus Asiae.* Ascona, 1954.

Morenz, S. *Die Begegnung Europas mit Egypten.* Berlin, 1968.

Morey, C. R. *Early Christian Art.* Princeton, 1942.

Moritz, Carl Philipp. *Die Symbolische Weisheit der Aegypter.* Berlin, 1793.

Mother Mary, and Ware, Kallistos. *The Festal Menaion.* London, 1969.

Mourey, G. 'L'art decoratif', in *Histoire générale de l'art français de la Révolution à nos jours.* Paris, 1922.

Mugnos, Filadelfo. *Historia della Augustissima Famiglia Colonna.* Venice, 1658.

Müller, D. *Aegypten und die griechischen Isis-Aretalogien.* Berlin, 1961.

München, Theatermuseum. *Das Bühnenbild im 19. Jahrhundert.* Munich, 1959.

Münster, M. *Untersuchungen zur Göttin Isis.* Berlin, 1968.

Müntz, E. *Raphael.* Paris, 1881.

Murray, P. *Piranesi and the grandeur of ancient Rome.* London, 1971.

Musgrave, C. *Regency Furniture.* London, 1961.

Musgrave, C. *Royal Pavilion: An Episode in the Romantic.* London, 1959.

Music Review, The.

N . . ., Mr. *Apologie Pour l'Ordre des Francs-Maçons.* The Hague, 1742.

Nash, E. *Pictorial Dictionary of Ancient Rome.* London, 1968.

Naudot, Jean J. *Chansons notées de la très vénérable confrérie des maçons libres.* Berlin, 1746.

Neale, J. P. *Views of Seats of Noblemen and Gentlemen in England, Wales, Scotland, and Ireland.* London, 1818–29.

Nerval, G. de. *Les Filles du Feu.* Paris, 1888.

Nettl, Paul. *Mozart und die königliche Kunst.* Berlin, 1932.

Nettleton's Guide to Plymouth, Stonehouse, Devonport and the Neighbouring County. Plymouth, 1836.

Neufforge, Jean François de. *Recueil élémentaire d'Architecture qui représente divers exemples d'églises et chapelles des grands Bâtiments depuis 12 toises de face jusqu'à 120 plusieurs décorations d'apartements et salles de spectacles.* Paris, 1757–80.

Neumeyer, Alfred. 'Monuments to "Genius" in German Classicism', *Journal of the Warburg and Courtauld Institutes,* vol. ii, 1938–9.

Newton, Joseph Fort. *The Builders. A story and study of masonry.* London, 1927.

Newton, R. H. *Town and Davis.* New York, 1942.

Nibby, A. *Roma Antica.* London, 1818–20.

Nicander. *Metamorphoses.*

Nichols, J., and Steevens, G. *The Genuine Works of William Hogarth.* London, 1810.

Nicholls, Richard Vaughan. *See* Masson, Olivier.

Nicholls, Richard Vaughan. *See* Budde, Ludwig.

Niebuhr, Carsten. *Reisebeschreibung nach Arabien und andern umliegenden Ländern.* Copenhagen and Hamburg, 1774–1837. (Several English and French editions of the above).

Niehaus, W. *Die Theatermaler Quaglio.* Munich Diss. 1956.

Nielsen, Fredrik. *Frimureriet i Norden.* Copenhagen, 1882.

Niessen, C. *See* Jung, O.

Nilsson, N. M. P. *A History of Greek Religion.* Oxford, 1925.

Nilsson, Sten Åke. 'Pyramid på Gustav Adolfs torg', *Konsthistorisk Tidskrift,* xxxiii, 1–2. Stockholm, 1964.

Noé, L. *Architecture et sculpture en France.* Paris, 1894.

Norden, F. L. *Travels in Egypt and Nubia.* London, 1757.

Normand Fils. *Monumens Funéraires choisis dans les Cimetières de Paris et des Principaux Villes de France, Dessinés, Gráves et Publiés Par Normand Fils.* Paris, 1832.

Norman's New Orleans and Environs. New Orleans, 1845.

North American Review, The. Boston and New York, 1815–81.

Nowinski, Judith. *Baron Dominique Vivant Denon.* Rutherford, Madison, Teaneck, 1970.

Oechslin, Werner. 'Pyramide et Sphère. Notes sur l'Architecture Révolutionnaire du XVIIIᵉ Siècle et ses Sources Italiennes', *Gazette des Beaux-Arts,* April, 1971.

Oncken, Alste. *Friedrich Gilly, 1772–1800.* Berlin, 1935.

Onofrio, C. d'. *Gli Obelischi di Roma.* Rome, 1965.

Orange, H. P. L'. *Studies on the Iconography of Cosmic Kingship in the Ancient World.* Oslo, 1953.

Orliac, J. d'. *The Moon Mistress.* London, 1931.

Orsini-Rosenberg, Justine. *Alticchiero, par Madᵉ J(ustine) W(ynne) C(omtesse) D(e) R(osenberg).* Padua, 1787. Edited by Count Benincasa, with plates.

Osborne, Harold. *The Oxford Companion to Art.* Oxford, 1970.

Otto, W. G. A. *Priester und Tempel im hellenistischen Aegypten.* Leipzig and Berlin, 1905–8.

Owen, Robert Dale. *Hints on Public Architecture.* New York, 1849.

Panofsky, E. *Albrecht Dürer.* Princeton, 1943.

Papadopoulos-Kerameus, A. I. *Varia Graeca Sacra.* St Petersburg, 1907.

Papworth, Wyatt. *J. B. Papworth.* London, 1879.

Papworth, Wyatt (Ed.). *The Dictionary of Architecture.* London, 1852–92.

Paribeni, Roberto. *The Villa of the Emperor Hadrian at Tivoli.* Milan, n.d.

Paribeni, Roberto. *Le terme di Diocleziano e il Museo nationale romano.* Milan, 1922.

Parker, John Henry. *A Glossary of Terms used in Grecian, Roman, Italian, and Gothic Architecture.* Oxford, 1850.

Parker, J. M. *Rochester.* Rochester, 1884.

Patte, Pierre. *Mémoires sur les objets les plus importans de l'architecture.* Paris, 1769.

Patte, Pierre. *Monumens érigés en France à la gloire de Louis XV.* Paris, 1765.

Pauli, G. *Die Kunst des Klassizismus und der Romantik.* Berlin, 1925.

Pauw, Cornelius de. *Recherches Philosophiques sur les Égyptiens et les Chinois.* Paris, 1773.

Pauw, Joannes Cornelius de. *Horapollonis Hieroglyphica.* Trajecti ad Rhenum, 1727.

Peake, A. S. *A Commentary on the Bible.* London, 1919.

Peck, W. *Isishymnus von Andros, und verwandete Texte.* Berlin, 1930.

Pendlebury, J. D. S. *Aegyptiaca: A Catalogue of Egyptian Objects in the Aegean Area.* Cambridge, 1930.

Penny, Nicholas. *Church Monuments in Romantic England.* New Haven and London, 1977.

Penny Magazine, The. London, 1832–45.

Percier, Charles, and Fontaine, P.-F. *Recueil de Décorations Intéreures.* Paris, 1801.

Pérouse de Montclos, Jean-Marie. *Etienne-Louis Boullée (1728–1798).* Paris, 1969.

Perrot, Georges and Chipiez, Charles (translated by Armstrong and Gonio). *A History of Art in Ancient Egypt.* London, 1883.

Petrie, W. M. Flinders. *Egypt and Israel.* London, 1925.

Pevsner, Nikolaus (with Lang, S.). 'The Egyptian Revival', *The Architectural Review,* vol. cxix (1956), pp. 242–54. Later published in *Studies in Art, Architecture and Design.* London, 1968.

Pevsner, Nikolaus. *A History of Building Types.* London, 1976.

Pevsner, Nikolaus. 'Pedrocchino and Some Allied Problems', *The Architectural Review,* vol. cxxii (1957).

Pevsner, Nikolaus. *Some Architectural Writers of the Nineteenth Century.* London, 1972.

Pevsner, Nikolaus. *The Buildings of England* Series. Harmondsworth, various years. *See* References.

Peyre, Marie-Joseph. *Oeuvres d'architecture.* Paris, 1795.

Picart, Bernard. *Cérémonies et coutumes religieuses de tous les peuples du Monde.* Paris, 1728.

Pierson, A. T. C., and Steinbrenner, Godfrey, W. *The Traditions, Origin and Early History of Freemasonry.* New York, 1885.

Pignorius, L. *Mensa Isiaca, qua sacrorum apud Aegyptios ratio et simulacra.* Amsterdam, 1669.

Pijoan, Joseph. *History of Art.* London, 1933.

Piranesi, Giovanni Battista. *Diverse Maniere d'adornare i Cammini.* Rome, 1769.

Piranesi, Giovanni Battista. *Le Antichità Romane di Giambatista Piranesi, Architetto Veneziano.* Rome, 1756.

Piranesi, Giovanni Battista. *Della magnificenza ed architettura de' romani.* Rome, 1761.

Plon, E. *Thorvaldsen, his Life and Work*. London, 1874.

Plutarch. *Parallel Lives*.

Plutarch. *De Iside et Osiride*.

Pococke, Richard. *Observations on Egypt*. London, 1743.

Poggio Bracciolini, Gian Francesco. *Poggii Opera*. Basle, 1538.

Poils, J. *See* Dens, Ch.

Poracchi, Thomas. *Funerali antichi de diversi popoli et nationi forma ordine et pompa di sepolture di esseque di consecrationi antiche et d'altro. Con le figure in rami di Girolamo Porro padouana*. Venice, 1574.

Porter, B., and Moss, R. L. B. *Topographical Bibliography of Ancient Egyptian Hieroglyphic Texts, Reliefs, and Paintings*. Oxford, 1927.

Posner, Oskar. *Bilder zur Geschichte der Freimaurerei*. Reichenberg, 1927.

Potterton, Homan. *Irish Church Monuments*. Belfast, 1975.

Praz, M. *An Illustrated History of Interior Decoration*. London, 1964.

Praz, M. *On Neoclassicism*. London, 1969.

Preger, T. *Scriptures Originum Constantinopolitanarum*. Leipzig, 1901.

Prieur, A.-P., and Cléemputte, P.-L. van. *Collection des Prix que la ci-devant Académie d'Architecture proposoit et couronnoit tous les ans*. Paris, 1787–c.96.

Publications of the American Jewish Historical Society. *See* References.

Pugin, A. Welby. *An Apology for The Revival of Christian Architecture in England*. London, 1843.

Pyne, W. *The History of the Royal Residences*. London, 1819.

Quibell, J. E. (*Ed.*). *Studies presented to F. Llewellyn Griffith*. London, 1932.

Quincey, Thomas De. *Collected Writings*. Edinburgh, 1890.

Quincy, Antoine Chrysostome Quatremère de. *De L'Architecture Egyptienne, Considérée Dans son origine Ses principes et son goût, et comparée Sous les mêmes rapports à L'Architecture Grecque. DISSERTATION Qui à remporté, en 1785, Le Prix proposé par L'Académie des Inscriptions et Belles-Lettres*. Paris, 1803.

Quincy, Antoine Chrysostome Quatremère de. *Historie de la vie et des ouvrages des plus célèbres architectes du XI^e Siècle jusqu'à la fin du XVIII^e*. Paris, 1830.

Ramsay, W. M. *Pauline and other Studies*. London, 1906.

Randall, James. *Architectural Designs for Mansions, Villas, Lodges, and Cottages*. London, 1806.

Raval, M. *C.-N. Ledoux*. Paris, 1945.

Rave, P. O. *Karl Friedrich Schinkel*. Munich and Berlin, 1953.

Raynouard, F. J. M. *Les templiers. Tragédie. Précédée d'un précis historique sur les templiers*. Paris, 1805.

Reade, Brian. *Regency Antiques*. London, 1953.

Reitzenstein, Richard. *Die hellenistischen Mysterien religionen nach ihren Grundgedanken und Wirkungen*. Darmstadt, 1956.

Ricci, C. *La Scenografia Italiana*. Milan, 1930.

Rietdorf, Alfred. *Friedrich Gilly, Wiedergeburt der Architektur*. Berlin, 1940.

Rimmer, W. G. *Marshalls of Leeds*. Cambridge, 1960.

Robison, John. *Proofs of a Conspiracy against all the Religions and Governments of Europe, carried on in the secret meetings of Free Masons, Illuminati, and Reading Societies*. Edinburgh, 1797.

Rodd, J. R. *The Customs and Lore of Modern Greece*. London, 1892.

Roeder, G. *Urkunden zur Religion des alten Aegypten*. Jena, 1923.

Roeder, G. *Die Denkmäler des Pelizaeus-Museums*. Berlin, 1921.

Roos, Frank J. 'The Egyptian Style', *Magazine of Art*, vol. xxxiii, 1940.

Roscher, W. H. *Ausführliches Lexikon für griechische und römische Mythologie*. Leipzig, 1882–1921.

Rosenau, Helen. *Boullée and Visionary Architecture*. London, 1976.

Rosenau, Helen. *Boullée's Treatise on Architecture*. London, 1953.

Rosenau, Helen. 'The Engravings of the Grands Prix of the French Academy of Architecture', *Architectural History*, iii, 1960.

Rosenau, Helen. *The Ideal City. Its Architectural Evolution*. London, 1974.

Rosenau, Helen. *Social Purpose in Architecture. Paris and London Compared 1700–1800*. London, 1970.

Rosenberg, Alfons. *Die Zauberflöte, Geschichte und Deutung von Mozarts Oper*. Munich, 1964.

Rosenblum, Robert. *Transformations in Late Eighteenth Century Art*. Princeton, 1969.

Rostortzev, M. I. *The Social and Economic History of the Hellenistic World*. Oxford, 1941.

Rothman, David J. *The Discovery of the Asylum*. New York, 1971.

Rouge, Georges-Louis Le. *Description du Colisée, élevé aux Champs-Elysées sur les dessins de M. Le Camus*. Paris, 1771.

Roullet, Anne. *The Egyptian and Egyptianizing Monuments of Imperial Rome.* Leiden, 1972.

Rousseau. *See* Marty.

Roussel, P. *Les cultes Egyptiens à Délos.* Paris and Nancy, 1915–16.

Routledge's Guide to the Crystal Palace.

Rusch, A. *De Sarapide et Iside in Graecia cultis.* Berlin, 1906.

S . . . M.; R.: de, Le F.: *La Maçonnerie, considérée comme le résultat des religions égyptienne, juive et chrétienne.* Paris, 1833.

St A . . ., M. P. *Promenade aux Cimetières de Paris, aux Sépultures Royales de Saint-Denis, et aux Catacombes, etc.* Paris, c. 1820.

Saint-Maux, Charles-François Viel de. *Principes de l'ordonnance et de la construction des bâtiments.* Paris, 1797.

Saint-Maux, Charles-François Viel de. *Décadence de l'architecture à la fin du 18ᵉ siècle.* Paris, 1800.

Saint-Non, Jean Claude Richard de. *Voyage pittoresque ou description des royaumes de Naples et de Sicile.* Paris, 1781–6.

Saintyres, P. *S. Christophe, successeur d'Anubis, d' Hermès, et d'Héraclès.* Paris, 1936.

Salandra, Serafino della. *Adamo Caduto.* Cosenza, 1647.

Sandman, M. Holmberg. *The God Ptah.* Lund, 1946.

Sandys, George. *Relation of a Journey, Begun Anno Domini 1610.* London, 1615.

Sass, Else Kai. *Thorvaldsens Portraetbuster.* Copenhagen, 1963-5.

Savreux, M. *Le biscuit de Sèvres.* Paris, 1923.

Saxl, Fritz. 'The Appartamento Borgia' in *Lectures.* London, 1957.

Sbordone, F. *Hori Apollonis Hieroglyphica.* Naples, 1940.

Schefer, C. (*Ed.*). *Le Voyage d'outremer de Jean Thenaud.* Paris, 1884.

Schefold, C. *Orient, Hellas, und Rom.* Bern, 1949.

Schefold, C. *Vergessenes Pompeji.* Munich, 1962.

Schéle, S. *Cornelis Bos.* Stockholm, 1965.

Schiffman, G. A. *Die Freimaurerei in Frankreich in der ersten Hälfte des XVIII Jahrhunderts.* Leipzig, 1881.

Schlosser, J. von. *Kunst- und Wunderkammern der Spätrenaissance.* Leipzig, 1908.

Schmitz, H. *Berliner Baumeister vom Ausgang des Achtzehten Jahrhunderts.* Berlin, 1914.

Schmitz, H. *Deutsche Möbel des Klassizismus.* Stuttgart, 1922.

Scholz, J. *Baroque and Romantic Stage Design.* New York, 1950.

Schütz, F. W. von. *Versuch einer vollstaendigen Sammlung Freimaurer – Lieder zum Gebrauch der Loge Christian zum Palmbaum in Kopenhagen.* Hamburg, 1790.

Scott, J. *Piranesi.* London, 1973.

Scullard, H. H. *From the Gracchi to Nero.* London, 1959.

Sedlmayr, Hans. *Johann Bernhard Fischer von Erlach.* Munich, 1956.

Sedlmayr, Hans. *Verlust der Mitte.* Salzburg, 1948.

Seel, Heinrich. *Die Mithrageheimnisse während der vor- und urchristlichen Zeit; historisch, kritisch, exegetisch dargestellt in der Geschichte der antiken Religionen wie im Tempelleben der alten Priester.* Aarau, 1823.

Semper, Hans. *Gottfried Semper. Ein Bild seines Lebens und Wirkens.* Berlin, 1880.

Seng, Nikolaus. *Selbstbiographie des P. Athanasius Kircher aus der Gesellschaft Jesu.* Fulda, 1901.

Serlio, Sebastiano. *Tutte l'Opere d'Architettura.* Venice, 1584.

Serlio, Sebastiano. *Livre extraordinaire de Architecture.* Lyon, 1551.

Sèvres, Musée National de Céramique. *Les Grands Services de Sèvres.* Paris, 1951.

Seyffert, Oskar. *A Dictionary of Classical Antiquities.* London and New York, 1899.

Seznec, J. *Survival of the Pagan Gods.* New York, 1953.

Shaw, Edward. *The Modern Architect.* Boston, 1855.

Sheppard, F. H. W. (*Ed.*). *Survey of London. The Parish of St Mary Lambeth,* vol. 26. London, 1956.

Sheppard, F. H. W. (*Ed.*). *Survey of London. Northern Kensington,* vol. 37. London, 1973.

Sievers, J. *Karl Friedrich Schinkel – Die Möbel.* Berlin, 1950.

Simond, Louis. *The Journal of a Tour and Residence in Great Britain during the Years 1810 and 1811.* London, 1817.

Singer, D. W. *Giordano Bruno, His Life and Thought.* New York, 1950.

Sirén, O. *China and the Gardens of Europe.* New York, 1950.

Skalicki, W. 'Das Bühnenbild der Zauberflöte', *Maske und Kothurn,* 2, 1956.

Sky, Alison, and Stone, Michelle. *Unbuilt America.* New York, 1976.

Smith, George. *Smith's Cabinet-Maker's & Upholsterer's Guide, Drawing Book, and Repository of New and Original Designs for Household Furniture and Interior Decoration in the most approved and modern taste; including specimens of the Egyptian, Grecian, Gothic, Arabesque, French, English, and other schools of the art.* London, 1826.

Smith, George. *A Collection of Designs for Household Furniture and Interior Decoration.* London, *c.* 1808.

Smith, H. Clifford. *Buckingham Palace.* London, 1931.

Smith, J. Jay. *See* Walter, Thomas U.

Smith, Oliver P. *The Domestic Architect.* New York, 1854.

Smith, William. *A Dictionary of the Bible.* London, 1863.

Snijder, G. A. S. *De forma matris cum infante sedentis.* Utrecht, 1920.

Soane, John. *Designs in Architecture.* London, 1778.

Soane, John. *Lectures on Architecture.* London, 1929.

Soane, John. *Plans, Elevations, and Sections of Buildings.* London, 1788.

Sommervogel, Carlos. *Bibliothèque de la Compagnie de Jésus.* Brussels and Paris, 1898.

Spartianus, Aelianus. *Scriptores Historiae Augustae.*

Spencer, E. P. *See* Howland, Richard H.

Spencer, J. R. (*Ed.*). *Filarete's Treatise on Architecture.* New Haven and London, 1965.

Sperlich, Hans G. *Phantastische Architektur.* Stuttgart, 1960.

Stampfle, F. 'An unknown group of drawings by G. B. Piranesi', *Art Bulletin,* June, 1948.

Starck, Johm. Aug. von. *Uber die alten und neuen Mysterien.* Berlin, 1782.

Starr, C. G. *The Roman Imperial Navy.* Ithaca, New York, 1941.

Statham, H. Heathcote. *A History of Architecture.* London, 1950.

Steinbrenner, Godfrey W. *See* Pierson, A. T. C.

Steiner, Rudolf. *Isis und Madonna.* Dornach, 1980.

Stewart, Cecil. *A Prospect of Cities.* London, 1952.

Stillman, D. 'Robert Adam and Piranesi', in *Essays in the History of Architecture presented to Rudolf Wittkower.* (Fraser, D. *Ed.*) London, 1967.

Stone, Michelle. *See* Sky, Alison.

Strang, John *Necropolis Glasguensis with Osbervations* (sic) *on Ancient and Modern Tombs and Sepulture.* Glasgow, 1831.

Stroud, Dorothy. *George Dance, Architect.* London, 1973.

Stuart J., and Revett, N. *The Antiquities of Athens.* London, 1762–1816.

Suetonius (Gaius Suetonius Tranquillus). *De Vita Caesarum.*

Summerson, John. *Architecture in Britain, 1580–1830.* Harmondsworth, 1953.

Summerson, John. *Sir John Soane.* London, 1952.

Sumner, George. *The Pennsylvania System of Prison Discipline Triumphant in France.* Philadelphia, 1847.

Symonds, R. W. 'Thomas Hope and the Greek Revival', *The Connoisseur,* vol. cxl, 1957.

Tarn, W. W. (Griffith, G. T. *Ed.*). *Hellenistic Civilisation.* London, 1952.

Tatham, Charles Heathcote. *Etchings, representing the best examples of Grecian and Roman Architectural Ornament; Drawn from the Originals, and chiefly collected in Italy, before the late revolutions in that country.* London, 1826.

Tatham, Charles Heathcote. 'A Collection of Manuscript Drawings from Various Antique and other models made in Rome in 1794, 95 and 96'. In the RIBA British Architectural Library Drawings Collection.

Taute, Reinhold. *Maurerische Bücherkunde. Ein Wegweiser durch die Literatur der Freimaurerei mit literarisch-kritischen Notizen und zugleich ein Supplement zu Kloss' Bibliographie.* Leipzig, 1886.

Taylor, René. 'Hermetism and Mystical Architecture in the Society of Jesus'. In Wittkower, Rudolf and Jaffe, Irma B. (*Eds.*) *Baroque Art: the Jesuit Contribution.* New York, 1972.

Terrasson, Jean. *Sethos, historie ou vie tirée des monumens anecdotes de l'ancienne Egypte. Traduite d'un manuscrit grec.* Paris, 1731.

Thieme, U., and Becker, F. *Allgemeines Lexikon der bildenden Künstler.* Leipzig, 1907–50.

Thiéry, Luc-Vincent. *Guide des étrangers.* Paris, 1787.

Thiéry, Luc-Vincent. *Almanach du voyageur.* Paris, 1784.

Thoma, H. *Residenz München.* Munich, 1937.

Thomas, H. *The Drawings of Giovanni Battista Piranesi.* London, 1954.

Thomson, E. A. *The Historical Work of Ammianus Marcellinus.* London, 1947.

Torrey, Harry Beal. 'Athanasius Kircher and the progress of medicine', *Osiris,* vol. 5, 1938.

Tower, F. B. *Illustrations of the Croton Aqueduct.* London and New York, 1843.

Toynbee, J. M. C. *Death and Burial in the Roman World.* London, 1971.

Tran-Tam-Tinh, Vincent. *Essai sur le Culte d'Isis à Pompéi.* Paris, 1964.

Trede, Theodor. *Das Heidentum in der römischen Kirche. Bilder aus dem religiösen und sittlichen Leben Süditaliens.* Gotha, 1889–91.

Trencsényi-Waldapfel, I. *Untersuchungen zur Religiongeschichte.* Amsterdam, 1966.

Truman, Charles. 'Emperor, King and Duke', *The Connoisseur,* vol. 202, no. 813 (November 1979), pp. 148–55.
Tschudin, P. F. *Isis in Rom.* Aarau, 1962.
Tuthill, Mrs Laurie C. H. *History of Architecture.* New York, 1844.

Udy, D. *Neo-Classical Works of Art.* London, 1966.
Udy, D. 'The Neo-Classicism of Charles Heathcote Tatham', *The Connoisseur,* vol. clxxvii, 1971.
Usener, H. *Legenden der heiligen Pelagia.* Bonn, 1879.

Vacquier, J. *Les Vieux Hôtels de Paris.* Contet, F. (*Ed.*). Paris, 1913.
Vacquier, J. *Le Style Empire.* Paris, 1924.
Valadier, G. *Aggiunte e correzioni all' opera sugli edifizi antichi di Roma.* Rome, 1843.
Valeriano Bolzani, Giovanni Pierio, otherwise Pierio Valeriano or Giovanni Pietro delle Fosse. *Hieroglyphica sive de Sacris Ægyptiorum Literis Commentarii.* Basle, 1556.
Valle, Pietro della. *Viaggi.* Venice, 1681. The first edition came out in Rome in 1650.
Vanderbeek, G. *De Interpretatio Graeca van de Isisfigur.* Leuven, 1946.
Vandier, J. *La Religion Egyptienne.* Paris, 1949.
Vaudoyer, A.-L.-T. See Allais, L.-J., and Baltard, L.-P.
Vaux, Richard. *The Pennsylvania Prison System.* Philadelphia, 1884.
Venditti, A. *Architettura neoclassica a Napoli.* Rome, 1961.
Venturi, A. *Storia dell' Arte Italiana.* Milan, 1904.
Verlet, P., Grandjean, S., and Brunet, M. *Sèvres.* Paris, 1953.
Vermeule, Cornelius C. *Transactions of the American Philosophical Society.* 1966.
Vidman, S. *Sylloge Inscriptionum Religionis Isiacae et Sarapiacae.* Berlin, 1969.
Vighi, Roberto. *Villa Hadriana.* Rome, 1959.
Vignola, J. Barozzio da. *Regola delli cinque ordini d'architettura.* Rome, 1763.
Visconti, E. *Museo Pio-Clementino.* Rome, 1784.
Vita del Venerabile servo di Fra Egidio da S. Giuseppe laico professo alcontarino. Naples, 1876.
Vogel, H. 'Aegyptisierende Baukunst des Klassizismus', *Zeitschrift für Bildende Kunst,* vol. xlii (1928–9), pp. 160–5.
Volkmann, L. *Bilderschriften der Renaissance: Hieroglyphik und Emblematik in ihren Beziehungen und Fortwirkungen.* Leipzig, 1923.
Volkmann, L. *Bilderschriften der Renaissance.* Nieuwkoop, 1962.
Vossnack, Liese Lotte. *Pierre Michel d'Ixnard.* Remscheid, 1938.

Waite, A. E. *A New Encyclopaedia of Freemasonry.* London, 1921. New revised edition. New York, 1970.
Walker, David. See Gomme, Andor.
Walker, David. 'Cairness House, Aberdeenshire'. *Country Life.* Vol. no. cxlix. 28 January and 4 February 1971.
Walpole, Horace. *Anecdotes of Painting in England.* London, 1786. Fourth Edition. Volume IV especially.
Walter, Thomas U., and Smith, J. Jay. *Two Hundred Designs for Cottages and Villas.* Philadelphia, 1846.
Walters, H. B. *The Art of the Greeks.* London, 1934.
Ward, William Henry. *The Architecture of the Renaissance in France.* New York, 1926.
Ward-Perkins, John, and Claridge, Amanda. *Pompeii AD 79.* London, 1976.
Ward-Perkins, John. *See* Boëthius, Axel.
Ware, Kallistos. *See* Mother Mary.
Watkin, David. *Thomas Hope 1769–1831 and the Neo-Classical Idea.* London, 1968.
Watzdorf, E. von. *Johann Melchior Dinglinger.* Berlin, 1962.
Weber, W. *Aegyptisch-griechische Götter im Hellenismus.* Groningen, 1912.
Wellen, G. A. *Theotokos.* Utrecht, 1961.
Wellesley, Lord Gerald. 'Regency Furniture', *Burlington Magazine,* vol. lxx, 1937.
Wessely, C. *Neue griechischer Zauberpapyri.* Vienna, 1893.
Westcott, W. Wynn. *The Isiac Tablet or the Bembine Table of Isis.* Los Angeles, 1976. A Reprint of the 1887 edition.
Westmacott, C. M. *British Galleries of Painting and Sculpture.* London, 1824.
Whistler, L. *The Imagination of Vanbrugh.* London, 1954.
Whitaker, H. *Practical Cabinet Maker and Upholsterer's Treasury of Designs.* London, 1847.
Whitrow, M. (*Ed.*). *Isis Cumulative Bibliography.* London, 1971.
Wightwick, George. Drawings in the RIBA British Architectural Library.
Wilkinson, J. G. *Manners and Customs of the Ancient Egyptians.* London, 1837.

Willard, S. *Plans and Sections of the Obelisk on Bunker's Hill.* Boston, 1843.

Willson, Thomas. *The Pyramid. A General Metropolitan Cemetery to be Erected in the Vicinity of Primrose Hill.* London, 1842.

Wilmowsky, Tilo Freiherr von. *Der Hügel.* Essen, 1978.

Wilson, R. M. *The Gospel of Philip.* London, 1962.

Wilson, Samuel. *A Guide to the Architecture of New Orleans 1699–1959.* New York, 1959.

Wilton-Ely, John. *Piranesi.* A Catalogue of the 1978 Arts Council Exhibition. London, 1978.

Wilton-Ely, John. *The Mind and Art of Giovanni Battista Piranesi.* London, 1978.

Wilton-Ely, John. (*Ed.*) *Giovanni Battista Piranesi. The Polemical Works.* London, 1972.

Winckelmann, Johann Joachim. *Gedanken über die Nachahmung der Griechischen Werke in der Malerey und Bildhauerkunst.* Dresden & Leipzig, 1756.

Winckelmann, Johann Joachim. *Monumenti antichi inediti spiegati ed illustrati.* Rome, 1767.

Wind, E. *Studies in Art and Literature for Bella de Costa Greene.* Princeton, 1954.

Winnefeld, H. 'Die Villa des Hadrian', *Jahrbuch deutschen Archäol. Inst.,* Berlin, 1895.

Winter, E. *See* Junker, H.

Wischnitzer, R. 'The Egyptian Revival in Synagogue Architecture', *Publications of the American Jewish Historical Society,* vol. xli, 1951–2.

Wischnitzer, R. *Synagogue Architecture in the United States.* Philadelphia, 1955.

Witt, R. E. 'The Importance of Isis for the Fathers', *Studia Patristica VIII.* Berlin, 1966, pp. 135–45.

Witt, R. E. *Isis in the Graeco-Roman World.* London, 1971.

Witt, R. E. 'Isis-Hellas'. *Proceedings of the Cambridge Philological Society.* Cambridge, 1966.

Wittkower, R. *Architectural Principles in the Age of Humanism.* London, 1965.

Wittkower, R. *Studies in the Italian Baroque.* London, 1975.

Wittkower, R. 'Piranesi's "Parere su l'architetture" ', *Journal of the Warburg and Courtauld Institutes,* vol. ii, 1938–9.

Wolfers, Nancy, and Mazzoni, Paolo. *La Firenze di Giuseppi Martelli (1792–1876). L'architettura della città fra ragione e storia.* Catalogue of the Exhibition in the *Museo di Firenze com'era.* Florence, 1980.

Wollin, Nils Gustaf. *Desprez en Italie.* Malmö, 1935.

Wollin, Nils Gustaf. *Desprez en Suède.* Stockholm, 1939.

Wollin, Nils Gustaf. *Les Gravures originales de Desprez.* Malmö, 1933.

Wolzogen, A. von. *Aus Schinkels Nachlass.* Berlin, 1864.

Woods, G. B. 'Egyptian Temple at Leeds', *Country Life,* vol. cxxviii, 1960.

Wynne, Justine. *See* Orsini-Rosenberg.

Yale Classical Studies.

Yates, Frances A. *The French Academies of the sixteenth century.* London, 1947.

Yates, Frances A. *Giordano Bruno and the Hermetic Tradition.* London, 1964.

Yates, Frances A. *The Rosicrucian Enlightenment.* London and Boston, 1972.

Zeitschrift für ägyptische Sprache und Alterthumskunde. Leipzig, from 1863.

Zeitschrift für Bildende Kunst. Especially 1928–9.

Ziller, H. *Schinkel.* Bielefeld and Leipzig, 1897.

Zoo. Uitgave van de Koninklijke Maatschappij voor Dierkunde van Antwerpen. See References.

Zucker, P. *Die Theaterdekoration des Klassizismus.* Berlin, 1925.

Index